FLORA
ILLUSTRATA

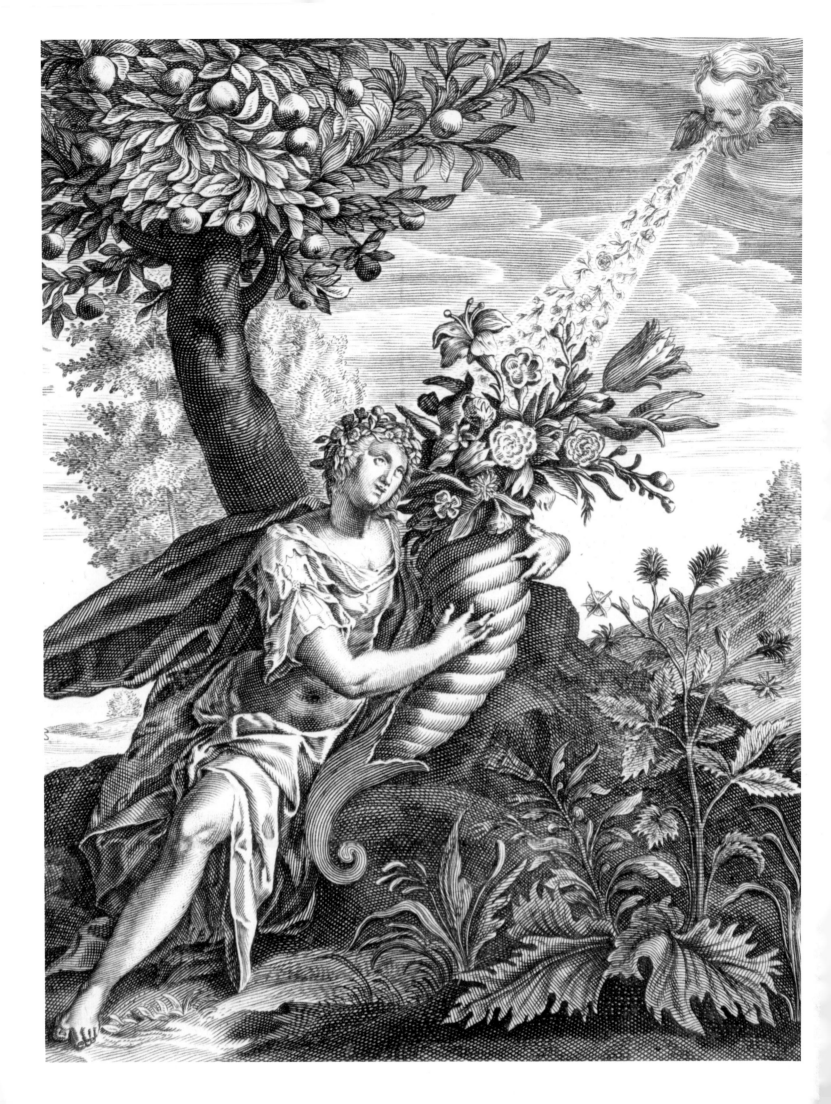

FLORA ILLUSTRATA

GREAT WORKS *from the*
LuESTHER T. MERTZ LIBRARY *of*
THE NEW YORK
BOTANICAL GARDEN

EDITED BY SUSAN M. FRASER AND VANESSA BEZEMER SELLERS

FOREWORD BY GREGORY LONG

THE NEW YORK
BOTANICAL GARDEN
Bronx, New York

Yale
UNIVERSITY PRESS
New Haven and London

Furthermore:
a program of the J.M.Kaplan Fund

10 9 8 7 6 5 4 3 2 1

Frontispiece: Engraved title page (detail),
in D. H. Cause, *De koninglycke hovenier*,
Amsterdam: Marcus Doornick, 1676.

SUBSCRIBERS

CONTENTS

FOREWORD

A commanding presence in the historic landscape of The New York Botanical Garden, the LuEsther T. Mertz Library is approached by way of the majestic, century-old Tulip Tree Allée, and the building's dramatic Beaux Arts façade provides a frontispiece to the Garden's research campus. This five-acre precinct is also home to the William and Lynda Steere Herbarium, the Lewis B. and Dorothy Cullman Program for Molecular Systematics, the Pfizer Plant Research Laboratory, and many classrooms and offices in which two hundred dedicated individuals—Ph.D. staff botanists, graduate students, college interns, teachers, and visiting scholars from abroad—pursue their plant-oriented professions.

Founded in the 1890s to support the research of a growing community of academic botanists, the Mertz Library today serves plant scientists in disciplines as varied as systematics, ethnobotany, molecular evolutionary studies, and plant genomics, as well as students in many other fields, including horticulture, floriculture, garden design, garden history, the exploration of the New World, botanical illustration, the book arts, land management, and the environmental humanities. Since the early days, we have attempted to collect comprehensively in all

of these areas. Just as botanical gardens have always been institutions in which the arts and sciences are conjoined, so also is this Library a repository of books, manuscripts, digital files, and electronic databases representing these intertwined disciplines.

With well over one million cataloged items and eleven million archival documents in such diverse subject areas, this is the most comprehensive resource about plants under one roof anywhere. The Library holds materials dating from 1190 to today, and they represent eighty-five languages—all the Romance and Slavic, and most Asian languages. In the past decade, millions of pages from the general stacks and thousands of items from the special collections have been digitized and are available through the Biodiversity Heritage Library (http://www.biodiversitylibrary.org), in the creation of which the Garden has played a leadership role.

It is remarkable, of course, that such a major research library has been built over such a relatively short period of time. It has been possible to do so in a single century primarily because of three driving forces: First, we must recognize the high ambitions for the Library

of various New York Botanical Garden chief executives, especially the founding Director, Nathaniel Lord Britton, who worked tirelessly to expand the Library Collections during his thirty-four-year tenure. Second, we have been blessed with fine research librarians with exacting professional standards, particularly, John Hendley Barnhart, librarian and then bibliographer from 1907 to 1942; Elizabeth C. Hall, librarian from 1937 to 1963; Charles Robert Long, librarian from 1972 to 1986; John F. Reed, librarian from 1966 to 1972 and again from 1986 to 2003; and Susan M. Fraser, who has been director since 2004.

The third force has been the stunning American philanthropy that has characterized the Library's dynamic growth and development from the beginning. Most notable among the Garden's founding Board members (the institution was established in 1891) for their support of the Library were Andrew Carnegie and J.P. Morgan. Both luminaries devoted themselves during their long years on the Board of the Garden to the enhancement of the Library. They created the Special Book Fund through their own generosity and fundraising, and this fund supported hundreds of notable purchases in the period before World War I. Andrew Carnegie even participated personally by bidding at auction for important items to be added to the Collections.

In our generation, the Library has been the recipient of tremendous generosity from LuEsther T. Mertz and the Trustees of the LuEsther T. Mertz Charitable Trust. Mrs. Mertz loved literature and the arts, and she had wanted to be a librarian, but circumstances led her to pursue a successful career as a businesswoman, which enabled her to support The New York Botanical Garden and this Library in many magnificent ways. Everyone who cares about plants and the natural world and the literature that documents botany

and horticulture owes to Mrs. Mertz and her Trustees a tremendous debt for their benefactions, which have helped build the Library's fine modern facilities and endowed many aspects of its operation.

Focusing particularly on illustrated books, the subject matter covered in this publication represents some of the great collecting strengths of the LuEsther T. Mertz Library— ancient, medieval, and Renaissance treatises on medicinal plants, as well as books and prints on the history of botany, floristics, European gardens and landscape design, the exploration of the New World, and American horticulture. This volume fills a significant gap in current literature by providing an authoritative new perspective on the history of botanical works relative to plant science, the art of the book, and the culture of gardening.

For their creative work in assembling this set of essays, the Board of the Garden, the Library Visiting Committee, and I wish to thank the editors, Susan M. Fraser and Vanessa Bezemer Sellers. We also wish to thank our friends from both American and European institutions for their fascinating contributions.

This book could not have been published without a major underwriting gift from the LuEsther T. Mertz Charitable Trust, nor would it have come to be without the gifts of the Subscribers, whom we acknowledge. The parallel histories of The New York Botanical Garden and this wonderful Library are full of examples of the ways generous Americans have made it all possible, and once again we have both scholars and philanthropists to thank.

Gregory Long

GREGORY LONG
Chief Executive Officer
The William C. Steere Sr. President
The New York Botanical Garden

PREFACE

Si hortum in bibliotheca habes, deerit nihil
If you have a garden in a library, nothing will be lacking

—CICERO, *Epistulae ad familiares,* BOOK IX, EPISTLE 4, 46 BC

In ascending the grand steps to the elegant central portico of the Mertz Library building, visitors are welcomed by two figures—a scholar and a gardener—that form part of The New York Botanical Garden's official seal (fig. p.1). Supporting a shield decorated with books and plants, they symbolize the dual function of the Botanical Garden as a place for research and horticultural activity, with the Library serving as a conduit of knowledge.

Flora Illustrata marks the 125th anniversary of The New York Botanical Garden, founded in 1891. The LuEsther T. Mertz Library is the vital education center at the heart of the Garden and introduces the general public to the history behind the Collection's important works. This book is meant to raise awareness of the continued availability of the Library as a key resource for the study of plants and their roles in the arts and humanities.

The works found in the Library express the creative effort of the world's preeminent explorers, scientists, publishers, artists, and printmakers across the centuries, as bookmaking and the graphic arts developed in tandem with knowledge of natural history. *Flora Illustrata* examines the Library's holdings in the broadest

sense of the word. The books, manuscripts, and collected ephemera are set within the context of larger cultural and historical events in the ages of botanical discovery, starting from the twelfth century onward.

Naturally one volume cannot provide a complete survey of the entire Collection. The authors and editors have carefully and purposely selected notable works that are representative of specific areas of concentration among the wealth of materials preserved in the historic Mertz Library. We hope that *Flora Illustrata* captures the wonderful experience of spending an afternoon in the intimate Shelby White and Leon Levy Reading Room among the rustling sound of turning pages, the smell of age-worn paper—worlds of wonder emerging from the heavy sheets. On leafing through antique volumes, it quickly becomes apparent that these tomes are not just texts on paper, but works that have lives of their own. Thus, stretching across distance and time, the Collection conveys a sense of the intellectual connectedness with the volumes' previous owners, whose thoughts are still tangible among the pages.

An example of such personal connections is keenly felt when holding the well-fingered

FIG. P.1. The seal of The New York Botanical Garden on the façade of the Library building features a scholar and a gardener, symbolizing the dual function of the Garden as a place for research and plant cultivation.

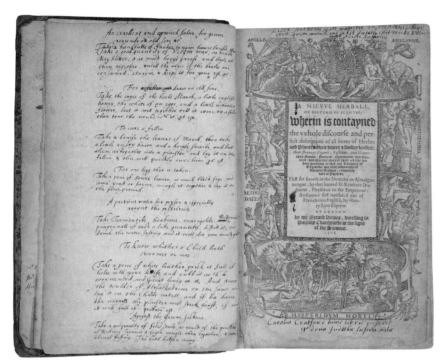

FIG. P.2. Rembert Dodoens'
Nievve Herball in its
1578 English translation
is filled with centuries-old
annotations by previous
owners, adding life to the
pages of the book.

encourages the reader to remember this
traditional interdependency, which benefitted
both—art fostering science, science fostering art.

This volume is divided in five parts, framed
by two "bookends," which focus on the creation
of the Garden's Library Collection and the
Garden's Landscape Records, respectively.
The narrative begins in New York, unfolds in
Europe, and continues across the ocean
into South America, traveling northward
to complete its journey, again at The New York
Botanical Garden.

Several commonly shared themes
recur throughout the book, in particular
the widespread exchange of botanical and
horticultural knowledge; the historical
progress leading to the improved identification
and representation of plants; related new
printing and publishing techniques; and
the key role of artists, both men and women,
in the advancement of botany. Along the way
one becomes acquainted with a group of
indefatigable explorers who had a lasting impact
on the botanical arts and sciences: Carolus
Linnaeus, Mark Catesby, André and François-
André Michaux, as well as artists Georg
Dionysius Ehret and Pierre-Joseph Redouté.
Included among them are several American
protagonists, especially William Bartram,
David Hosack, Andrew Jackson Downing, and
John Torrey.

By illuminating the histories of botanical
exploration, horticultural progress, and garden
design represented in the Collection of the
LuEsther T. Mertz Library, we trust *Flora
Illustrata* will give new emphasis to the shared
scientific importance and aesthetic beauty of
plants, flowers, and gardens and the remarkable
fascination they have held throughout the ages
for botanist and layperson alike.

SUSAN M. FRASER and
VANESSA BEZEMER SELLERS, *Editors*

1578 leather-bound English edition of Flemish
physician Rembert Dodoens' famous *Nievve
Herball* (fig. p.2), translated by Henry Lyte—the
very man who taught English to the botanist
Carolus Clusius. One can well imagine Queen
Elizabeth I, to whom this book was dedicated,
consulting her own copy at court. Herbals
were second only in importance to the Bible in
households of the era, and were handed down by
generations of proud owners, each leaving notes
on useful remedies in the margins. One can find
recipes for "precious oyles" to "drive poison
from the hart," to heal "greene slimy wounds," or
how to ascertain "whither a child hath worms
or not." Scrawled beneath these remedies is yet
the most stern, if heartfelt, admonition added in
the year 1635: "Live here today as if tomorrow
death were for to come and take away thy breath."
This annotation is just one of the hundreds of
untold stories waiting to be discovered.

Flora Illustrata contains eleven essays written
by an international group of experts. Their
contributions collectively reveal the close
relationship between the arts and sciences,
harking back to the Early Modern Period when
the various disciplines, now independent
studies, were still interwoven. *Flora Illustrata*

ACKNOWLEDGMENTS

The preparation of this book involved the cooperation of the entire LuEsther T. Mertz Library staff, as well as the assistance of colleagues from many other departments in The New York Botanical Garden. Every step of the way, we had the benefit of the administrative talents and logistical efficiency of Linda DeVito, who alleviated our tasks in ways too numerous to mention. We are most grateful for her dedication and cheerful demeanor. We are also indebted to Stephen Sinon, who provided the visual material from the Garden's Archives for the various essays, especially the contribution highlighting the historical development of The New York Botanical Garden. His remarkable archival knowledge and creative input were essential to the whole project.

The staff of the Conservation Department, Olga Marder, Kelsey Miller, and Catherine Stephens, deserve special recognition not only for preparing numerous books and objects for photography, but also for their expert restoration work, bringing back to life several important old books, prints, and maps. Many thanks go to Ivo M. Vermeulen, the Garden's dedicated photographer, who, accommodating a tight schedule, took a large number of excellent photographs.

During the research and preparation of this volume, hundreds of books were pulled from the shelves and carefully reshelved. For that we thank the Library assistants Luis Serrano, Holly Birk, and Deanna Korey. We also wish to thank the catalogers, Lisa Studier and Yumi Choi, for improving the catalog documentation, especially where inconsistent records hampered efficient research.

We are much indebted to the individuals who kindly read and commented on the manuscript during its various stages of completion, especially Jane Dorfman, as well as Bobbi Angell, Todd Forrest, Noel Holmgren, Marie Long, Stephen Massey, Robbin Moran, Rob Naczi, and Donald Wheeler. Their suggestions have made this book more complete. Sally Armstrong Leone generously reviewed the manuscript and her eagle eye caught many inconsistencies. We owe thanks to Mia D'Avanza, who, with intern Delia Grizzard, carefully researched and checked many bibliographical references. Along the way we were also assisted by Marilan Lund, Jane Lloyd, Alan Steinfeld, Terry Skoda, Mark Pfeffer, and Paul Silverman.

Our sincere appreciation is extended to David Andrews and James Reveal for sharing their knowledge and expertise on the history of

the plants and publications relating to American botany. Elizabeth S. Eustis deserves special mention, not only for contributing *two* essays to this volume, but also for her help in developing the original concept for the Mertz Library publication project.

We are thankful to the LuEsther T. Mertz Charitable Trust for providing the initial funds for this undertaking. Finally, we are profoundly grateful to Gregory Long, whose valuable insights and tireless commitment contributed to the realization of this project.

ILLUSTRATIONS

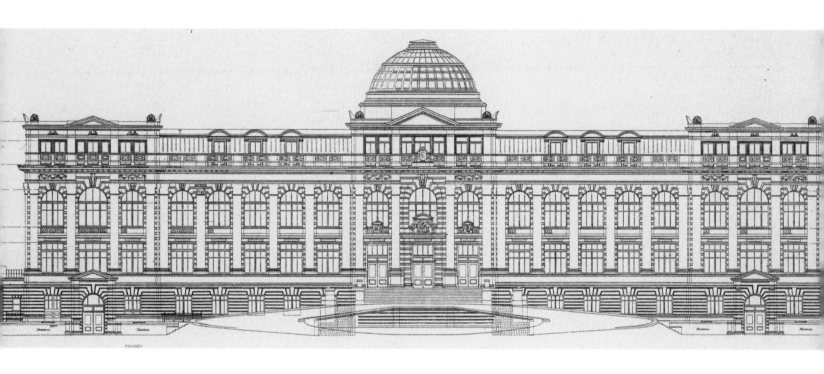

THE

Tasked with preserving the world's botanical and

LIBRARY

horticultural heritage and serving as a testament to

OF THE

the early visionary founders of the Garden,

NEW YORK

the LuEsther T. Mertz Library is a unique repository

BOTANICAL

of knowledge, containing seminal scientific works

GARDEN

of botany, horticulture, and plant exploration.

Photograph of a blueprint by Robert W. Gibson, ca. 1896,
showing the principal façade of the Library building.

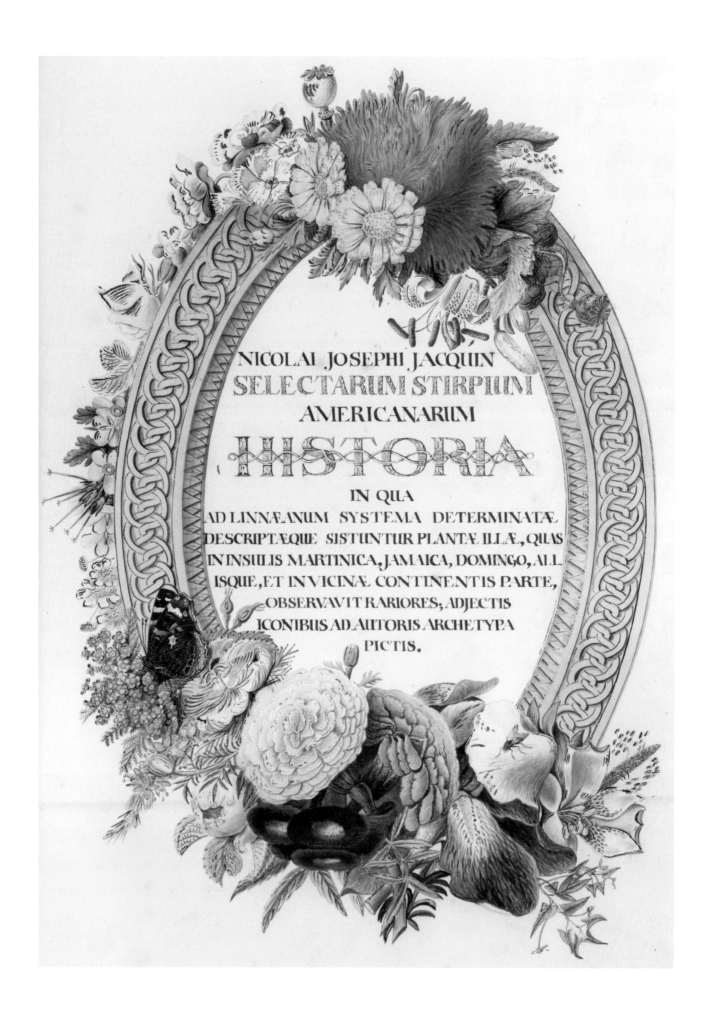

NICOLAI JOSEPHI JACQUIN
SELECTARUM STIRPIUM
AMERICANARUM
HISTORIA
IN QUA
AD LINNÆANUM SYSTEMA DETERMINATÆ
DESCRIPTÆQUE SISTUNTUR PLANTÆ ILLÆ, QUAS
IN INSULIS MARTINICA, JAMAICA, DOMINGO, ALL.
ISQUE, ET IN VICINÆ CONTINENTIS PARTE,
OBSERVAVIT RARIORES; ADJECTIS
ICONIBUS AD AUTORIS ARCHETYPA
PICTIS.

NOBLE SCIENCE: BUILDING THE LIBRARY COLLECTION

SUSAN M. FRASER

The visionary founders of The New York Botanical Garden understood the important role scholarship would play in the development of a public garden and placed equal emphasis on establishing its three main collections: the living plants in the landscape and glasshouses, the Herbarium, and of course, the Library. For more than a century, the LuEsther T. Mertz Library, so named in 2002, has developed into a treasury of knowledge about the plant world and the role plants have played in the cultural and scientific endeavors of humankind.

The inscription on the cornerstone of the Library building reads: "Erected for the New York Botanical Garden by the City of New York for the Advancement of Botanical Knowledge."[1] More than eight centuries of this knowledge, from the twelfth century to the present, can be found in the Mertz Library in the form of books, manuscripts, and printed images offering

FIG. 1.10. Nikolaus Joseph Jacquin was the first Linnaean botanist to explore the New World. His findings were published in Vienna in 1763 under the title *Selectarum stirpium Americanarum historia*. The second edition (ca. 1780), issued as a luxurious hand-colored, limited edition, features individually painted title pages attributed to the renowned botanical artists Franz and Ferdinand Bauer.

a complete overview of the most beautiful and pioneering botanical and horticultural works ever created.

It all started in 1885 when Henry Hurd Rusby (1855–1940), Professor of Materia Medica at Columbia College, began leading collecting trips to South America. Upon returning with botanical specimens from Bolivia, Rusby and his colleague Nathaniel Lord Britton (1859–1934), Professor of Botany at Columbia College, realized they lacked the literature necessary to identify the newly collected plants. To resolve this problem, Britton and his wife, Elizabeth Knight Britton (1858–1934), traveled to England to visit the Royal Botanic Gardens in Kew, where they used the herbarium and library to study the plants Rusby had discovered in South America. Upon their return, the two were inspired to rally members of the Torrey Botanical Club and other concerned citizens to promote the idea of a botanical garden in New York. Through their efforts, the New York State Legislature set aside land in 1891 for the creation of "a public botanic garden of the highest class" in the City of New York.

Nathaniel Lord Britton's ability to lead this new enterprise was immediately apparent as he was said to combine "an extraordinary

FIG. 1.1. Formerly in the collection of the Lyceum of Natural History, this is one of twenty-nine copper plate engravings of plants discovered by Constantine Samuel Rafinesque (1783–1840), meant to illustrate his *Select New Plants of North America*. A note on the first plate reads: "The following plates are the proofs of plates lost in my shipwreck of 1815."

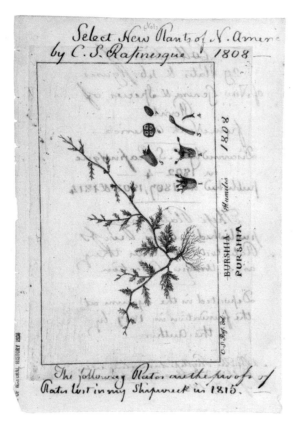

capacity for organizational and administrative detail with a breadth of vision that was always several steps ahead of his colleagues."[2] Prior to the founding of the Garden, Britton's ambition had been to position New York City as "not only the commercial, literary and artistic but also the scientific centre of North America."[3] As early as 1869, while serving as Secretary of the Scientific Alliance of New York, he, along with Charles Finney Cox (1846–1912), then President of the Alliance, laid out an ambitious plan to establish a single headquarters in New York for the many scientific societies and their respective libraries.[4] Although this initial plan did not prove to be successful, it did lay the groundwork for Britton's pursuits to establish The New York Botanical Garden, where he spent enormous energy developing a scientific Library.

Along with his colleagues John Strong Newberry, President of the New York Academy of Sciences, and Addison Brown, President of the Torrey Botanical Club, Britton established the Garden's Library in 1899 by gathering together the botanical literature from Columbia College, the Torrey Botanical Club, and the New York Academy of Sciences (formerly the Lyceum of Natural History) (fig 1.1). The nascent Library became a repository for the libraries of local amateur naturalists, horticulturists, and other scientists, including Britton's own collection and that of John Torrey (1796–1873), America's preeminent nineteenth-century botanist. Torrey's library contained important works received as gifts from his American contemporaries and respected European colleagues who inscribed them accordingly. William Darlington inscribed his *Flora Cestrica* (1837), "…with the grateful respects of his oft-obliged friend," and Ferdinand von Mueller's copy of *Select Plants, Exclusive of Timber Trees* (1872), sent to Torrey in 1872, reads, "…with the writers deep regard."[5] These words indicate the

high esteem in which John Torrey was held by his peers and provide noteworthy association value to many volumes in the Collection.

Enthusiasm for growing the Library and the zeal with which the new collections were amassed was impressive. When describing the Library in an article published in *Popular Science Monthly* in 1900, the acting librarian, pioneering plant physiologist and director of the Garden's laboratories, Daniel Trembly MacDougal (1865–1958), wrote, "The collection of botanical periodicals is nearly complete and the library is especially rich in the literature concerning mosses, ferns and the flora of North and South America."[6] These subjects remain primary areas of collecting today.

As The New York Botanical Garden became firmly established, other cultural and academic institutions transferred their botanical works to the Library, with collections coming from the Union Theological Seminary and the American Museum of Natural History. This exchange of valuable materials among the city's cultural institutions was *de rigueur* and exemplified the civic mindedness that pervaded the culture of the day. As a result of this concentration of botanical literature, there was an informal understanding that the New York Public Library would not collect in fields that were already covered by other institutions.

Noteworthy among these early donations was the receipt of over two hundred botanical books from the New York Academy of Medicine (formerly the New York Hospital). They had originally formed part of the library of David Hosack (1769–1835), a prominent medical doctor and botanist in the early nineteenth century.[7] Hosack was the founder of the first botanical garden in the State of New York, the Elgin Botanic Garden, formerly situated where Rockefeller Center stands today. Hosack's collection included important works on medical botany, as well as key early works on American

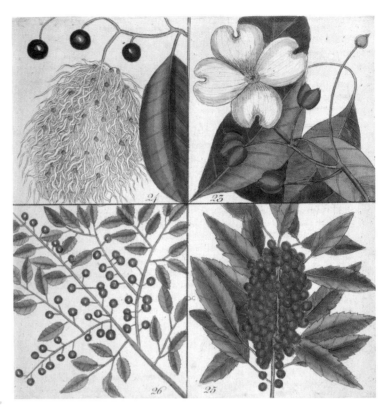

FIG. 1.2. After Mark Catesby completed his magnum opus, *Natural History*, he began work on *Hortus Europae Americanus*, London, 1767, plates 23–26. In this rare work, published posthumously, Catesby provides detailed information on the care of tender American plants for English gardeners along with valuable information about their medicinal properties.

trees. A copy of Mark Catesby's *Hortus Europae Americanus* (London, 1767) (fig. 1.2), with hand-colored plates drawn and engraved by Catesby himself, came from Hosack's library, as did Humphry Marshall's *Arbustrum Americanum*, printed in Philadelphia in 1785, and considered the first work by an American on native plants published in America.[8]

Gifts came from around the world from luminaries such as William Thiselton-Dyer, Director of the Royal Botanic Gardens, Kew, who sent a complete set of the London edition of *The Cyclopaedia, or Universal Dictionary of Arts, Sciences, and Literature* (1802–1820) by Abraham Rees for which he remarked, "you will no doubt be glad to add this to your library."[9] This encyclopedic work contains more than three thousand articles of botanical interest

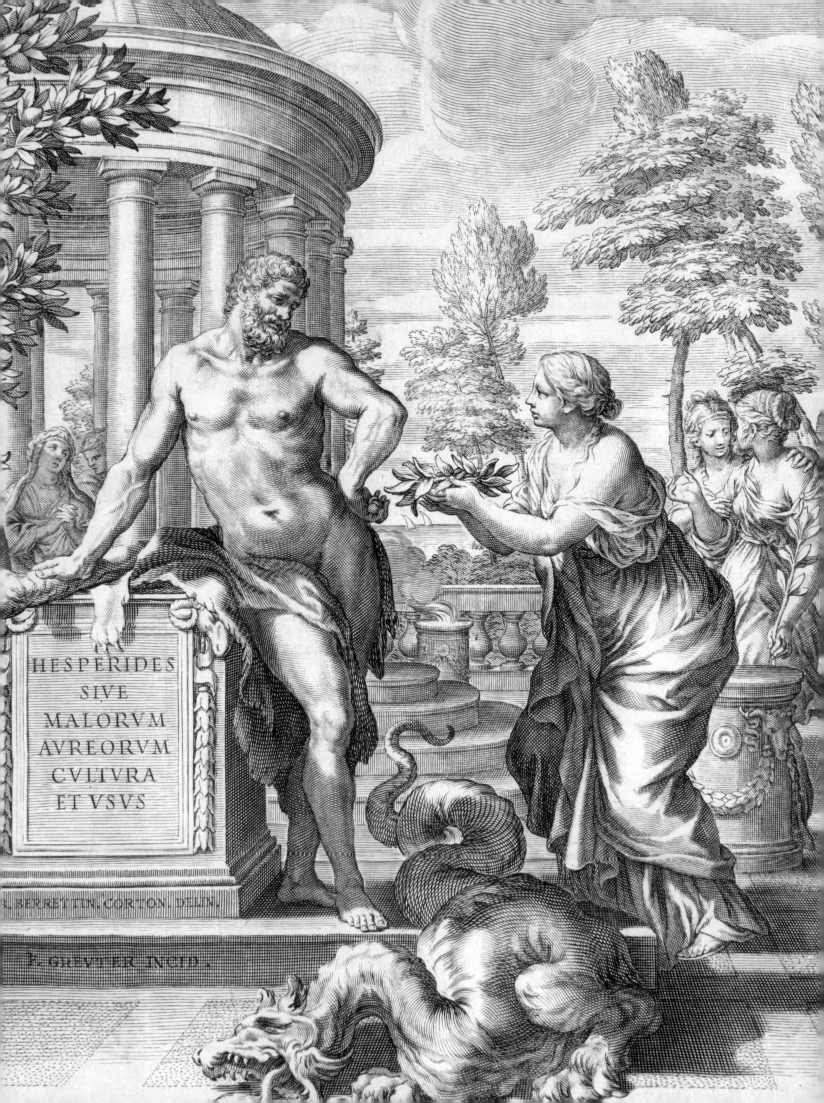

HESPERIDES
SIVE
MALORVM
AVREORVM
CVLTVRA
ET VSVS

P. BERRETTIN. CORTON. DELIN.

I. GREVTER INCID.

written by James Edward Smith, founder of the Linnean Society of London, and is known for its importance in popularizing science and technology in early nineteenth-century England and America.[10]

Early benefactors included board members, bankers, lawyers, clergymen, gardeners, and private citizens. In 1901 J. Pierpont Morgan, prominent philanthropist, book collector, and member of the Board of The New York Botanical Garden, donated several antiquarian rarities,

including a fine leather-bound copy of the first edition of Giovanni Battista Ferrari, *Hesperides*, published in Rome in 1646 (fig. 1.3).[11] Morgan also collected illustrated journals and horticultural magazines which he in turn gave to the Library. The Reverend Dr. Haslett McKim, amateur botanist and member of the Torrey Botanical Club, contributed over ninety significant botanical volumes, including Carl Friedrich Philipp von Martius' three-volume folio set *Nova genera et species plantarum* (1823–1832), with three hundred richly lithographed plates. Mr. and Mrs. Samuel Hoyt gave many books from the library of the Honorable Charles P. Daly, both families being early incorporators of the Garden.[12] W. Gilman Thompson, founding member and President of the Garden from 1913 to 1923, donated the forest books of Franklin

FIG. 1.5. Title page, in Johann Kniphof, *Botanica in originali, seu, Herbarium vivum*, Halle, 1757–1764, vol. 4. This German botanist assembled a large herbarium, which he illustrated using the technique of nature printing.

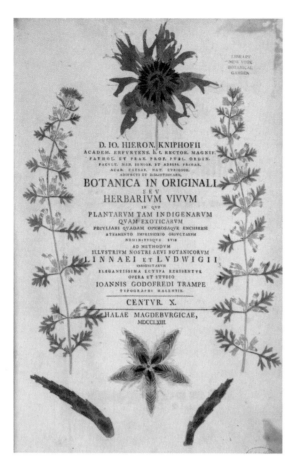

Benjamin Hough, who was considered the father of American forestry and founder of the short-lived *American Journal of Forestry*.[13]

Through the enlightened and continued patronage of public-spirited citizens, the Library acquired the most glorious iconographic orchid books produced during the height of orchid collecting in the nineteenth century. In 1901 Darius Ogden Mills, a banking, mining, and railway executive who also sat on the Board of the Garden, gave numerous large folio volumes, including the *Pescatorea* (1860) by Jean Jules Linden, the complete series of Robert Warner's *Select Orchidaceous Plants* (London: 1862–1865 and 1865–1875) and *The Orchid Album* (1882–1897), with descriptions of new and rare orchidaceous plants and beautiful illustrations by John Nugent Fitch.[14] That same year, Mrs. Alfred Corning Clark donated a

copy of the *Reichenbachia: Orchids Illustrated and Described* (1888–1890), written by Henry Frederick C. Sander. The collection of books on orchids continued to grow, and in 1954, H. W. Kunhardt donated both the first and second series of the extravagant Imperial edition of the *Reichenbachia*.[15] This monumental work, of which only one hundred copies were printed, is considered a Victorian masterpiece (fig. 1.4).[16]

The establishment of a Special Book Fund, created in 1899, provided a means for Britton to achieve his grand vision of amassing all the important literature published in the Western world. The fund allowed individual subscribers to help develop the collection. Prominent contributors included many of New York's social elite, notably Samuel Avery, Addison Brown, Andrew Carnegie, Charles Finney Cox, Louis Haupt, Samuel Hoyt, Darius Ogden Mills, J. P. Morgan, W. G. Schermerhorn, and Cornelius Vanderbilt. Among early acquisitions purchased with the fund were spectacular large-format volumes, including Johann H. Kniphof, *Botanica in originali, seu, Herbarium vivum* (1757), a remarkable four-volume set of nature prints with beautifully colored letterpress titles surrounded by hand-colored, color-printed, and nature-printed borders of flowers and leaves (fig. 1.5);[17] *Icones plantarum rariorum* (1781–1793) an impressive three-volume set with 648 hand-colored plates by the renowned Austrian botanist Nikolaus Joseph Jacquin (1727–1817), originally from the library of the English artist-collector William Morris;[18] the lavishly illustrated *Hortus nitidissimis* (1768–1786) by

FIG. 1.6. *Anemone*, in Christoph Jacob Trew, *Hortus nitidissimis*, 1768–1786, vol. 3, [p. 80]. Nuremberg physician Trew created a work of astonishing splendor illustrating European garden flowers at the height of their beauty, approaching them as works of art instead of specimens of science by using talented artists, including Georg Ehret, A. L. Wirsing, and J. M. Seligmann.

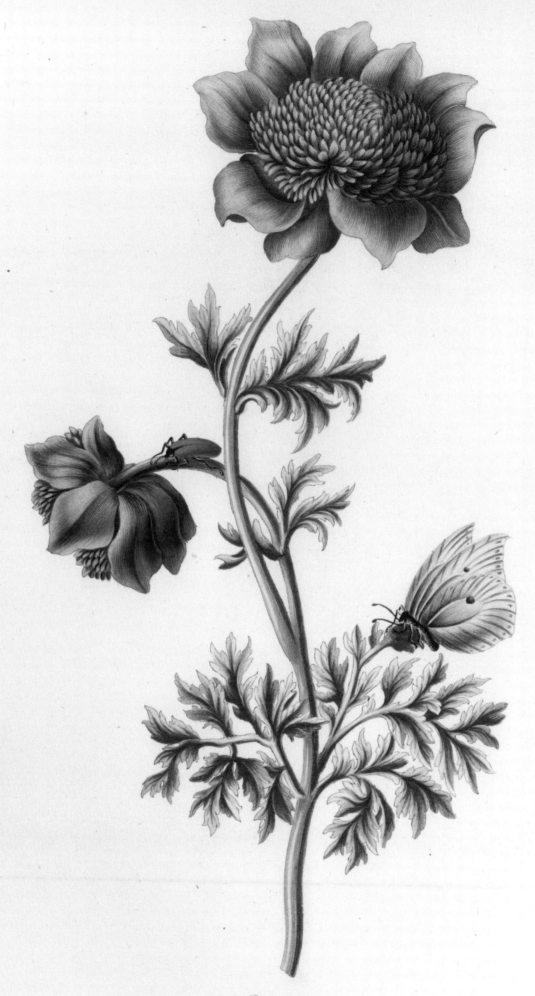

B.R.Dietzschin pinx.

Clodina.
129.

A.L.Wirsing Sc. et excud. Norimberg 1776.

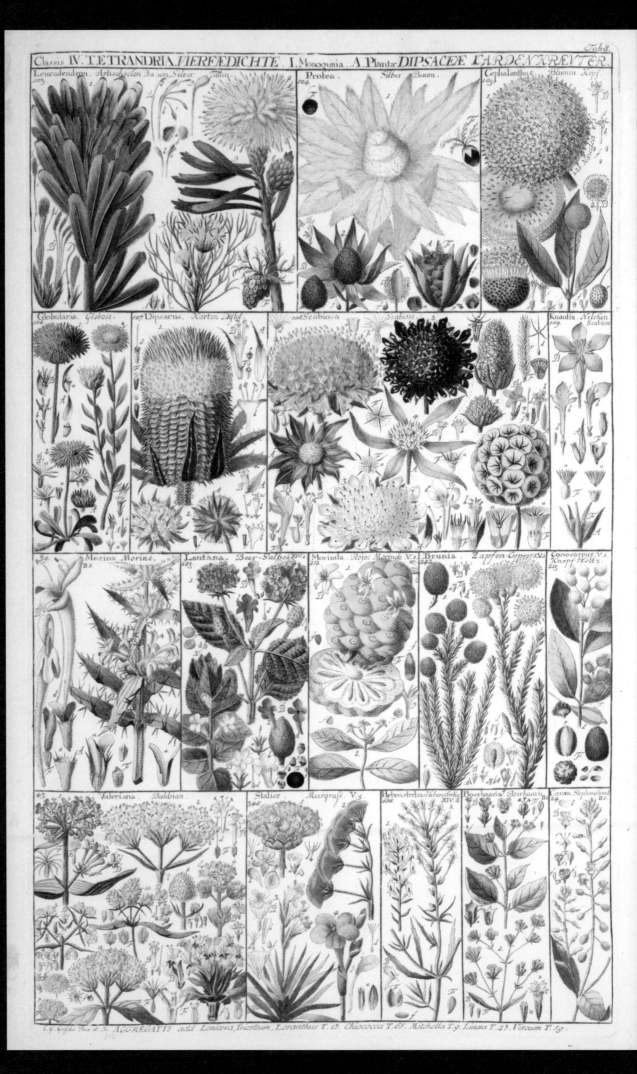

Fig. 1.7 a–b. In *Tabulae phytographicae*, Turici [Zurich], 1795–1804, vol. 1, tabs. 8 and 12, Swiss naturalist Johannes Gessner explains the Linnaean system of plant classification by offering a series of instructional plates depicting the complex relationships among a wide variety of plants that share the same classification.

Tab. 12
Tab. 12

Classis V. PENTANDRIA FÜNF-FÆDICHTE. A Monogynia b. Monopetalæ, capsula intra florem.

177. Diapensia Bergsneid 178. Aretia Aretie. PRECIÆ d. ROTACEA. FLŒ-BLUHMEN. Schlüssel-bluhme, Auricule 181. Cortusa Cortus.
179. Androsace. Mannsch-bluhme 180. Primula, Auricula Ursi.

182. Soldanella Firnseu 183. Dodecatheon Meadie 184. Cyclamen Schwein-brod. 185. Menyanthes Nymphoides: Biberklee, Teichs-Seeblühme 186. Hottonia Wasser-Viole

188. Lysimachia Weidrich 189. Anagallis Gauch-heil 234. Swertia Dreystlchten 235. Gentiana Centaurium minus, Entian, Bitterwurtz, Tausentgüldenkraut.

206. Samolus Weiss-Bachbunge 227. Chironia Chironie 172. Exacum Africa-Inisch Bitter-kraut 174. Sarothra Virginisch-Bart-Jenint 190. Theophrasta Brent 191. Patagonula Patagon 193. Ophiorhiza Mungos 194. Randia Stachlichte Cacao 196. Plumbago Bley-Kraut

187. Hydrophyllum v. Borntginist 192. Spigelia v. Arckcladus 195. Azalea v. Glicorier. PRECIS add. Limosella T. 13.
ROTACEIS add. Trientalis T. 24. Centunculus T. 9. Phlox T. 13. CISTOIDEÆ T. 30.

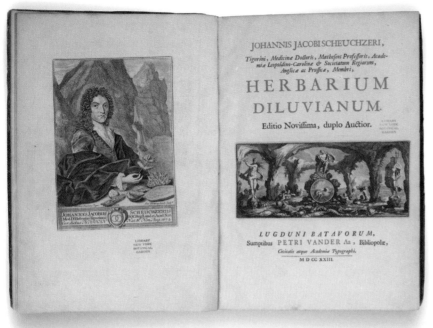

FIG. 1.8. *Herbarium diluvianum*, Lugduni Batavorum [Leiden], 1723, by the Swiss geologist Johann Scheuchzer, is regarded as the first comprehensive, illustrated treatise on fossil plants and remained an important reference in the field of paleobotany well into the nineteenth century.

Christoph Jacob Trew (1695–1769), containing illustrations masterfully executed by many talented artists including the premier German botanical illustrator Georg Dionysis Ehret (1708–1770) (fig. 1.6), and the rare color copy of *Tabulae phytographicae* (1795–1804) by Swiss scientist and botanist Johannes Gessner, featuring 64 exquisitely executed plates (fig. 1.7).[19]

An important and sizable purchase from the Special Book Fund came in 1902 when Britton acquired more than four hundred pre-Linnaean botany and natural history books from a private collection in Berlin. Described as a chance of a lifetime Dr. MacDougal added, "Botanical literature covering this full period is extremely rare and hard to procure, and with the more modern works in our already populous library, the New York Botanical Garden will now be in a position to offer facilities to botanical students second to none in the world."[20] On September 21, 1902, *The New York Times* described the sale as "one of the finest collections of old and rare works devoted to botany," which included many early herbals considered landmark publications in the history of both botany and of book production and design. The article noted the works as "in illustration, binding and typography they are the highest products of the printers' art."[21] The crown jewel of the sale was *De virtutibus herbarum* produced in the fifteenth century by Macer Floridus. This rare manuscript was one of the most popular medical books of medieval times, and contains Latin descriptions of medicinal plants written in poetic verse.[22] Other accessions included Johann Scheuchzer's *Herbarium diluvianum* (1723), an early work on paleobotany, originally from the library of the famed French nobleman and chemist, Antoine-Laurent de Lavoisier (1743–1794), noted for naming both oxygen and hydrogen (fig. 1.8),[23] and the 1771 edition of *Histoire générale des insectes de Surinam et de toute l'Europe* by Maria Sibylla Merian (fig. 1.9).[24]

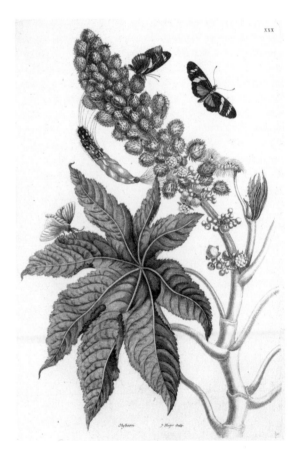

FIG. 1.9. *Ricinus americanus major* or Olyboom, in Maria Sibylla Merian's entomological masterwork, *Histoire générale des insectes de Surinam et de toute l'Europe...*, Paris, L. C. Desnos, 1771, tome 1, plate XXX.

Several significant lots from the notable botanical library of the French botanist Professor Alexis Jordan (1814–1897) were acquired in 1903 when Miss Anna Murray Vail (1863–1955), the Garden's first Librarian, sailed for Europe on the *S. S. Germanic* for the purpose of making extensive purchases at the Jordan auction in Paris.[25] Over five hundred books and pamphlets were purchased. Three hundred forty of those were the gift of philanthropist Andrew Carnegie and the remaining were purchased through the Special Book Fund.[26] The *pièce de résistance* of the sale was the magnificent multivolume *Flora Graeca* (1806) (see fig. 3.20) by John Sibthorp (1758–1796), Professor of Botany at Oxford University.[27] Sibthorp met the young artist Ferdinand Bauer in Vienna while studying the plants named in Dioscorides' *Codex Vindobonensis*,[28] and the two collaborated in producing what is widely considered the greatest illustrated Flora ever written.

In 1895 Andrew Carnegie was elected as Vice President of the Board of Managers of the Garden, a post he maintained until his death in 1919. His generosity to the development of libraries is legendary and his largesse toward The New York Botanical Garden's Library was no exception. When explaining how libraries can benefit a community, Carnegie described them as "a never failing spring in the desert."[29] In addition to his generous contributions to the Special Book Fund, Carnegie presented the Garden with many historically and botanically important volumes. A truly notable gift was Nikolaus Joseph Jacquin's *Selectarum stirpium Americanarum historia* (1780–1781). The work, published in a limited number with fewer than thirty copies known to exist, features hand-painted images rather than engraved plates (fig. 1.10: see p. 2).[30]

By 1903 the Library was well on its way to becoming an essential scholarly resource for the appreciation and study of the history of science. That year, Charles Finney Cox, the Garden's Treasurer from 1899 to 1912, donated eighty volumes, mostly on microscopy. Cox had no formal scientific background, but a keen interest in all areas of the natural sciences.[31] After his death, a special subscription program

FIG. 1.12. With his *Natural History of the Rarer Lepidopterous Insects of Georgia*, London, 1797, vol. 1, tab. XII, based on observations by John Abbott, James Edward Smith published the first illustrated work on the moths and butterflies of North America. Illustrated by Abbott, this work is noted for the beautiful representations of insects as well as the early images of American plants.

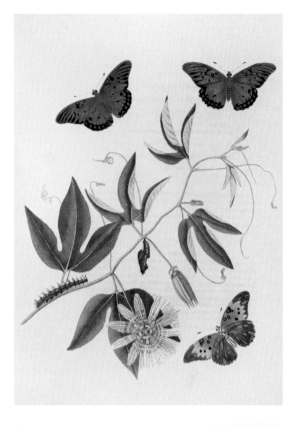

FIG. 1.13. *Aloe rhodacantha*, in Augustin Pyramus de Candolle, *Histoire naturelle des plantes grasses*, Paris, 1799–1804, plate 44. A sumptuously illustrated scientific treatise on succulent plants, this was the first major botanical work to feature color printed plates using the stipple point engraving technique developed and popularized by Pierre-Joseph Redouté.

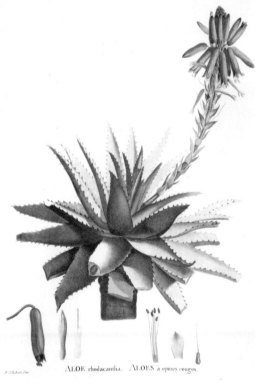

ALOE rhodacantha. ALOES à épines rouges.

was formed to provide for the purchase of his collection of Darwiniana, which included many first editions, as well as correspondence to and from Charles Darwin, including rare and unique grangerized volumes (fig. 1.11). In the same period the Library acquired many valuable books from the collection of Job Bicknell Ellis (1829–1905), the well-known founder of the *Journal of Mycology*. Ellis sold his collection of over 100,000 fungal specimens to the Garden for its cryptogamic herbarium in 1896, and in January 1900 he deposited on loan several volumes from his personal mycology library. The loan agreement was cancelled when the Garden purchased the collection.

John J. Crooke, a businessman and Staten Island naturalist and long-time associate of Nathaniel Lord Britton, donated the earliest book ever published on American insects, *The Natural History of the Rarer Lepidopterous Insects of Georgia* (1797) by James Edward Smith (1759–1828) (fig. 1.12).[32] The Crooke collection also included a very fine copy of the original issue of *Plantarum historia succulentarum* (1799), the first major botanical work to rely on color printing plates using the technique of colored stipple engraving, perfected by the masterful botanical artist Pierre-Joseph Redouté (1759–1840) (fig 1.13).[33] Widely known by its French title *Histoire naturelle des plantes grasses*, the work was published by Augustin Pyramus de Candolle (1778–1841). Before his death in 1911, Crooke gave his friend Britton two exceedingly rare copper plates engraved by Robert Havell for John James Audubon's famous *Birds of America*.[34]

A well-timed plea by Nathaniel Lord Britton came in 1905 when he published a notice in the *Journal of The New York Botanical Garden*, stating that additional income was needed "…to complete the botanical library, by purchasing the most important works of the

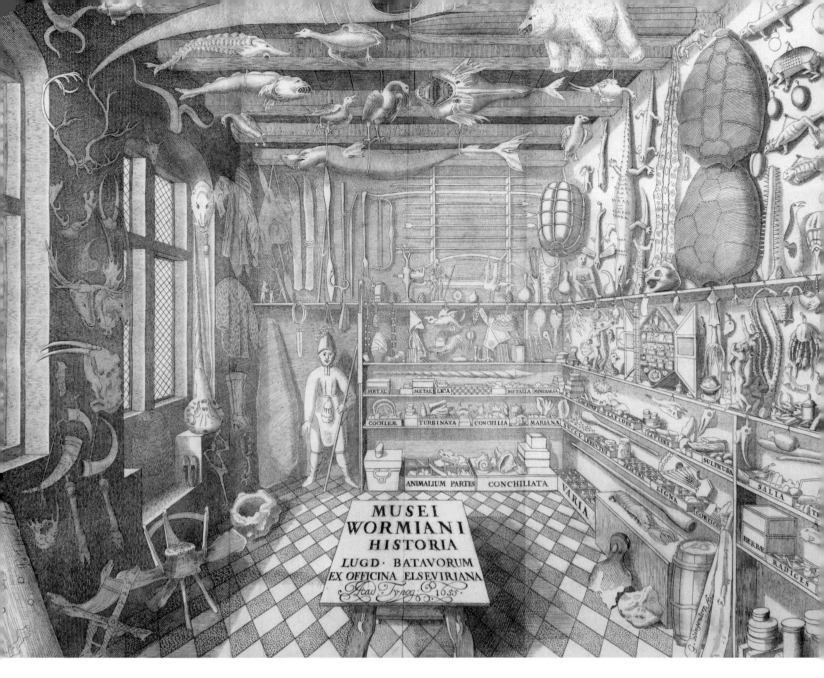

past, as well as current publications."[35] In May of that year, the Board approved the appropriation of ten thousand dollars to acquire additional library material from European sources. The Garden was working with a book agent in Berlin, W. Junk, who was helping to procure some of the most significant botanical books available in Europe at that time. The firm of Georg and Co., located in Geneva, also supplied shipments of older literature. Among the extraordinary volumes purchased from European sources was a copy of *Museum Wormianum* by Ole Worm published in Amsterdam in 1655,

with figures and descriptions of commercial tropical plants and a foldout engraving of his cabinet of curiosities (fig. 1.14);[36] *Nürnbergische Hesperides*, by Johann Christoph Volkamer, published in Nuremberg (1708-1714) (fig. 1.15); two lavishly illustrated works published in Paris, *Histoire naturelle, agricole et économique du maïs* (1836) by Matthieu Bonafous (fig. 1.16); and *Flore d'Amérique* (1843–1846) by Etienne Denisse (fig. 1.17); [37] and the magnificent *Illustrationes algarum in itenere circa orbem jussu Imperatoris Nicolai I* by Aleksandr Postels (fig. 1.18), published in Saint Petersburg in

FIG. 1.14. Frontispiece, in *Museum Wormianum*, published in Amsterdam in 1655, depicting the "Musei Wormiani Historia," the famous cabinet of curiosities filled with natural history objects collected by the Danish natural historian Ole Worm.

[15]

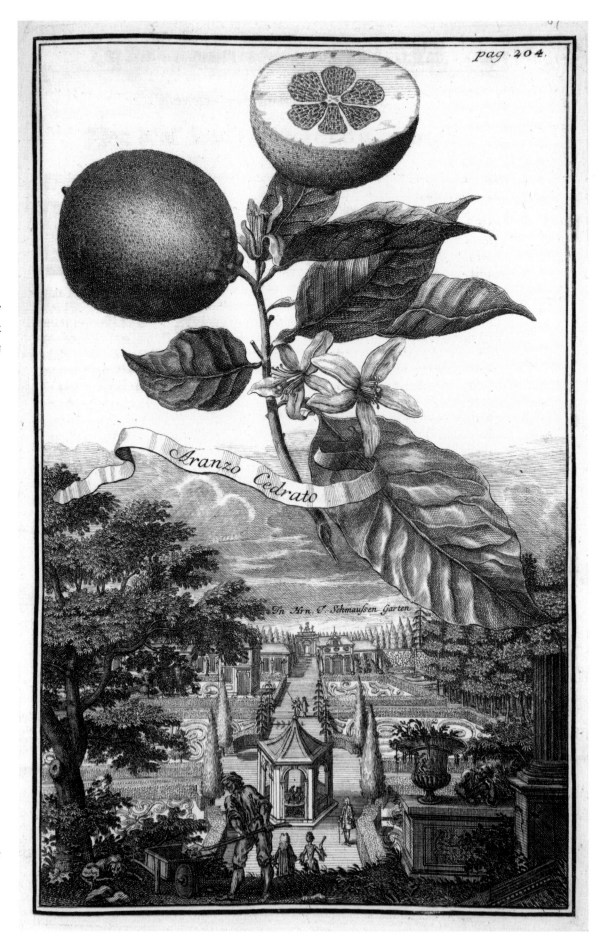

FIG. 1.15. Engraving of
Aranzo cedrato, depicted
against the backdrop of
an early eighteenth-century
garden in the Nuremberg
region, in Johann Christoph
Volkamer, *Nürnbergische
Hesperides*, Nuremberg,
1708–1714, vol. 1, p. 204.

1840. This outstanding oversized folio volume on algae includes forty life-size lithographs of seaweeds. Ordered by Tsar Nicolas I, the work was the result of a three-year voyage from 1826 to 1829, one of the most productive botanical expeditions of the era.[38]

In 1907 the Garden purchased the library and herbarium of William Mitten (1819–1906), the premier bryologist of the second half of the nineteenth century. Mitten was one of the first to realize that the same taxa occur throughout broad geographical ranges. He classified and named thousands of specimens that came into the Royal Botanic Gardens, Kew, from around the British Empire. At the time of his death he had amassed the largest and most important private collection of bryophytes—some fifty thousand specimens. Distinguished British naturalist Alfred Russel Wallace (1823–1913) was Mitten's son-in-law and served as executor to his estate. In a letter to Elizabeth Britton, Wallace offered the Garden the first opportunity to purchase the library and herbarium (fig. 1.19). Garden scientist Robert Statham Williams (1859–1945) was sent to England on behalf of the Garden to pack and arrange for the transport of the important collection of bryophytes containing type specimens of hundreds of new species described by Mitten. Mitten's daughter presented Mrs. Britton with her father's own copy of his greatest work, *Musci Austro-Americani* (1869), which Mrs. Britton later donated to the Library.[39]

When the Garden Librarian Anna Murray Vail announced her plans to retire in 1907, John Hendley Barnhart (1871–1949) was appointed to fill the position.[40] Although he held a medical degree from Columbia College of Physicians and Surgeons, Barnhart never practiced medicine; instead he devoted his long and fruitful career at the Garden to botany and botanical literature. His annual report for the year 1910 states, "the

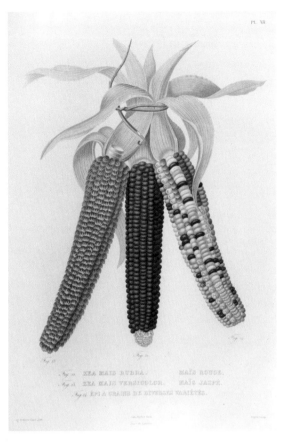

FIG. 1.16. *Zea mais rubra* and other varieties, in *Histoire naturelle, agricole et économique du maïs*, Paris, 1836, plate XII, in which French agronomist Mathieu Bonafous discusses the several varieties of corn grown in Europe, their botanical history and economic impact. This publication contains colored plates by four different botanical artists, including the last illustrations of Pierre-Joseph Redouté.

NOBLE SCIENCE:
BUILDING THE
LIBRARY COLLECTION

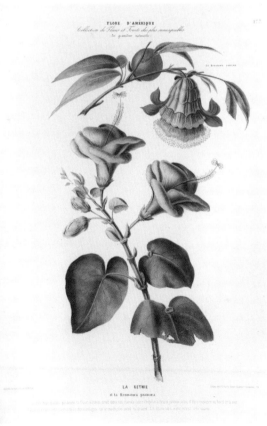

FIG. 1.17. *La Ketmie*, one of 200 chromolithograph plates of plants drawn from nature and growing in the French Caribbean by natural history painter Etienne Denisse. Working in the West-Indies, he published the plates separately from the unfinished text in *Flore d'Amérique*, Paris, 1843–1846, plate 177. The Mertz Library copy contains the complete set of plates in an unbound state.

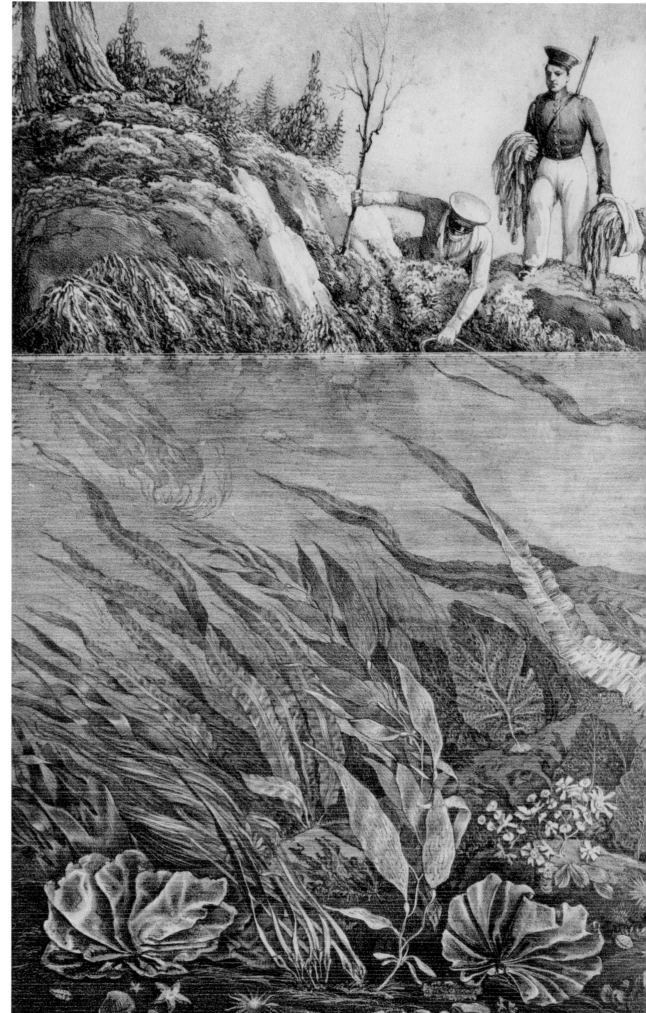

FIG. 1.18. Frontispiece, in Aleksandr Postels, *Illustrationes algarum in itenere circa orbem jussu Imperatoris Nicoliai I*, Sanktpeterburg [Saint Petersburg], 1840. A member of a scientific team sent by the Tsar to explore Russian coastal areas, Postels worked closely with botanist Franz Joseph Ruprecht to produce an astonishing selection of life-size seaweeds.

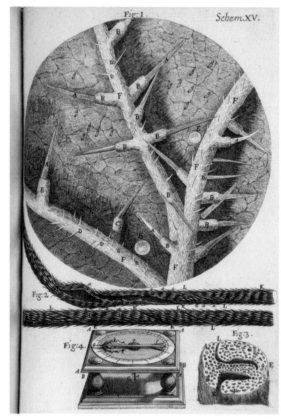

Librarian spent the months of May, June, and July in Europe, his chief mission being the purchase of books for the library: nearly all the books purchased with the Special Book Fund."[41] By 1917 Barnhart had become the Garden's first bibliographer. Growing the collection was more than just accumulating titles, and Barnhart systematically used G. A. Pritzel's botanical standard work, *Thesaurus literaturae botanicae* (1872–77), as a practical acquisition guide. He wrote, "This has been used as a handbook

in our Library ever since its establishment, and persistent effort has been made, while not neglecting the new literature, to complete the representation of the older literature as recorded by Pritzel."[42]

His legacy includes his editorial contributions toward the publication of *North American Flora*; a leadership role in formulating the first set of international rules for the Code of Botanical Nomenclature adopted in Vienna in 1905; and his famous Biographical Index of Botanists consisting of hundreds of index cards, published in 1965 in a three-volume set entitled *Biographical Notes upon Botanists*.[43]

Barnhart also amassed an important personal library that he later sold to the Garden. Among the items in his collection was the landmark work *Micrographia* (1665) by Robert Hooke, considered one of the one-hundred most important books in science (fig. 1.20).[44] His library also contained an exemplary copy of Catesby's 1754 *The Natural History of Carolina, Florida, and the Bahama Islands* (see figs. 5.16 and 8.2). When Catesby's work was first published, it was widely recognized by naturalists throughout the world. The famous botanist Carolus Linnaeus, named several species based directly on drawings in Catesby's *Natural History*, and the American botanist John Bartram described it as "an ornament for the finest library in the World."[45]

Acquisition activity was severely curtailed between 1914 and 1919 as a result of World War I, but smaller donations critical to the growth of the Library continued. Addison Brown was a U. S. Federal judge and avid amateur botanist, who along with Nathaniel Lord Britton, published *An Illustrated Flora of Northern United States, Canada, and the British Possessions...*(1896–1898).[46] Brown made several gifts of material to the Library during his distinguished association with the Garden,

and after his death in 1913 his widow donated a notable collection of original drawings by Isaac Sprague and Arthur Schott produced to illustrate the *U. S. Pacific Railroad Reports* (see fig. 7.14).

Throughout his directorship, Nathaniel Lord Britton maintained a strong interest in the Library. In 1920 he returned from a collecting trip in Europe with a number of sumptuous folio volumes pertaining to tropical botany, including the four-volume *Flora Antillarum* (1808–1827) by François Richard Tussac.[47] The set reveals the splendor of botanical illustration at its peak, containing colored stipple engravings from drawings by famed artists Pierre-Antoine Poiteau, Pierre-Joseph Redouté, and Pierre Jean François Turpin (fig. 1.21). But it was not until 1922, in a virtuoso achievement, that Britton helped assure that the Garden's Library would rival any botanical library in Europe. Working with Professor John Briquet, Director of the Conservatoire et Jardin Botaniques de la Ville de Genève, Britton negotiated the sale of thousands of duplicate volumes from the merger of three important botanical libraries in Switzerland. On August 23, 1923, ninety-two cases of books, containing more than six thousand scientific tomes from the libraries of botanists Augustin Pyramus de Candolle, Benjamin Delessert, and Emile Burnat, were received from the steamer *S. S. Rochambeau*. In an article in *The New York Times* on January 20, 1924, Britton declared it "the most important collection of books on botany that has ever passed from the old world to the new."[48] This major purchase contained many landmarks of scientific research, and provided a solid foundation for the continued development of a strong collection of floristics, including vernacular and local floras. Among the key Floras were *Flora Rossica* (1789-1790) by Peter Simon Pallas, *Icones florae Germanicae et Helveticae* (1834–1912) by Heinrich Reichenbach, and the 1832 edition of *Flora Indica* by William

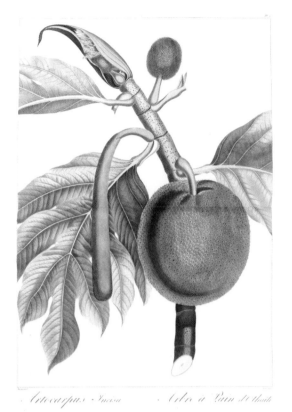

FIG. 1.21. *Artocarpus incisa*, in François Richard Tussac, *Flora Antillarum*, Paris, 1808–1827, tome 2, plate II. Tussac spent fifteen years in the French West Indies studying its native plants. As Director of the Botanical Garden of Angers, France, he published this full color folio study, famed for the quality of its illustrations by the renowned artists Poiteau, Redouté, and Turpin.

NOBLE SCIENCE:
BUILDING THE
LIBRARY COLLECTION

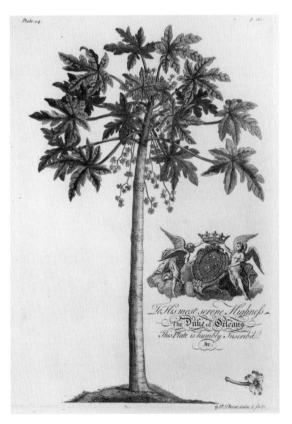

FIG. 1.22. The plates in Griffith Hughes, *The Natural History of Barbados*, London, 1750, plate 14, are each embossed with a crest of the specific benefactor. Hughes was a Welsh naturalist whose deteriorating health required him to take a post in Barbados, where he wrote what became the most comprehensive natural history of the island.

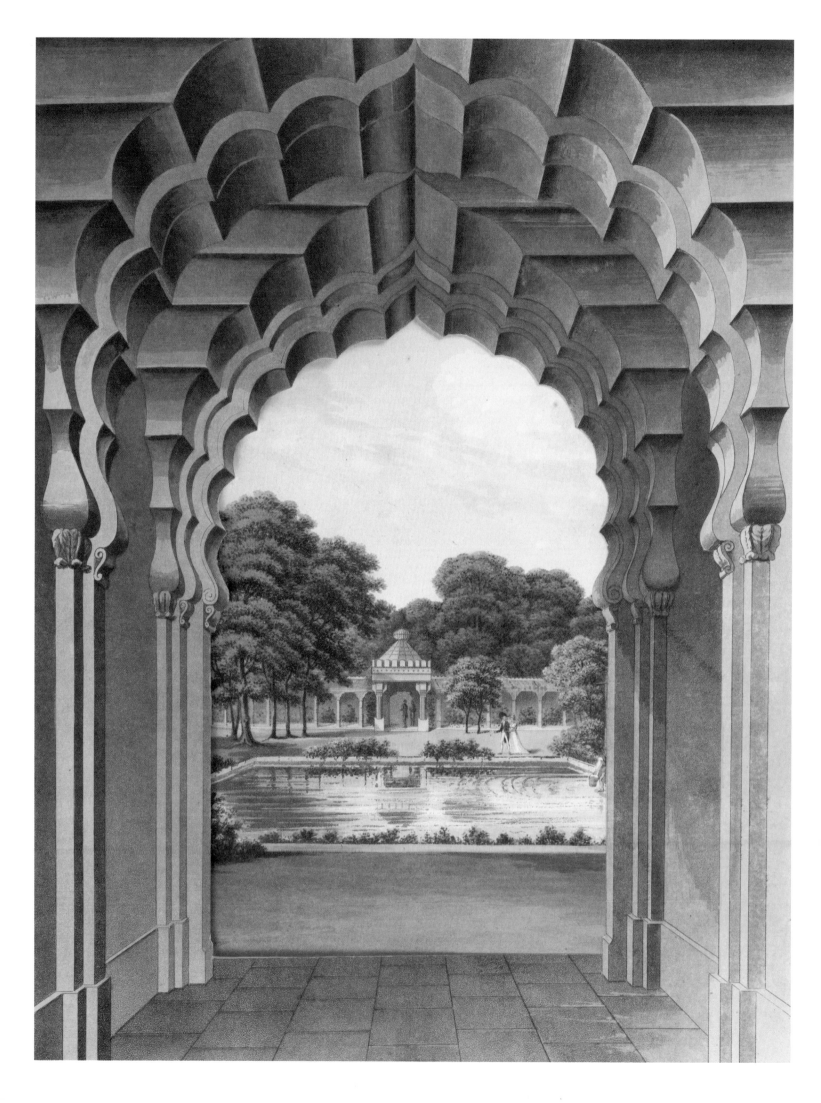

Roxburgh.[49] The Geneva sale remains the Mertz Library's largest single purchase of material to this day.

In 1926 the Garden announced plans to install electricity in the Library building, a welcome addition that would extend study hours and the regular use of an elevator. Until that time the building was only open during the day, with natural light used almost exclusively, supplemented by gas light when necessary. Even the elevator was operated by a dynamo in the power plant and could be used only sparingly.[50] Coincidentally, it was in the same year that the inventor of modern lighting himself, Thomas Edison, along with botanist John Kunkel Small conducted experiments at the Garden with plant fibers as filaments for use in light bulbs.

In a letter to the Scientific Directors dated May 25, 1929, Britton announced his plans to retire. Having served the Garden for thirty-four years, he built the world's most preeminent botanical museum, which "contained the largest herbarium in the United States and one of its most valuable library collections."[51] Shortly thereafter, the Great Depression deeply diminished all available resources at the Garden and the growth of the collections stagnated during the interwar years. However, in 1940 two outstanding group purchases were made: 120 volumes from the Royal Horticultural Society Red Cross Sale, which included a set of William Curtis, *Flora Londinensis* (1777–1798),[52] and fifty-one volumes from the library of Raymond Pearl, a pioneer in American population biology and ecology. That same year the Horticultural Society of New York donated more than one thousand nursery and seed catalogs; Mrs. Clement S. Houghton of Chestnut Hill, Massachusetts, presented the Library with a fine set of thirteen volumes of Benjamin Maund's *Botanic Garden* (1825–1850),[53] and Mr. F. Rockwell, Garden Editor of *The New York Times*,

gave several hundred bulletins, pamphlets, and periodicals. The Librarian, Elizabeth Hall, stated in the Annual Report of 1941, "It is gratifying to receive these contributions not only because the gifts become a valuable part of our collection, but also because they represent a strong connecting link of thoughtfulness, interest and generosity from the donors themselves."[54]

This history of giving included the libraries of several grand women of horticulture: the popular American garden writers Helen Morgenthau Fox (1884–1974) and Louise Beebe Wilder (1878–1938), and the avid book collector Sarah Gildersleeve Fife (1885–1949), founder and first President of the Hroswitha Club of women book collectors.[55] The more than 225 volume library of the Fife bequest of 1949 contained classic gardening titles, as well as antiquarian rarities such as Griffith Hughes' *The Natural History of Barbados* (1750), in which each beautifully colored plant illustration was dedicated to a patron-subscriber, with an engraved coat of arms or monogram (fig. 1.22).[56]

During the Garden's Fiftieth Anniversary Celebration in 1945,[57] Henry Forest Baldwin, Vice President of the Board of Managers, aptly declared, "We're no longer a speculation. An investment in the New York Botanical Garden is a sound and seasoned investment."[58] That year gifts included an attractive group of books dealing with botanical gardens and garden landscapes from Clarence McKenzie Lewis, including many notable works by Humphry Repton, such as *Sketches and Hints on Landscape Gardening* (1794), *Observations on the Theory and Practice of Landscape Gardening* (1803), and *Designs for the Pavillon at Brighton* (1808) (fig. 1.23).[59]

Board member and gentleman collector, Gilbert H. Montague[60] bequeathed many rare volumes to the Garden. After his death in 1961, the Library received several important and

FIG. 1.23. In *Designs for the Pavillon at Brighton*, published in London in 1808, Humphry Repton, the famous landscape designer of Regency England, published his innovative Indian-themed seaside pleasure pavilion for the Prince Regent, illustrating the then prevalent taste for exoticism in "before" and "after" views of his projects.

deluxe volumes, including Johann Wilhelm Weinmann, *Phythanthoza iconographia* (1737-1745) and John Martyn, *Historia plantarum rariorum* (1728-1737). But the crown jewel of the bequest was an exclusive edition of *Recueil des plantes dessinées et gravées par ordre du roi Louis XIV* by Denis Dodart with engravings after Nicolas Robert, published in 1675 (fig. 1.24). Wilfred Blunt, noted authority on botanical art and illustration considered this "The finest collection of flower engravings made during the seventeenth century."[61] When first printed, the sets were used as royal gifts and had never been offered for sale, making them extremely rare.

By the early 1960s, the Library had outgrown its space, and construction for a "six-story new home for one of the world's great scientific libraries" was begun.[62] The new Pratt Wing was named for the philanthropist and gardening advocate, Harriet Barnes Pratt, and dedicated in 1965, providing important sources "for scholars and the general public around the world, on both sides of the Iron Curtain," as *The New York Times* proclaimed.[63] This was particularly relevant statement because the Library had maintained its extensive exchange program, trading scientific publications with institutions in the Eastern Bloc throughout the Cold War.

It was shortly after this first expansion and in conjunction with the Board's approval of new book funds that some of the oldest and most extraordinary works in the Library Collection were acquired. The Kress Foundation

and Enid A. Haupt provided major donations for the purchase of 160 rare volumes from the former Emil Starkenstein collection. Emil Starkenstein, a professor of pharmacology in Prague and noted historian of science and medicine, with a keen eye for collecting, amassed a remarkable collection of rare printed herbals and manuscripts including several incunabula. Starkenstein died in 1942 and some of his library, dispersed for safekeeping during World War II, was reunited in Amsterdam after the war. The collection was put up for sale through his cousin, Ludwig Gottschalk, of Biblion, Inc. The selection of titles was made by Garden Librarian John F. Reed.[64] Through this extraordinary purchase, the Library acquired the two earliest-known extant medieval manuscript copies of the enormously important *Circa instans*.[65] This rare work represents a convergence of medical knowledge that included all the classical, Arabic, and Graeco-Roman medical traditions known by the twelfth century. Incorporated in the sale were several incunabula, including Bartholomaeus Anglicus' *De proprietatibus rerum*, printed in Lyon in 1482, and *Ortus sanitatis*, printed in Strassburg in 1497, both contributing to the Library's already rich collection of early herbals.

In a deal brokered by Charles Robert (Bob)

FIG. 1.25. This *New York City Plantsman's Ledger*, 1793–1796, contains the accounts of numerous New York residents who purchased goods and services from this unknown plantsman. The manuscript details specific fruits, vegetables, herbs and flowers available during the period 1793–1796.

FIG. 1.24. *Mandragore* or mandrake, in Denis Dodart, *Recueil des plantes*, Paris, 1701, vol. 2, plate 76. This was the first publication commissioned by the newly formed Royal Academy of Sciences. The ambitious project originally entitled "A History of Plants" featured hand-colored engravings by the royal miniature painter Nicolas Robert. Drawn from life at full size, the illustrations represent the plants in cultivation at the time.

FIG. 1.26. (next spread) *View of the Volcano of Chimborazo*, in Alexander von Humboldt and Aimé Bonpland, *Vues des Cordillères*, Paris, 1810, vol. 2, plate 25. This scientific work documents the 1799–1804 exploration of South America, addressing issues of ethnography, geology, and demographics along with the natural sciences. It is noted for the aquatint plates by Thibaut and Bouquet after drawings by Von Humboldt.

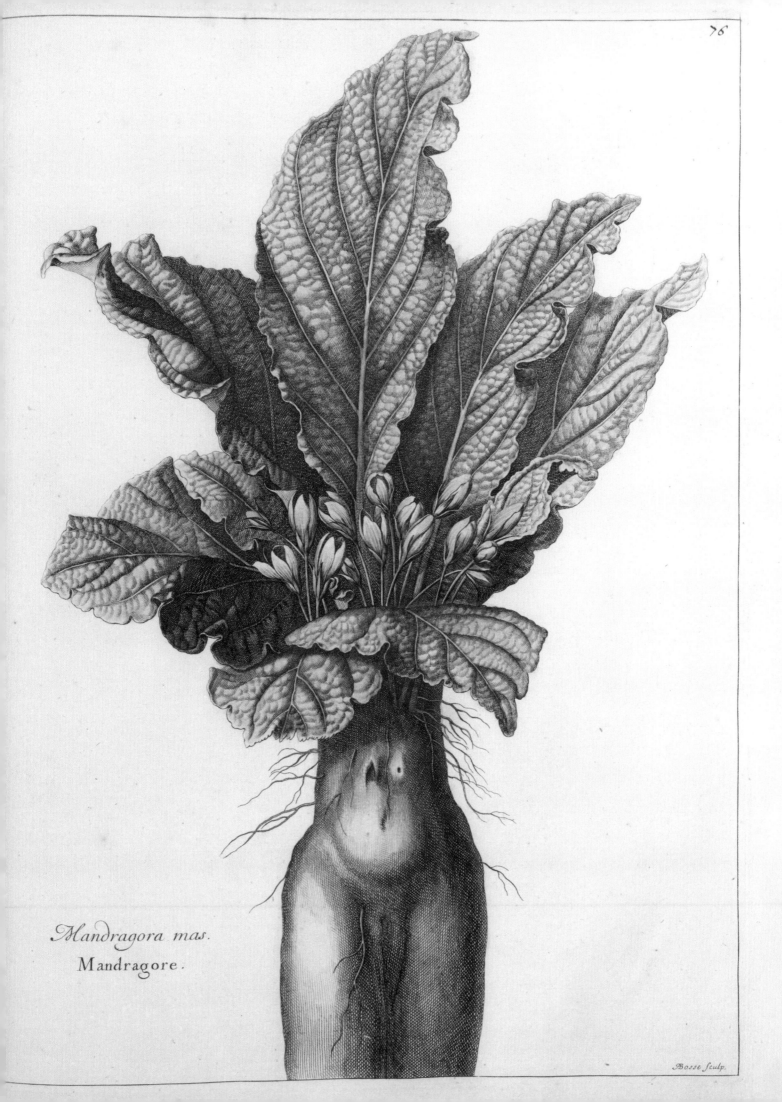

Mandragora mas.
Mandragore.

Bosse sculp.

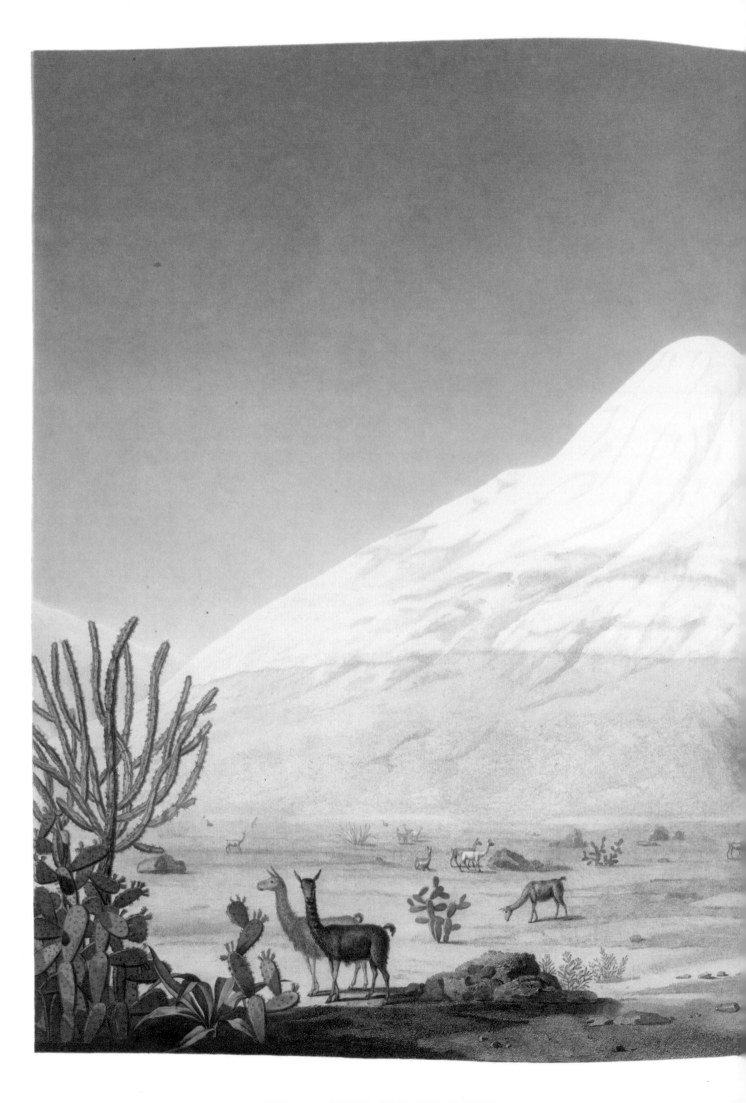

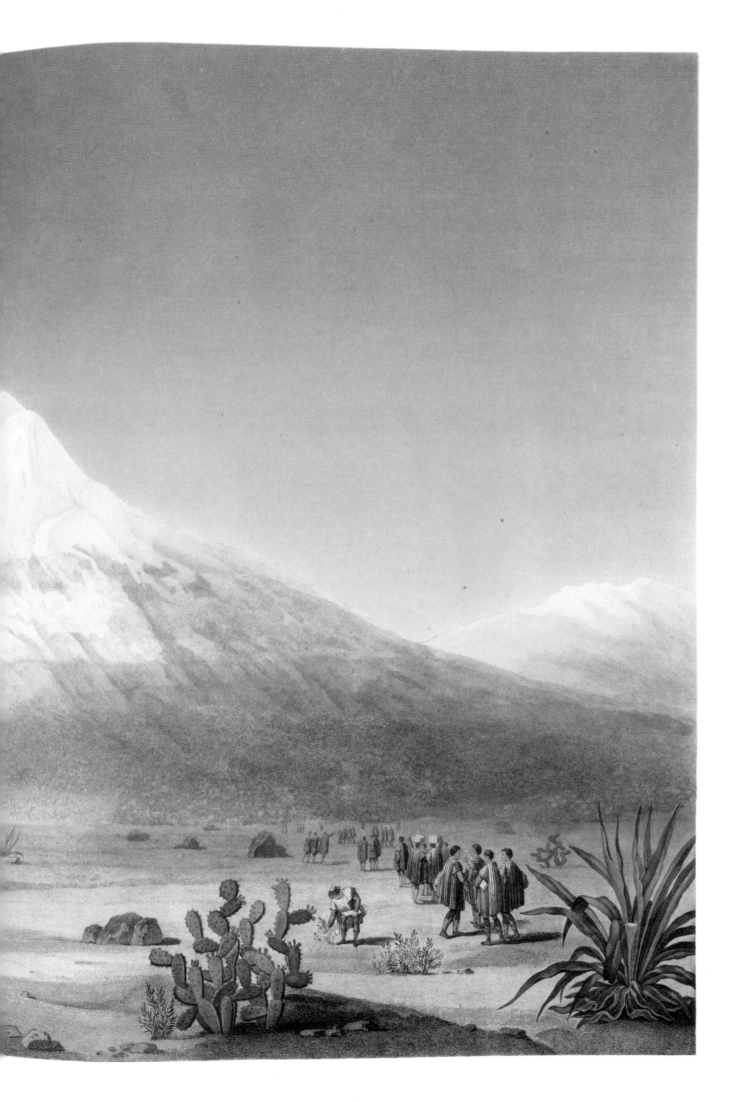

as well as shrubs and greenhouse plants. Clients included such notable New York personalities as Colonel Aaron Burr, James Beekman, and "Chancellor" Robert Livingston.

While opportunities to find and purchase rare antiquarian publications have diminished, there nevertheless have recently been numerous exceptional acquisitions, including the limited edition of *Banks' Florilegium* (1980–1988). The British Museum had uncovered a collection of original copper plates of Daniel Solander's plant illustrations from the Captain Cook expedition (1760–1771) on the *H.M.S. Endeavour*, led by Joseph Banks. Alecto Historical Editions, in association with the British Museum, undertook the enormous task of producing a limited edition of one hundred copies of a set of prints from the original plates. Kerry Packer, an Australian businessman, not only provided the seed money to have the plates printed but also generously provided a set of the *Florilegium* to the Library.[66]

Over the next decade, the Garden was represented at the auctions of a number of significant botanical collections. In 1997 Christie's auction house was selling the important botanical library of Robert de Belder. The Library acquired the first edition of *Voyage aux régions équinoctials du nouveau continent* or *Vues des Cordillères* (1810) by Alexander von Humboldt and Aimé Bonpland. This impressive volume with the armorial bookplate from the library of the Earl of Leigh, contains sixty-nine engraved, etched, and aquatint plates (fig. 1.26).[67] With the generous support of then-Board Vice Chairman William C. Steere, Jr. and Lynda Steere, the Library acquired a few other antiquarian rarities at auction. These works include the first edition of a very fine eight-volume set of Johann Simon Kerner's *Figures des plantes économiques* (1786–1796); *Les Oeuvres pharmaceutiques* (1626) by Jean de Renou, chief physician to the French King;

Long, then botany librarian at Harvard, the Garden was given the opportunity to make a first selection of materials from the duplicate collections of the Gray Herbarium and the Arnold Arboretum of Harvard University. In 1972 Bob Long became the Librarian at the Garden. After his death in 1986, monetary contributions were made in his honor towards the purchase of a unique manuscript, an early New York City Plantsman's Ledger (fig. 1.25). The ledger book, with entries dated from 1793 to 1795, contains an accounting of the many varieties of plants available in New York in the late eighteenth century, including specific vegetables and herbs,

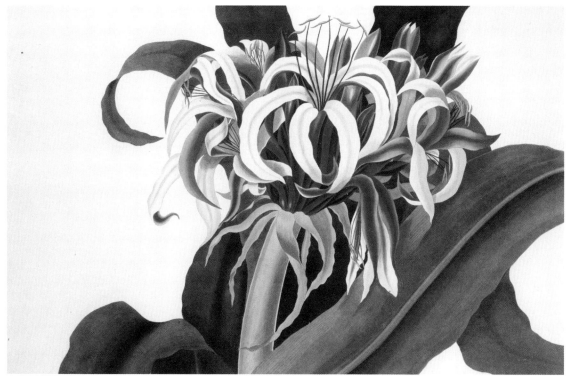

FIG 1.28 *Crinum augustum*, in Priscilla Susan Falkner Bury, *A Selection of Hexandrian Plants*, London, 1831–1834, plate 4. Bury was a flower painter who worked with the botanist William Roscoe and engraver Robert Havell to produce this work of stunning beauty.

and a very rare drawing manual published in 1818 by Gaetano Testolini, entitled *Rudiments of Drawing, Shadowing and Colouring Flowers in Water Colours* (fig. 1.27).[68] The Steeres also donated their fine copy of Priscilla Susan Falkner Bury's *A Selection of Hexandrian Plants*, with engravings by Robert Havell (fig. 1.28).[69]

In 2002 the Collections were cleaned and inventoried before being moved to their renovated space, with an expanded stack area, replete with compact shelving and room for growth. A climate-controlled Rare Book and Folio Room was constructed to provide an appropriate home for the rare book collections. The William D. Rondina and Giovanni Foroni LoFaro Gallery was built adjacent to the entrance to Library to offer space for exhibiting and interpreting these works for the public.

During the celebrations to commemorate the expansion of the newly named LuEsther T. Mertz Library,[70] then-Chairman of the Library Visiting Committee and member of the Board of Managers, David Andrews, announced his plans to donate his personal library. His extensive collection of books and ephemera record

the history of the exploration, classification, and development of America's botanical and horticultural wealth and provide evidence of the rich printing history of these works. Of particular note are the many variant copies and different editions of the works of André and François-André Michaux, as well as those of Thomas Nuttall (1786–1859).[71]

Elizabeth Kals Reilley, a bibliophile and connoisseur of fine books, also arranged to give over four hundred volumes from her collection of horticulture, gardening, and architecture books.[72] This donation of one of the finest private collections on garden history was celebrated with an exhibition and illustrated catalog, *European Pleasure Gardens* (2003).[73] Her collection contains significant works from the sixteenth through the nineteenth century and has a particular focus on the role of water in the garden, providing context to the history of hydraulics. Among these treasures is a suite of six etchings, *Views of Pratolino* by Italian printmaker Stefano della Bella (1610–1664) (see fig. 4.7), showing the abundance of water throughout the gardens at the Florentine Villa

Pratolino; and an extraordinary watercolor and manuscript proposal for new landscape designs at Whitton, known as a "Red Book" by Humphry Repton (see fig. 4.19).[74] Recent donors such as David Andrews, Elizabeth K. Reilley, and Lynda and William C. Steere, Jr., join the ranks of great benefactors who have played a key role in solidifying The New York Botanical Garden's position as a major international botanical and horticultural research center. Gifts continue to enrich the Library holdings immeasurably.

Since its founding, the LuEsther T. Mertz Library has expanded its core collecting beyond the pure sciences to also support the humanities. Art, cultural, and social historians alike recognize the great value of the Collections and their unlimited potential for future study. Botanists and horticulturists worldwide have long acknowledged the remarkable strength of the book and journal collections, and the singular advantage of having such a comprehensive library in close proximity to the world-class William and Lynda Steere Herbarium. Today the Mertz Library holds millions of items, including 550,000 physical volumes and 1,800 individual journal titles. The Collection constitutes a treasury of knowledge that contributes to the understanding of the relationship between plants and people and the landscape they inhabit and strive to shape. Through careful and intelligent stewardship, the Library continues to collect and preserve works of merit about the natural world.

Thus, more than one hundred years later, the words written by Nathaniel Lord Britton in his Report of 1904 continue to serve as a guiding principle, "We should certainly aim to make the library as complete as possible in pure botany, and in its related sciences of horticulture, agriculture, forestry, and such portions as general biology as apply to plants, and I believe that no greater service could be rendered to these subjects in America, than by some provision by means of which our library should be perfected."[75]

ENDNOTES

1. Formerly called the Museum building, it was renamed the Library building in 2002. The building was designed by Robert Gibson and completed in 1900.

2. Simon Baatz, *Knowledge, Culture and Science in the Metropolis: The New York Academy of Sciences 1817–1970* (New York, NY: New York Academy of Sciences, 1990): 145.

3. In an 1869 address by Nathaniel Lord Britton he described the building requirements for the Scientific Alliance—recognizing that these societies "were increasing in strength and influence," Archives NYBG, Records of the Scientific Alliance-Box 2.

4. Ibid. The founding members of the Alliance included the New York Academy of Sciences, the Torrey Botanical Club, the New York Mineralogical Club, the New York Microscopical Society, the Linnaean Society of New York, the New York Mathematical Society, and the New York section of the American Chemical Society, with additional societies to join later. The Lyceum of Natural History changed names to the New York Academy of Sciences is 1876. Archives NYBG, Records of the Scientific Alliance-Box 2. After a failed plea to the Tilden Trust to fund the construction of a building for the Alliance, many of the societies agreed to deposit their accumulated libraries at the newly formed New York Public Library. An exception was the library of the Torrey Botanical Club, which had already been incorporated into that of Columbia College and would soon form the basis of The New York Botanical Garden's Library. The Records of the Torrey Botanical Club are held in the Archives NYBG.

5. William Darlington, *Flora Cestrica: an Attempt to Enumerate and Describe the Flowering and Filicoid Plants of Chester County, in the State of Pennsylvania* (West-Chester: S. Siegfried, 1837). Ferdinand von Mueller, *Select Plants, Exclusive of Timber Trees, Readily Eligible for Victorian Industrial Culture, with Indications of Their Native Countries and Some of Their Uses* (Melbourne: 1872).

6. Daniel Trembly MacDougal (1865–1958) was the Director of the Laboratories and interim librarian at the Garden until Anna Murray Vail was hired in 1900. An article describing the newly established Botanical Garden entitled "The New York Botanical Garden," appeared in *Popular Science Monthly* 57 (June 1900): 171–178.

7. Anna Murray Vail, "Botanical Books of Dr. Hosack," *The Journal of The New York Botanical Garden* 1, no. 2: 22–26.

8. Humphry Marshall. *Arbustrum Americanum: the American Grove, Or, An Alphabetical Catalogue of Forest Trees and Shrubs, Natives of the American United States* (Philadelphia, Printed by J. Cruikshank, 1785). The work was dedicated to Benjamin Franklin. The Library also possesses original uncut sheets (quires) of Marshall's work donated to the Mertz Library by David Andrews in 2003. Mark Catesby. *Hortus Europae Americanus* (London: Printed for J. Millan, 1767).

9. "Notes, News and Comments," *The Journal of The New York Botanical Garden* 5, no. 60 (December, 1904): 223. Abraham Rees, *The Cyclopaedia, or Universal Dictionary of Arts, Sciences, and Literature* (London: Longman, Hurst, Rees, Orme & Brown, 1819–1820 [i.e. 1802–1820]).

10. Emanuel Rudolf, "Creating a Reader's Guide to Rees's Cyclopaedia," *Emanuel D. Rudolf's Studies in the History of North American Botany.* (Fort Worth, Texas: Botanical Research Institute of Texas, 2000): 29.

11. Giovanni Battista Ferrari, *Hesperides; sive, De malorum aureorum cultura et usu libri quatuor* (Romae, Sumptibus Hermanni Scheus, 1646).

12. Daly was a founding member of the The New York Botanical Garden as well as a member of the New York State Assembly and President of the American Geographical Society. Carl Friedrich Philipp von Martius, *Nova genera et species plantarum*...(Monachii: Typis Lindaueri, 1823–1832).

13. Due to lack of subscribers, the *American Journal of Forestry* only published ten issues and ran from October 1882 to September 1883.

14. Jean Jules Linden, *Pescatorea: iconographie des orchidées, premier volume* (Bruxelles: M. Hayez, 1860). Robert Warner, *The Orchid Album: Comprising Coloured Figures and Descriptions of New, Rare, and Beautiful Orchidaceous Plants*...(London: B. S. Williams, 1882–1897). Robert Warner, *Select Orchidaceous Plants* (London: L. Reeve, 1862–1865 and London: L. Reeve, 1865–1875).

15. Henry Frederick C. Sander, *Reichenbachia: Orchids Illustrated and Described* (London: H. Sotheran, 1888–90; St. Albans: F. Sander; New York: I. Forstermann, 1888–1890). Imperial edition (1892–1894). H. Rudolf Kunhardt was President of the Venezuela Petroleum Co. ca. 1950, collected orchids for fifteen years in South America and sponsored The New York Botanical Garden's scientific expedition to Venezuela led by Bassett Maguire, ca. 1948.

16. Marc Montefusco, "Sander's Reichenbachia— A Victorian Masterpiece," *American Orchid Society Bulletin* 50, no. 5 (May 1981): 541–546.

17. Johann H. Kniphof, *Botanica in originali, seu, Herbarium vivum*...(Halae Magdeburgicae, 1757–1764).

18. Nikolaus Joseph Jacquin, *Icones plantarum rariorum* (Vindobonae: C. F. Wappler; Londini: B. White, 1781–1793). The volume contains a Kelmscott Manor book plate, likely designed by William Morris.

19. Christoph Jacob Trew, *Hortus nitidissimis omnem per annum superbiens floribus; sive, Amoenissimorum florum imagines, quas magnis sumtibus collegit...* (Nürnberg: Auf Kosten der Seligmännischen Erben, 1768–1786). Johannes Gessner, *Tabulae phytographicae, analys in generum plantarum exhibentes, cum commentatione edidit Christ. Sal. Schinz* (Turici: Impensis J. H. Fuessli, 1795–1804).

20. "Got Rare Botanical Library," *The New York Times*, September 21, 1902.

21. Ibid.

22. Macer Floridus, *De virtutibus herbarum*, a fifteenth-century manuscript on vellum.

23. Johann Scheuchzer, *Herbarium diluvianum* (Lugduni Batavorum: Sumptibus Petri Vander Aa, Bibliopolæ, 1723).

24. Maria Sibylla Merian, *Histoire générale des insectes de Surinam et de toute l'Europe* (Paris: L. C. Desnos, 1771). Earlier titles, *Dissertation sur la génération et les transformations des insectes de Surinam* (La Haye: P. Gosse, 1726), bound with *Histoire des insectes de l'Europe* (Amsterdam: J. F. Bernard, 1730), were acquired by the Garden in 1910.

25. Anna Murray Vail, "Report of the Librarian," *Bulletin of The New York Botanical Garden* 3, no. 10: (Mar. 1904): 229–230. Anna Murray Vail was a student of Britton's and a member of the Torrey Botanical Club. She was active in the movement to establish a botanical garden. In 1900 she was hired as the first librarian of the Garden, a post she retained until 1907.

26. Anna Murray Vail, "Report on a trip to France and Holland by Miss A. M. Vail, Librarian," *Journal of The New York Botanical Garden* 4, no. 45 (Sept. 1903), 141–149. A list of books presented by Andrew Carnegie is included in the Library Accession list on p. 151 in this volume.

27. John Sibthorp, *Flora Graeca: sive plantarum rariorum historia, quas in provinciis aut insulis Graeciae legit...* (Londini: Typis Richardi Taylor, 1806–1840).

28. Anna Murray Vail, "An Interesting Accession to the Library," *Journal of the New York Botanical Garden* 7, no. 74 (Feb. 1906): 25. The original *Dioscurides codex Anicie Julinae picturis illustratus, non Vindobonensis*, is held in the Imperial Library of Vienna. The Mertz Library has a reproduction of the same title, issued in 1906 (Lugduni Batavorum: Sijthoff, 1906).

29. Andrew Carnegie, *The Gospel of Wealth, and Other Timely Essays* (New York: Century Company, 1901).

30. Nikolaus Joseph Jacquin, *Selectarum stirpium Americanarum historia* (Vindobonae [Vienna], ca. 1780). Santiago Madriñán, Nikolaus *Joseph Jacquin's American Plants: Botanical Expedition to the Caribbean (1754-1759) and the Publication of the Selectarum stirpium Americanarum historia* (Boston: Brill, 2013).

31. Charles Finney Cox was an active member of many scientific associations and societies. He served as President of the New York Microscopical Society in 1888, the Council of the Scientific Alliance of New York from 1891–1906, and of the New York Academy of Sciences in 1908 and 1909.

32. Sharon E. Kingsland, *The Evolution of American Ecology, 1890–2000* (Baltimore: The Johns Hopkins University Press, 2005), 20. James Edward Smith, *The Natural History of the Rarer Lepidopterous Insects of Georgia...*(London: Printed by T. Bensley, for J. Edwards [etc.], 1797).

33. Wilfrid Blunt and William T. Stearn, *The Art of Botanical Illustration* (Woodbridge, Suffolk: Antique Collectors' Club, 1994); Augustin Pyramus de Candolle, *Planta-rum historia succulentarum [Histoire naturelle des plantes grasses]* (A Paris: Chez A. J. Degour et Durand. [i.e.1798]–1841). Redouté's exceptional treatment of the succulent plants, was critical for their study, since they were difficult to represent with a pressed herbarium specimen.

34. "Two Rare Audubon Copper Plates Rediscovered in the Library," *The New York Botanical Garden Newsletter* 3, no. 2 (Feb. 1969). This article describes how the plates were re-discovered in the Library in 1969 and how the plates were originally purchased by J. J. Crooke, for the price of scrap copper.

35. Nathaniel Britton and Charles Finney Cox, "The Need of Additional Endowment," *Journal of the New York Botanical Garden* 6, no. 6 (April 1905): 57.

36. Ole Worm, *Museum Wormianum; seu, Historia rerum rariorum, tam naturalium, quam artificialium...* (Amstelodami: Apud L. & D. Elzevirios, 1655).

37. Matthieu Bonafous, *Histoire naturelle, agricole et économique du Maïs* (Paris: Huzard, 1836); Etienne Denisse, *Flore d'Amérique, dessinée d'après nature sur les lieux...*(Paris: Gihaut [1843–1846]).

38. Lincoln P. Paine, *Ships of Discovery and Exploration* (Boston: Houghton Mifflin Co., 2000), 127. Traveling on the warship *Senyavin*, sent to survey the coasts of Russian America and Asia, Litke's voyage was among the most productive expeditions during the nineteenth century. Alexander Postels described over 2,500 different plants, algae and rocks in his *Illustrationes algarum in itenere circa orbem jussu Imperatoris Nicoliai I...*(Sanktpeterburg, 1840).

39. William Mitten, *Musci Austro-Americani...*(London: Longmans, Green, Reader and Dyer: and Williams and Norgale, 1869).

40. Sarah Harlow became Librarian in 1913 and remained in the post until 1937. She was replaced by Miss Eliza-beth Hall. Barnhart became bibliographer in 1917 and remained in the position until he retired in 1942.

41. "Report of the Librarian," *Bulletin of The New York Botanical Garden* 7, no. 25 (Mar. 1911): 324.

42. Ibid.; G. A. Pritzel, *Thesaurus literaturae botanicae...* (Lipsiae: F. A. Brockhaus, 1872–[1877]).The Mertz Library owns Barnhart's annotated copy of Pritzel's *Thesaurus*.

43. John Hendley Barnhart, *Biographical Notes upon Botanists* (Boston: G. K. Hall, 1965). The index cards for Barnhart's "Biographical Notes on Botanists" are held in the Archives NYBG, Records of the Library, RG5.

44. Harrison D. Horblit, *One Hundred Books Famous in Science: Based on an Exhibition Held at the Grolier Club* (New York: Grolier, 1964).

45. William Hubert Miller, "Mark Catesby, Eighteenth-Century Naturalist," *Journal of The New York Botanical Garden* 50, no. 589 (1949): 1–7. Mark Catesby, *The Natural History of Carolina, Florida, and the Bahama Islands, Containing the Figures of Birds, Beasts, Fishes, Serpents, Insects, and Plants...*(London: Printed for C. Marsh, T. Wilcox, and B. Stichall, 1754). The Garden holds five variant copies of Catesby's *Natural History*. The 1741 edition was purchased from the Barnhart Library and the 1750 edition was purchased using the Special Book Fund. The first copy of the 1754 edition came from Columbia College and the second copy of the 1754 edition was from the library of Catherine Colt Dickey, given in 2003 by her daughter Mary Lindsay Dickey. The 1771 edition was accessioned in January 1909.

46. Addison Brown and Nathaniel Lord Britton, *An Illus-trated Flora of the Northern United States, Canada, and the British Possessions* (New York: C. Scribner's Sons, 1896–1898).

47. Francois Richard Tussac, *Flora Antillarum; seu, Historia generalis botanica, ruralis, oeconomica vegetabilium in Antilles indigenorum...*(Parisiis: Apud auctorem et F. Schoell, 1808–1827).

48. "Botanical Garden Enriched by Books," *The New York Times*, January 20, 1924.

49. Peter Simon Pallas, *Flora Rossica, seu, Stirpium Imperii Rossici per Europam et Asiam indigenarum descriptiones* (Francofurti; Lipsiae: I. G. Fleischer, 1789–1790); Heinrich Reichenbach, *Icones Florae Germanicae et Helveticae...*(Lipsiae: F. Hofmeister [etc.] 1834–1912). William Roxburgh, *Flora Indica, or, Descriptions of Indian Plants* (Serampore: Printed for W. Thacker, 1832).

50. Ruth Caviston, *A History of The New York Botanical Garden*. Typescript (New York, 1952), 97. In the year 1922 the Edison Company changed the current in New York City from two-phase DC to three-phase AC.

51. Caviston, 97.

52. William Curtis, *Flora Londinensis: or, Plates and Descriptions of Such Plants as Grow Wild in the Environs of London...*(London: The author and B. White, 1777–1798).

53. Benjamin Maund, *The Botanic Garden; Consisting of Highly Finished Representations of Hardy Ornamental Flowering Plants, Cultivated in Great Britain...*(London: Simpkin & Marshall [etc.], 1825–1850).

54. Elizabeth Hall, "Annual Report of the Librarian for the Period from December 1, 1940, to November 30, 1941," Records of the Library, Archives NYBG, RG6.

55. Fife served on the NYBG Advisory Committee from 1936 to 1948 and was associated with the New York Horticultural Society, as well as the Garden Club of America.

56. Griffith Hughes, *The Natural History of Barbados. In Ten Books* (London: Printed for the author, 1750).

57. Despite being incorporated in 1891, the Garden did not begin active operation until 1895.

58. William Robbins, "Annual Report of the Director for 1945," *Journal of The New York Botanical Garden* 47, no. 562b (Oct. 1946), 1.

59. Clarence Mackenzie Lewis was a trustee of the New York Botanical Garden and in 1953 donated to the Library a collection of 1177 bound volumes, 439 unbound, over 1000 periodicals and the same number of reprints and bulletins. Humphry Repton, *Sketches and Hints on Landscape Gardening*...(London: Printed by W. Bulmer and Co., Shakspeare Printing-Office, and sold by J. and J. Boydell and by G. Nicol..., [1794]), and his *Observations on the Theory and Practice of Landscape Gardening*...(London: Printed by T. Bensley for J. Taylor, 1803), and *Designs for the Pavillon at Brighton* (London: Printed for J. C. Stadler, and sold by Boydell, 1808).

60. Montague was a lawyer, economist and book collector, and member of the Board of Managers of the Garden from 1952 until his death in 1961.

61. Blunt and Stearn, *Art of Botanical Illustration*: 118.

62. "New Library is Dedicated by the Botanical Garden," *The New York Times*. December 17, 1965.

63. Ibid.

64. John F. Reed was the Curator of the Library from 1966 to 1972 and Director of the Library from 1986 to 2003. In the interim he was Vice President for Education at the Garden.

65. Frank J. Anderson, "New Light on Circa instans," *Pharmacy in History* 20, no. 2 (1978): 65–68. The Library holds two copies of the *Circa instans*, one from ca. 1190 and the other dated ca. 1275.

66. While on an expedition in Venezuela in 1988, the Garden's bryologist, William (Bill) Buck, had met Kerry Packer, who after revealing that he had two copies of the set was asked to donate one to the Garden. Several weeks later, thirty-six large portfolio boxes of the *Banks Florilegium* arrived on the loading dock at the Garden, and the set was quickly transported to the Library.

67. Alexander von Humboldt, *Vues des Cordillères, et monumens des peuples indigènes de l'Amérique* (Paris: F. Schoell, 1810). Garden staff members Susan Fraser (Librarian) and Scott Mori (Botanist) attended the auction at Christies in June 1997 and successfully bid on this book. The purchase was made possible with funds provided by Garden patron Marcia Coyle.

68. Susan Fraser attended the auction of Important Botanical Books, at Christies in June 2009 along with Library Visiting Committee members Stephen Massey and Lynda Steere. With support from William and Lynda Steere, Jr. they successfully bid on several works new to the collection. Johann Simon Kerner, *Figures des plantes économiques* (À Stoutgard: Imprimé chez Christofle Frédéric Cotta, 1786–1796). Jean de Renou, *Les Oeuvres pharmaceutiques* (A. Lyon: Chez Antoine Chard [Imprimé par Pierre Colombier], 1626) and Gaetano Testolini, *Rudiments of Drawing, Shadowing and Colouring Flowers in Water Colours* (London: G. Testolini, 1818).

69. Priscilla Susan Falkner Bury, *A Selection of Hexandrian Plants* (London: R. Havell, 1831–1834).

70. The former Museum building was renamed the Library building and the Library was given the name LuEsther T. Mertz Library, in recognition of Mrs. Mertz's enduring commitment to the Garden, her dedicated support of the Garden's science programs, and her lifelong love of literature. During the 1980s she was involved with programs in horticulture and science at The New York Botanical Garden. After her death in 1991, important gifts from her estate and from the LuEsther T. Mertz Charitable Trust have contributed to core programs at the Garden, involving horticulture, science, and visitor services.

71. Ian MacPhail, *André & François-André Michaux* (Lisle, IL: The Morton Arboretum, 1981). MacPhail arranges his bibliography chronologically by publication date and assigns a number to each title. Titles and their later editions are grouped under one number, with each edition assigned a letter. Therefore MacPhail has 25 numbers, with 39 titles and editions. The Mertz Library holds 26 titles and editions or 66.67 percent of all known variants.

72. Books from the library of Elizabeth Kals Reilley were transferred to The New York Botanical Garden between 1991 and 2002.

73. Elizabeth S. Eustis, *European Pleasure Gardens: Rare Books and Prints of Historic Landscape Design From the Elizabeth K. Reilley Collection* (Bronx, NY: The New York Botanical Garden, 2003).

74. Humphry Repton, *Whitton, Seat of Samuel Prime Esqr.* [manuscript] ["Red Book"] [1796]. Stefano della Bella, Views of Pratolino. Art and Illustration Collection, EKR 376.

75. Nathaniel L. Britton, "Report of the Secretary and Director-in-Chief for the Year 1904," *Bulletin of The New York Botanical Garden* 4, no. 12 (May 1905): 10.

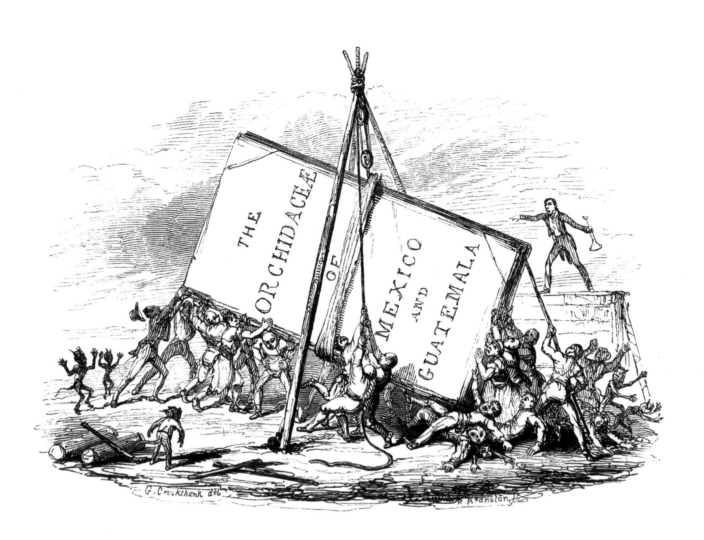

GREAT

In addition to their extravagant size, unusual heft,

HERBALS,

and great expense at the time they were created,

FLOWER

these iconic works share an overall grandeur and vitality

BOOKS,

that bring to life the history of the herbal,

AND

the interdependence of the botanical garden and the book,

GARDEN

and the splendor of grand European gardens.

PRINTS

Vignette by G. Cruikshank, in James Bateman, *The Orchidaceae of Mexico & Guatemala*, London, 1837–1843.

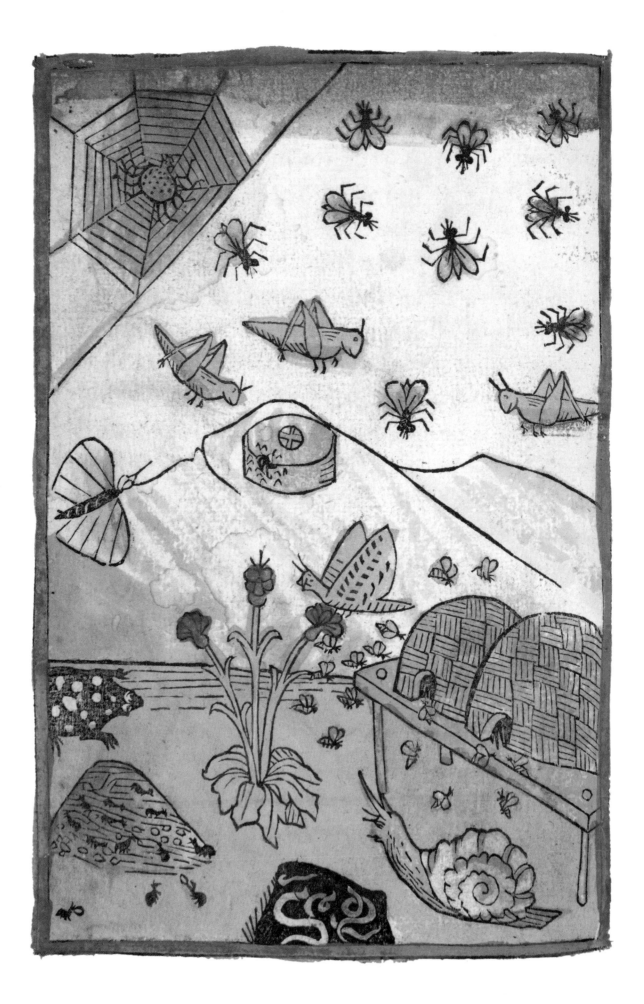

EUROPEAN MEDIEVAL AND RENAISSANCE HERBALS

LUCIA TONGIORGI TOMASI

In the LuEsther T. Mertz Library a large number of rare herbals, botanical, and pharmacological manuscripts, and incunabula are preserved that exemplify the remarkable history of medieval and Renaissance herbals and the classical traditions from which they evolved. As ancient formulas for plant remedies show, from the dawn of history the knowledge of plants was closely tied to the practice of medicine. Studies of herbs and their medicinal properties were gathered in works known as herbals. Following centuries of further research and efforts to improve plant identification and classification, these texts evolved to form a standardized body of work, which ultimately would acquire the attributes needed to be considered real modern botanical treatises.

Among the many works that have been passed down to us from the ancient world, two texts exerted a particularly profound influence on the development of medicine and the natural sciences up to the Renaissance. Both works were written by outstanding naturalists active in

the first century AD, Greek physician Pedanius Dioscorides (fl. 50–70) and Roman writer and politician Gaius Plinius Secundus (23–79), known as Pliny the Elder. Dioscorides' celebrated *De materia medica* and Pliny's encyclopedic work *Naturalis historia* circulated widely in the ancient world and by the early Middle Ages had become mandatory sources for the compilation of herbal texts. Over time, however, as these writings were being copied repeatedly, the text became corrupted. Only with the invention of the printing press could more accurate editions and translations be produced, allowing for greater accuracy and broader dissemination of such fundamental works.

The first printed edition of Dioscorides' *De materia medica* was published in Latin in the town of Colle near Siena in 1478. This work would be followed by many other editions, including a Greek edition prepared by the Italian humanist Gian Francesco Torresani d'Asola (Franciscus Asulanus) (ca. 1498–ca. 1558), published in Venice in 1518 by the famous Aldine Press, established in 1494 by Aldus Manutius (1449–1515).[1] Among the most notable works held in the Library are two very early incunabula of Pliny the Elder's writings: a 1483 edition of *Naturalis historia*

FIG. 2.5. A vivid, hand-colored woodcut, in Konrad von Megenberg, *Hye nach volget das Puch der Natur*, Augsburg, 1475.

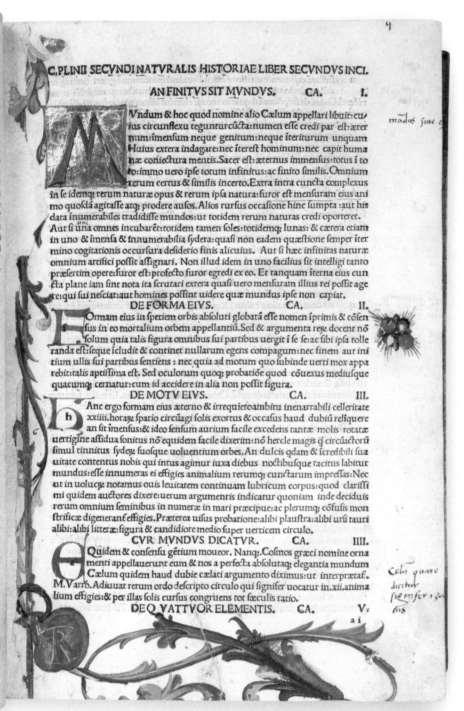

FIG. 2.1. Illuminated text page, in Pliny the Elder, *Naturalis historia*, Venice, 1483. This encyclopedic work on natural history devotes five books to the discussion of plants.

by Reynaldus de Novimagio (fig. 2.1), and a 1559 edition revised by the German philologist Sigismund Gelenius (1497–1554).[2]

Another important herbal which enjoyed considerable popularity during the medieval era was *De virtutibus herbarum* (*On the Virtues of Herbs*). The text of this botanical work was written in Latin hexameter, a poetic verse form that facilitated memorization of the herbs' medicinal properties. Traditionally attributed to Macer Floridus, the book is now believed to be a compilation of various ancient texts by Dioscorides, Pliny the Elder, and Galen (130–200), gathered during the first half of the eleventh century by the French physician Odo de Meung. Though initially published in 1477 in Naples, it was the later Milan edition of 1482 that for the first time included woodcut engravings. Various revised versions would continue to appear up until the sixteenth century. The 1510 Paris edition is especially significant. It not only features a portrait of the author (fig. 2.2), but has a new and considerably improved set of woodcut illustrations, showing more extensive botanical details of the plant's roots, flowers, and seeds.[3]

Throughout the medieval period botanical studies were largely pursued behind the walls of monasteries by learned monks devoting themselves to cultivating plants and studying their medicinal properties. Concurrently, medical botany was taught at the universities by reading and interpreting the classical texts, such as those by Dioscorides and Pliny the Elder. The scientific traditions inherited from the Arab culture of Spain and northern Africa contributed meaningfully to the development of Western knowledge of medicine and botany. The fame of scholars such as Ibn Scrapion Yuhanna (ninth century), Al Dinawari (828–896), Avicenna (980–1037), and Ibn al-Baitari (d. 1248) spread throughout Europe, as numerous transcriptions and translations of their works came to light.[4]

FIG. 2.3. The illustrated title page, in Ibn Serapion, *Practica*, Lyon, 1525, contains small portraits of the scholars Matthaeus Platearius, Ibn Serapion, and Petrus Hispanus.

Contributing to the enrichment of Europe's scientific heritage was the medical school of Salerno in southern Italy, reaching its apogee in the twelfth century.[5] A significant figure from Salerno—who remains little known apart from his name—was the physician Matthaeus Platearius (d. 1161). Platearius' importance is reflected in the insertion of a woodcut engraving with a portrait of him in the company of the scientist Ibn Serapion and the physician Petrus Hispanus (ca. 1215–ca. 1277) in the 1525 Lyon edition of Serapion's *Practica* (fig. 2.3).[6]

The most important work historically attributed to Platearius, is *Circa instans*,[7] a work that was to be translated into many languages, consulted by many physicians, and adopted as a standard textbook at universities throughout Europe. The work was usually accompanied by a set of highly original illustrations of plants (as well as some animals and minerals), used for medicinal purposes and known as "simples."[8] The oldest known surviving Latin copy in the *versio minor* or smaller version, is a vellum manuscript dating from around 1190. It is made up of sixty-nine folios without illustrations (fig. 2.4).[9] The text, executed in an eminently legible pre-Gothic script, arranged in a single column on each folio, with space left in the margins for notes, stylistically seen, must have been written in a country north of the Alps (possibly Germany). The work is divided into short chapters, with each new chapter delineated by headings known as *lemmas*. Using Arabic numbering, the *lemmas* are arranged in alphabetical order from "Aloe" to "Zuccaro" (sugar). Each *lemma* is followed by a list of plant names that begin with that letter in the alphabet. These plants were used as components in medicinal remedies and referred to as "simples," providing a dense compendium of botanical and pharmacological information.

The manuscript's text is written alternately in black or red ink, and opens and closes with two endleaves written in Carolingian minuscule,[10] which contains a patchwork of quotations (*centos*) on themes relating to death and man's destiny (*Novissimi*).[11] The text concludes with the exhortation: "Finis est libri gloria Christi tibi" (Here ends the book, for you the glory of Christ).

A second Latin copy of *Circa instans*, is also preserved in the Mertz Library.[12] This later manuscript was produced sometime during the last quarter of the thirteenth century, probably in France, is quite different, although the influence of Italian manuscript models can be recognized in both. This later codex consists of thirty-eight folios with *lemmas* arranged in a more orderly manner than that of the earlier copy. The text begins with an elegant initial

FIG. 2.2. Frontispiece, in *De virtutibus herbarum*, Paris, 1510. The woodcut shows the author, Macer Floridus, working in his studio.

letter decorated in black, red and gold, inscribed with the words "*Circa instans.*" Each chapter begins with a beautiful initial letter decorated alternately in red or blue ink. The body of the work is divided into two hundred and sixty chapters arranged in alphabetical order from "De Aloe" to "De Zedoaria" (*Curcuma zedoaria*). The text is laid out with two columns to the page in a form of handwriting known as Textura script and presents a description of each substance, with various glosses added in the margins. The last two pages of the herbal consist of an *explicit* (end) with the declaration "Grazia sit tibi Criste quia liber explicit iste" (Thanks be to Christ, the book is finished), followed by expressions of piety and invocations to ward off evil with magical formulas designed to protect against disease. The work opens and closes with two endleaves in Chancery script, possibly dating from the thirteenth century. These endleaves were added when the manuscript was rebound, using palimpsest sheets on which parts of a statute written in Latin pertaining to the Tuscan city of Prato is noticeable.[13]

The importance of *Circa instans* is evident from the many subsequent works that drew direct inspiration from it. Compilers of various medieval encyclopedias boldly copied descriptions of plants from this codex. This can be clearly seen in the treatises of Thomas of Cantimpré (1201–1272), Albertus Magnus (1206–1280), and Vincent of Beauvais (1190–1264), and in what was the first German book of natural history, *Das Puch der Natur* (*The Book of Nature*), published in 1475 by Konrad von Megenberg (1309–1374) (fig. 2.5).[14] Moreover, the thirteenth-century English scholar Bartholomaeus Anglicus (ca. 1203–1272) borrowed entire passages from *Circa instans* for his nineteen-part compendium *De proprietatibus rerum* (On the Properties of Things), originally written in 1240.[15] Another scholar, Pietro de Crescenzi of Bologna (1233–

1320), made similar use of Platearius' work when he wrote his celebrated treatise on agronomy, *De agricultura vulgare* or *Ruralia commoda*, the fifth and sixth books of which form a herbal, describing each plants medicinal properties. The Mertz Library owns two copies of this work: a beautiful edition published in Venice in 1519

containing a modest set of woodcut engravings, and another, published in Strassburg in 1518 under the title *Von dem Nutz der Ding* by the preeminent printer Johannes Schott (1477–1550) (fig. 2.6).[16] The invention of the printing press had an immediate and profound impact on the study of the sciences, and botany in particular. Texts dating from antiquity were among the

first works to be printed, and their illustrations constituted one of their most important features. The earliest illustrations were produced in the form of woodcut engravings, a technique that had been perfected by the late fifteenth century. This is demonstrated by the artwork from the period, especially the print work of the well-known

FIG. 2.4. *Circa instans*, dated around 1190 and attributed to the medieval physician Matthaeus Platearius, is one of the oldest extant manuscripts related to the Medical School of Salerno.

artist, Albrecht Dürer (1471–1528). Woodcuts would be used in natural history texts well into the second half of the sixteenth century.[17] Initially, this new form of illustration did not offer accurate portrayals of a specific plant, but an exact

likeness did not seem to be the engraver's main concern. Since it was quite expensive to prepare original illustrations for each new edition, the practice of reusing images from earlier published works became widespread. Herbals compiled and illustrated by physicians and apothecaries for their own use, continued to circulate during the Middle Ages. An Italian herbal manuscript from the sixteenth century provides an interesting example of such a work (fig. 2.7).[18]

Among the most rare and interesting incunabula in the Mertz Library is a first edition of *Gart der Gesundheit*, or *Garden of Health*, written in a Bavarian dialect and published in 1485 in Mainz by the celebrated printer Peter Schoeffer (ca. 1425–ca. 1503).[19] This herbal presents a rich catalog of the native plants of Germany, arranged in alphabetical order with a description of their properties. Commissioned by an unknown but wealthy patron, its author was most likely the Frankfurt physician Johann Wonnecke von Kaub (ca. 1430–ca. 1503). This folio edition is embellished with one hundred and eighty-five botanical woodcuts based on faithfully rendered, boldly outlined plant depictions, skillfully colored by hand (fig. 2.8).[20] Publishers did not hesitate to pillage images from this work. The printer Hannsen Schönsperger reissued *Gart der Gesundheit* under the title *Hortus Sanitatis* in Augsburg in 1502, and most likely pirated the illustrations from the original.[21]

Another work based on the acclaimed *Gart der Gesundheit* that was groundbreaking for the breadth and originality of its text and image, was *Ortus Sanitatis* (fig. 2.9). Written anonymously, it was first printed in 1491 in Mainz by Jacob Meydenbach and a few years later, in 1497, in Strassburg by Johann Prüss (ca. 1447–ca. 1510). The work was later translated into French, German, and Italian. A genuine encyclopedia, presenting hundreds of plants, animals, and minerals in a series of 1,066 brief chapters,

FIG. 2.6. Charming vignettes illuminate the text describing the care for field and vineyard, in Pietro de Crescenzi, *Von dem Nutz der Ding*, Strassburg, 1518, fols. XXXVI and XXXVII.

FIG. 2.7. This Italian herbal, ca. 1550, contains colored ink drawings of plants, including *Aconitum vulparia* or wolfbane (left) and *Solatro maggiore* or deadly nightshade (right), with annotations by its owner.

Ortus Sanitatis was above all famous for its vast set of woodcut illustrations. These have been attributed by some to the Master of the Hausbuch, an artist active in southern Germany during the last quarter of the fifteenth century, and by others to Erhard Reuwich or Reeuwijk, a Dutch engraver active in Mainz around 1480. In comparison to *Gart der Gesundheit,* these illustrations have been executed in a more naturalistic manner.[22]

The Mertz Library collection holds a rare edition of the famed *Tractatus de virtutibus herbarium* known as *Herbarius Latinus,* which was compiled from various medieval and Arabic manuscripts by an anonymous author. Printed in 1491 in Vicenza by Leonardus Achates and Guglielmo de Papia, the *incipit* or opening statement of the work contains a double portrait, which, due to the random reuse of an old woodblock, was mistakenly presumed to represent Arnaldus de Villanova of Catalonia (1240–1313) and the Persian physician Avicenna (fig. 2.10).[23] This mistake in turn resulted in the erroneous attribution of later versions of *Herbarius Latinus* to Villanova, who, while not responsible for this work, did in fact publish many other studies relating to alchemy.[24]

During the Renaissance the study of natural history was gradually transformed into a professional discipline, with both botanists and artists playing an active role in the creation of a more modern scientific and cultural climate. Important artists such as Leonardo da Vinci (1452–1519) and the aforementioned Albrecht Dürer, considered the natural sciences essential to their art. They studied various aspects of the plant and animal world and created images that are not only incredibly realistic and beautiful, but also express astounding scientific acumen.

The intellectual renewal that would revolutionize the study of botany and natural history began in the first decades of the sixteenth

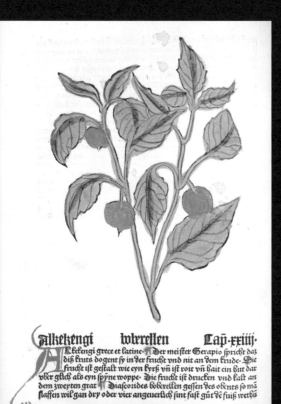

FIG. 2.8. Woodcut of *Alchekengi* or bladder cherry, the bright coloring of which added a degree of naturalness to the simple outlines of the plant as illustrated in *Gart der Gesundheit*, Mainz, 1485.

Fig. 2.9. The *Ribes* or dragon tree-currant, one of the many small images to decorate the highly popular *Ortus sanitatis*, Strassburg, ca. 1497.

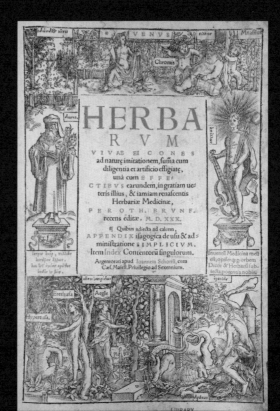

FIG. 2.10. Title page, in *Incipit Tractatus de virtutibus herbarium*, or *Herbarius Latinus*, published in Venice in 1491. The two men portrayed were mistakenly identified as the famous medieval physician Arnaldus Villanova and the Persian physician Avicenna.

FIG. 2.11. The title page in Otto Brunfels, *Herbarum vivae eicones*, Strassburg, 1530, is filled with references to the classical past, including mythological scenes of the Garden of the Hesperides. The realistic woodcut illustrations represent images of plants directly drawn from nature.

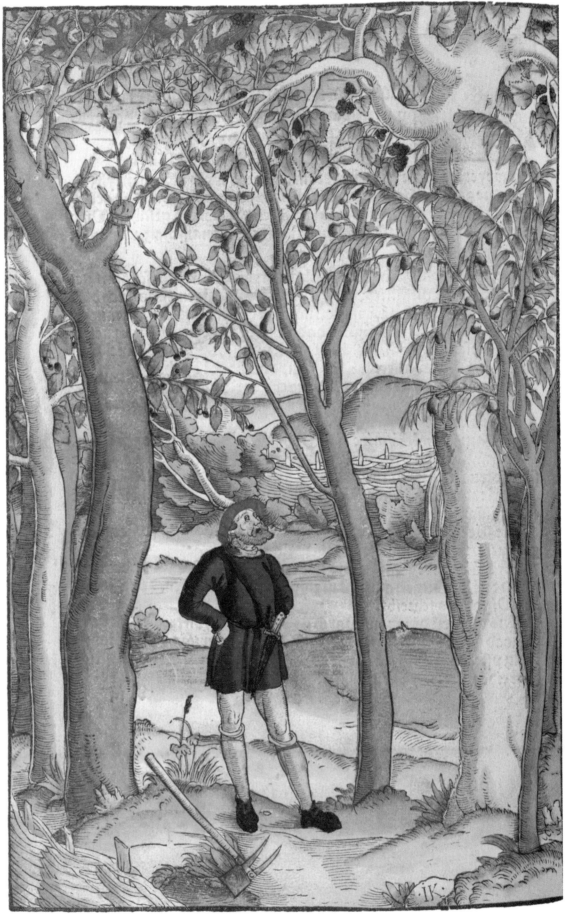

FIG. 2.12. *Malva alcea* L. or musk-mallow, in Otto Brunfels, *Contrafayt Kreüterbüch*, Strassburg, 1532–1537, fol. CCXXXII. The outstanding representations of plants show images of local German plants studied and drawn directly from nature.

FIG. 2.13. Hand-colored woodcut of a man standing in an orchard, in Otto Brunfels, *Contrafayt Kreüterbüch*, Strassburg, 1532–1537. This rare image features a monogram on the stone in the foreground, identified as belonging to artist Jacob Kallenberg.

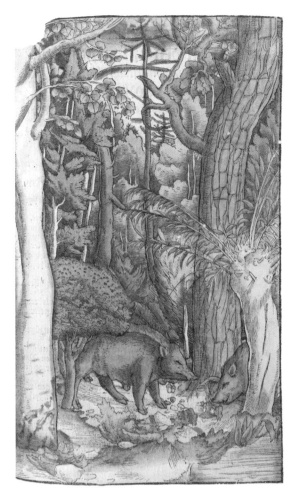

FIG. 2.14. Hand-colored woodcut of boars in a forest attributed to the Swiss artist Jacob Kallenberg, in Otto Brunfels, *Contrafayt Kreüterbüch*, Strassburg, 1532–1537.

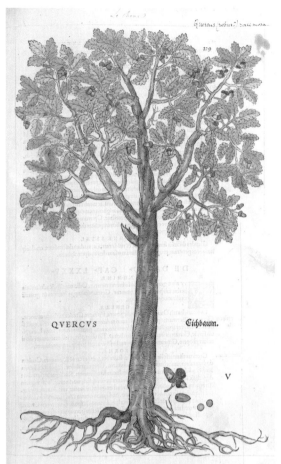

FIG. 2.16. *Quercus* or oak tree, in Leonhart Fuchs, *De historia stirpium*, Basel, 1542, fol. 229.

FIG. 2.15. *De historia stirpium*, Basel, 1542. Depicting the artists absorbed in their task, the illustrations in this work were meant to assist doctors and apothecaries in properly identifying plants for medicinal use.

century with the pioneering works of several German and Italian physicians, all notable men of science. The development of the arts and natural sciences owed much to the establishment of botanical gardens by some of the most prestigious universities in Europe. Whereas during the Middle Ages, the study of botany was substantially empirical, scholars during the Renaissance embarked on more systematic analyses, addressing questions of morphology and classification and taking an interest in the economic importance of medicinal plants.

Between 1530 and 1550 a series of botanical works were published that introduced an array of radical innovations. Now, for the first time, the representations in books were based on the actual experience and direct observation of plants in their natural habitat, combined with comparative studies rather than a relying on classical authorities. The authors of these works not only brought the ancient and medieval tradition of the herbal to an end, but transformed the study of plants. Botany became an independent discipline with its own criteria and methodology and was no longer viewed as part of the study of medicine. The first example of such a revolutionary work was *Herbarum vivae eicones ad naturae imitationem*, printed around 1530 by the aforementioned Johannes Schott in Strassburg.

Fig. 2.17. *Armeniaca maiora* and *Armeniaca minora* or apricot, in Pietro Andrea Mattioli, *New Kreüterbuch*, Prague, 1563, fols. 95–96. One of the most popular books of its age, filled with beautiful as well as realistic images, Mattioli's work was published in many languages.

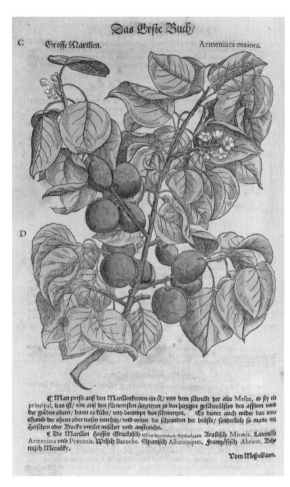

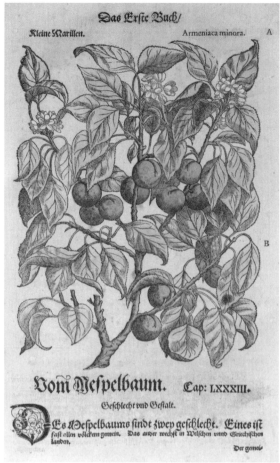

The title is significant in itself, implying that the plants were drawn from life (*ad naturae imitationem*) rather than simply copied from earlier works. The elaborate title page, embellished with a scene from the Garden of the Hesperides and the figures of Apollo, Venus, and Hercules (fig. 2.11), is an expression of the refined classical culture that permeated the arts and sciences of Northern Europe during the Renaissance. The author, Otto Brunfels (1488–1534), was a German monk whose single greatest achievement was to have collected and documented specimens of plants from his own region providing clear descriptions using the vernacular name of each plant. Following a rigorously systematic method he compared the local German plants with the well-known flora of the Mediterranean. When he encountered

unknown species—many of them originating from the Near or Far East or the New World—he was careful to refer to them as *nudae* ("nude"), that is, without name or identity. The illustrations in his herbal, often filling an entire page, were clear and lifelike, thus greatly aiding botanists in their task to collect and identify plant species.

The gifted artist responsible for the innovative images in Brunfels' work was Hans Weiditz (1495–ca. 1537). Trained as a painter in the tradition of Albrecht Dürer, Weiditz specialized in book illustration and worked for various publishers in Strassburg. With a steady hand, and by carefully observing, or, as Brunfels noted, painstakingly "copying nature," Weiditz succeeded in creating both beautiful and highly realistic portrayals of plants. He even included such details as wilting leaves, indicating that the

plant specimen was drawn some time after it had been collected.

A later Strassburg edition of Brunfels' *Herbarum vivae eicones* appeared between 1532 and 1537 under the German title *Contrafayt Kreüterbüch*.[25] This work is of particular interest for its vividly colored images with skillfully shadowed outlines (fig. 2.12). Included in the Mertz Library copy are two pages with beautifully executed wood engravings that are not found in the first printing of this book and must have been inserted into this volume by the printer or binder.[26] One image depicts a man standing in an orchard. The monogram "IK" appears inscribed on a rock on the foreground, referring to the artist Jacob Kallenberg (ca. 1500–1569), an engraver who primarily worked in his native Swiss city of Bern. The second woodcut depicts a group of wild boars rummaging through the forest (figs. 2.13 and 2.14).

In 1542, the German naturalist and physician Leonhart Fuchs (1501–1566), published *De historia stirpium*.[27] Like Brunfels often called the "father of early modern botany," Fuchs also sought to reorder the flora of his country, taking as his starting point the tradition of Dioscorides and Pliny the Elder. Fuch's stunning work constituted such a milestone in the history of botanical publication that it was rightfully compared to and placed on equal footing with two other ground-breaking works appearing the following year: Andreas Vesalius' *De humani corporis fabrica,* and Nicolaus Copernicus' *De revolutionibus orbium coelestium;* the first modern works on anatomy and astronomy, respectively.

As in the case of Brunfels' herbals, the most important feature of *De historia stirpium* was its illustrations. To underline their significance, Fuchs noted the great effort and expense that had gone into their preparation by actually publishing a portrait of the contributing artists (fig. 2.15). Each artist is seen deeply absorbed in

his task: Albrecht Meyer (fl. 1542) is preparing the botanical drawings, Heinrich Füllmaurer (fl. 1540) is transferring them to woodblocks, and Veit Rudolph Speckle (d. 1550) is holding a knife to carve out the images. For the first time all 519 plants, including about 400 native species, are generally depicted life-size. Printed on large botanical sheets indicating both common and Latin names, the plants have been carefully arranged on the page and boldly drawn with sharply defined contours to allow for the easy addition of color by hand (fig. 2.16).[28]

Another "father of early modern botany" was the physician Pietro Andrea Mattioli of Siena (1500–1577), whose completely revised and augmented edition of Dioscorides *Libri cinque della historia e materia medicinale* earned him international reputation. The work was first printed in Venice in 1544, without illustrations. Ten years later a Latin translation entitled *De materia medica* appeared, this time embellished with 562 small woodcut engravings.[29] A particularly fine edition with numerous engravings in a larger folio size was published in 1562 under the title *Herbarz* in Prague, where Mattioli had transferred to serve as the Hapsburg emperor's personal physician. The German translation, also published in Prague, followed a year later under the title *New Kreüterbuch* (fig. 2.17).[30]

The success of this work led to the publication of another Latin edition— *Commentarii in sex libros,* which was printed in Venice by Vincenzo Valgrisi in 1565. The celebrated Valgrisi folio edition contained close to one thousand botanical illustrations drawn "with inestimable art, patience, and skill"—as the author declared—by the artist Giorgio Liberale of Udine (1527–ca. 1579), and was carefully engraved by Wolfang Meyerpeck of Meissen (d. 1578).[31] The style of these strongly outlined drawings contrasts with the more

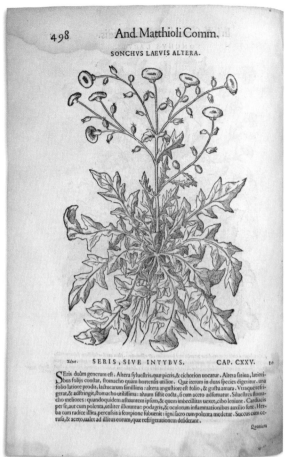

FIG. 2.18 A–B. *Sonchus laevis altera* or sow thistle, in Pietro Andrea Mattioli, *Commentarii*, Venice, 1565, vol. 1, fol. 498. A comparison between the woodblock and the printed image helps to clarify the wood carving technique and printing process.

FIG. 2.19. The frontispiece in Rembert Dodoens, *Trium priorum de stirpium historia*, published in Antwerp in 1553, includes a colored woodcut portraying the famous author at the age of thirty-five.

delicate and crisply rendered woodcuts in the herbals of Brunfels and Fuchs. The Mertz Library holds four of the original woodblocks that were used to illustrate both the 1562 Prague and the 1565 Venice edition of Mattioli's work (fig. 2.18 A–B). These artifacts provide a rare glimpse into the technical processes involved in the illustration of these large format editions. The exceptional success of Mattioli's work encouraged publishers in other parts of Europe to produce their own editions in Italian, Latin, French, or German. Such revised versions would continue to appear up until the eighteenth century. Mattioli's declared objective was to bring together in a single volume the vast quantity of botanical knowledge that had been accumulated over the centuries.

Between the second half of the sixteenth and early seventeenth century, the work begun by Brunfels, Fuchs, and Mattioli continued in Northern Europe and was carried to higher scientific level. Hieronymus Bock (1498–1554) and Adam Lonicer (1528–1586) in Germany; William Turner (1510–1568) and John Gerard (1545–1612) in England were to become well known for their herbals. However, it was especially in the Low Countries with works by such outstanding Flemish botanists as Rembert Dodoens (1517–1585) (fig. 2.19),[32] Carolus Clusius (1526–1609), and the French born Matthias de L'Obel (1538–1616) that the herbal entered the modern era.[33] The texts written by these naturalists represented a clear departure from and immense improvement over the traditional typology of the herbal. Their publications are considered the first modern scientific treatises to appear in Europe. The result of a genuine collective effort that brought together botanists,

artists, and publishers, they represent a milestone in the art of book printing. Many of these works were produced by the illustrious Officina Plantiniana or Plantin-Moretus Printing House in Antwerp, founded in the 1550s by Christopher Plantin (ca. 1520–1589) (fig. 2.20). From its presses emerged an unending stream of books written by the most celebrated naturalists in Europe including the translations of many fundamental texts that were first published in other countries, and embellished with exceptional wood-block engravings.[34]

The dissemination of natural history and botanical knowledge provided an incentive for the scientific exploration of different regions of Europe and beyond, as exemplified by the botanical expeditions undertaken by Carolus Clusius.[35] The detailed scientific work resulting from these and other explorations would make it possible to define the modern concept of a "flora." During this period the gardens of Europe began to fill with exotic species and sophisticated hybrids, as gardeners and wealthy collectors vied to produce exemplars of rare flowers, fruits, and vegetables that would provoke wonder and amazement. In this uniquely stimulating climate of scientific experimentation, botany was able to free itself from its traditional role as an adjunct to the practice of medicine and establish its own place in the history of the sciences, becoming a separate discipline with its own precise nomenclature.

Translated by LISA CHIEN

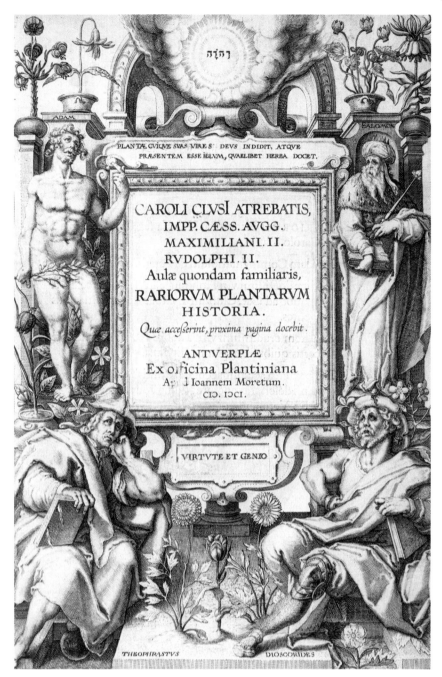

FIG. 2.20. Title page, in Carolus Clusius, *Rariorum plantarum historia*, Antwerp, 1601. This richly illustrated engraving was often reused by the publishing house Plantin-Moretus, and juxtaposes the figures of Adam and Salomon on top, with the Greek Fathers of Botany, Theophrastus and Dioscorides, below.

A significant number of the botanical and pharmacological manuscripts in the Mertz Library belonged to the former collection of Emil Starkenstein (1884–1942), which, together with other important works, are described in the pioneering study by Frank Anderson, *An Illustrated History of the Herbals* (New York: Columbia University Press, 1977).

1. *Pedacii Dioscoridis de materia medica* [Venetiis, in aedibus Aldi et Andreae soceri, 1518]. The celebrated Italian printer and humanist Aldo Pio Manuzio (Aldus Pius Manutius), who was born in Bassano in 1449 and died in Venice in 1515, is considered by many scholars to be the first modern publisher.

2. Pliny the Elder, *Naturalis historia* (Venetiis, Reynaldus de Novimagio, 1483) and ibid., *Naturalis historiae libri trigintaseptem* (Venetiis, apud Paulum Manuntium, Aldi F., 1559). Also published by the Aldine Press, was a delightful short treatise on the *Vetonica* or purple betony. It was originally written around AD 23 by the Roman physician Antonius Musa, and was highly regarded by physicians during the entire course of the Middle Ages. See also Lucia Tongiorgi Tomasi, "The Renaissance Herbal," Catalog published in association with the exhibition held in the William D. Rondina and Giovanni Foroni LoFaro Gallery, the LuEsther T. Mertz Library in The New York Botanical Garden (Bronx, New York: The New York Botanical Garden, 2013), 8–10.

3. Macer Floridus, *De virtutibus herbarum* [Paris: Baquetier [sic], ca. 1510].

4. See Ibn Serapion, *Liber Serapionis agregatus* [Mediolani, 1473].

5. Salvatore De Renzi, *Storia documentaria della scuola medica di Salerno* (Napoli: D'Auria, 1857–1859).

6. Ibn Serapion, *Practica Io[anni] Serapionis* (Lugduni [Lyon]: Impressum per Iacobum Myt, 1525).

7. This work appeared under different titles: *Tractatus de herbis, secreta salernitana, Circa instans*, depending on the opening *incipit*. In addition to ms. Egerton 747 (British Library, London), cf. *Le Livre des simples medicines*, Bibliothèque Royale, Brussels (Cod. Bruxell., M.S. IV. 1024) and the two manuscripts in the Biblioteca Estense in Modena: *Tractatus de herbis*, Lat. 993 and *Le Grant herbier*, Est. 28, all three of which contain their original illustrations.

8. *Circa instans negotium de simplicibus medicinis....* Cf. *Tractatus de herbis* (ms. Egerton 747, British Library, London), Iolanda Ventura, ed. (Florence: Edizioni del Galluzzo, 2009).

9. There are two versions of *Circa instans* in the Mertz Library, this *minor* version (69 leaves, bound; 17 cm.), consisting of about 500 chapters (QK 99 .P575 1190; previously Ms. 0011 or Ms. A), and a *maior* or large version (38 leaves, bound; 26 cm), with about 250 to 270 chapters (QK 99 .P575 1275; previously Ms. 0012 or Ms. B). For further reading, see Frank J. Anderson, "The Springtime of Science. The Twelfth Century

Circa instans," *Garden Journal* (Oct. 1975): 141–143; Frank J. Anderson, "New Light on *Circa instans*," *Pharmacy in History* XX, no. 2 (1978): 65–68. Cf. also Ventura 2009, 29–30, 37, 53. I like to thank my colleagues Antonino Mastruzzo, Lia Amico, and above all Livio Petrucci for their assistance in the analysis of the two *Circa instans* manuscripts.

10. Carolingian minuscule was widely used during the tenth century. Created in the scriptoria that flourished during the reign of Charlemagne (742–814), during the course of the thirteenth century it was widely adopted for the copying of documents and evolved into the script known as Chancery minuscule. Chancery in turn became the script *par excellence* for the copyists of official papers in Italy and the rest of Europe during the fourteenth century, when local variants of the official hand also emerged.

11. See the passages from *Prognosticon futuri saeculi* by Saint John of Toledo (seventh century), Book I, chapter 14 and the beginning of chapter 27.

12. QK 99 .P575 1275 (previously Ms. 0012 or Ms. B). See note 9 above.

13. The original text on these palimpsest sheets probably consisted of passages from the *Ordinamenti sacrati e sacratissimi* dating to 1292. This information was kindly provided by Livio Petrucci.

14. The Mertz Library holds the incomplete copy of the incunabulum printed in Augsburg by Hanns Bämler in 1475, with hand-colored woodblock engravings (QH41 .K6 1475). The technique of the woodcut produced a simple contour drawing in black and white and, to help the reader in the identification of the plants, color might be added by painters specially engaged for this purpose. Indeed, the beauty and scientific accuracy of a herbal was greatly enhanced by the addition of color, and copies carefully colored became prestigious gifts that were presented to persons of high rank.

15. Cf. Bartolomeus Anglicus *De proprietatibus rerum* [Lyon, Petrus Ungar, 1482].

16. Some of the illustrations in Schott's treatise were copied from *Hortus Sanitatis* and others were prepared *ex novo* by a highly talented but anonymous local engraver. Cf. Pietro de' Crescenzi, *Ruralia commoda* [Venetiis: A. Bindoni, 1519]; Pietro de Crescenzi, *Von dem Nutz der Ding die in Aeckeren gebuwt werden* [Strassburg: Joannem Schott for J. Knoblauch, 1518].

17. Gavin D. R. Bridson and Donald E. Wendel, *Printmaking at the Service of Botany* (Pittsburgh: Hunt Institute for Botanical Documentation, Carnegie-Mellon University, 1986), 16–25.

18. Italian herbal [manuscript]. [Italy, circa 1550] (QK 99 .I82).

19. QK 99 H6 1485. See Arber, *Herbals*, 22. Cf. also Ellen Shaffer, *The Garden of Health. An Account of Two Herbals: The Gart der Gesundheit and The Hortus Sanitatis* (San Francisco: The Book Club of California,

1957, limited edition). Cf. also the new and expanded edition of this book published in Augsburg in 1534 under the title *Das Kreüterbuch, oder, Herbarius : das Buch von allen Kreütern, Wurtzlen und anderen Dingen: wie mans brauchen soll zu Gesundthayt der Menschen* (Gedruckt zu Augspurg: Durch Heinrichem Stayner, 1534).

20. Some of the illustrations are quite realistic, such as the bladder cherry or Chinese lantern (*Physalis alkekengi*), the camphor tree (*Cinnamomon camphora*), and the columbine (*Aquilegia vulgaris*).

21. Cf. in the Mertz Library a hand-colored copy of Hannsen Schönsperger's *Herbarius zu teütsch und von allerhand Kreüttern* (QK 99 H6 1502), also referred to as *Hortus Sanitatis*, the uniform designation chosen to describe this group of related early books, which often lacked a clear title.

22. The development of the set of illustrations can be followed by comparing the portraits, including the changing style of dress, between the 1497 edition printed by Prüss and the first Italian edition published in Venice in 1511 by Bernardinus Benalius and Johannes de Cereto. See *Ortus sanitatis*...[Strassburg, Johann Prüss, not after Oct, 21, 1497]; *Hortus sanitatis* (Venetiis, Bernardinus Benalius et Johannes de Cereto, 1511). See also Gundolf Keil, "Hortus Sanitatis, Gart der Gesundheit, Gaerde der Sunthede," in Elizabeth Blair MacDougall, ed., *Medieval Gardens* (Washington DC: Dumbarton Oaks, 1986), 55–68.

23. *[Herbarius] Incipit tractatus de virtutibus herbarium. Arnoldi de Noua Uilla Auicenna.* [Vincenciae, Leonardum de Basilea & Guilielmum de Papia, 27 Oct. 1491].

24. The woodblock engraving in the *Herbarius Latinus* with the presumed portraits of Arnaldo and Avicenna is actually a copy of an illustration published in 1490 in *Opus Ruralium Commorum* by Pietro de Crescenzi, which portrayed the author with his patron, Charles d'Anjou. Cf. Anderson, *An Illustrated History of the Herbals* (New York: Columbia University Press, 1977), 85.

25. Otto Brunfels, *Contrafayt Kreüterbüch nach rechter vollkommener Art* (Strassburg: Hans Schotten, 1532–1537).

26. Reference to such added images is found in Karl Becher, *A Catalogue of Early Herbals Mostly from the Well-known Library of Dr. Karl Becher...With an Introduction by Arnold C. Klebs* (Lugano: L'Art Ancien, 1925), and Frank J. Anderson, *Herbals through 1500. The Illustrated Bartsch*, vol. 90 (New York: Abaris Books, 1984), 254–255.

27. Leonart Fuchs, *De historia stirpium commentarii insignes*...(Basileae, In Officina Isingriniana, 1542).

28. Cf. also the folios in the other copy of this work. On Brunfels and Fuchs, see Luca Zucchi, "Brunfels e Fuchs: l'Illustrazione botanica quale ritratto della singola pianta o immagine della specie," *Nuncius* 18 (2004), 411–466.

29. The Latin editions of Mattioli's work were generally published with the title *Commentarii*, and the Italian editions with the title *Discorsi*.

30. Mattioli, *New Kreüterbuch, mit den allerschönsten und artlichsten Figuren aller Gewechss*...(Prag: G. Melantrich von Auentin, auff sein und V. Valgriss zu Venedig uncosten, 1563).

31. See L. Tongiorgi Tomasi, "Il problema delle immagini nei *Commentarii*," in *Pietro Andrea Mattioli. La Vita. Le Opere*, ed. Sara Ferri (Perugia: Quattroemme, 1997), 369–375. Valgrisi also published an Italian edition of the *Discorsi* in 1568 with an even larger number of illustrations. Many copies of this work are conserved in the Mertz Library, among them the first illustrated edition published in Venice by Valgrisi in 1554, and two copies of the 1565 Venice edition.

32. Rembert Dodoens, *Remberti Dodonaei... Trium priorum de stirpium historia...*Antverpiae: Ex Officina I. Loei, 1553.

33. The Mertz Library has various copies of works by all of these authors.

34. F. de Nave and D. Imhof, eds., *Botany in the Low Countries: (End of the 15th century-ca. 1650): Plantin-Moretus Museum Exhibition* (Antwerp: Plantin-Moretus Museum, 1993).

35. Florike Egmond, *The World of Carolus Clusius. Natural History in the Making, 1560–1610* (London: Pickering and Chatto, 2010).

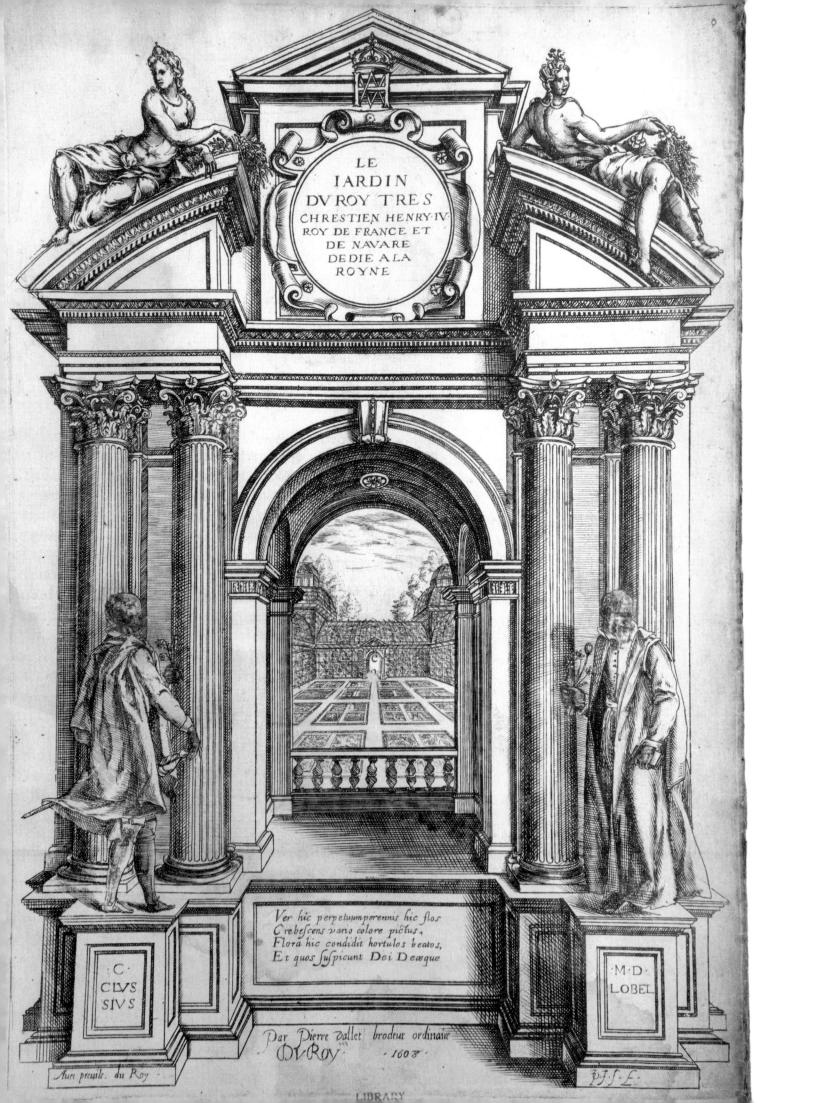

"PLANTS IN THEIR PERFECTION": THE BOTANICAL GARDEN AND THE ILLUSTRATED BOOK

THERESE O'MALLEY

The history of botanical gardens demonstrates that, as early as the sixteenth century, books as well as drawings, field notes and dried specimens, have been as vital to the mission of true botanical gardens as living plants. It is because botanical gardens shared their documentation, description, and depiction of plants through the medium of the book that the modern botanical sciences and related arts could evolve internationally.[1] The LuEsther T. Mertz Library is exemplary in the breadth and depth of its holdings, and fully representative of the entwined history of books and gardens that followed from a passion for and commitment to both the description of plants and their cultivation. Highlighted here are just a select number of important works in the Mertz Library that illustrate *par excellence* the closely linked histories of botanical gardens and botanical literature. Their connection was so close that

during the emergence of the botanical sciences in the Early Modern Period, the word *hortus* evolved to mean both the place of the garden, and the book of the garden. This brief overview will consider different kinds of botanical gardens—public, private, and institutional—and the many genres of books that botanical gardens have produced, sponsored, or collected.

The symbiotic relationship between the botanical garden and the book is aptly illustrated in a number of works in the Mertz Library, as various frontispieces provide testament to the importance of the living garden for the production of knowledge. On the title page of Pierre Vallet's treatise *Le Jardin du Roy très chrestien* (1608) an open archway invites the reader to enter the book as one would the garden, showing in perspective the various garden beds (fig. 3.1).[2] This familiar device for the design of botanical books underscores the essential pairing of the study of living plants and the dissemination of that knowledge through books. Here, on either side of the archway, two of the most influential botanists of the sixteenth century, Carolus Clusius (1526–1609) and Matthias de l'Obel (1538–1616), turn to enter. At the very center of the page, an opening allows a

FIG. 3.1. Title page, in *Le Jardin du Roy très chrestien, Henry IV, Roy de France et de Navare* by Pierre Vallet, Paris, 1608. While documenting new species collected by Jean Robin the Younger, Director of the Royal Gardens at the Louvre under Henri III, Henri IV, and Louis XIII, the book also was used as a source for ornamental floral motifs in embroidery and jewelry design.

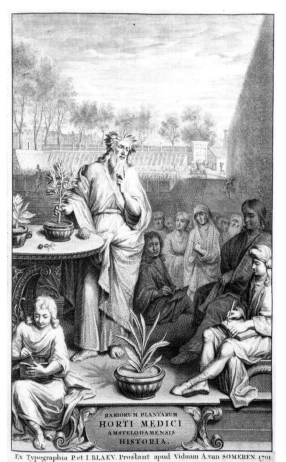

FIG. 3.2. Title page, in *Horti Medici Amstelodamensis*, Amsterdam, 1697–1701, by Johannes Commelin. The botanical garden at Amsterdam, founded in 1682, was a center for the collection and study of medicinal plants. Commelin, its first superintendent, initiated its mission to publish representations of the various plants collected from the Dutch East and West Indies, South Africa, Ceylon, and the Americas.

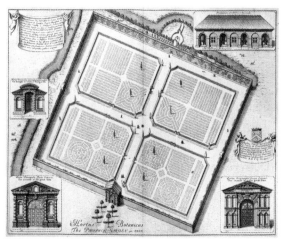

FIG. 3.3. "Hortus Botanicus/The Physick Garden in Oxon," illustrated in *Oxonia Illustrata* by David Loggan, Oxford, 1675. The earliest botanical garden in England, it was founded in 1621 "to promote the furtherance of learning and to glorify nature." Art and Illustration Collection, EKR 140-20.

peek inside showing letters from the next page. As one would enter the garden, the reader opens the book that depicts all the plants growing in the garden of the royal botanist, Jean Robin (1550–1629). In *Horti Medici Amstelodamensis* (1697–1701) by Johannes Commelin (1629–1692),[3] the famous glasshouses and teaching beds of the Amsterdam Physic Garden are the setting for a senior figure meant to resemble a classical scholar such as Dioscorides or Theophrastus, teaching students who, in exotic dress, symbolize the four continents (fig. 3.2). The

garden as the world in miniature was a frequent theme in books that was also carried out in the quadripartite layout of a garden, where plants were gathered in a microcosmic representation of the four corners of Earth. This image portrays two practices—observation in the garden, and description in words and images from living plants—that were fundamental principles for the ideal of the botanical garden. The tropes of "drawn from life" and "eye witnessing" pervade botanical literature and art. As much as possible, these and many of the great books produced in and under the aegis of botanical gardens attempted to recreate the experience in which, as Johann Wolfgang von Goethe (1749–1832) said of Padua's *Orto Botanico*, "it is pleasant and instructive to walk through."[4]

Since the Renaissance, botanical gardens were established for practical, scientific, and aesthetic reasons. Drawings and dried specimens were combined with living plants in the earliest botanical gardens at Pisa, Padua, Rome, Bologna, Leiden, and Oxford (fig. 3.3), where they provided material for medicinal

study. Competition and the passion for collecting and studying newly discovered plants arose rapidly. The interest in Mediterranean flora was explored first but enthusiasm for the floras of the Americas, Africa, and Asia quickly followed, spurred on by the explorations and colonial possessions of the Dutch, British, French, Spanish, and Portuguese from the sixteenth century onward. New plants were both scientifically and aesthetically appealing. With the collection and study of these plants came progress in systems of classification, naming, description, and illustration. Impelled by a surge in the availability of plants, Europe saw the proliferation of botanical gardens built to display royal patronage, serve medical schools, and delight private collectors.[5]

The late sixteenth century was a crucial moment in the formation of botanical gardens due to the growth of academic institutions that could support them, as well as the expansion of travel and exploration overseas that brought news and actual specimens of native and exotic plants. Concurrently, advances in reproductive printing processes allowed for the rapid dissemination of new knowledge that resulted from the collection and study of these plants.[6] One of the most important figures in this period was Carolus Clusius (1526–1609), who is considered the first modern botanist because of his international reach and dedication to botany for purely scientific purposes.[7] In his writings, Clusius often stressed the important contributions toward furthering plant history made by books and descriptions featuring images made after direct observation.[8] Active in botanical gardens across Europe, he cultivated plants such as the tulip, potato, chestnut, and others from around the world. He was the director of the Holy Roman Emperor Maximilian II's garden in Vienna (1573–1587), where he was among the first to study Austrian flora. He spent

his later years developing and teaching at the *Hortus Botanicus* in Leiden, the first botanical garden in the Netherlands. His cultivation of tulips marked the beginning of Dutch floriculture and the subsequent bulb industry. Under Clusius' direction, the *hortus academicus* moved beyond the traditional medical physic garden with the introduction of flower bulbs for scientific, economic, and aesthetic purposes. His collected works, published in the *Rariorum plantarum historia* (1601) and the *Exoticorum libri decem* (1605),[9] were attempts to use pictures to establish credible and true representations, substantiated by texts, based on fieldwork and reports from a vast network of correspondents (fig. 3.4).[10]

In 1602, the Dutch East India Company (VOC)—the largest of the early modern trading companies in Asia—was established in Amsterdam. Clusius immediately recognized this as an opportunity to expand the plant collection of the Leiden *Hortus Botanicus* specifically and of the existing knowledge of the plant world in general. With his broad contacts and authority as the director of the *Hortus*, he surely influenced the botanical activities of the VOC.[11] Thus botanical gardens as sites for the production of knowledge expanded at this point to become powerful agents far beyond the garden walls and simultaneously into the burgeoning industry of the illustrated book.

During the late seventeenth century when the VOC controlled trade along the Malabar Coast, the southwest shoreline of India, the former Dutch governor Hendrik Adriaan van Rheede tot Drakestein (1636–1691) collaborated with local doctors, botanists, translators, and artisans—partly of Indian, partly of European origin—to produce *Hortus Indicus Malabaricus* (1703) (fig. 3.5). A comprehensive treatise dealing with the medicinal properties of the flora in the Indian state of Kerala, it provides the name of each plant in as many as five different

FIG. 3.4. Tulips, in Carolus Clusius, *Atrebatis...rariorum plantarum historia...*Antwerp, 1601, p. 146. The cultivation of these flowers took place under Clusius' direction at the Leiden *Hortus Botanicus* for scientific, economic, and aesthetic purposes, an endeavor that marked the beginning of the Dutch bulb industry.

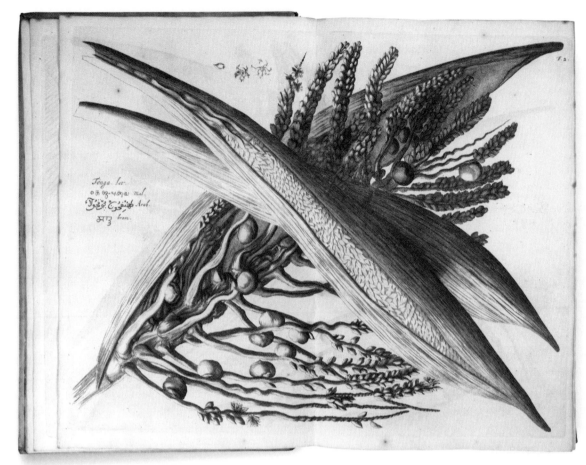

FIG. 3.5. *Tenga* or coconut palm, in *Hortus Indicus Malabaricus* by Hendrik Adriaan van Rheede tot Drakestein, Amsterdam, 1703, vol. 1, fig. 2. A stunning twelve-volume work illustrated with 791 copper engravings of double folio format, based on drawings by Indian and European artists, made in a garden in Cochin, Kerala, where fresh specimens of medical plants had been gathered for study and documentation.

languages: Latin, Malayalam, Nagari, Arabic, and Konkani. Printed in Amsterdam between 1678 and 1693, it is a stunning twelve-volume work illustrated with 791 copper-engravings of double folio format.[12] Indian and European artists and botanists made 1,200 botanical drawings in the medical garden at Van Rheede's residence in Cochin, Kerala, where fresh specimens of plants had been gathered for study and documentation. The directors of the Leiden and Amsterdam Botanical Gardens finished editing the book and oversaw its publication. The book's large format presents plants in their actual size, the one-to-one scale allowing the reader to experience the plants' visual presence as if one is in the garden.

Equally adventurous was Carl Peter Thunberg (1743–1828), a Swedish naturalist and a student of Carolus Linnaeus, whose global explorations earned him the titles "the father of

South African botany," as well as the "Japanese Linnaeus." With the impetus coming again from a Dutch botanical garden, he was commissioned by Johannes Burman (1707–1780) and his son to travel in order to collect plants for the *Hortus Botanicus* in Amsterdam. Before reaching Japan, Thunberg spent time in South Africa, Java, and Sri Lanka, sending back numerous new plant specimens from everywhere he went. Upon his return to Uppsala, Thunberg established a new botanical garden and his research there became the basis for many subsequent publications. The various important new works followed each

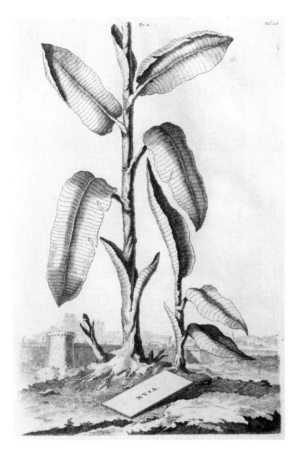

FIG. 3.6. *Musa* or "Bananienboom," fig. 4, fol. 26, in *Naauwkeurige beschryving der aardgewassen*, Leiden, 1696, by Abraham Munting, is one of more than one thousand highly decorative and whimsical etchings of rare tropical plants from the botanical garden at Groningen, founded in 1626.

other in quick succession: *Icones plantarum Japonicarum* from 1775 to 1776; *Flora Japonica* in 1784; and finally, from 1807 to 1820 *Flora Capensis*.[13] As with all these new illustrated books about foreign regions, they brought the flora of distant lands to scholars and collectors who could not travel there themselves.

In 1642 Hendrik Munting (1583–1658) founded the second oldest botanical garden in Holland at the University of Groningen. He had extensive contacts throughout Europe with colonial counterparts in America, Asia, and Africa. As a result, the Groningen botanical garden was famous for the early introduction of tropical

plants such as the banana tree (fig. 3.6). Munting's son Abraham (1626–1683), who succeeded his father as director from 1658 until his death, expanded the garden's size and collections. His publications were very successful, including *Waare oeffening der planten* (1672), which was later retitled *Naauwkeurige beschryving der aardgewassen* (1696) and enlarged to include over one thousand highly decorative botanical illustrations.[14]

As universities established botanical gardens, so too did private collectors. They spent much effort and personal fortune to amass comprehensive collections and document them through illustrated books. Not always botanical gardens in the strictest sense—that is, having both scientific and educational functions— still, many private gardens engaged the most important botanists and artists of their time to study and publish their collections. The result of publishing the collections in these private gardens made them "public," in a sense, although some of the most spectacular volumes remained available only to a privileged few.

One of the earliest and most ambitious pictorial records of a single private garden was *Hortus Eystettensis* (1613), undertaken at Eichstätt in Germany by Basilius Besler (1561–1629), apothecary at Nuremberg (fig. 3.7).[15] According to a contemporary visitor, the Prince Bishop of Eichstätt had eight gardens that contained flowers from eight different countries, including an especially rich selection of roses, lilies, and tulips "in five hundred colours."[16] The visitor also reported that Basilius Besler himself received two boxes full of fresh flowers from this garden every week to be sketched. The resulting book contained no less than 374 engraved plates depicting approximately one thousand plants.[17] The Mertz Library has an exceptional copy of *Hortus Eystettensis*—exceptional because it consists of imperfect plates of what must

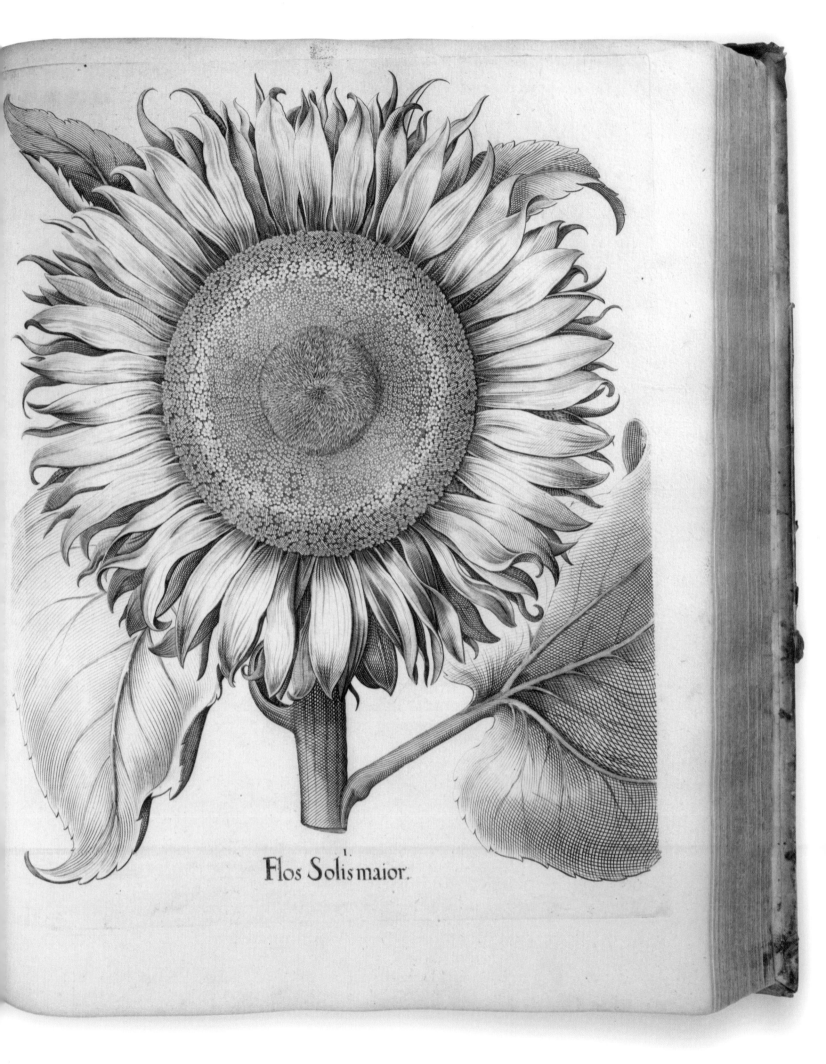

Flos Solis maior.

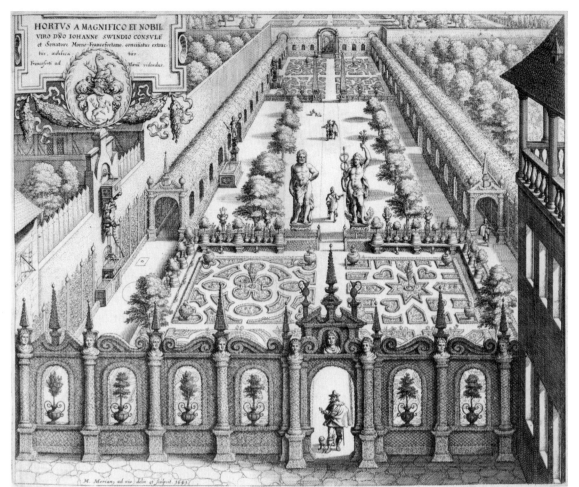

FIG. 3.8. Frontispiece "Hortus a Magnificio et Nobil...," in Johann Theodor de Bry, *Florilegium renovatum et auctum*, Frankfurt, 1641, shows the private garden of Johannes Schwindt, Burgomaster of Frankfurt, renowned for its rare, exotic flowers.

"PLANTS IN THEIR
PERFECTION"

be actual printer's proofs. It provides a rare opportunity to see the step-by-step process of making this complex work. Saving imperfect "states" of the prints, in their uncolored form, allows one to see the details of its facture.

In *Florilegium renovatum et auctum* (1641), the capable engraver and publisher Matthaeus Merian (1593–1650)—father of the well-known botanical artist Maria Sybilla Merian (1647–1717)—used the private garden of Johannes Schwindt for the frontispiece "Hortus a Magnifico et Nobil," making the connection between the garden and its rare plant collection explicit

FIG. 3.7. Engraving of *Flos solis maior*, in a unique studio-copy of *Hortus Eystettensis* by Basilius Besler, Nuremberg, 1613. This florilegium, in which the plants in the garden of the Prince Bishop of Eichstatt are arranged by the four seasons of the year, is considered the earliest pictorial record of flowers in a single garden.

(fig. 3.8). The book is an enlarged edition of the famous *Florilegium novum* (1612–1618) by his father-in-law, Johann Theodor de Bry (1561–1623), almost doubling the number of plates. Both books depict exotic flowers and plants growing in the gardens in and around Frankfurt.[18]

An English private botanical garden in Eltham, outside of London, inspired the publication of what historians of science consider one of the most important pre-Linnaean works: the *Hortus Elthamensis*, published in 1732. The botanist William Sherard (1659–1728) encouraged his wealthy brother James Sherard (1666–1738) to undertake the two-volume *Hortus Elthamensis*,[19] which was written and illustrated by the renowned German-born botanist Johann Jakob Dillenius (1684–1747), first professor of botany at Oxford University (fig. 3.9). The book's significance lies in the goal of the undertaking,

which was to collect all the names that botanical writers had ever given to each known plant.[20] As a concordance, the treatise drew upon all the pre-existing botanical literature of the sixteenth and seventeenth centuries and depended upon the vibrant contemporaneous network of correspondents—"botanical savants" as they are known—who, through their textual and pictorial communication, maintained a highly intellectual exchange of commentary, plants, and new ideas.[21]

The naming and classification of plants in books laid the foundation for building worldwide understanding and knowledge. The botanical garden as a laboratory of living plants provided the opportunity for experiments in cultivation and hybridization, as well as classification and taxonomy. The major works of Carolus Linnaeus (1707–1778), the father of modern botany (see chapter 5), offer the perfect illustration of the reciprocal relationship among gardens and books. It has been said of even the great Linnaeus that his written descriptions were so inadequate that the identification of many of his species depended upon the quality and faithfulness of the accompanying illustrations.[22] He himself recognized the critical combination of text and image in the organization of botany: "There is in the whole of Uppsala not a soul who can make a careful figure. I had in summer over 150 new admirable flowers which must pass into oblivion."[23] Linnaeus underscored the critical interrelationship of the living plant, the timely visual documentation, and subsequent publication:

> Lest the rarer plants of this sort, once acquired, should be lost from sight, the Collectors have devoted great effort and zeal to publishing them with ample and sufficient descriptions, resplendent and large-size figures.[24]

Linnaeus identified some of those "rare, magnificent, and very expensive," yet essential works upon which he himself depended, specifically such illuminated books with hand-colored plates as Mark Catesby's *Natural History* (1731–1743).[25] He also mentioned John Martyn's *Historia plantarum rariorum* (1728–1737), with fifty refined color plates by Jacob van Huysum, based on plants that grew mostly in the Chelsea Physick Garden (fig. 3.10), as were those illustrated in Elizabeth Blackwell's *A Curious Herbal* (1737–1739).[26] In addition to these, Linnaeus also held up Johann Wilhelm Weinmann's florilegium *Phytanthoza iconographia* (1737–1745) and several others by Georg Dionysus Ehret (1708–1770), as exemplary works (fig. 3.11).[27]

At the same time Linnaeus complained about such "sumptuous books," worrying that the innovation of engraving illustrations in copper, although more effective, was too luxurious and "the ruin...of several kingdoms, so too, perhaps of this noble science itself."[28] Yet Linnaeus himself would play a key role in the creation of one of the most sumptuous productions ever made that drew upon the critical experience in botanical gardens: *Hortus Cliffortianus* (1737). This work was written entirely while Linnaeus was at the botanical garden of De Hartecamp, the seat of Anglo-Dutch merchant banker George Clifford (1685–1760), located between Haarlem and Leiden. The elaborate gardens had four large glasshouses devoted to plants from Southern Europe, Asia, South Africa, and America, thus—like its many predecessors—attempting to be a microcosm of the world. De Hartecamp, being one of the largest collections of different species in the world at that time, offered the perfect place to undertake this grand project.[29]

After leaving De Hartecamp, Linnaeus returned to the *Hortus Botanicus* at Leiden, recognized by then as the center for medical

FIG. 3.9. *Mesembryanthemum falcatum majus*, in *Horti Elthamensis*, vol. 2, fig. 272, tab. CCXII, Leiden, 1774, written and illustrated by Johann Jakob Dillenius, Director of the Oxford Botanical Garden, who in this work collected all the names that botanical writers had ever given to each illustrated plant.

FIG. 3.10. *Aloe africana*, in *Historia plantarum rariorum*, by John Martyn, London, 1728. Dedicated to new plants growing in the Chelsea Physic Garden and Cambridge University Botanic Garden, this was the first botanical book with printed color plates. It was also one of the earliest to be issued serially and supported by private subscription.

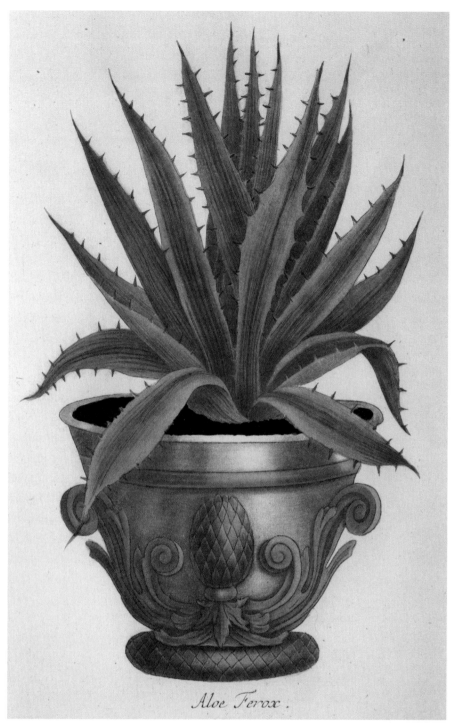

FIG. 3.11. *Aloe ferox*, in *Phytanthoza iconographia*, Ratisbonae [Regensburg], 1737–1745, plate 65, by Johann Weinmann, a wealthy German apothecary and important collector of botanical drawings, founder of the Regensburg botanical garden.

FIG. 3.12. "Prospectus Horti Academici Lugduno-Batavi," in *Florae Leydensis prodromus*, Leiden, 1740, by Adriaan van Royen, Director of the Leiden Botanical Garden (1730–1754), the preeminent center for botany in Northern Europe.

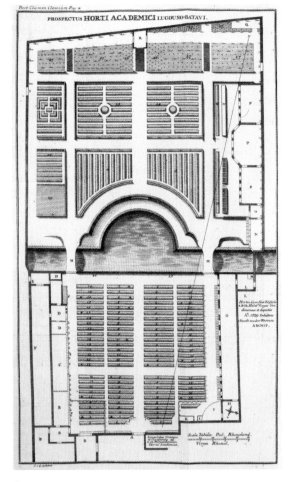

GREAT HERBALS,
FLOWER BOOKS, AND
GARDEN PRINTS

and botanical studies in Europe. All the most important figures passed through its gates, and often issued their publications from this Dutch city. Under Adriaan van Royen's (1704–1779) directorship, the Leiden botanical garden's layout (fig. 3.12) was influenced by the emerging taxonomic systems of classification, partly based on principles and methods Linnaeus established while at Clifford's botanical garden. As such— in the arrangement of the order beds—it was the physical expression of a new system that was made possible in part by the availability of Linnaeus' writings.[30] Thus, the notion of the book as a facsimile of a garden was here reversed so that the garden became the material corollary to the book, a reflexive relationship between gardens and books that prevailed through the centuries.[31]

The fame of *Hortus Cliffortianus,* with its thirty-six superbly engraved botanical plates and allegorical frontispiece, was not due to the author's abilities alone, but also to those of the illustrator, Georg Dionysius Ehret. Originally from Heidelberg, Germany, Ehret's career would take him across Europe, from one important garden to another.[32] He married into the family of Philip Miller (1691–1771), who directed the Chelsea Physic Garden in London. Founded in 1673, this institution originated some of the most important botanical and horticultural publications of the period.[33] Within two years of his appointment, Philip Miller published *The Gardeners and Florists Dictionary*, which appeared in 1724 and would see seven more editions by 1768. More than any other publication, this work reflects the history of the progress of horticulture in Britain as it recorded all the new and rare plants introduced at the Chelsea garden that poured in from around the world. Several years after the *Dictionary* appeared Ehret, with other artists, produced three hundred plates for yet another work by Miller: his *Figures of the Most Beautiful, Useful, and Uncommon Plants Described in the Gardener's Dictionary* (1755–1760) (fig. 3.13).[34] The author, in the rhetoric that had become commonplace, extolled the authenticity of his book's illustrations:

> The Drawings were taken from the living Plants; the Engravings were most of them done under the Author's Inspection; and the Plates have been carefully coloured from the original Drawings, and compared with the Plants in their Perfection, where-ever it could be done, as well with regard to the Leaves as Flowers, so that Gentlemen who are least conversant with the Plants described, should not be drawn into any Mistake relating to them; and the less, as he has taken their Descriptions from the living Plants.[35]

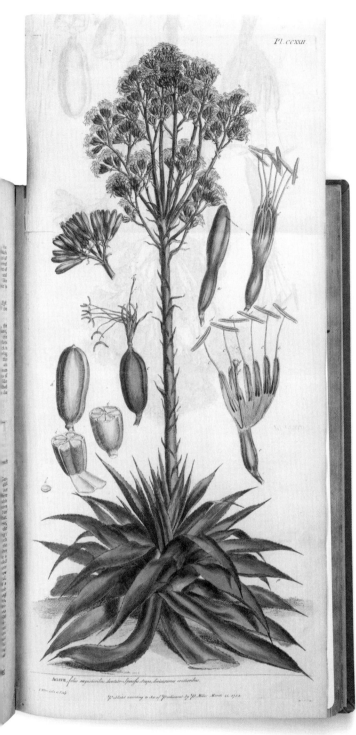

Pl.ccxxii

AGAVE. folis amplioribus dentato-spinosis longis, lacinispinoso erectioribus.

Published according to Act of Parliament by JO. Miller March 24. 1752.

FIG. 3.13. *Agave*, plate CCCXXII, in Philip Miller, *Figures of the Most Beautiful, Useful, and Uncommon Plants*, London, 1760. Following the success of his unillustrated *Gardeners Dictionary*, Miller, Curator of the Chelsea Physic Garden, published this elaborate work with three hundred hand-colored copperplate engravings after drawings made by Georg Dionysius Ehret and other important artists.

Again, the effort is made to ensure the interchangeability between the book and the actual garden as places for "plants in their perfection."

The New York Botanical Garden holds outstanding examples of Ehret's work, including important volumes published by Christoph Jacob Trew (1695–1769) of Nuremberg, and one of the greatest German flower books ever created, *Plantae selectae* (1750–1786).[36] Although published in Germany, the plant specimens were drawn in the Chelsea Physic Garden, and the drawings then sent to Nuremberg for printing (fig. 3.14). The Mertz Library also holds two copies of the rare and complex *Hortus nitidissimis* (1768–1786), which again resulted from the combined efforts of Trew and Ehret, and also of the artist-engraver J. M. Seligmann (1720–1762).[37]

Botanical gardens published for various purposes with different audiences or readers in mind. *Hortus Medicus Edinburgensis* (1683) by James Sutherland (ca. 1639–1719) was said to have had only one reason for its publication: it "signaled the Scottish entry into the established fraternity of European botanical gardens."[38] In the preface, Sutherland claimed that his catalog of plants in the garden (founded in 1675) could stand comparison with similar publications by or about foreign botanical gardens, both in the number and rarity of the plants listed. He promoted the medical significance of the garden because its "usefulness in Physick, may now by Industry and culture be had in plenty at home."[39] Thus, in order to take their place on the international stage, botanical gardens published to promote their establishment, and in this case, the economic self-sufficiency of Scotland. As a record of medicinal plants, it is the first systematic account of its kind in Scotland.

While this garden and its publication served a national purpose, Edinburgh, as a center for the study of botany and medicine, also was

[63]

FIG. 3.14. (right) *Cedrus*, in Christoph Jacob Trew, *Plantae selectae*, Nuremberg, 1750–1773, tab. 1, fol. LX. Georg Dionysius Ehret's drawings made at the Chelsea Physic Garden were sent to Nuremberg for engraving and publication. Chelsea's cedars of Lebanon, germinated in 1683, were the first in England to produce seed.

FIG. 3.15. (opposite, top left) *Caesalpinia sappan*, vol. 1, plate 16, in *Plants of the Coast of Coromandel*, London, 1795–1819, by William Roxburgh, first Superintendent of the Royal Botanic Garden, Calcutta, who is credited with bringing the botany of India to the global scientific community through the medium of the book.

FIG. 3.16. (opposite, top right) *Crinum herbertianum*, vol. 2, plate 145, in Nathaniel Wallich, *Plantae Asiaticae rariores*, London, 1830–1832. Produced under the auspices of the English East India Company's Royal Botanic Garden, Calcutta, drawings by several Indian artists were translated into hand-colored lithographs by Maxim Gauci. This image was drawn by Vishnupersaud, one of the most famous Indian botanical artists of his day.

FIG. 3.17. (opposite, bottom left) *Galeandra baueri*, part 1–4, plate XIX, in James Bateman, *The Orchidaceae of Mexico & Guatemala*, London, 1837–1843. These visually breathtaking colored lithographs of previously unknown Central American orchids appealed to both the amateur orchid collector and professional botanist.

FIG. 3.18. (see p. 67)

FIG. 3.19. (opposite, bottom right) *Garcinia mangostana*, in *Fleurs, fruits et feuillages*, Brussels, 1880, by Berthe Hoola van Nooten. As she traveled worldwide, the author/artist sent back to Dutch botanical gardens plants and exquisite drawings from collections in places as diverse as Suriname, America (New Orleans), and Indonesia (Java).

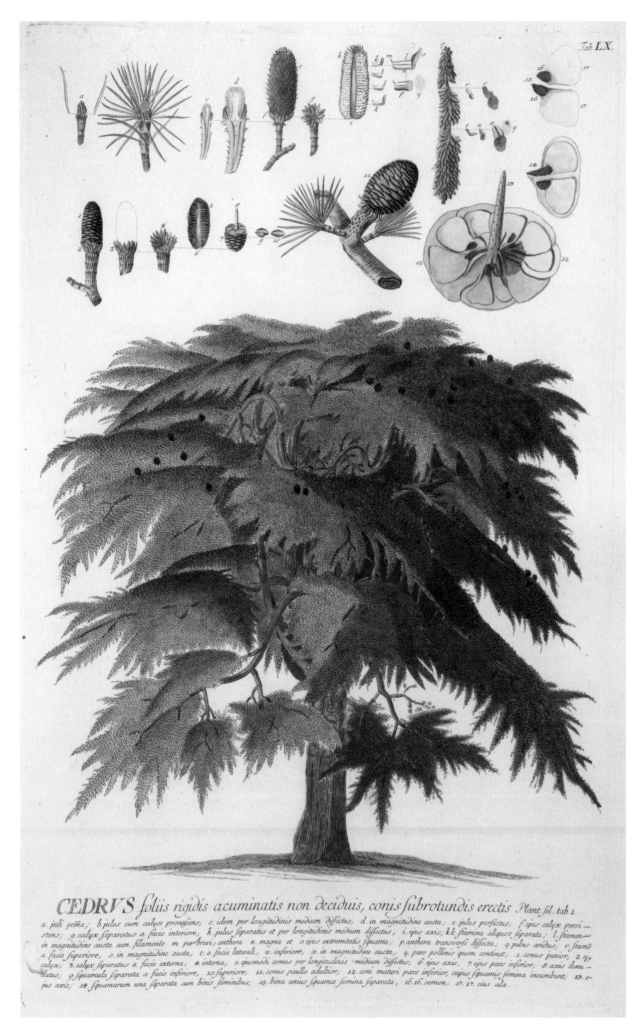

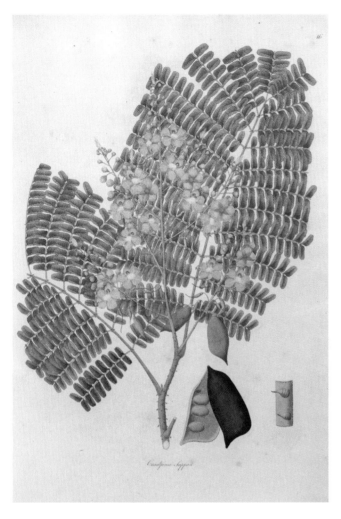

Caesalpinia sappan

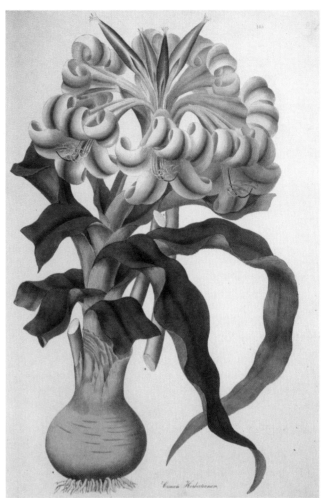

Crinum Herbertianum

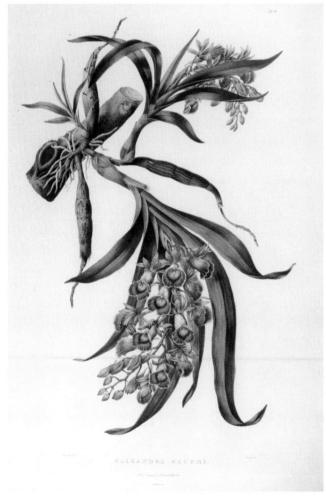

CALLIANDRA BAUERI

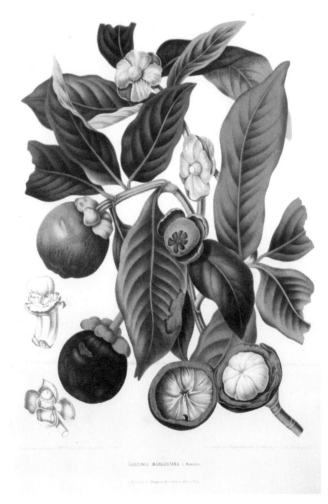

GARCINIA MANGOSTANA L. MANGIS

responsible for training important historic figures in global botanical endeavors. Since the eighteenth century, many American botanists trained there, including David Hosack (1769–1835), who founded the Elgin Botanic Garden in New York City (1801), which, in many ways, is the antecedent of The New York Botanical Garden (see chapter 8). Another Edinburgh-trained botanist, William Roxburgh (1751–1815), is credited with bringing the botany of India to the global scientific community through the medium of the book. When appointed in 1793 to the Royal Botanic Garden, Calcutta, in addition to setting up an important herbarium, he initiated a program of publication, collecting, and exchange with other botanical gardens and world botanists.

The Royal Botanic Garden, Calcutta, had been founded in 1787 as a garden of acclimatization with the purpose of introducing new crop plants to combat the massive starvation that followed a series of crop failures in the province.[40] Although started for strictly economic reasons, such as the introduction of the tea plant from China, under Roxburgh's capable leadership it quickly grew into a venerable scientific institution. Moreover, the English East India Company, which regularly received copies of botanical descriptions and drawings, supported his work. From 1795 to 1819, Sir Joseph Banks (1743–1820), advisor to the Royal Botanic Gardens at Kew, published Roxburgh's *Plants of the Coast of Coromandel* in three volumes, each issued in four parts (fig. 3.15). Some of Roxburgh's work was also published posthumously. His *Hortus Bengalensis*, the first comprehensive catalog of Indian plants, appeared in 1814, followed in 1820 by the two-volume *Flora Indica*.[41] In addition to their scientific import, these publications have great aesthetic value: Roxburgh employed local Bengali artists who produced around 2,500

drawings under his supervision to make these magnificent works.[42]

Nathaniel Wallich (1786–1854), a Danish botanist who followed Roxburgh as superintendent of the Royal Botanic Garden, Calcutta, built on his predecessor's work to publish one of the great Floras of India, *Plantae Asiaticae rariores* (1830–1832). Maxim Gauci (1774–1854) made almost three-hundred hand-colored lithograph plates after drawings by "India[n] artists, of the Calcutta Garden, and on my various journeys," as Wallich acknowledges in his preface. A plate illustrating *Crinum herbertianum* made by Vishnupersaud, one of the most famous Indian botanical artists of his day, provides a beautiful example (fig. 3.16).[43] Gauci continued his career as a pioneering botanical lithographer and went on to translate drawings by Augusta Withers (1793–1877) and Sarah Ann Drake (1803–1857) for the spectacular *Orchidaceae of Mexico & Guatemala* (1837–1843) by James Bateman (1811–1897), one of the only 125 published copies of which is in the Mertz Library (fig. 3.17).[44] The grand size of the work (28.5 × 18 inches [72 × 45 cm]), advertised (inaccurately) by the author as the largest book ever made, was lampooned in a vignette by the satirical artist, George Cruikshank (fig. 3.18). The achievement of these works, which set new standards for quality and technical innovation, continued the tradition of the previous two centuries of bringing the garden to the page. *Fleurs, fruits et feuillages choisis de l'Ile de Java peints d'après nature* (1880) was another landmark in botanical chromolithography. It was published by Berthe Hoola van Nooten (1817–1892), a world traveler who lived in Suriname, New Orleans, and Java, and who, as a young woman, sent plants back to the botanical gardens in her native Holland. In addition to collecting rare plants, she made exquisite drawings at botanical collections of

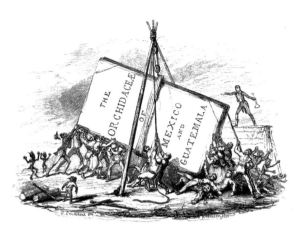

FIG. 3.18. "Librarian's Nightmare" by G. Cruikshank, in *The Orchidaceae of Mexico & Guatemala*, London, 1837–1843, by James Bateman. Vignettes and caricatures thread through the forty colored engravings in this extravagant book of which only 120 copies were produced.

native and exotic plants in Java and Batavia (present-day Jakarta) that were translated into chromolithographs for this book, first published in 1863–1864, with two later editions (fig. 3.19).[45]

Flora Graeca, a ten-volume masterpiece of botanical art in folio format with 966 plates and ten beautifully colored frontispieces, is one of the finest botanical works of the nineteenth century (fig. 3.20).[46] Reporting on the results of a week-long auction of a botanical library in Paris, the international *New York Herald* announced on May 12, 1903 that Andrew Carnegie had purchased *Flora Graeca,* "pour en faire homage au Jardin Botanique de New York." The article notes that nearly one quarter of the proceeds from the Paris auction was generated from the sale of that single work.[47] The brief notice in French, of only a dozen lines, speaks volumes not only about Carnegie as a philanthropist and his relationship to the fledgling New York Botanical Garden, but also about the high value of the illustrated work and the place of books in the newly established institution.[48] The Mertz copy is one of only twenty-five original sets.

Flora Graeca (1806–1840) originated with expeditions to find the plants first described by the renowned Greek physician, Dioscorides

(fl. 50–70), the author of *De materia medica,* a five-volume encyclopedia that was the most popular botanical authority for more than 1,500 years (see chapter 2).[49] John Sibthorp (1758–1796) from the Oxford Botanic Garden, John Hawkins (1761–1841), and the artist Ferdinand Bauer (1760–1826) traveled to Greece to rediscover the plants of Dioscorides *in situ* and to make the ancient text more accurate in light of modern botanical principles.[50] This effort had many implications: it consolidated the critique or at least the questioning of ancient authority that had emerged since the mid-sixteenth century; it reflected the impetus to gain new knowledge empirically, through the observation of living plants in their natural habitats, and it inspired the documentation and publication of local flora and national floras. This fieldwork and the resulting publications were made possible through increased trade, expanded diplomatic intercourse, and the expansion of empires in the late eighteenth and early nineteenth centuries, which made vast numbers of plants, as well as all natural historical materials, more easily available.[51]

Sibthorp and Bauer met in Vienna, a city famous for its important botanical collections. Since 1573, when Carolus Clusius directed Emperor Maximilian II's botanical garden at the royal palace, the Habsburg commitment to their imperial research gardens was evident in the arrangement of plants on a scientific basis in aesthetically designed display gardens.[52] The University of Vienna's baroque botanical garden, founded in 1754 by Empress Maria Theresa, is illustrated as the frontispiece in *Hortus Botanicus Vindobonensis* (fig. 3.21).[53] Published in three volumes from 1770 to 1776, it includes three hundred hand-colored copper engravings by the noted German botanical artist Franz von Scheidel (1731–1801).

Undertaken on behalf of the House of

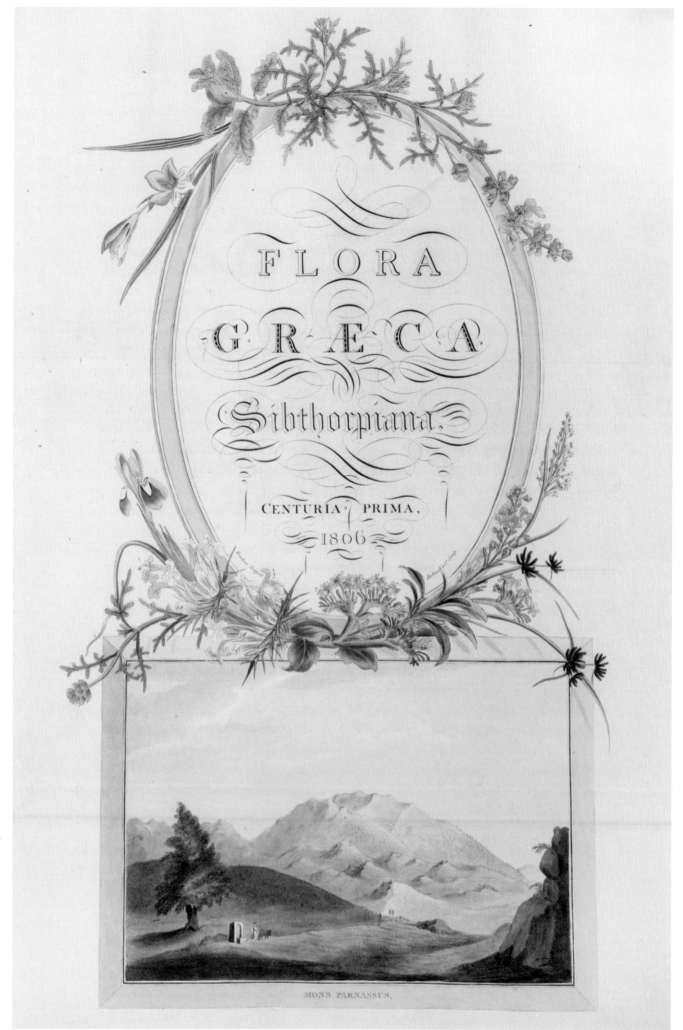

FLORA GRÆCA

Sibthorpiana.

CENTURIA PRIMA.
1806

MONS PARNASSUS.

FIG. 3.20. Title page, in *Flora Graeca*, London, 1806–1840, vol. 1, by John Sibthorp. One of the finest botanical publications of the nineteenth century, it was the work of botanists from the Oxford Botanic Garden who sought to find *in situ* the plants first described by Dioscorides, the renowned ancient Greek physician.

Habsburg and under the leadership of Nikolaus Joseph Jacquin (1727–1817), expeditions to the Caribbean, South America, South Africa, and the island of Mauritius, brought back to Vienna huge collections of living exotic plants and animals, as well as shells, minerals, and fossils. The sensational research findings were published to great acclaim. Among the most sumptuous books that resulted from these explorations are those by Jacquin himself, who was one of the first to introduce the new binomial nomenclature developed by Linnaeus. Two exemplary volumes include *Oxalis. Monographia, iconibus illustrata...*(1794) and *Selectarum stirpium Americanarum* (1763).[54] The latter is a large folio edition with colored illustrations copied by hand—not engraved—from Jacquin's originals. In the course of his career, Jacquin produced more than 2,700 plates, many of plants that were new to science and had never been depicted before. He is credited with training some of the greatest botanical artists of the next generation, including Ferdinand Bauer and his brother Franz (1758–1840).[55]

When the French occupied Vienna in the early nineteenth century, Empress Josephine (1763–1814) of France had six hundred plants removed from the great Schönbrunn gardens, Napoleon's headquarters, and sent to Malmaison, her country château.[56] The botanical collections were taken in the same spirit as Napoleon's notorious sacking of collections of art and archaeological materials throughout Europe and the Mediterranean, which he brought back to create the Louvre. In the foreword of *Jardin de la Malmaison* (1803), the author, Etienne Pierre Ventenat (1757–1808), wrote: "You have gathered around you the rarest plants growing on French soil.... They offer us, as we inspect them in the beautiful gardens of Malmaison, an impressive reminder of the conquests of your illustrious husband."[57]

FIG. 3.21. Frontispiece, in Nikolaus Joseph Jacquin, *Hortus Botanicus Vindobonensis*, Vienna, 1770–1776. In addition to this plan of the University of Vienna's baroque botanical garden, the book has three hundred hand-colored copper engravings by the noted German botanical artist Franz von Scheidel.

Empress Josephine's gardens at Malmaison were as scientifically significant as they were beautiful (fig. 3.22). It is estimated that nearly two hundred plants, which had never been seen in France, and many of those never seen in Europe, were introduced in her gardens of Malmaison and Navarre. She sponsored scientific

expeditions, promoted new design in glasshouse construction, and commissioned some of the most beautiful florilegia ever produced.[58] The botanical treasures of Malmaison are linked inextricably with the renowned French botanical artist, Pierre-Joseph Redouté (1759–1840). He had been a successful botanical artist in Paris, illustrating the works of botanists Augustin Pyramus de Candolle (1778–1841) and Charles-Louis L'Hériter de Brutelle (1746–1822). He was draughtsman to the Cabinet of Queen Marie-Antoinette, before receiving the benefaction of Empress Josephine. The illustrations in the eight folio volumes of *Les Liliacées* (1802–1816), and the three-volume *Les Roses* (1817–1824) were scientifically precise and designed to support modern classification, yet set new standards for artistic expression and technique as well. An original drawing by Redouté of the delicate purple allium is one of nine original watercolors

FIG. 3.22. *Hemerocallis coerulea*, tome 1, plate 18, by Pierre-Joseph Redouté, *Jardin de la Malmaison*, Paris, 1803, by Etienne Pierre Ventenat. Only two hundred copies were printed of this exquisite two-volume work. The royal porcelain manufactories of France and Germany, Sèvres and KPM, reproduced these botanical illustrations, featuring flora from the Malmaison garden in their chinaware.

in the Mertz Library and can be directly compared to the printed version in *Les Liliacées* (figs. 3.23 A–B).[59] These celebrated records of the collections at Malmaison engaged leading botanists of the period. They still stand today as some of the most important creations of the union of art and science.

Malmaison was the second botanical garden for which Ventenat and Redouté published a book together. Their first collaboration was *Description des plantes nouvelles et peu connues, cultivées dans le jardin de J.-M. Cels* (1800–1802), a work that recorded the plants in the garden of French botanist Jacques Philippe Martin Cels (1740–1806), who, on the outskirts of Paris, cultivated foreign plants for sale to feed a growing demand for exotics. Cels received and acclimatized numerous plants sent back from North America by André Michaux (1746–1802) and his son François-André (1770–1885).[60] Commissioned by the French government, the Michaux established two botanical gardens, one in Charleston, South Carolina, and one in New Jersey, as collecting points for living plants as they traveled and explored the East Coast of the United States. "Belles plantes" were collected at the southern garden for "les jardins botaniques et pour les progrès de la Science," and the northern garden was intended for "objets de la plus grande utilité."[61] The elder Michaux published *Flora Boreali-Americana* (1803) and *Histoire des chênes de l'Amérique* (1801). The younger Michaux's *Historie des arbres forestiers de l'Amérique septentrionale* (1810–1813) was illustrated by Pierre-Joseph Redouté and his brother, Henri-Joseph (1766–1852).

Empress Josephine also commissioned a publication from the botanist Aimé Bonpland (1773–1858) on the botanical collections at her two royal estates. The beautiful illustrations in Bonpland's *Description des plantes rares cultivées à Malmaison et à Navarre*, published

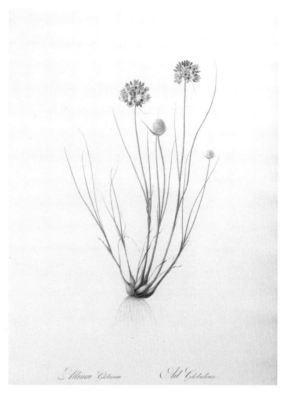

"PLANTS IN THEIR
PERFECTION"

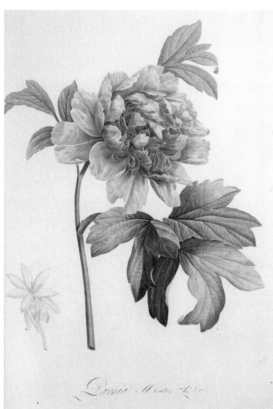

FIG. 3.24. Engraving of *Paeonia moutan* var., one of fifty-four plates made by Pierre-Joseph Redouté for Aimé Bonpland's *Description des plantes rares cultivées à Malmaison et à Navarre*, Paris, 1813. Bonpland wrote the text for this book when he was head botanist for Empress Josephine Bonaparte from 1808 to 1814.

in 1813 (fig. 3.24), were made also by Redouté, together with his collaborator, and sometime rival, Pancrace Bessa (1772–1846).[62] Before overseeing the gardens at Malmaison, Bonpland accompanied the renowned Prussian explorer and naturalist Alexander von Humboldt (1769–1859) on his five-year expedition to South America. Their exploration is documented in various exhaustive publications, including the thirty-four volume *Nova genera et species plantarum* (1815–1825), illustrating Von Humboldt's own drawings translated into hand-colored stipple engravings.[63] The encyclopedic *Vues des Cordillères, et monumens des peuples indigènes de l'Amérique* (1810), was Von Humboldt's first major atlas depicting his findings (see chapter 1). Scholars concur that Von Humboldt's impact on the natural sciences in the nineteenth century is unsurpassed.[64]

After Ferdinand Bauer returned from the *Flora Graeca* expedition, he joined six scientists accompanying navigator and cartographer Matthew Flinders (1774–1814) on another

FIG. 3.25. *Rhododendron dalhousiae*, Hook. fil *(in its native locality)*, tab. 1, in Joseph D. Hooker, *The Rhododendrons of Sikkim-Himalaya*, London, 1849–1851. The botanist and future Director of the Royal Botanic Gardens at Kew brought back twenty-six new species of rhododendron. Kew's botanical illustrator, Walter Hood Fitch, translated Hooker's field sketches.

the most famous botanical artists of his time, including Ehret and James Sowerby (1757–1822), to complete the ambitious *Hortus Kewensis* (1789), a catalog of all the plants cultivated at Kew written by William Aiton (1731–1793).[67] The value of such undertakings—and the many rival publications they spawned—is the insight they provide into the evolution over time of horticultural practice and botanical studies in a locale, including the dating of introductions and tracking of those botanists who introduced new plants.

The Royal Botanic Gardens at Kew played a key role in the early history of The New York Botanical Garden. "An American Kew" was the title of an article by Julian Hawthorne in *Lippincott's Magazine* (1891), and a rallying cry for the founding of a scientific garden in America of the standards of Kew (see chapter 11).[68] It follows that all the publications of, and related to, that august model would find their way into the Library collection in New York sooner or later. One of the most beautiful publications associated with Kew is *The Rhododendrons of Sikkim-Himalaya* (1849–1851) by Joseph Dalton Hooker (1817–1911), with chromolithographs by Walter Hood Fitch (1817–1892), who succeeded Franz Bauer in becoming the sole artist for Kew for decades, working closely with its director Sir William Hooker (1785–1865) (fig. 3.25).[69]

The continuation of ambitious publishing projects into the twentieth century is well represented at the Mertz Library. The four-volume work *The Cactaceae* (1919–1923), a collaboration of The New York Botanical Garden, the United States National Museum, and the United States Department of Agriculture, and published by the Carnegie Institution of Washington, is a fine example. In their introduction, Nathaniel Lord Britton (1859–1934), Director-in-Chief of The New York Botanical Garden, and botanist Joseph

expedition, this time sponsored by the Royal Botanic Gardens at Kew, to circumnavigate Australia. He made two thousand drawings of plants and animals. Upon his return to England, Bauer did all the engraving himself for the resulting publication, *Illustrationes Florae Novae Hollandiae*, on which he worked for five years. In contrast to his world travels, his brother Franz joined the staff of the Royal Botanic Gardens at Kew by 1790, where he became the first botanical artist employed there, remaining almost fifty years.[65] He owed his position to Sir Joseph Banks who had argued successfully that every botanical garden should have its own flower painter at the ready to record new plants as they bloomed or fruited.[66] Franz Bauer worked with some of

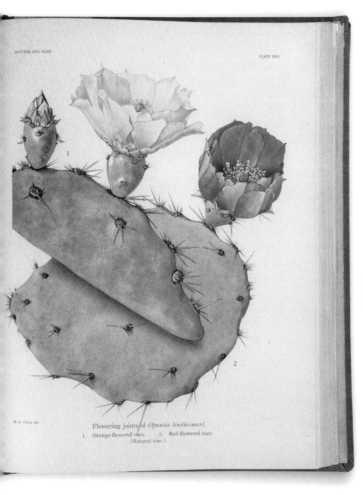

Flowering joints of *Opuntia lindheimeri*.
1. Orange-flowered race. 2. Red-flowered race.
(Natural size.)

FIG. 3.26 A–B. (above) *Opuntia* in an original watercolor by Mary Eaton, whose watercolors and line drawings are recognized as exceptional examples of botanical illustration. *Opuntia* was published as plate 31 (left) in Nathaniel Lord Britton and Joseph N. Rose, *The Cactaceae*, Washington, DC, 1919–1923, the first exhaustive study on the topic, taking fifteen years to complete, with visits to every region in the world where cacti are collected in botanical gardens.

Nelson Rose (1862–1928) explained the history and approach of this ambitious undertaking to prepare the first complete investigation of the family Cactaceae. The history of its production, as explained in the preface, echoes so many of the large-scale botanical projects mentioned in this essay. The first line of investigation for any study was to reexamine all type specimens and original descriptions of the relevant plants. For this project, extensive greenhouse facilities were established at The New York Botanical Garden and the United States Department of Agriculture. The special libraries at the Garden and United States National Museum served as centers for research. The New York Botanical Garden contributed funds for field operations, clerical work, and the work of staff artist Mary Emily Eaton (1873–1961), who made line drawings and paintings there. While the living material for the greenhouse collections and herbaria were important, explorations to observe the plants "as individuals in their form, habit, habitat, and their relations to other species" were also deemed critical to the success of the project.[70]

Eaton was the principal artist for Britton and Rose's *The Cactaceae*. From 1911 until 1932 she worked at The New York Botanical Garden as the illustrator for the Garden's serial *Addisonia* (preparing over eighty percent of the eight hundred plates). Other scientific illustrations published while she was in New York appeared regularly in the *National Geographic Magazine* and in *Contributions from the U.S. National Herbarium*.[71] Many of Eaton's original paintings for *The Cactaceae*, now in the Collection of the Mertz Library, were prepared as chromolithographs by the Baltimore firm A. Hoen & Co. (figs. 3.26 A–B). This exhaustive work has remained the definitive text on the family Cactaceae.

What makes all these publications so valuable to us today, in addition to their beauty and artistry, is that they present accurate records of the achievements of botanical gardens from the very beginnings of modern botanical and horticultural sciences. Many of the illustrated books preserved in such institutions as the Mertz Library contain plants that are now extinct and thus provide a historical point of reference, whether the plants were uncultivated wild species, medicinal, ornamental, or culinary. As collaborations over time and space, these precious works attest to the international community and fellowship of men and women in the identification, exchange, and, ultimately, conservation of plants. Most importantly, the passion for and pleasure in seeking knowledge and creating works of art are embodied in illustrated books and botanical gardens, in which science and art have always intersected.

ENDNOTES

1. Douglas Holland, "Introduction," in Francesca Herndon-Consagra, *The Illustrated Garden, Books from the Missouri Botanical Garden, 1485–1855* (St. Louis: Missouri Botanical Garden, 2004), 9: "The classification and naming of plants is fundamentally tied to its literature. Unlike some fields of science, botany depends heavily upon publications of the eighteenth and nineteenth centuries to maintain a stable system of names for plants. Under the rules of the International Code of Botanical Nomenclature, any botanist dealing with the names of plants must account for all relevant names published since the formalization of the naming system. Since the genus-species 'binominal' system was established with the publication of Carolus Linnaeus' *Species plantarum* in 1753 that means botanists must consult over 250 years of books and journals, often on a daily basis."

2. Pierre Vallet, *Le Jardin du Roy très chrestien Henry IV, Roy de France et de Navare dédié à la royne...*([Paris] 1608).

3. Johannes Commelin, *Horti Medici Amstelodamensis rariorum tam Orientalis...*(Amstelodami: Apud P. & J. Blaeu, nec non Abrahamum à Someren, 1697–1701).

4. Quoted in William Thomas Stearn, "Botanical Gardens and Botanical Literature in the Eighteenth Century," *Catalogue of Botanical Books in the Collection of Rachel McMasters Miller Hunt* (Pittsburgh: Hunt

Botanical Library, 1961), xlvi. As he walked in the Padua botanical garden in 1786, the poet Johann Wolfgang von Goethe expressed the dual appeals of exotic plants: "It is pleasant and instructive to walk through a vegetation that is strange to us. With ordinary plants as well as with other objects that have been too long familiar to us, we at last do not think at all, and what is looking without thinking?"

5. As the renowned British historian of botany William Stearn (1911–2001) has written, gardens possessing the most beautiful and rare plants became focal points for the development of botany and closely linked to the publication of illustrated works. Stearn, "Botanical Gardens and Botanical Literature in the Eighteenth Century," xlv–xlvii. This essay remains one of the most thorough overviews of the relationship of botanic gardens and botanical literature and, as such, was very instrumental in preparing this chapter.

6. Leah Knight, *Of Books and Botany in Early Modern England; Sixteenth-Century Plants and Print Culture* (Surrey: Ashgate, 2009), 4–6.

7. Florike Egmond, Paul Hoftijzer and Robert Visser, eds., *Carolus Clusius, Towards a Cultural History of a Renaissance Naturalist* (Amsterdam: Koninklijke Nederlandse Akademie van Wetenschappen, 2007), 3.

8. Carolus Clusius, *Caroli Clusii Atrebatis Rariorum aliquot stirpium, per Pannoniam, Austriam...* (Antverpiae, Ex Officina C. Plantini, 1583), introduction, p. 3: "Quoniam porro in istis meis peregrinationibus nonnullas obseruaui, quarundam etiam icones & descriptiones ab amicis accepi, quae nostro argumento deseruiebant, eas in suas classes inferre, & commodis locis inserere libuit, ut tanto absolutior fieret nostra historia."

9. Carolus Clusius, *Rariorum plantarum Historia* (Antverpiae: Ex Officina Plantiniana apud Ioannem Moretum, 1601); Ibid., *Exoticorvm libri decem* ([Antverpiae]: Ex Officinâ Plantianâ Raphelengii, 1605).

10. See Sachiko Kusukawa, "Uses of Pictures in Printed Books: The Case of Clusius' *Exoticorum libri decem*," in Egmond et al., eds., *Carolus Clusius*, 221, 241.

11. Kasper van Ommen and Florike Egmond, *The Exotic World of Carolus Clusius, 1526–1609: Catalogue of an Exhibition on the Quatercentenary of Clusius' Death, 4 April 2009* (Leiden: Leiden University Library, 2009), 10. See also Claudia Swan, "The Uses of Botanical Treatises in the Netherlands, c. 1600," in Therese O'Malley and Amy R.W. Meyers, eds., *The Art of Natural History: Illustrated Treatises and Botanical Paintings, 1400–1800* (Washington, DC: National Gallery of Art, 2008), 76–79.

12. Hendrik Adriaan van Rheede tot Drakestein. *Hortus Indicus Malabaricus; continens regni Malabarici apud Indos cereberrimi onmis generis plantas rariores, Latinas, Malabaricis, Arabicis, Brachmanum charactareibus hominibusque expressas...*(Amstelaedami: sumptibus Johannis van Someren, et Joannis van Dyck, 1678–1703). See Marian Fournier, "Enterprise in Botany: Van Reede and his Hortus Malabaricus,"

Archives of Natural History 14, no. 2 (1987): 123–158; no. 3 (1987): 302–305; and J. Heniger, *Hendrik Adriaan van Reede tot Drakenstein (1636–1691); and Hortus Malabaricus: a Contribution to the History of Dutch Colonial Botany* (Rotterdam: A. A. Balkema, 1986), and, most recently, K.S. Manilal, *Hortus Malabaricus and the Socio-Cultural Heritage of India* (Calicut, Kerala: Indian Association for Angiosperm Taxonomy, Dept. of Botany, University of Calicut, 2012).

13. Carl Peter Thunberg, *Icones plantarum Japonicarum: insulis Japonicis annis 1775 et 1776* (Tokyo: Shokubutsu Bunken Kankokai, 1934); *Flora Japonica: sistens plantas insularum Japonicarum secundum systema sexuale emendatum redactas ad 20 classes, ordines, genera et species* (Lipsiae: In Bibliopolio I. G. Mülleriano, 1784); *Flora Capensis: sistens plantas promontorii Bonæ Spei Africes: secundum systema sexuale emendatum...*(Uppsala: Litteris J. F. Edman, 1807–1813). Richard C. Rudolph, "Thunberg in Japan and His Flora Japonica in Japanese," *Monumenta Nipponica* 29, no. 2 (Summer, 1974), 163–179. See also Johannes Burman to Carolus Linnaeus, 30 October 1773, in *The Linnaean Correspondence*, an electronic edition prepared by the Swedish Linnaeus Society, Uppsala, and published by the Centre international d'étude du XVIIIe siècle, Ferney-Voltaire, linnaeus.c18.net, letter 4902.

14. Abraham Munting, *Naauwkeurige beschryving der aardgewassen, waar in de veelerley aart en bijzondere eigenschappen der boomen, heesters, kruyden, bloemen...beschreeven worden...Nu eerst nieuwelijks uitgegeeven, en met meer dan 250 afbeeldingen... vercierd* (Leyden: Pieter van der Aa; Utrecht: Francois Halma, 1696). See Lucia Tongiorgi Tomasi, *An Oak Spring Flora: Flower Illustration from the Fifteenth Century to the Present Time: A Selection of the Rare Books, Manuscripts, and Works of Art in the Collection of Rachel Lambert Mellon* (Upperville, VA: Oak Spring Garden Library, 1997), 172–175.

15. Basilius Besler, *Hortus Eystettensis, sive, Diligens et accurata omnium plantarum, florum, stirpium, ex variis orbis terrae partibus...*([Norimbergae: s.n.], 1613). Cf. Gill Saunders, *Picturing Plants, An Analytical History of Botanical Illustration* (Berkeley: University of California Press in association with the Victoria and Albert Museum, London, 1995), 41.

16. Nicolas Barker, *Hortus Eystettensis, The Bishop's Garden and Besler's Magnificent Book* (New York: Harry N. Abrams, 1994), 3.

17. Ibid., 4. Barker, who has studied this work extensively, wrote that the account of 1611 and the great book are "the only witnesses we have to what must have been one of the most remarkable gardens of its time."

18. Johann Theodor de Bry, *Florilegium renovatum et auctum: variorum maximeque rariorum germinum, florum ac plantarum...*(Francofurti, Apud M. Merianum, 1641).

19. Johann Jakob Dillenius, *Hortus Elthamensis, seu, Plantarum rariorum quas in horto suo Elthami.... Jacobus Sherard...*(Londini: Sumptibus auctoris, 1732).

20. Stearn, "Botanical Gardens and Botanical Literature in the Eighteenth Century," lxv.

21. Forbes W. Robertson, "James Sutherland's *Hortus Medicus Edinburgensis* (1683)," *Garden History* 29, no. 2 (Winter, 2001), 126.

22. Cf. also John L. Heller, "Linnaeus on Sumptuous Books," *Taxon* 25, no. 1 (Feb., 1976), 51.

23. Stearn, "Botanical Gardens and Botanical Literature," lxxiii.

24. Heller, "Linnaeus on Sumptuous Books," 25.

25. See Mark Laird's chapter in this volume for an extended discussion of Mark Catesby's publication, *The Natural History of Carolina, Florida, and the Bahama Islands...*(London: Printed at the expence of the author, 1731–1743). The naturalist explorer Mark Catesby relied on plants he had brought from America to grow in London nurseries and gardens such as Chelsea Physick Garden for the accuracy in color and scale of his illustrations.

26. Blanche Henrey, *British Botanical and Horticultural Literature Before 1800: Comprising a History and Bibliography of Botanical and Horticultural Books Printed in England, Scotland, and Ireland from the Earliest Times until 1800*, 3 vols. (London: Oxford University Press, 1975), vol. 2, 53. John Martyn's *Historia plantarum rariorum* (Londini: Ex Typographia Richardi Reily, 1728–[1737]), an illustrated flower book that "contains some of the earliest examples of colour–printing from a single metal plate," was the first flower book to be printed in color. The mezzoprint process was used, and the book was issued serially, with parts offered to subscribers who paid in advance. It was followed in 1730 by another color-printed book, the *Catalogus plantarum* of the Society of Gardeners, which had only twenty-one plates. By contrast, Elizabeth Blackwell's *A Curious Herbal Containing Five Hundred Cuts, of the Most Useful Plants, Which Are Now Used in the Practice of Physick Engraved on Folio Copper Plates, after Drawings Taken from the Life* was issued in 2 vols., and was published in London between 1737 and 1739. Later, Trew produced *Herbarium Blackwellianum emendatum et auctum* (Norimbergae: Typis Christiani de Lavnoy, 1754–1773), a new edition published in Nuremberg with re-engraved plates, translated into German and Latin.

27. Johann Wilhelm Weinmann, *Phytanthoza iconographia, sive, Conspectus aliquot millium, tam indigenarum quam exoticarum...*(Ratisbonae: Per Hieronymum Lentzum, 1737–1745). Published over a period of almost ten years, this was an ambitious project which resulted in eight folio volumes with more than one thousand hand-colored engravings of several thousand plants.

28. Heller, "Linnaeus on Sumptuous Books," 33–35.

29. Carl von Linné, *Hortus Cliffortianus: plantas exhibens quas in hortis tam vivis quam siccis, Hartecampi in Hollandia, coluit...Georgius Clifford...reductis varietatibus ad species, speciebus ad genera, generibus ad classes, adjectis locis plantarum natalibus*

*differentiisque specierum. Cum tabulis aeneis.
Auctore Carolo Linnaeo* (Amstelaedami, 1737). Stearn,
"Botanical Gardens and Botanical Literature," lx–lxi
and ibid., 1957, 44–46.

30. Stearn, "Botanical Gardens and Botanical Literature,"
 lxii.

31. Knight, *Of Books and Botany*, 28–29.

32. Susan Fraser, "The Genius of Georg Ehret: His Art and
 Influence," *The Botanical Artist* 15, no. 1 (March 2009).

33. Stearn, "Botanical Gardens and Botanical Literature,"
 lxxvii.

34. Philip Miller, *Figures of the Most Beautiful, Useful,
 and Uncommon Plants Described in The Gardeners
 Dictionary: Exhibited on Three Hundred Copper Plates,
 Accurately Engraved After Drawings Taken from
 Nature*...(London: Printed for the author and sold by J.
 Rivington, 1760).

35. Ibid., preface.

36. Christoph Jacob Trew, *Plantae selectae/quarum
 imagines ad exemplaria naturalia Londini, in hortis
 curiosorum nutrita manu artificiosa doctaque pinxit
 Georgius Dionysius Ehret...in aes incidit et vivis
 coloribus repraesentavit Ioannes Iacobus Haid...*
 ([Norimbergae: s.n.], 1750–1773). Cf. Stearn, "Botanical
 Gardens and Botanical Literature," lxxix.

37. Christoph Jacob Trew, *Hortus nitidissimis omnem per
 annum superbiens floribus, sive, Amoenissimorum
 florum imagines...in publicum edidit Johannes Michael
 Seligmann...*(Nürnberg: J.J. Fleischmann, 1750–1786).
 See W. L. Trajen, "Hortus Nitidissimis," *Taxon* 20, no. 4
 (August 1971), 461.

38. James Sutherland, *Hortus Medicus Edinburgensis; Or,
 A Catalogue of the Plants in the Physical Garden at
 Edinburgh...*(Edinburgh, Printed by the Heir of Andrew
 Anderson..., 1683). Cf. Forbes Robertson, "James
 Sutherland's *Hortus Medicus Edinburgensis*," *Garden
 History* (The Garden History Society) 29, no. 2 (winter
 2001), 121.

39. Ibid., 121.

40. Edward Hyams, *Great Botanical Gardens of the World*
 (London: Bloomsbury, 1985), 220–224. William Rox-
 burgh, *Plants of the Coast of Coromandel, Selected
 from Drawings and Descriptions Presented to the
 Hon. Court of Directors of the East India Company, by
 William Roxburgh, M.D. Published by their Order under
 the Direction of Sir Joseph Banks...*(London: Printed by
 W. Bulmer and co. for G. Nicol, Bookseller, 1795–1819).

41. Roxburgh and W. Carey, ed., *Hortus Bengalensis, or,
 A Catalogue of the Plants Growing in the Honourable
 East India Company's Botanic Garden at Calcutta*
 (Serampore: Printed at the Mission Press, 1814); *Flora
 Indica: or, Descriptions of Indian Plants* (Serampore:
 Printed at the Mission Press, 1820–1824).

42. For further reading see: "Roxburgh's Flora Indica"
 on the Royal Botanic Gardens, Kew webpage. See also
 J. R. Sealy "The Roxburgh Flora Indica Drawings at
 Kew," *Kew Bulletin* 11, no. 2 (1956), 297–348.

43. Nathaniel Wallich, *Plantae Asiaticae rariores, or,
 Descriptions and Figures of a Select Number of Unpub-
 lished East Indian Plants* (London: Treuttel and Würtz,
 1830–1832). On the subject of Indian botanical artists
 see Theresa M. Kelley, *Clandestine Marriage: Botany
 and Romantic Culture* (Baltimore: The Johns Hopkins
 University Press, 2012), 197–209.

44. James Bateman, *The Orchidaceae of Mexico &
 Guatemala* (London: The author, J. Ridgway
 [1837–1843]). Cf. R.J. Ferry, "James Bateman and
 Orchid Literature," *The McAllen International
 Orchid Society Journal* (2007), 5–13. See also Kelley,
 Clandestine Marriage, 248–249, esp. 249 for
 Drake's and Withers' illustrations.

45. Berthe Hoola van Nooten, *Fleurs, fruits et feuillages
 choisis de l'Ile de Java peints d'après nature* (Bruxelles:
 C. Muquardt, [1880]), See also Tomasi, *An Oak Spring
 Flora*, 330.

46. John Sibthorp, *Flora Graeca: sive Plantarum rariorum
 historia, quas in provinciis aut insulis Graeciae
 legit* (Londini: Typis Richardi Taylor, 1806–1840).
 See also Bernadette Callery, "Collecting Collections:
 Building the Library of The New York Botanical
 Garden" *Brittonia* 47, no. 1 (Jan.-Mar., 1995), 44–56.

47. Notice in the *New York Herald*, May, 1903, attached
 to the inside of volume 1 of the *Flora Graeca* in
 the Mertz Library: "BIBLIOTEHQUE BOTANIQUE—Hier
 soir s'est terminée, à la Salle Sylvestre, la vente
 de l'importante bibliothèque de Alexis Jordan, de Lyon.
 Parmi les nombreuses raretés et beaux livres, un
 des plus disputes, 'Flora Graeca, sive plantarum
 rariorum historia in provincilis aut insulis Graecia,
 lectae,' Londres, 1806–1840, dix volumes in folio,
 avec 966 planches et dix beaux frontispices coloriés,
 demi-reliure en maroquin, complet et en bon état,
 a été adjugé 4,350fr. à M. Andrew Carnegie pour en
 faire homage au Jardin Botanique de New York.
 Cette vente a produit un total de 60,000 fr., et a été
 faite par M. Delestre, assisté de M. Paul Klincksieck,
 libraire, comme expert."

48. See Callery, "Collecting Collections," 44–56. For a full
 history of this publication, see Hans Walter Lack,
 *The Flora Graeca Story: Sibthorp, Bauer, and Hawkins
 in the Levant* (Oxford, New York: Oxford University
 Press, 1999).

49. The Collection of the Mertz Library includes
 Dioscorides, *De materia medica libri sex* (Venetiis: In
 aedibus Aldi et Andreae soceri, 1518). For a history of
 Dioscorides' work, see also Alain Touwaide, "Botany
 and Humanism in the Renaissance: Background, Inter-
 action, Contradictions," in O'Malley and Meyers, *The
 Art of Natural History*, 32–61.

50. John Sibthorp, *Flora Oxoniensis: exhibens plantas in agro Oxoniensi sponte crescentes...*(Oxonii: Typis Academicis, 1794) and *Flora Graecae prodromus; sive Plantarum omnium enumeratio...*(Londini, Typis Richardi Taylor, veneunt apud J. White, 1806–1813).

51. See also "The Digital *Flora Graeca*," in the Oxford Digital Library. Bauer's work was to become one of the most valuable treasures of Oxford's natural history collections. Based on the original diaries, letters, and specimens, this fine work is illustrated with the original illustrations, which are still housed at the Department of Plant Sciences there.

52. Hans Walter Lack, *Florilegium Imperiale: Botanical Illustrations for Francis I of Austria* (Munich: Prestel, 2006), 19–31. See also Nikolaus Joseph Jacquin, *Plantarum rariorum Horti Caesarei Schoenbrunnensis descriptiones et icones* (Viennae: Apud C.F. Wappler, 1797–1804).

53. Nikolaus Joseph Jacquin, *Hortus Botanicus Vindobonensis, seu, Plantarum rariorum, quae in Horto Botanico Vindobonensi...*(Vindobonae, Typis L.J. Kaliwoda, 1770–1776).

54. Nikolaus Joseph Jacquin, *Oxalis. Monographia, iconibus illustrata* (Viennae: Wappler, 1794); *Selectarum stirpium Americanarum historia, in qua ad Linnaeanum systema determinatae descriptaeque sistuntur plantae illae...*(Vindobonae: Ex Officina Krausiana, 1763).

55. Stearn, "Botanical Gardens and Botanical Literature," lxxii.

56. Under the French occupation in 1805 and 1809, Schönbrunn Palace was Napoleon's headquarters.

57. Etienne Pierre Ventenat, *Jardin de la Malmaison* (Paris: Impr. de Crapelet, et se trouve chez l'auteur, à la Bibliothèque nationale du Panthéon, 1803).

58. Hans Walter Lack, ed., *Jardin de la Malmaison: Empress Josephine's Garden* (Munich: Prestel, 2004), 24–32. Cf. also Bernard Chevallier, "Empress Josephine and the Natural Sciences," in *Of Elephants & Roses: Encounters with French Natural History, 1790–1830,* (Philadelphia: American Philosophical Society Museum, 2011), 35–43.

59. Pierre-Joseph Redouté, *Les Liliacées* (Paris: Chez l'auteur, Impr. de Didot jeune, an x, 1802–[1816]); and ibid., *Les Roses* (Paris: Impr. de F. Didot, 1817–1824).

60. Etienne Pierre Ventenat, *Description des plantes nouvelles et peu connues: cultivées dans le jardin de J. M. Cels* (A Paris: De l'imprimerie de Crapelet, 1800–1802). A second work with illustrations by a "student of Redouté," Pancrace Bessa, appeared in 1803: *Choix de plantes dont la plupart sont cultivées dans le jardin de Cels* (Paris: Impr. de Crapelet, et se trouve chez l'auteur, à la Bibliothèque Nationale du Panthéon, 1803).

61. See Mark Laird's chapter in this volume. For Michaux see Sandra Raphael, *An Oak Spring Sylva: A Selection of the Rare Books on Trees in the Oak Spring Garden Library* (Upperville, VA: Oak Spring Garden Library, 1989), 60–69. See also Elizabeth Hyde, "André Michaux and French Botanical Diplomacy in the Cultural Constructions of Natural History in the Atlantic World," in *Of Elephants & Roses*, 89, 98–99, 100.

62. Aimeé Bonpland, *Description des plantes rares cultivées à Malmaison et à Navarre* (Paris: De l'Impr. de P. Didot l'aîné, 1813). See also David Scrase, *Flower Drawings* (Cambridge: Fitzwilliam Museum, Cambridge University Press, 2000), 102.

63. Elizabeth S. Eustis, John F. Reed, and David L. Andrews, *Plants and Gardens Portrayed: Rare and Illustrated books from the LuEsther T. Mertz Library: an Exhibition in the William D. Rondina and Giovanni Foroni LoFaro Gallery, The New York Botanical Garden.* ([Bronx]: New York Botanical Garden, 2002), 26. Aimé Bonpland, *Nova genera et species plantarum: quas in peregrinatione ad plagam aequinoctialem Orbis Novi collegerunt...*(Lutetiae Parisiorum: Sumtibus Librariae Graeco-Latino-Germanico, 1815–1825).

64. Alexander von Humboldt, *Vues des Cordillères, et monumens des peuples indigènes de l'Amérique* (Paris: F. Schoell, 1810). *The Illustrating Traveler,* Beinecke Rare Book & Manuscript Library Exhibition, organized by William S. Reese and George Miles, last revised September 4, 1996: brbl-archive.library.yale.edu/exhibitions/illustratingtravels/illus.htm

65. Ray Desmond, *Kew: The History of the Royal Botanic Gardens* (London: Harvill Press, 1995), 108.

66. Saunders, *Picturing Plants*, 84.

67. William Aiton, *Hortus Kewensis. Sistens herbas exoticas, indigenasque rariores, in area botanica...*(London, R. Baldwin and J. Ridley, 1768). This was the garden's first catalog of Princess Augusta's garden. Cf. also Ian MacPhail and Joseph Ewan, *Hortus Botanicus: The Botanic Garden and the Book* ([Chicago]: The Newberry Library, 1972), 82.

68. Julian Hawthorne, "An American Kew," in *Lippincott's Magazine* 47 (February 1891), 252–260.

69. Joseph Dalton Hooker, *The Rhododendrons of Sikkim-Himalaya; Being an Account, Botanical and Geographical, of the Rhododendrons Recently Discovered in the Mountains of Eastern Himalaya...* (London: Reeve, 1849–1851).

70. Nathaniel Lord Britton and Joseph Nelson Rose, *The Cactaceae: Descriptions and Illustrations of Plants of the Cactus Family,* 4 vols. (Washington, DC: The Carnegie Institution of Washington, 1919–1923), 3. Cf. also: http://carnegiescience.edu/publications_online/cactaceae/

71. Smithsonian Department of Botany, Artists Represented in the Catalog of Botanical Illustrations index: http://botany.si.edu/botart/eaton.htm

PLEASURE GARDENS IN PRINT:
RECREATION AND EDUCATION
IN THE LANDSCAPE 1550–1850

VANESSA BEZEMER SELLERS

Thy wearied mynde with other paines,
Come recreate and see:
How Lively Natures growth (by Arte)
Presentes it selffe to thee.[1]

Gardens have traditionally played a prominent role in the history and development of the European arts and sciences by connecting the disciplines of botany, printmaking, and book publishing. The large collection of prints and books in the LuEsther T. Mertz Library provides a fascinating glimpse into the ever changing appearance and historical role of gardens over the course of five centuries. These publications reflect the artists' remarkable ability to render the grand European gardens as actual spatial presences, making it possible to walk through their verdant parks while seated in the Mertz Library. This survey will focus on seventeenth- and eighteenth-century garden print books—

FIG. 4.3 A–B. View of the *Viale Grande* or *Terrace of One Hundred Fountains* in the Villa d'Este, in Giovanni F. Venturini, *Le Fontane del giardino Estense in Tiuoli*, Rome, ca. 1691 (top), and as depicted a few centuries later in its romantic looking overgrown state, in Charles Percier and Pierre Fontaine, *Choix des plus célèbres maisons de plaisance de Rome*, Paris, 1809, plate 60 (bottom).

high points of the art form—and emphasize key aspects of the gardens' decoration, deeper meaning, and function as centers of art, entertainment, and education.

It was largely due to the development of the graphic arts that knowledge of the grand estates and their design features was able to spread across Europe. A flood of richly decorated architectural print works providing an illustrative record of particular sites started to inundate the European market in the early seventeenth century. These prints gave an estate owner the opportunity to not only admire gardens on paper, but to also physically re-create them on his property by using the printed images as models. Knowledge of garden architecture was further enhanced by travel experiences abroad, especially those taken by young aristocratic gentlemen crossing Europe on their final educational "rite of passage," known as the Grand Tour. Their newly acquired print collections, featuring scenes of sun-drenched Mediterranean estates, greatly impressed family and friends back home in Northern Europe, sparking a desire for further southward journeys (fig. 4.1).[2] The images of these princely estates had a significant impact

FIG. 4.1. Festive engraving of an Italian garden filled with waterworks and figures from classical mythology. Seated in the front right corner, Hercules invites all to enter this Garden of the Hesperides, symbolizing the revival of ancient *villeggiatura* in seventeenth-century Rome. Giovanni B. Falda, *Li Giardini di Roma*, 1683, title page.

on the artistic imagination, influencing the vision of ideal landscapes and gardens for centuries to come.

Naturally, the architectural form and decoration of a garden depends not solely on artistic considerations or financial circumstances, but, primarily on a property's geographical location, climate and cultural context. This made it quite difficult to recreate Mediterranean estates in the windswept Northern European level plains, as is evident when comparing prints of Rome's hilly gardens with those built in the flat polderlands around Amsterdam.[3] In terms of cultural and artistic setting, the works in the Mertz Library illustrate how garden art—in tandem with other arts and architectural disciplines—reflects a series of style periods and various trends, broadly ranging from Renaissance and Baroque to Rococo and Romantic. Two main garden-

architectural categories can be distinguished: formal or geometric and informal or naturalistic garden layouts, although combinations of the two can be found as well. As is evident from the many print works in the Library, gardens laid out in the Renaissance and Baroque Ages, namely those around sixteenth- and seventeenth-century Italian villas, French châteaux, and Northern European palaces, exemplify the first category, while the eighteenth-century English Landscape Garden with its more natural, irregularly shaped features, belongs to the second category.

Arguably the most spectacular of gardens, just as celebrated today as when they were first created, are those of the grand Italian villa. From the sixteenth century onward, these villa gardens were built throughout Italy, dotting the landscape from the Veneto to Tuscany and Latium. The grand villa complexes, the defining feature of which was the fusion of building, garden and surrounding landscape in one grand composition held together by systems of avenues, all formed part of an extensive network of estates. Often located on cherished ancient building sites, they were recreated in purposeful imitation of the classical Roman tradition of *villeggiatura*, combining country living with studied leisure. What true *villeggiatura* entailed was gathered from descriptions in ancient agricultural treatises, which, rediscovered in the Renaissance period, were reprinted and eagerly reread.[4] Several of these are kept in the Mertz Library, the oldest among them is *Libri de re rustica* published in Venice in 1514.[5]

Magnificent print books evoking true visions of "Elysium" or "Paradise" were published throughout the sixteenth and seventeenth centuries by Italian and French artists, such as Stefano della Bella (1610–1664), Dominique Barrière (1622–1678), Giovanni Battista Falda (1640–1678) and Giovanni Francesco Venturini (1650–1700). In their works, the Italian villa gardens are displayed in all their regal beauty, filled with fountains and classical sculpture. Marble statues are placed against high laurel hedges, vases with orange trees line avenues of ancient cypresses and elegant umbrella pines. Among the oldest and most illustrious of these Renaissance villas still gracing the hills around Rome today are the Villa Farnese at Caprarola and the Villa d'Este at Tivoli.

A particularly impressive large-scale engraving in the Mertz Library records the Villa Farnese (fig. 4.2).[6] Looming large above the little town of Caprarola, it was one of the earliest fortified villa strongholds ever built. Designed by the foremost Renaissance architect Giacomo Barozzi da Vignola (1507–1573), the building is instantly recognizable by the classically inspired form of a giant pentagon. The geometric shape and axial alignment of building, garden and townscape are clearly accentuated in the print and were to inspire many spatial ideals in the ensuing Baroque Age. Extending diagonally behind the residence and to be viewed from the private apartments above, are two walled-in *giardini segreti*: the Summer and Winter Gardens, each reflecting classical Italian design principles in their strict symmetrical layout and mathematical proportion. At the rear of the surrounding hunting park lay the Casino Garden, the sculptural water chain of which formed an attractive, more intimate component of the estate grounds.

It was the nearby Villa d'Este, however, which, more than any other estate, came to be associated with the culture of the villa during the Italian Renaissance. Perched high above the slopes of the town of Tivoli, seventeen miles east of Rome and fed by the waterfalls of various tributaries of the Aniene, this villa complex enjoyed a commanding view of the Roman *campagna*, including the remains of the ancient Villa Adriana. The gardens were designed by the architect-archaeologist Pirro Ligorio (1510–1583) for Cardinal Ippolito d'Este, Duke of Ferrara (1509–1572). Closely involved with his estate's layout and decoration, the Cardinal was a pivotal figure in the garden's complex iconographic narrative, which, as so many Renaissance gardens did, centered on the familiar iconological theme of Hercules balancing vice and virtue. An impressive engineering feat, the

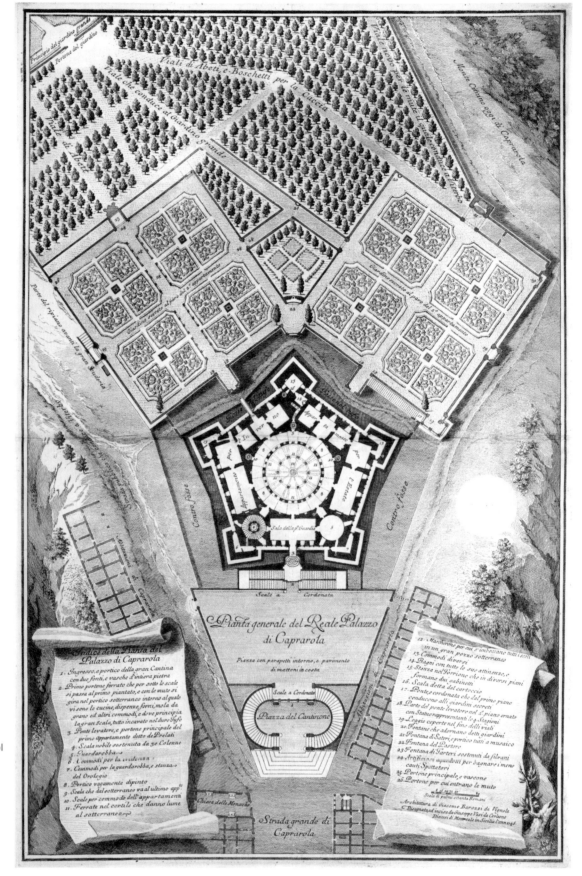

GREAT HERBALS,
FLOWER BOOKS, AND
GARDEN PRINTS

FIG. 4.2. Plan of the Villa
Farnese and its gardens
at Caprarola, a powerful symbol
of dynastic aspirations in
the hillsides of Rome.
Engraving by Taddeo Zuccaro,
in Giorgio G. de Prenner,
*Illustri fatti Farnesiani coloriti
nel Real Palazzo di Caprarola*,
1748. Art and Illustration
Collection, 137–1.

Fig. 4.4. The quintessential English Landscape Garden, the classical, Arcadian character of which is enhanced by the round *Tempietto*, an icon of antiquity itself. *Stowe; A Description of the House and Gardens*, Buckingham, 1817.

Drawn & Engraved by T. Medland, Abingdon Str. Westm.^r

PLEASURE GARDENS

IN PRINT

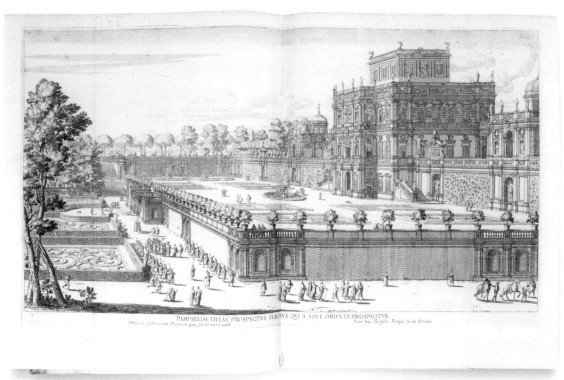

PAMPHILIAE VILLAE PROSPECTVS TERTIVS, QVI A SOLE ORIENTE PROSPICITVR.
Deliciis fabricant Domum que festo coronant Sunt hec Regalia Regia festa Domus

FIG. 4.5. Designed as a status symbol, the Villa Pamphili's magnificent gardens served as an entertainment center and political meeting point for the important people of the day, including the pontiff, Pope Innocent X Pamphili, accompanied here by his Swiss Guards. Engraving by Dominique Barrière, in *Villa Pamphilia*, Rome, ca. 1650.

FIG. 4.6 A–B. The Villa Aldobrandini Water-Theater's hidden jets have just surprised an unsuspecting visitor, who, all drenched, is seen to run down the stairs in a bewildered state. Giovanni B. Falda, *Le Fontane delle ville di Frascati*, Rome, ca. 1667.

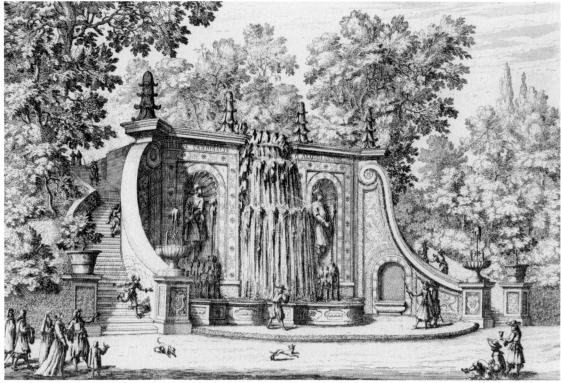

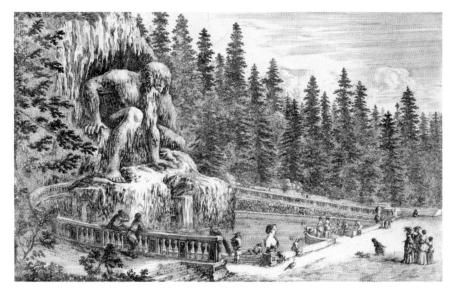

FIG. 4.7. The water basin with colossal, rustic figure of Appennino made by sculptor Giovanni da Bologna for the Villa Medici at Pratolino, from a mid-seventeenth-century series of etched views by Stefano della Bella. Art and Illustration Collection, EKR 376.

gardens extended downward in a sequence of steep terraces, connected by a series of diagonally placed allées.

Celebrating the life-giving power of water, the grounds of the Villa d'Este were decorated by an array of richly sculpted fountains, all precisely delineated in Giovanni F. Venturini's and Giovanni B. Falda's remarkable series

of prints found within the Mertz Library Collection.[7] Particularly impressive among them are engravings of *Fountain of the Organ* and the famous *Terrace of the Hundred Fountains*, masterfully expressing the splendid adornment and verdant atmosphere of these places more than three centuries ago. As it happens, an exquisite print published in Charles Percier and Pierre Fontaine's *Choix des plus célèbres maisons de plaisance de Rome* (1809), depicts the very same section within the garden, but now in its somewhat overgrown state a few centuries later (fig. 4.3 A–B: see p. 78). Comparison between the two images demonstrates the shifting beauty of villas and gardens over time: the terraced allée is now hidden under the romantic, shaded green of overhanging vegetation. The artist has tried to capture the ever-changing appearance and altering "mood" of the garden as experienced by different generations.[8] The melancholic beauty of the Villa d'Este in the slightly ruinous state brought on by the

passage of time, expresses Romantic sensibilities typical of the early nineteenth century. The same quiet ambiance lingers there today, offering a sense of the layers of history evoked by a particular garden spot.[9]

The Villa d'Este would continue to constitute a much copied model for garden architects and artists throughout the Baroque and Enlightenment periods. This is especially true of the Temple of Sibyl, a structure whose graceful silhouette on top of the hill, fascinated artists through the ages. Its architectural form, a round classical *Tempietto,* would become an icon of antiquity itself. Featured centrally in numerous eighteenth-century garden prints, the *Tempietto* had the power to instantly transform English landscape parks into real Elysian Fields (fig. 4.4).[10]

During the Baroque period in Italy, proud Roman families competed with each other to host spectacular outdoor events. Their shaded gardens were filled with an increasingly imposing collection of ancient statues, ebullient fountains, and mysterious grottoes. Such places formed the ideal stage for what was essentially an intricate social theater, a place of pomp and circumstance. The magnificent grounds of the Villa Pamphili served as such a veritable entertainment center *cum* political stage. In the magnificent views by the French engraver Dominique Barrière the Roman *beau monde* and such prominent figures as the Pope and his retinue are seen promenading through the perfectly manicured terraces (fig. 4.5).[11]

Containing the latest water tricks, a stroll through these splendid gardens was not without its risks: a scene in the Villa Aldobrandini captures the very moment in which an unwary visitor is completely doused by hidden water jets, much to the amusement of onlookers (fig. 4.6 A–B).[12] The Baroque *giochi d'acqua* illustrated in many Italian prints were based

directly on hydraulic expertise forwarded by ancient treatises, such as the *Pneumatics* by the Greek engineer Hero of Alexandria (10–70), all republished in this period. A page from the 1592 Venice edition illustrates how garden sculptures forming part of certain water mechanisms or *automata* could be set into motion by water pressure; how a statue of Hercules, for example, could mechanically move as if charging the dragon in the Garden of the Hesperides.[13] The Villa Medici at Pratolino, outside Florence, an example of the great Tuscan tradition of villa architecture, was particularly famous for its extensive waterworks. An extraordinary series of six etched garden scenes by the Italian draughtsman and printmaker Stefano della Bella (1610–1664), includes a view of the water basin with the colossal rustic statue of Appennino by the famous Mannerist artist Giovanni da Bologna (1529–1608) (fig. 4.7).

THE CLASSICAL BAROQUE GARDEN IN NORTHERN EUROPE

Having completed his training with a study trip through Italy and subsequently employed at German and English courts, the Franco-Flemish engineer Salomon de Caus (1576–1626) was among several architects-authors responsible for bringing the knowledge of Italian gardens and waterworks to Northern Europe. One highly influential work was his *Raisons des forces mouvantes* (1624), which contains diverse models for waterworks and mechanically driven objects, including a design for the Grotto of Neptune (fig. 4.8).[14] In addition to waterworks, the most sought after item in the seventeenth-century Baroque garden was classical sculpture, its presence transforming one's estate into a veritable ancient *museion*. In imitation of Rome's fabled collections of statues (fig. 4.9),[15] bronze copies of ancient Hercules, Venus, Sleeping

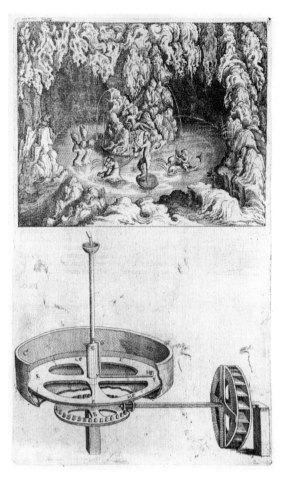

FIG. 4.9. Assortment of classical statues and monuments in the gardens of the Villa Borghese, in Charles Percier and Pierre Fontaine, *Choix des plus célèbres maisons*, Paris, 1809, plate 20. The use of classical sculpture in imitation of Rome's fabled collections would turn one's garden into a veritable ancient *museion*.

FIG. 4.8. Design for a grotto with a moving figure of Neptune and other sea creatures, driven by hydraulic mechanisms based on descriptions of *automata* in ancient treatises. Salomon de Caus, *Raisons des forces mouvantes*, Paris, 1624, book II, no. XXVII.

Nymphs, or little putti would soon come to adorn the Northern European garden.

In an effort to imitate the classical past, the Northern European architect also consulted the newly translated Italian architectural treatises by Andrea Palladio (1508–1580), Vincenzo Scamozzi (1552–1616) and Francesco Sansovino (1521–1586).[16] Their works' classical mathematical proportion, symmetry, and regularity of parts are directly reflected in the geometrical layouts of late sixteenth-century French châteaux built by Jacques Androuet Du Cerceau (fl. 1549–1584),[17] and intricate garden courtyards designed by the Flemish architect-

designer Hans Vredeman de Vries (1537–1612). Following classical architectural terminology, the gardens in De Vries' work are named Doric, Ionic, or Corinthian. One ideal garden layout, entitled "Corinthia," offers a direct example of such a classically-inspired design that is at once mathematical and whimsical when it comes to its ornamental details (fig. 4.10).[18] While Du Cerceau and De Vries were instrumental in introducing principles of classical architecture into Northern Europe, both artists still thought of buildings and gardens as separate entities, visually unrelated to one other. Prints published by the next generation of French architects, however, clearly show how palace and garden came to be envisioned as one unity, placed within the same architectural framework.

The trajectory of the French garden characterized by its classical form and

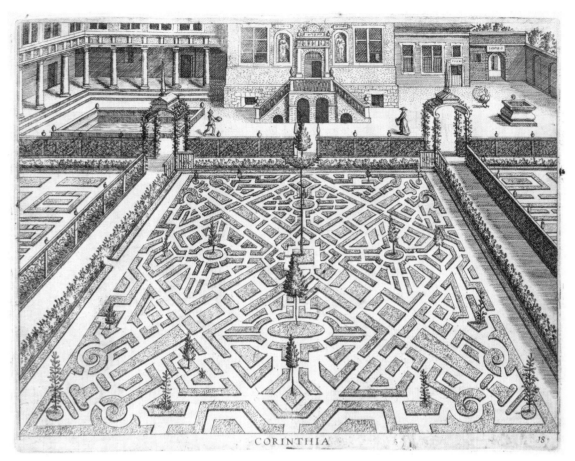

CORINTHIA

FIG. 4.11. Two of the more than sixty different models for ornamental parterres offered by the French architect Jacques Boyceau de la Barauderie, in his much acclaimed *Traité du jardinage selon les raisons de la nature et de l'art*, Paris, 1638.

increasingly unified composition, combined with a new focus on the ornamentation of parterres, can be followed step-by-step by looking at various garden treatises published from the year 1600 onward. An important milestone is the print work, *Traité du jardinage selon les raisons de la nature et de l'art* (1638) by Jacques Boyceau de la Barauderie (1560–1633), superintendent of the French Courtly gardens under Louis XIII (1601–1643). Moving away from traditional agricultural treatises such as Olivier de Serres *Théâtre d'Agriculture* (1600), Boyceau's work, as the title clearly indicates, focused for the first time on the more aesthetic qualities rather than practical aspects of gardening; it offers its readers sixty elegant models for parterre ornamentation (fig. 4.11).[19] Claude Mollet (1564–1649) and André Mollet (ca. 1600–1665), members of a veritable dynasty of architects working as

FIG. 4.10. An ideal garden design entitled "Corinthia," following the mathematical grammar of classical architecture, illustrated in Hans Vredeman de Vries, *Hortorum viridariorumque elegantes & multiplicis formae*, Antwerp, 1583, plate 18.

premier jardiniers du Roy for three successive generations of French kings, continued to build on Boyceau's principles. Seen together, their works reveal the artistic concepts that formed the foundation of the *Jardin à la française*, a highly manicured landscape that would find its apex in the layouts of André Le Nôtre (1613–1700), Louis XIV's own celebrated garden architect.

The gardens laid out by Le Nôtre at Versailles and the princely residences of the Sun King's courtiers are generally considered the highpoint of Baroque garden art, combining in a most eloquent way all the diverse and distinctive aspects of formal gardening developed

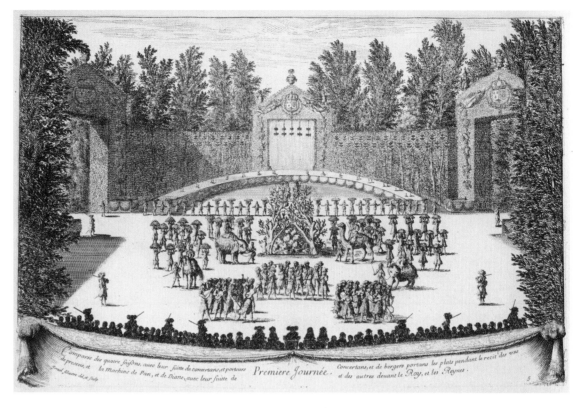

FIG. 4.12. Depiction of the grand opening day of one of the many garden festivities held at Versailles during the reign of Louis XIV, featuring banquets, musical performances, and pageants with exotic animals, in Israel Silvestre, *Premiere Journée* in *Vue du Château de Versailles*, Paris, 1674. Art and Illustration Collection, EKR 382.

since the Renaissance. They demonstrate the garden architect's extraordinary spatial vision combined with the technical prowess to manipulate topographical features on a grand scale. Situated just outside Paris, Versailles' enormous park is the result of one of Europe's most extensive building activities. Lasting for over a century, building and planting activities are still ongoing here, though not driven by the need to entertain one King, but to accommodate millions of visitors each year.

Israel Silvestre's *Vue du Château de Versailles* depicts the various festivities held within the gardens in the 1660s, featuring grand banquets with theatrical performances and pageants with exotic animals (fig. 4.12 A–B).[20] To heighten the impact of a visit to this iconic place, already during the seventeenth century "travelogs" with maps of the estate were being published, each one outlining a tour of the garden's main monuments, including its fabled labyrinth and grotto.[21] The elegant printworks

by Jean Le Pautre (1618–1682) and Adam Perelle (1640–1695) may be considered early examples of "tourist-industry" publications offered in a multitude of languages, including Dutch, English, and German.[22] The prints celebrate the French Baroque garden's grandiose expanse, characterized by its strictly symmetrical composition among various garden sections, from open parterre to wooded *bosquets*, each arranged around a central axis. The rectilinear formality is interrupted only by the swirling arabesque motifs of large *parterres de broderie*— embroidered green "carpets" consisting of organic plant material combined with colored gravel, shells or little stones. The *parterres* are encompassed by precisely clipped boxwood hedges and topiary trees, individually conceived of as sculptural elements and thus matching the geometry of the palace's architecture.

It was the architect Antoine-Joseph Dézallier D'Argenville (1680–1765), who with the publication in 1707 of *La Théorie et la pratique du jardinage*,

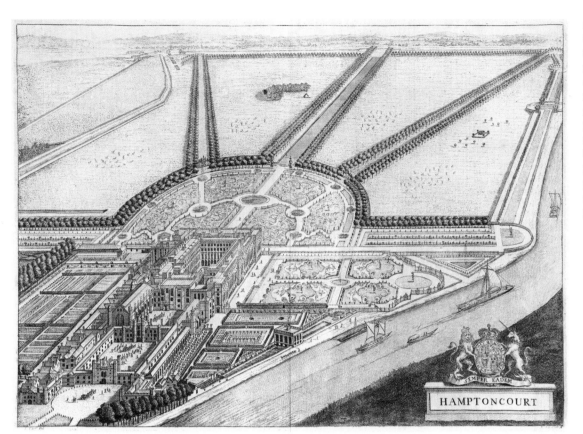

PLEASURE GARDENS

IN PRINT

HAMPTONCOURT

would finally "codify" the French formal style, thus assuring its continued dissemination abroad and into the eighteenth century (fig. 4.13). The work was highly popular, seeing many editions in various languages. It covered for the first time all aspects relating to the refined arts of the pleasure garden, as reflected in the book's full title: *The Theory and Practice of Gardening: Wherein Is Fully Handled All that Relates to Fine Gardens, Commonly Called Pleasure-Gardens, Consisting of Parterres, Groves, Bowling-greens, &c., Together with Remarks and General Rules in All that Concerns the Art of Gardening.*[23]

Several late seventeenth- and early eighteenth-century print series demonstrate the influence of the French garden style on the grand Princely gardens across Northern Europe, especially upon seats of the nobility in England (Badminton, Castle Howard, Chatsworth), Germany (Herrenhausen),[24] and the Netherlands (Het Loo; Enghien).[25] Most striking are the monumental bird's-eye views of English estates published by Johannes Kip (1653–1722) and Leonard Knyff's (1650–1721) in *Britannica Illustrata*,[26] and by Colen Campbell in *Vitruvius Britannicus*.[27] An excellent example, in particular, is Kip's print of the grandiose, semicircular French-style parterre garden of Hampton Court near London, laid out during the reign of William and Mary (1689–1702) (fig. 4.14). The print's elevated viewpoint emphasizes the immense scale of such an ensemble. All the prints in these works masterfully depict the sweeping vistas extending from the formal gardens into the surrounding countryside along a carefully arranged system of axes. The far-reaching tentacles of these axes unmistakably symbolize aristocratic dominion, while at the same time revealing a new sense of worldwide expansion, typical for the ensuing Age of Enlightenment.

Disposition generale d'un Jardin de six arpents

fig.ᵉ 1.ᵉ

Mariette excud

30 15 10 5 Toises

FIG. 4.13. Models for diverse ideal garden layouts, in Antoine-Joseph Dézallier D'Argenville, *La Théorie et la pratique du jardinage*, Paris, 1703, plate 4, a publication that "codified" the French formal style, assuring its continued popularity throughout eighteenth-century Europe.

Disposition generale d'un Jardin de douze arpents

30 15 10 5 Toises

Planche 4.e A

[91]

IMP.CÆS.NERVA TRAIANUS.AUG

C.PLI.N.CÆCIL.SECUND. MUSTIUS.ARCHITECTUS

PLINIUS MUSTIUS

Concurrently, the early reaction against such highly artificial, strict geometrical layouts can be recognized in English print works. Among these is the rare, oversized edition of Robert Castell's *Villas of the Ancients Illustrated* (fig. 4.15),[28] published in London in 1728, and commissioned by the well-known dilettante-architect and early proponent of landscape design, Richard Boyle, Earl of Burlington (1694–1753). The author not only offers rather convincing reconstruction plans of ancient Roman villa gardens based on Pliny the Younger's (61–112) own *Letters,* combined with newly available archaeological data, but in doing so also uses striking irregular form features.[29] These features reveal the burgeoning notions of naturalistic landscape gardening that soon were to take England by storm.

Meanwhile, the impact of French Baroque garden art continued on the European Continent, as evidenced by a rare set of engravings in *Die Fürst-Bischofliche Olmucische Residentz-Stadt Cremsier…Lust- Blum- und Thier-Garten* (1691), illustrating the still frequented castle and garden complex of Prince-Bishop of Olmütz (Olomouc) at Kremsier (Kroměřiž) in the Czech Republic.[30] Not far from here, in the German city of Kassel, another Baroque layout was begun in the first decade of the eighteenth century at Wilhelmshöhe, this one expressing a more dramatic design approach with grand cascades running the full length of the mountainous site (fig. 4.16).[31]

FIG. 4.15. Reconstruction plan for the ancient Villa at Tusculum, in Robert Castell, *Villas of the Ancients Illustrated*, London, 1728. The surprising early use of irregular form features in the garden plan demonstrates impending new directions in garden art, resulting in the English landscape style.

Devised by the Italian garden architect Giovanni Francesco Guerniero (1665–1745), this vast garden project was never fully completed, but survives today in somewhat altered form as a popular landscape park.

Other important contemporary publications depicting French inspired gardens include Matthias Diesel's (1675–1752) prints depicting the gardens at the Bavarian Court, and Salomon Kleiner's (1703–1759) charming print books, celebrating the Baroque and Rococo layouts at the Viennese court.[32] Both print series are populated by fashionably dressed ladies and gentlemen, idly strolling through the gardens, seemingly unaware of the number of laborers working on the grounds to assure its perfect upkeep (fig. 4.17 A–D). The aristocrats' nonchalant demeanor and impeccable appearance is set in direct contrast to the effort expanded by the gardeners in their working clothes, wielding the various tools of their trade; each group would have experienced the garden in quite a different manner, as a place of repose or a place of toil.

The Rococo style, featured in Salomon Kleiner's print series, often went hand in hand with a taste for the Orient in garden art. These notions had been fed by descriptions—real and imaginary—of mysterious countries in the Far East since the late seventeenth century. The first publication ever to depict Far Eastern gardens was Dutch explorer Johannes Nieuhof's (1618–1672)—a sumptuously illustrated tome published in 1665, describing the Dutch Embassy to China around the year 1655. Immediately recognized for its aesthetic and commercial potential, the book was quickly translated into English as *An Embassy from the East-India Company of the United Provinces, to the Grand Tartar Cham, Emperor of China* (fig. 4.18).[33] Inspired by images of China's irregular garden parks with winding paths and jagged rock formations, the

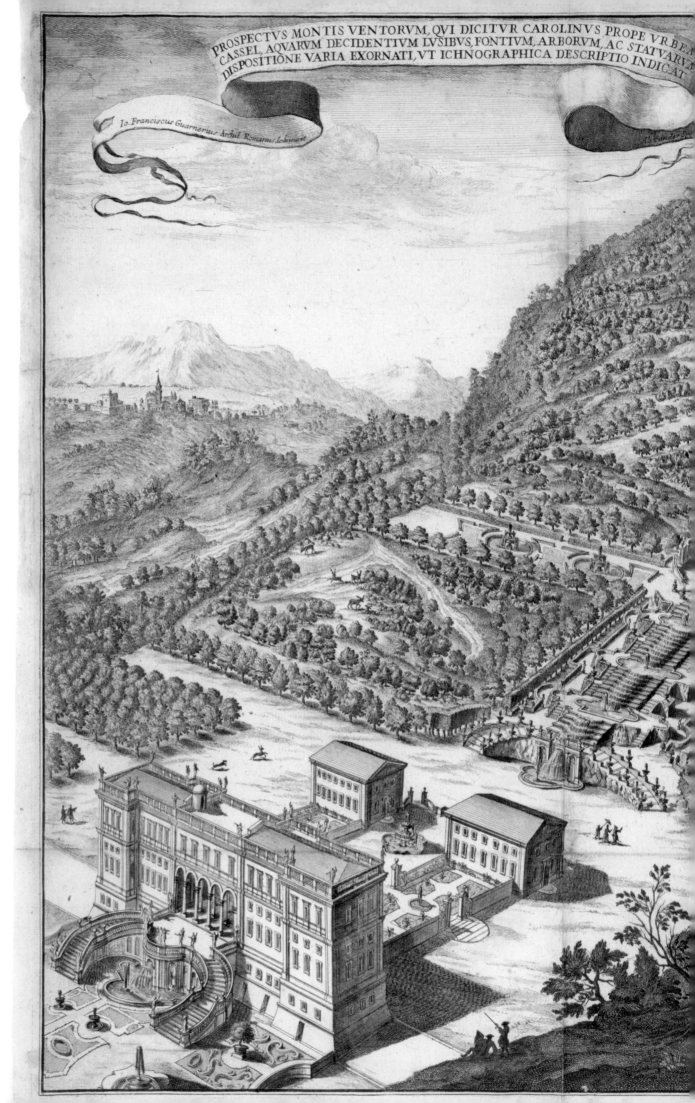

FIG. 4.16. Hand-colored engraving offering a grandiose proposal for a garden layout with dramatic central cascades along the steep slopes of the Karlsberg at Wilhelmshöhe, Kassel, Germany, designed by the Roman architect Giovanni Francesco Guerniero and illustrated in *Delineatio montis a metropoli Hasso-Cassellana...*, 1706. Art and Illustration Collection, EKR 373.

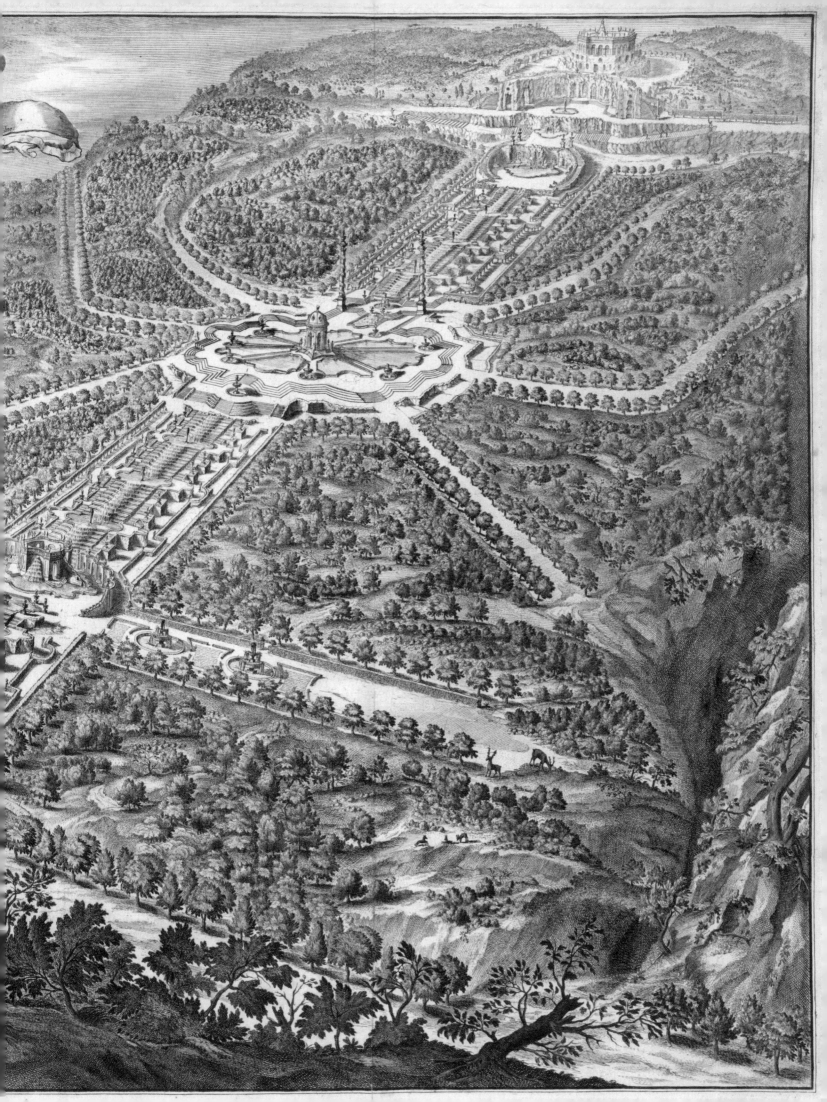

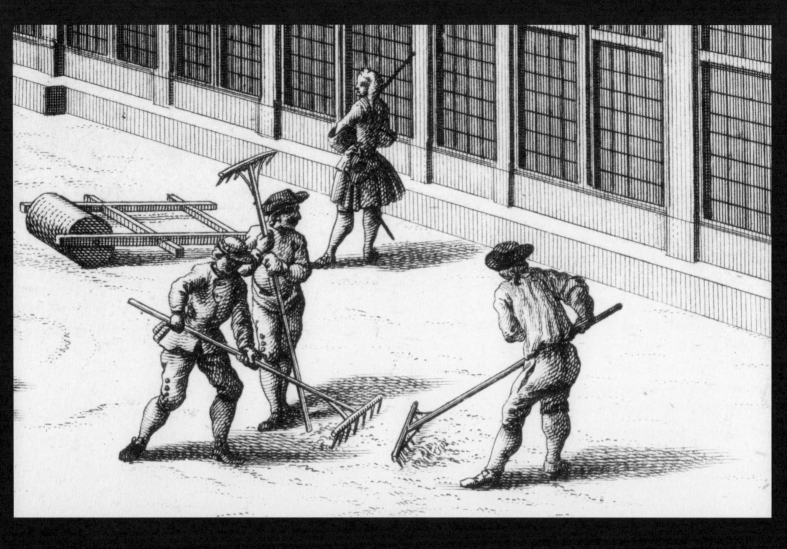

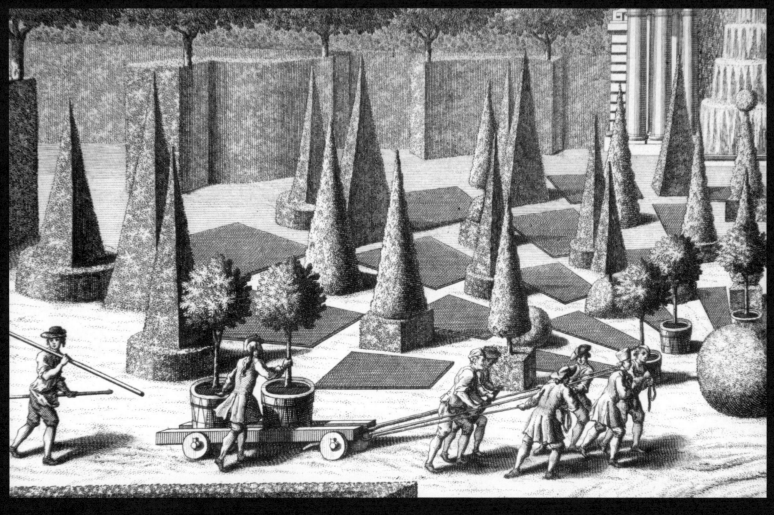

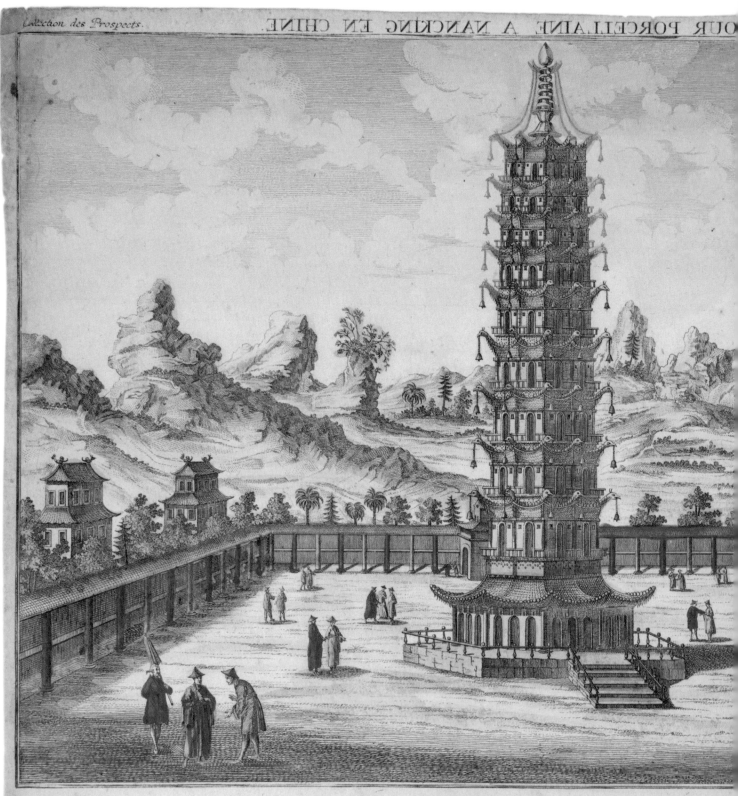

Vuë de Tour Porcellaine a Nancking

Se vend à Augsbourg au Negoce comun de l'Academie Imperiale d'Empire des Arts liberaux avec Privilege de Sa Majesté Imperiale et avec De...

vogue for the Orient would soon impact garden design throughout Europe and ultimately result in the development of the so-called *Jardin Anglais-Chinois*. Delightful prints of gardens filled with whimsical Chinese bridges, pavilions and follies would soon appear in print books such as *Détail des nouveaux jardins à la mode* (1776) by George-Louis Le Rouge (1707–1790).[34] A highpoint of this Oriental aesthetic can be found within the publications of the English architect William Chambers (1723–1796), including *Designs of Chinese Buildings* (1757) and *A Dissertation on Oriental Gardening* (1772). These publications offer quite accurate depictions of Chinese architecture and garden furnishings, set within an extensive landscape park.[35]

THE ENGLISH LANDSCAPE GARDEN TRADITION

By the mid-eighteenth century, it was this increasingly natural looking, though just as artfully designed landscape that defined the ideal English estate. Exemplified *par excellence* by the extensive parklands at Blenheim, Stourhead, and Stowe,[36] the gardens consisted of softly sloping lawns, serpentine lakes, and densely wooded areas with meandering paths. In clear contrast to the seventeenth-century

FIG. 4.17 A–D. (previous spread) Fashionably dressed members of the Viennese *beau monde* stroll through an elegant Rococo park, seemingly unaware of the army of gardeners around them attending to the necessary upkeep of such manicured realms. Details from various engravings in Salomon Kleiner, *Viererleÿ Vorstellungen*, Augsburg, ca. 1730.

FIG. 4.18. "Vue de Tour Porcellaine a Nancking en Chine," showing a pagoda in a Chinese garden-landscape, the irregular layout and exotic decoration of which greatly influenced the development of landscape gardening in Europe. Colored engraving after a print in Johannes Nieuhof, *An Embassy from the East-India Company to... the Emperor of China*, London, 1673. Art and Illustration Collection, EKR 379.

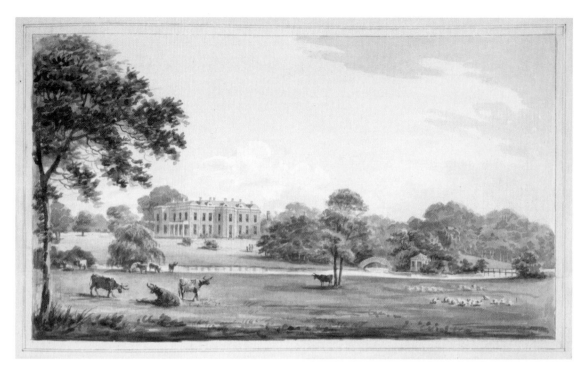

formal gardens with their manicured planting schemes, prints of these estates show various clumps of trees and shrubs planted in seemingly random fashion that no longer conform to strict architectural boundary lines.

Initially envisioned in relation to ideal, painted landscape scenes, the early English landscape garden is shown, throughout, to have drawn its inspiration from Arcadian visions of the Roman *campagna* presented in the works of the famous French artists Nicolas Poussin (1594–1665) and Claude Lorrain (1604/5–1682). The name of the landscape architect Lancelot or "Capability" Brown (1716–1783) is often mentioned in connection with the recreation of such landscapes in nature, permeated with an Arcadian pastoral atmosphere. To create such idyllic parks and imbue them with a timeless poetic quality, Brown would compose various "picturesque scenes" that centered on a classical temple or Roman bridge. His design principles were further developed by Humphry Repton (1752–1818). Repton, however, would start to move away from such artificially

FIG. 4.19. Watercolor illustrating the estate of Whitton, Middlesex, in one of Humphry Repton's much admired hand-written albums known as "Red Books." Dated 1796, his work illustrates an idealized landscape with serpentine lakes and fields with peacefully grazing cattle.

created picturesque "scenes" to embrace more naturalistic landscapes of less "affectation," as examples in his many publications and famous "Red Books" indicate. Named for their bright leather bindings, Repton's "Red Books" were particularly innovative, illustrating his clients' estates before and after suggested landscape improvements, using moveable paper overslips (fig. 4.19). The various beautifully executed landscape scenes clearly show how, by adding just a few features one might enhance the natural beauty of the place and bring out its "true Character."

FIG. 4.20 A–B. Late-eighteenth-century scenes in Parc Monceau, in L. C. de Carmontelle, *Jardin de Monceau, près de Paris*, 1779. Such intimately planted park-landscapes filled with diverse architectural structures were popular meeting places, ideal for discussing latest news and fashion. Details from plates III and XV.

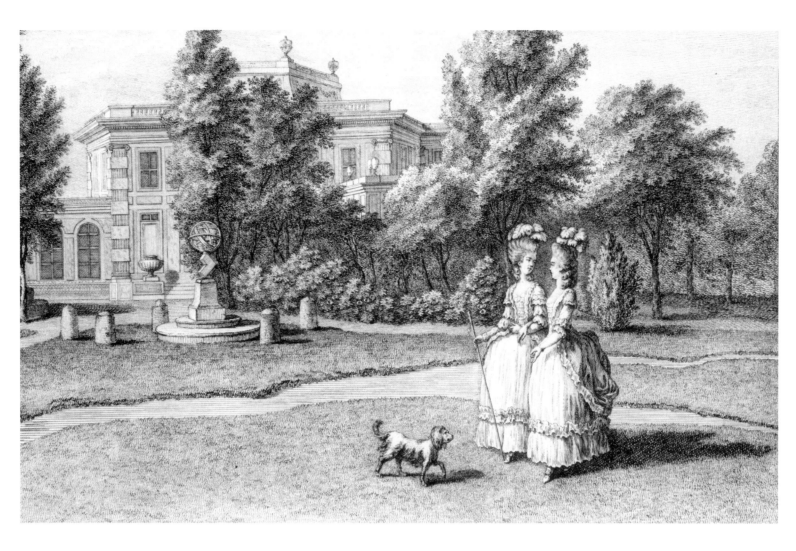
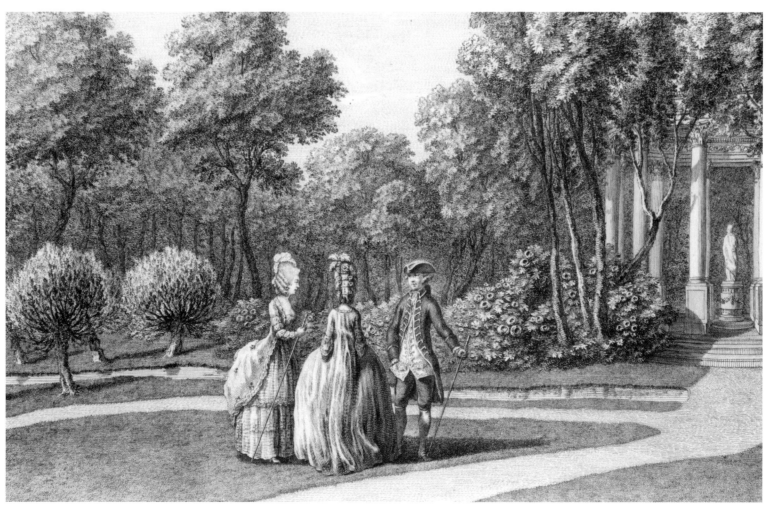

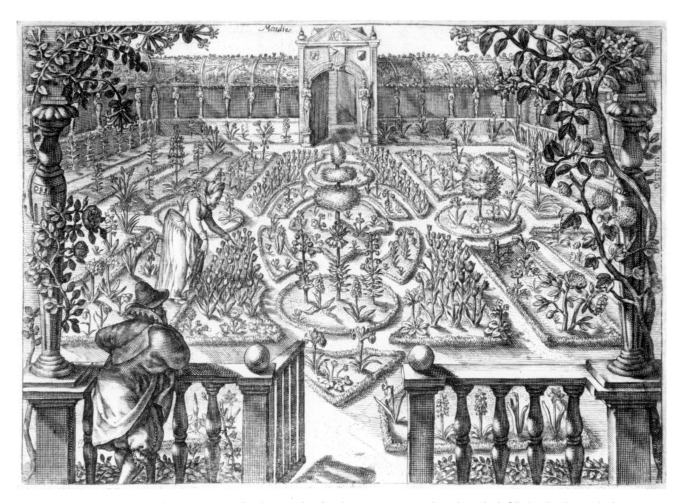

FIG. 4.21. Engraving in Crispijn de Passe, *Hortus Floridus*, Utrecht, 1615, depicting a courtyard-garden, which, filled with tulips and other rare bulbous flowers, functions as an outdoor museum or curiosity cabinet. Ensuing speculative frenzy known as "tulipomania" resulted in the crash of the Amsterdam commodity market in 1637, with major consequences for the Dutch economy.

FIG. 4.22 A–B. Several samples of *ars topiaria*, the art of shaping shrubs or laurel hedges, revealing an enchanting array of topiary figures, from hunters with dogs to monograms and heraldic devices, illustrated in gardener Johann Royer's rare booklet, *Beschreibung des ganzen Fürstl. Braunschw. Gartens zu Hessem*, Braunschweig [Brunswick], 1658.

Various informative garden printbooks published in England, France, and Germany during the last quarter of the eighteenth century stress the highly ornamental appearance of the fashionable park of the day. Gardens here are seen filled with structures in a variety of distinctive decorative styles, each associated with a different place and historic period. Jean Charles Krafft's pattern books, published in three languages for an international clientele, offers the architect and amateur alike "embellishments, of every kind of architecture, such as Chinese, Egyptian, English, Arabian, Moorish, etc," for the adornment of the garden.[37] A beautiful set of views of the Jardin de Monceau, still one of Paris' most frequented parks, illustrates the effect of such a mixed array of building types and follies in the landscape, with an Egyptian pyramid and Roman colonnade here, a Dutch Mill and Chinese merry-go-round there. Such new forms of garden design and decoration came to directly affect traditions of social leisure within increasingly intimately planted spaces, ideal for a stroll in the open air while debating events of the day (fig. 4.20 A–B).[38]

In spite of growing caution in contemporary literature for the excessive use of such artificial structures, including Christian C. L. Hirschfeld's *Theorie der Gartenkunst*,[39] the vogue for historicizing styles in garden art would continue well into the nineteenth century. This tendency can be gleaned from various popular "anthologies" dating from that period, such as Louis. E. Audot, *Essai sur la composition et l'ornement des jardins*.[40] At the same time, the impact of the Romantic Movement must also be recognized in the growing presence of memorials and tombstones in the garden. Conveying a sense of pensive melancholia typical in the Romantic Age, commemorative plaques designating the burial place of a deceased pet, or busts commemorating a loved

one or mythical hero, would enhance the way one experienced a walk through the garden.[41]

The latter part of the nineteenth century witnessed the slow reintroduction of pre-existing geometric style elements, including terraces with decorative flower parterres and sculptural fountains; typical examples are depicted in E. Adveno Brooke, *The Gardens of England* and Karl Götze, *Album für Teppichgärtnerei*.[42] The tendency toward a "mixt style," harking back to the past by combining formal and informal elements, with more manicured, geometrically composed sections near the main building and irregular landscaped areas farther removed from it, was typical for the late nineteenth and early twentieth century, bringing the history of garden design, as shown in the art of the print, to a full circle.

EXPERIENCING THE GARDEN: RECREATION AND EDUCATION

While the garden is often appreciated as a place for enjoyment, its function as an outdoor learning center for the express study of nature, or rare flowers, is an aspect highlighted by several print works dating from the early seventeenth century. During Holland's "Golden Age" the use of a garden as a place for plant study went hand-in-hand with the development of floriculture. Especially important was the influx of exotic botanical material from overseas, such as the tulip. A wonderful depiction of a courtyard garden that resembles a veritable cabinet-of-curiosities, filled with treasures in the form of organically grown objects such as richly colored tulips, is shown in Crispijn de Passe, *Hortus Floridus* or *Garden of Flowers* (fig. 4.21).

Another, equally enchanting garden is illustrated in a curious German booklet entitled *Beschreibung des ganzen Fürstl. Braunschw. Gartens zu Hessem* (1658).[43] Filled with practical

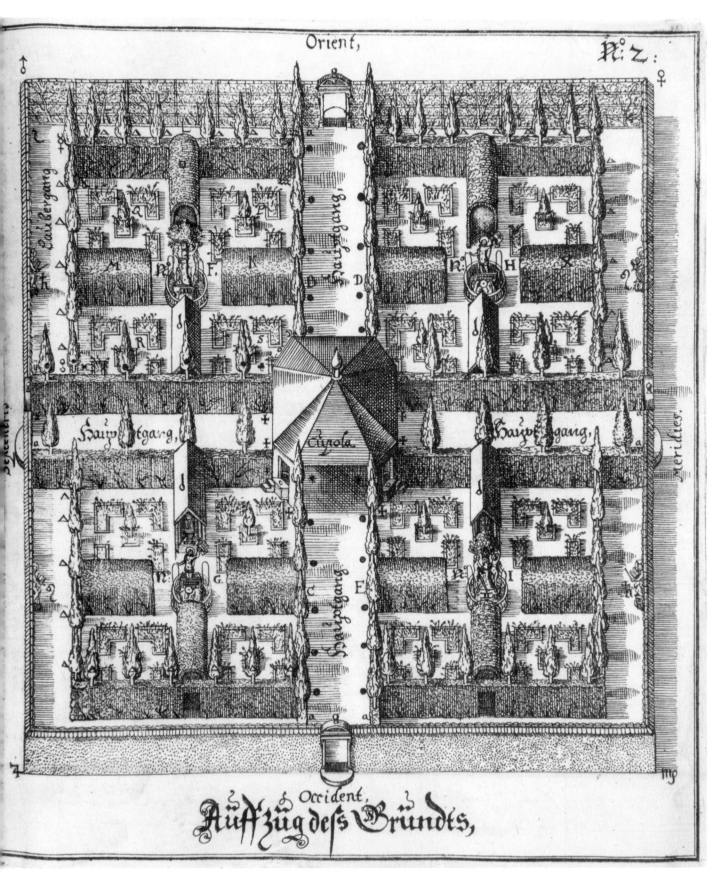

FIG. 4.23. Perspective plan of an ideal kindergarten or
"School Paradise Garden," as author Joseph Furttenbach
calls his densely planted outdoor place designed for the
education of children, as illustrated in *Mannhafter Kunst-
Spiegel*, Augsburg, 1663, between pp. 46–47.

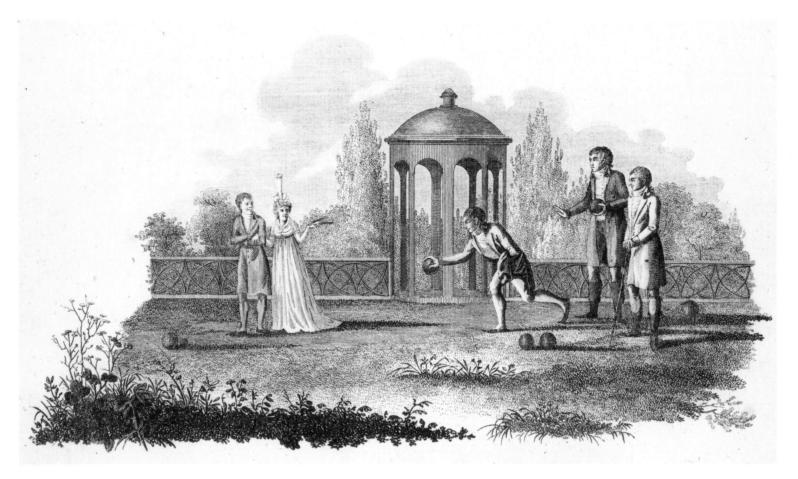

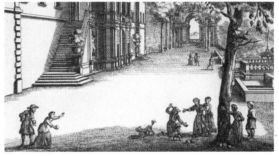

FIG. 4.24 A–B. The enduring role of the garden as a place for outdoor recreation is demonstrated by two prints featuring people playing *bocce* or *jeux de boules*; one game is set in an Italian Renaissance villa, the other a nineteenth-century German landscape park (top). Prints in Giovanni F. Venturini, *Li Giardini di Roma*, ca. 1691 (detail), and in Friedrich G. Baumgartner, *Neues Ideen-Magazin für Liebhaber von Gärten*, Leipzig, 1806, Heft 49, No.1, 12.

gardening advice by the Hessen gardener Johann Royer (1574–1655), it offers detailed instructions on the art of topiary, or how to shape shrubs in ornamental forms to create living plant sculpture. The accompanying prints illustrate designs for decoratively shaped boxwood or laurel hedges topped by topiary figures, including hunters with their dogs and heraldic devices (fig. 4.22 A–B). From about the same period dates another intriguing work entitled *Architectura Recreationis*, published by the notable German architect Joseph Furttenbach (1591–1667). Though this work

presents plans for magnificent princely palace gardens, even more interesting, certainly from an educational point of view, is Furttenbach's unique architectural-mathematical work *Mannhafter Kunst-Spiegel* (fig. 4.23).[44] It includes a plan and perspective design for what may well be the first kindergarten ever designed. The layout of this "School Paradise Garden," as Furttenbach describes his densely planted, safely walled-in courtyard garden adorned with Biblical scenes, is specifically devised "for enjoyment, health and educational purposes." The author explains in detail how

FIG. 4.25 A–B. Whether in the formal setting of a Dutch estate, or the natural English landscape park, enjoying a cup of tea, reading, or drawing, belonged to cherished outdoor activities, central to the experience of gardens throughout history. Details from engravings in Hendrik De Leth, *Zegenpralent Kennemerlant*, Amsterdam, 1732, plate 99 (below), and from Barbara Hofland, *A Descriptive Account of the Mansion and Gardens of White-Knights*, London, 1819, plate opp. p. 70 (top).

the children are to memorize the names of all the plants while tending to their own sections of flowerbeds and fruit trees, thus combining learning with much needed movement and tactile experience.

Also expressly designed for children is Humphry Repton's "Children's Garden" at Woburn Abbey, which, in use since the early nineteenth century, was just recently restored.[45] In contrast to its seventeenth-century

[106]

forerunner, this kindergarten was not designed for public religious education, but as a private playground on a grand estate. Dating from around 1830 and situated right behind the old manor, the Woburn Children's Garden is laid out as a charming miniature landscape garden, with meandering paths and curvilinear planting areas.

Whether child or adult, the pleasures derived through the ages from spending a day in the garden, escaping hot summer days in the cool shade of green verdure, has been beautifully recorded in the many prints that have come down to us since the Renaissance. The enduring role of the garden as an ideal place for outdoor activities, from picnicking to drawing or playing outdoor games, is evidenced by many of the prints in the Mertz Library; here, a direct link can be recognized between the delightful depiction of a ball game (*bocce* or *jeux de boule*) in an Italian Villa around the year 1680, and one played centuries later on the lawn of a German landscape garden (fig. 4.24 A–B).[46] Other timeless outdoor activities included eating or drinking, and reading or drawing under the open sky. A print illustrating a tea ceremony set in a formal Dutch garden offers a wonderful comparison with a print depicting a lady sketching the picturesque surroundings of an English landscape park (fig. 4.25 A–B). Both art works highlight the diverse, but equally delightful experiences one would have had over the course of time in the garden; each place, whether geometrical or informal, having its own unique atmosphere and rich allure.

The Mertz Library's many garden books and prints offer an extraordinary wide overview of the development of garden art and architecture in all its rich diversity, from the Renaissance and Baroque's geometric tradition to the more naturalistic landscape style of the eighteenth and early nineteenth century. An analysis of their main design features, seen against the background of contemporary aesthetic, cultural, and technical advances, has demonstrated how the layout and ornamentation of gardens, following trends in the arts overall, changed constantly. Their appearance through the centuries was enhanced by increasingly impressive waterworks, ever more intricate parterres, and an abundance of garden structures in countless decorative styles. The garden's deeper associative and symbolic meaning can be gleaned from the numerous allegorical figures and mythological scenes illuminating these print works. They express, finally, the age-old vision of the garden as an Elysium, a place both to rest *and* to edify the mind.

ENDNOTES

1. From Crispijn de Passe, *Hortus Floridus*, in its English translation: *Garden of Flowers: Wherein Very Lively Is Contained a True and Perfect Description of All the Flowers* (Utrecht: By Salomon de Roy, for Crispian de Passe, 1615), opening verse.

2. Giovanni Battista Falda, *Li Giardini di Roma: con le loro piante, alzate, e uedute in prospettiua / disegnate ed intagliate da Gio. Battista Falda; nuouamente dati alle stampe, con direttione, e cura di Gio: Giacomo de Rossi...*(In Roma: [G.G. de Rossi], l'anno 1683).

3. Matthaeus Brouerius van Nidek and Daniel Stopendaal, *Het verheerlykt Watergraefs- of Diemer-Meer, by de stadt Amsterdam* (Amsterdam: Andries en Hendrik de Leth, 1725).

4. Marcus Porcius Cato (234–149 BC), *De agricultura*, and Lucius Junius Moderatus Columella (AD 4–70), *De re rustica*.

5. *Libri de re rustica*: M. Catonis lib. I. M. Terentii Varronis lib. III. L. Junii Moderati Columellae ([Venetiis] Aldus [1514]).

6. Plan of the house and gardens by Giorgio Gasparo de Prenner, *Illustri fatti Farnesiani coloriti nel Real Palazzo di Caprarola* (Rome: Cardinale Trojano d'Acquaviva d'Aragona, 1748).

7. Giovanni F. Venturini, *Le Fontane del giardino Estense in Tiuoli: con li loro prospetti e vedute della cascata del fiume Aniene* (Roma: Data in luce da Gio: Giacomo de Rossi, [ca. 1691]). Cf. also Giovanni F. Venturini and Giovanni B. Falda, *Le Fontane ne' palazzi e ne' giardini di Roma: con li loro prospetti et ornamenti.* Roma: Gio. Giacomo de Rossi, [ca. 1689]).

8. Charles Percier and Pierre Fontaine, *Choix des plus célèbres maisons de plaisance de Rome et de ses environs* (Paris: Impr. P. Didot l'aîné, 1809).

9. Term taken from B. G. Fryberger, *The Changing Garden* (Berkeley, Los Angeles, London: University of California Press, 2003), 141.

10. *Stowe; A Description of the House and Gardens of the Most Noble and Puissant Prince, Richard Grenville Nugent Chandos Temple, Marquess of Buckingham* (Buckingham: Printed and Sold by J. Seeley, 1817).

11. Dominique Barrière, *Villa Pamphilia: eiusque palatium, cum suis prospectibus* .. (Romae: Formis Io. Iacobi de Rubeis, [ca. 1650–55]).

12. Giovanni B. Falda, *Le Fontane delle ville di Frascati nel Tusculano: con li loro prospetti...Roma: Date in luce con direttione, e cura da Gio: Giacomo de Rossi...*, [ca. 1667]; Cf similar water tricks in Venturini's prints of the Villa d'Este, in *Fontane nel Giardino Estense* (Rome: A. de Rossi, 1684).

13. Design for a mechanical theater and concept of water tricks and mechanics are taken from Hero of Alexandria, *Pneumatics*, republished as *De gli automati, ouero, machine se moventi* (Venetia: Appresso Girolamo Porro, 1589).

14. Salomon de Caus, *Les Raisons des forces mouvantes: avec diverses machines tant utiles que plaisantes...* (Paris: Chez Hierosme Droüart, 1624). Among various other important garden books in the Mertz Library dating from this period is Georg Andreas Böckler's richly illustrated *Architectura curiosa nova, das ist, Neue Ergötzliche Sinn- und Kunstreiche auch nützliche Bau- und Wasser-Kunst vorstellend...*(Nürnberg: In Verlegung Paul Fürstens Kunst- und Buchhändlers... Gedruckt daselbst bey Christoff Gerhard [ca.1664]).

15. Percier, *Choix des plus célèbres maisons*, plate 20.

16. Cf. Francesco Sansovino's publication on Palladio's work in *Palladius, Rutilius Taurus Aemilianus. La Villa di Palladio Rutilio Tauro Emiliano* (In Venetia: Appresso Francesco Sansovino, 1560).

17. Jacques Androuet du Cerceau, *Le Premier volume des plus excellents bastiments de France: auquel sont designez les plans de quinze bastiments, & de leur contenu...*(A Paris: Pour ledit Iacques Androuet, du Cerceau, 1576).

18. Hans Vredeman de Vries, *Hortorum viridariorumque elegantes & multiplicis formae* (Antuerpiae: Philippus Gallaeus excudebat, 1583).

19. Jacques Boyceau de la Barauderie, *Traité du jardinage selon les raisons de la nature et de l'art* (Paris: Chez Michel Van Lochom, 1638).

20. Israel Silvestre, "Premiere Journée" in *Vue du Château de Versailles*, Paris, 1674, nr 5. Art and Illustration Collection, EKR 382.

21. André Felibien, *Description de la grotte de Versailles* (Paris: S. Mabre-Cramoisy, 1672), and *La Description du Château de Versailles* (Paris: s.n., 1694); Charles Perrault, *Labyrinte de Versailles* (Paris: Imprimerie royale, 1679). On tourism and gardens, see Shoemaker, Candine A. *Encyclopedia of Gardens: History and Design* (Chicago: Fitzroy Dearborn, 2001), vol. 3, 1313–14.

22. Jean Le Pautre, *Nouveaux desseins de jardins, parterres et fassades de maisons* ([Paris]: Se vend a Paris chez N. Langlois [ca. 1680]). The Mertz Library also holds a series of thirty views designed and engraved by Adam Perelle entitled "Diverses Vues de Chantilly: Vue générale de Chantilly du côté de l'Entrée," Paris, Nicolas Langlois, ca. 1683. Art and Illustration Collection, EKR 388. Many editions in several languages followed up to the mid-eighteenth century, for example: *Versailles Illustrated, or, Divers Views of the Several Parts of the Royal Palace of Versailles* (London: Printed & sold by John Bowles, 1726). Cf. also Elizabeth S. Eustis, *European Pleasure Gardens: Rare Books and Prints of Historic Landscape Design from the Elizabeth K. Reilley Collection.* ([Bronx, N.Y.]: New York Botanical Garden, 2003), 42–43.

23. London: Printed by Geo. James, and sold by Maurice Atkins..., 1712; and a later augmented edition, London: Printed for Bernard Lintot..., 1728.

24. *A General Prospect of the Royall House and Garding* [sic] *at Hernhausen / I.I. Müller delineavit; I. van Sasse fecit* (Amsterdam: Chez Pierre Schenk...[ca. 1720]).

25. Important garden print series illustrating Baroque gardens in Holland, and in parts of present-day Belgium were published in the period 1680–1710 by the map and print makers Nicolaes Visscher and Petrus Schenk in Amsterdam. A good example are the extraordinary series of etchings by Romeyn de Hooghe in *Villa Angiana, vulgo het Perc van Anguien*, published ca. 1685, illustrating scenes in the park of Enghien (Edingen) near Brussels. Cf. Eustis, *European Pleasure Gardens*, 99. See also Henk van Nierop (ed.), *Romeyn de Hooghe. De verbeelding van de late Gouden Eeuw* (Zwolle: Waanders Uitgevers, 2008).

26. *Britannia Illustrata, or, Views of Several of the Queens Palaces: As Also of the Principal Seats of the Nobility and Gentry of Great Britain...*(London: Printed for Joseph Smith, 1714–1717).

27. Colen Campbell, *The Third Volume of Vitruvius Britannicus, or, The British Architect...*(London: Printed and Sold by the Author and by Joseph Smith, 1725).

28. Robert Castell, *The Villas of the Ancients Illustrated* (London: Printed for the Author, 1728).

29. Several different reconstruction plans were published by the French architect André Félibien in *Les Plans et les descriptions de deux des plus belles maisons de campagne de Pline le consul* (Amsterdam: Aux dépens d'Estienne Roger, 1706).

30. *Die Fürst-Bischofliche Olmucische Residentz-Stadt Cremsier: sambt denen nechst darbeÿ Neü-erhöbt, und von Grund zugericht, und erbauten Lust- Blum- und Thier-Garten* (Cremsier: Urban Frantz Augustin Heger, anno 1691), with prints by Justus van Nypoort after Georg Matthaeum Vischer. See Eustis, *European Pleasure Gardens*, 52, and also Monique Mosser and Georges Teyssot (eds.), *The Architecture of Western Gardens: A Design History from the Renaissance to the Present* (Cambridge, Mass.: MIT Press, 1991), 317–319.

31. Various other views of this garden are published in *Delineatio montis a metropoli Hasso-Cassellana...* (Casselis: Typis Henrici Harmes, Aulae Hassiacae Typograhi, MDCCVII). Art and Illustration Collection, EKR 373.

32. Matthias Diesel, *Erlustierende Augenweide in Vorstellung herrlicher Garten und Lustgebäude* (Aug[ustae] Vind[elicorum]: Ieremias Wolff excudit, [ca. 1717–1722]). Salomon Kleiner, *Viererleÿ Vorstellungen angenehm- und zierlicher Grundrisse folgender Lustgärten und Prospecten, so ausser der Residenz-Stadt Wienn zu finden* (Augspurg: Verlegt u. zu finden beÿ Johann Andreas Pfeffel, ca. 1730). Cf. also Salomon Kleiner, *Representation exacte du chateau de chasse de S.A. Sme. Monseigneur l'Eveque de Bamberg* (Augsbourg: Aux depens et chez les héritiers de feu Ieremie Wolff, 1731).

33. Johannes Nieuhof, *An Embassy from the East-India Company of the United Provinces, to the Grand Tartar Cham, Emperor of China* (London: Printed by the Author [i.e., Ogilby], 1673).

34. George-Louis Le Rouge, *Détail des nouveaux jardins à la mode* (Paris : Chez le Rouge, [1776]).

35. William Chambers, *Designs of Chinese Buildings, Furniture, Dresses, Machines, and Utensils* (London: Published for the Author, 1757) and *A Dissertation on Oriental Gardening* (London: Printed by W. Griffin, 1772).

36. William Fordyce Mavor, *New Description of Blenheim, the Seat of His Grace the Duke of Marlborough: Containing a Picturesque Tour of the Gardens and Park* (London: Printed for Cadell and Davies and E. Newbery, 1797); Sir Richard Colt Hoare, *A Description of the House and Gardens at Stourhead* (Bath: Barratt and Son, 1818); Stowe; *A Description of the House and Gardens of the Most Noble and Puissant Prince, Richard Grenville Nugent Chandos Temple, Marquess of Buckingham* (Buckingham: Printed and Sold by J. Seeley, 1817).

37. Jean Charles Krafft, *Plans des plus beaux jardins pittoresques de France...—Plans of the Most Beautiful Picturesque Gardens in France, England and Germany, and of the Edifices, Monuments, Fabrics, etc., which Contribute to Their Embellishment, of Every Kind of Architecture, such as Chinese, Egyptian, English, Arabian, Moorish, etc.* (Paris: Impr. de Levrault, 1809–1810).

38. L. C. Carmontelle, *Jardin de Monceau, près de Paris: appartenant a Son Altesse Sérénissime Monseigneur le duc de Chartres* (Paris: Chez M. Delafosse et chez tous les marchands d'estampes, 1779). Cf. also J. Mérigot, *Promenades ou itinéraire des Jardins de Chantilly* (A Paris: Chez Desenne; Et à Chantilly: Chez M. Hédouin, 1791).

39. Christian C. L. Hirschfeld, *Geschichte der Gartenkunst* (Leipzig: M.G. Weidmanns Erben und Reich, 1779–1785). Cf. ibid., *Theory of Garden Art*, ed. and trans. Linda B. Parshall (Philadelphia: University of Pennsylvania Press, 2001), 107 and 136–137.

40. Louis. E. Audot, *Essai sur la composition et l'ornement des jardins* (A Paris: Chez Audot, 1818) and *Traité de la composition et de l'ornement des jardins...des fabriques propres a leur décoration* (Paris: Audot, 1825), and various later editions.

41. See Elizabeth Barlow Rogers, Elizabeth S. Eustis, and John Bidwell, *Romantic Gardens. Nature, Art, and Landscape Design* (New York: The Morgan Library and Museum and the Foundation for Landscape Studies; Jaffrey, NH: David R. Godine, 2010). See also Vanessa Bezemer Sellers, *The Romantic Landscape Garden in Holland: Gijsbert van Laar (1767–1820) and the Magazijn van Tuin-sieraaden or Storehouse of Garden Ornaments*. Digital publication, Virtual Rare Books, Foundation for Landscape Studies, New York, 2011.

42. E. Adveno Brooke, *The Gardens of England* (London: T. McLean, 1857) and Karl Götze, *Album für Teppichgärtnerei und Gruppenbepflanzung* (Erfurt: L. Möller, [1897]).

43. *Beschreibung des ganzen Fürstl. Braunschw. Gartens zu Hessem: mit seinen künstliche[n] Abteihlungen... herfürgegeben durch Johann Royern Fürstl. Br. bestelten Gärtnern zu Hesse* ([Braunschweig]: In Verlegung Gotfrid Mullers in Braunschweig, 1658).

44. Joseph Furttenbach, *Mannhaffter Kunst-Spiegel... Fortsetzung allerhand mathematisch- und mechanisch-hochnutzlich-so wol auch sehr erfröhlichen Delectationen...*(Augsburg: Johann Schultes, 1663).

45. James Forbes, *Hortus Woburnensis: A Descriptive Catalogue of Upwards of Six Thousand Ornamental Plants Cultivated at Woburn Abbey* (London: J. Ridgway, 1833), 287.

46. Friedrich G. Baumgärtner, *Neues Ideen-Magazin für Liebhaber von Gärten, Englischen Anlagen und für Besitzer von Landgütern* (Leipzig: In der Baumgärtnerischen Buchh., 1806), Heft 49, No. 1, 12.

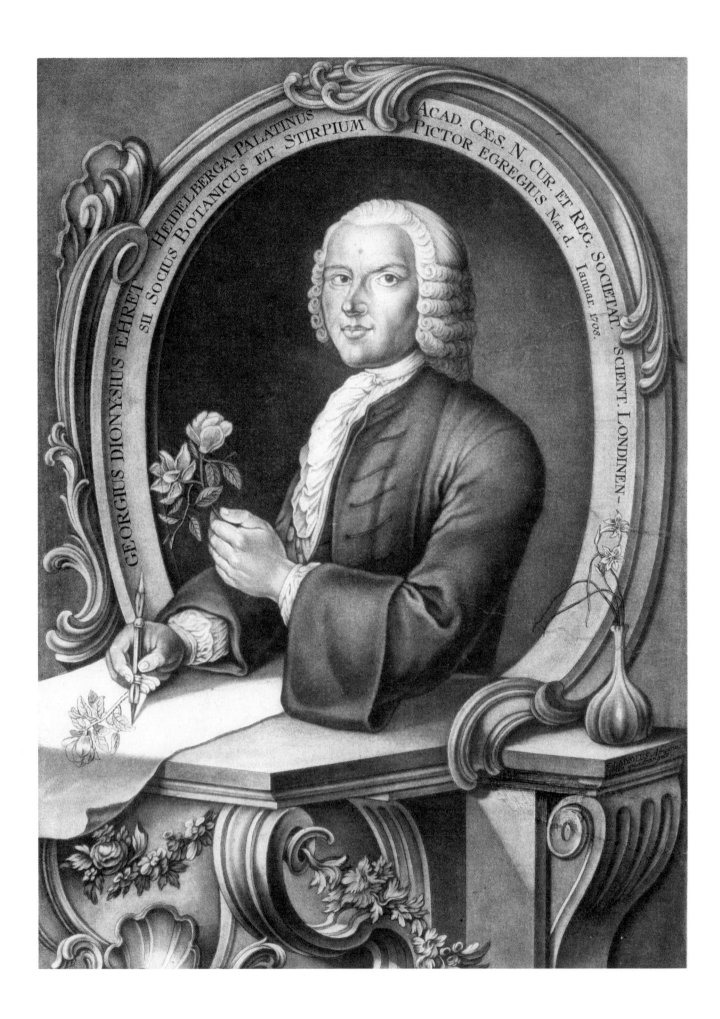

GEORGIUS DIONYSIUS EHRET HEIDELBERGA-PALATINUS ACAD. CÆS. N. CUR. ET REG. SOCIETAT.
SII Socius BOTANICUS ET STIRPIUM PICTOR EGREGIUS Nat. d. Ianuar. 1708. SCIENT. LONDINEN-

GROUND-

The extraordinary advancement of the botanical sciences

BREAKING

in the eighteenth and nineteenth centuries

WORKS

include Carolus Linnaeus' system of naming plants

ON

and the search for and publication of

BOTANICAL

new plant species in the uncharted regions

DISCOVERY

of North and South America.

Portrait of the botanical artist Georg Dionysius Ehret,
frontispiece, in Christoph J. Trew, *Plantae selectae*,
Nuremberg, 1750–1773.

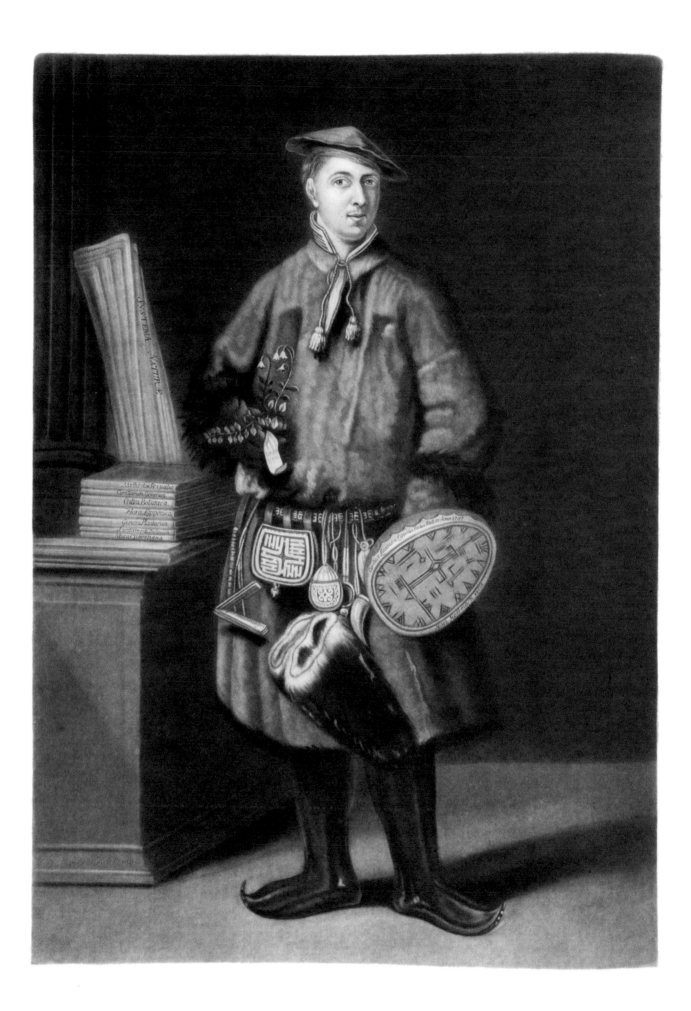

LINNAEUS
AND THE FOUNDATION OF
MODERN BOTANY

GINA DOUGLAS

Our modern systems for identifying and classifying plants have their origins in the work of the son of a country priest born in Sweden in 1707, the remarkable Carl von Linné, also known as Carolus Linnaeus (fig. 5.1). While the well-known ancient authors Theophrastus, Dioscorides, and Pliny the Elder had already described plants and their attributes in detail, they had not developed a standardized vocabulary that could be easily used for such descriptions. Scholars, especially medical doctors, needed to know the key characteristics of each particular plant to make herbal medicines, but used lengthy and complicated Latin descriptions, open to misinterpretation.[1]

Linnaeus' fascination with plants began when his father took him into the fields to name the flowers. Although he was meant to follow in his father's footsteps, Linnaeus was not much interested in his theological studies. A schoolmaster suggested that medicine might be a better course of study and agreed to coach him in the necessary subjects. This gained him a place at Lund University, where he enrolled as a student in 1727. A year later he transferred to the University of Uppsala and was fortunate to find—in addition to good lodgings—an excellent private library with Professor of Botany Olof Celsius (1670–1756), the acclaimed author of what was then the definitive text on plants of the Bible.[2] The young Linnaeus was an exceptional student in matters concerning botany and could often be found bent over the plants in the Uppsala Botanical Garden. By 1730 he had gained the post of demonstrator here, assisting Professor of Medicine Olof Rudbeck (1660–1740). It was Rudbeck who a few years later would encourage Linnaeus to explore the natural history of Lapland; an adventure which in 1737 would result in the publication of Linnaeus' *Flora Lapponica*.[3] Both Celsius and Rudbeck must have recognized the potential in their student and later, acknowledging their help in turn, Linnaeus would name a genus of flowers after them—one being the Cretan Mullein, *Celsia cretica*, the other *Rudbeckia*, commonly known as Black-eyed Susan or coneflower (fig. 5.2).

In 1735 Linnaeus traveled to Holland to complete his academic education, working

FIG. 5.1. Portrait of Carolus Linnaeus as a young explorer wearing Lapland dress and holding his signature flower, *Linnaea borealis*. Mezzotint by Robert Dunkarton after a 1737 painting by Martin Hoffman, in Robert J. Thornton, *New Illustration of the Sexual System of Carolus von Linnaeus...*, London, 1807.

there for the next three years. This was to be an important period for his development as botanist, laying the foundation for the new international cooperation between collectors and botanists that would result in rapid advances in standardizing plant descriptions and classification. Having first obtained his doctoral degree in medicine at Harderwijk, Linnaeus gained an introduction to the eminent Professor of Botany and Medicine at the University of Leiden, Dr. Herman Boerhaave (1668–1738). In the *Hortus Botanicus* of Leiden

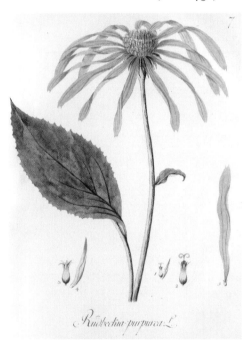

FIG. 5.2. *Rudbeckia purpurea* L., named by Linnaeus in honor of his teacher and mentor Olof Rudbeck, as illustrated in Jean S. Kerner, *Figures des plantes économiques*, Stoutgard [Stuttgart], 1786–1796, tome 1, plate 7.

(fig. 5.3), Linnaeus also met two other learned botanists, Jan Frederik Gronovius (1686–1762) and Adriaan van Royen (1704–1779). Van Royen was to be especially important in the development of a system of plant classification. Linnaeus worked with him on his *Florae Leydenensis prodromus*, a listing of the plants growing in the Leiden Botanical Garden, combined with a diagrammatic key, outlining a natural system of classification (see chapter 3).[4]

Linnaeus had arrived in Holland with several manuscripts ready for publication and Gronovius, with his friend, the Scottish doctor Isaac Lawson (d. 1747), were impressed by these, agreeing to pay for the cost of printing of *Systema naturae*, published in Leiden in 1735.[5] Linnaeus had written this work in fulfillment of his self-appointed task of classifying, in a simple and practical manner, everything God had created. The large double folio size book has only eleven pages, with the animals, vegetable, and minerals kingdoms

classified in tabular form. It could be used to assign a plant, animal, or rock to a particular category by checking on a few major features, using the schematic approach that Linnaeus had devised. Being grounded in the classics, he included a category called "Paradoxa" to list mythical creatures that might just exist somewhere as yet unexplored, as he was aware of the limitations of his knowledge. Mythical creatures feature in other contemporary publications, including the work of another of Linnaeus' benefactors in Amsterdam, Albertus Seba (1665–1736) (fig. 5.4). Later editions of *Systema naturae* would exclude mythical entities and contain much fuller and accurate information (fig. 5.5).[6]

Systema naturae of 1735 introduced one of Linnaeus' major innovations: the use of the sexual parts of the flower as the key to identifying twenty-four different major groups, or "Classes" of plants, based on the numbers and arrangement of the female ovary and male stamens. Linnaeus' Latin descriptions of the different major plant groups, shown in tabular form both in *Systema naturae* and the concurrently published *Genera plantarum* (fig. 5.6), were easy to understand and apply, but when they were translated, the explicit sexual terminology resulted in problems of acceptance outside academic circles. Though an artificial system of classification—since only a small part of the plant, the reproductive elements of the flower, was analyzed rather than the plant as a whole—it functioned well at a time when the full richness of the plant kingdom remained largely unknown and a simple identification system accelerated botanical information. Encouraged by Boerhaave, Linnaeus first outlined his concepts for naming plants in his *Fundamenta botanica* published in Amsterdam in 1736, dedicated to the outstanding botanists of the day.[7] *Fundamenta botanica* was

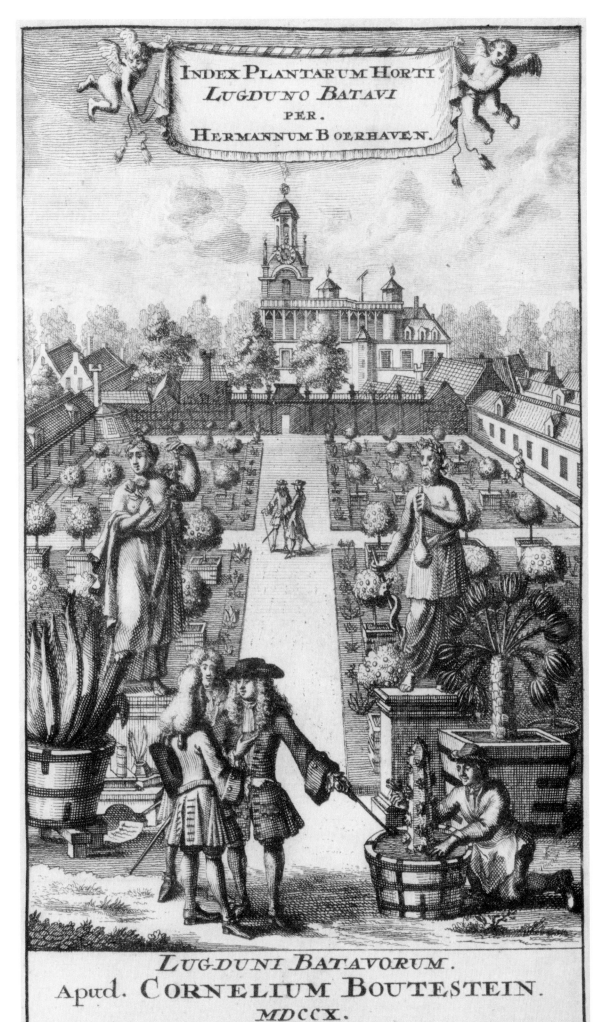

INDEX PLANTARUM HORTI
LUGDUNO BATAVI
PER.
HERMANNUM BOERHAVEN.

LUGDUNI BATAVORUM.
Apud. CORNELIUM BOUTESTEIN.
MDCCX.

LINNAEUS AND
THE FOUNDATION OF
MODERN BOTANY

FIG. 5.3. Frontispiece, in Herman Boerhaave, *Index plantarum quae in Horto Academico Lugduno Batavo reperiuntur*, Leiden, 1710. Engraving of the *Hortus Botanicus* of Leiden, visited by Linnaeus during his time in Holland.

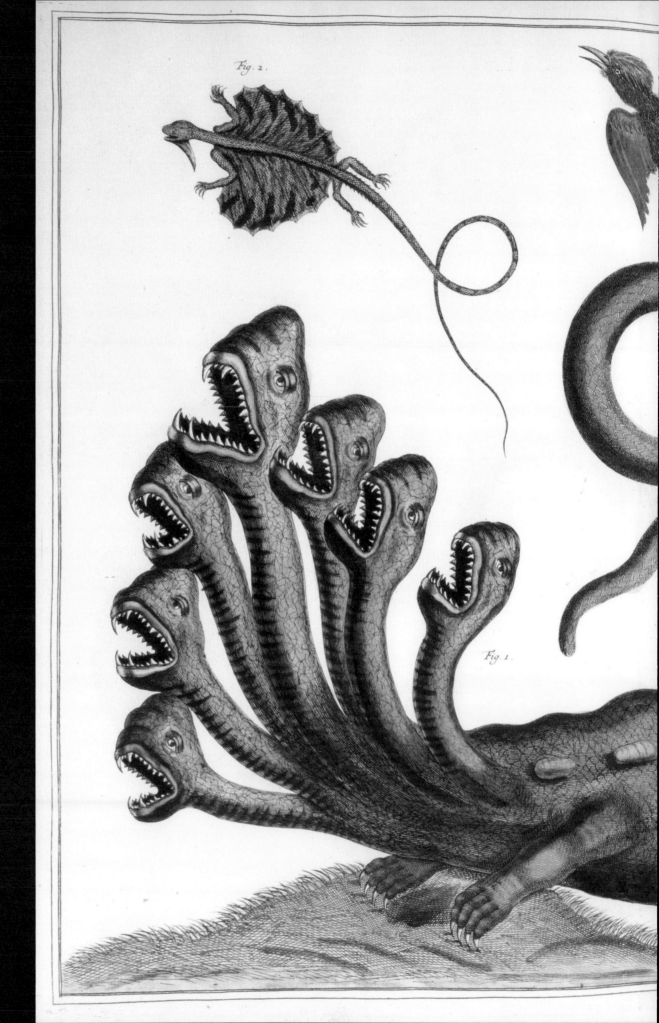

Fig. 2.

Fig. 1.

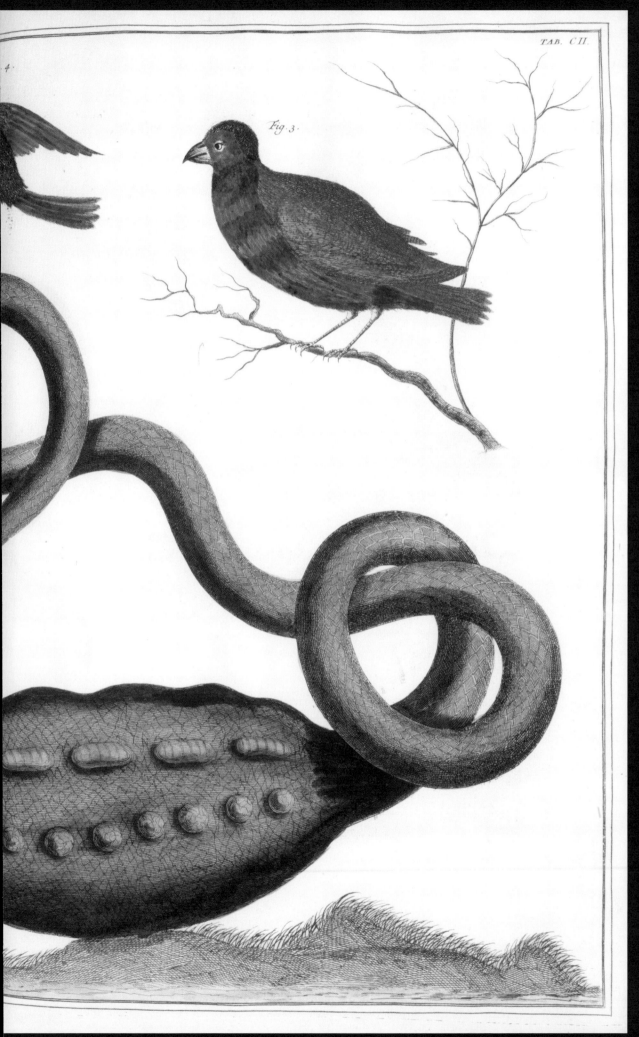

TAB. CII.

Fig. 3.

FIG. 5.4. Mythical creatures were included in the category "paradoxa" in early editions of Linnaeus' work. The seven-headed hydra is illustrated in Albertus Seba's cabinet of curiosities, *Locupletissimi rerum naturalium thesauri accurata descriptio*, Amsterdam, 1734–1765, tome 1, tab. CII.

FIG. 5.5. The 1748 edition of Linnaeus, *Systema naturae*, published in Leipzig, contains a frontispiece with portrait of Linnaeus holding one of his botanical works.

followed in quick succession by *Bibliotheca botanica* (1736),[8] *Critica botanica* (1737),[9] and finally *Genera plantarum* (1737).[10] Each of these works was groundbreaking for the discipline of botany. Together they provided an overview of botanical history, a standard procedure for botanical nomenclature, and a new classification method, laying the foundation for Linnaeus life's accomplishment, aptly described as "producing order out of chaos."[11]

Professor Boerhaave, who had warmly received Linnaeus in the Leiden *Hortus Botanicus*, gave him an introduction to the professor in charge of the Amsterdam botanical garden, Johannes Burman (1706–1779). Burman not only offered hospitality to his visitor from Sweden, but became Linnaeus' lifelong friend, correspondent and respected colleague. [12] It was with the help of Burman and Gronovius

CLAVIS CLASSIUM.

Florescentia plantarum profert flores, vel

Visibiles cuique; qui sunt vel
Hermaphroditi cum staminibus & pistillis in eodem flore, staminibus
nulla sui parte inter se connatis; quæ
proportionem longitudinis nullam accuratam inter se invicem habent, vel

1 MONANDRIA stamen unicum in flore hermaphrodito.
2 DIANDRIA stamina duo in flore hermaphrodito.
3 TRIANDRIA stamina tria in flore hermaphrodito.
4 TETRANDRIA stamina quatuor in flore hermaphrodito.
5 PENTANDRIA stamina quinque in flore hermaphrodito.
6 HEXANDRIA stamina sex æqualia, vel alterna breviora; in fl. herm.
7 HEPTANDRIA stamina septem in flore hermaphrodito.
8 OCTANDRIA stamina octo in flore hermaphrodito.
9 ENNEANDRIA stamina novem in flore hermaphrodito.
10 DECANDRIA stamina decem in flore hermaphrodito.
11 DODECANDRIA stamina duodecim in flore hermaphrodito.
12 ICOSANDRIA stamina duodecim plura, calycis parieti interno, non receptaculo, insidentia in fl. herm.
13 POLYANDRIA stamina duodecim plura, receptaculo adnata, in fl. hermaphrodito.

staminibus duobus reliquis brevioribus.
14 DIDYNAMIA stamina duo longiora.
15 TETRADYNAMIA stamina quatuor longiora.

cohærentibus vel inter se invicem aliqua sui parte, vel cum pistillo.
16 MONADELPHIA stamina filamentis in unum corpus coalita.
17 DIADELPHIA stamina filamentis in duo corpora coalita.
18 POLYADELPHIA stamina filamentis in tria vel plura corpora coalita.
19 SYNGENESIA stamina antheris in cylindrum coalita.
20 GYNANDRIA stamina pistillo, non receptaculo, insidentia.

Masculini & feminini in eadem specie.
21 MONOECIA flores masculini & feminini in eadem planta.
22 DIOECIA flores masculini & feminini in distincta planta.
23 POLYGAMIA flor. hermaphroditi & masculini vel feminini in eadem spe.

Oculis vix obvios:
24 CRYPTOGAMIA florent vel intra fructum vulgo dictum, vel parvitate oculos nostros subterfugiunt.

Ordines a feminis seu pistillis desumuntur.
MONOGYNIA, Digynia, Trigynia &c. id est, pistillum unicum, duo, tria &c.
Numerus feminarum desumitur a basi styli: si stylus autem deficiat, a numero stigmatum calculus fit.
Vide Legesdivisionis Methodi nostræ dilucide explicatas in *Systemate* nostro *Naturæ*, Lugd. Bat. 1735. impresso.

FIG. 5.6. The "Clavis Classium," or Latin description of the major plant groups shown in tabular form, first published by Linnaeus in his *Genera plantarum*, Leiden, 1737, opp. p. 1.

that Linnaeus secured employment with George Clifford (1685–1760), a wealthy banker and governor of the Dutch East India Company, with a rich collection of exotic plants growing at his estate De Hartecamp near Haarlem. For two years, from 1735 to 1737, Linnaeus became the resident physician and curator there, and persuaded Clifford's banana plant to flower and fruit, in spite of the harsh Dutch climate, writing a small book on this achievement.[13] Linnaeus also compiled a detailed catalog of Clifford's large collection of exotic plants entitled *Hortus Cliffortianus* (fig. 5.7), a key example of the connection between the botanical garden and the book (see chapter 3). The frontispiece, engraved by Jan Wandelaar (1690–1759), depicts a pedestal with a bust believed to portray Clifford. Apollo—uncovering the figure of Mother Earth and holding a torch shedding light where there was botanical darkness—symbolizes Linnaeus. The exquisitely executed plant illustrations in *Hortus Cliffortianus* were made by the German artist Georg Dionysius Ehret (1708–1770).[14] After meeting Linnaeus at De Hartecamp, Ehret published his own illustration of Linnaeus' sexual system, keeping in touch with him through letters after they had both

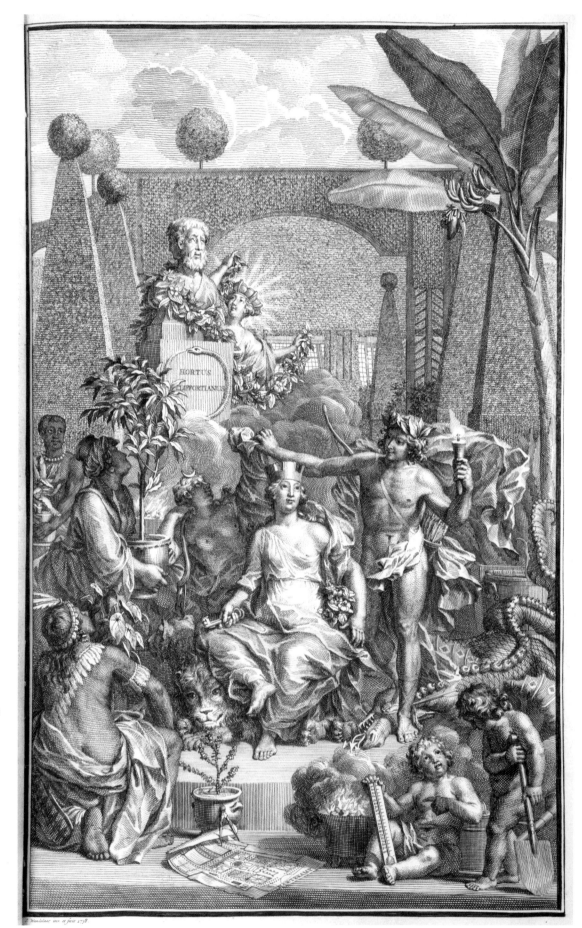

FIG. 5.7. Frontispiece, in *Hortus Cliffortianus*, Amsterdam, 1737. This allegorical scene depicts Linnaeus in the guise of Apollo, uncovering Mother Earth. His patron George Clifford can be recognized in the bust on the pedestal in the background, opposite a flowering banana tree.

left Holland. Ehret's superb skills as a botanical illustrator can be seen in his published work for the Nuremberg physician Christopher Jacob Trew. His *Plantae selectae* includes Ehret's own illustration of *Ehretia,* the plant commemorating his friendship with Linnaeus (fig. 5.8).[15]

Linnaeus traveled to England in 1736 to collect plants and seeds for Clifford. During this visit he met several important collectors and botanists, including Sir Hans Sloane (1660–1753), and the merchant and curious naturalist Peter Collinson (1694–1768). Collinson was a pivotal figure in the international botanical exchange with America, being a correspondent of both John Bartram (1699–1777) and Benjamin Franklin (1706–1790). Linnaeus also met with the naturalist John Ellis (1710–1776) and Johann Jakob Dillenius (1687–1747), Professor of Botany at Oxford University. Linnaeus greatly admired the beautiful images in Dillenius' recently published *Hortus Elthamensis* (fig. 5.9)[16] and would cite numerous descriptions of these newly discovered and illustrated plants in his own subsequent publications. Meeting other botanists and collectors and having access to books and libraries thus played an essential role in helping Linnaeus bring together all the existing knowledge of the natural world into his new classification system.

In 1738, after a brief excursion to France, Linnaeus finally returned to Sweden, to discover that while his reputation abroad was already established, thanks to dissemination of his publications, it was not so in his home country. His knowledge of medical practice applied at the Swedish court and connections with eminent politicians such as Count Carl Gustav Tessin (1695–1770) soon helped to advance his career, however, and led to his appointment as physician to the Admiralty.[17] By 1741 he had married, had a son—the only surviving son of six children— and been appointed as Professor of Botany at

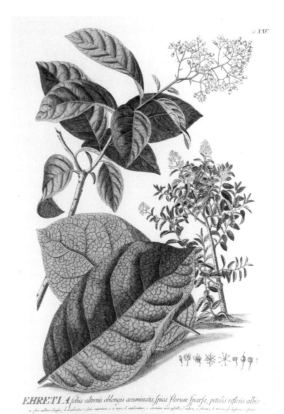

FIG. 5.8. *Ehretia*, named by Linnaeus for his friend, the supreme botanical artist Georg Dionysius Ehret, in Christoph J. Trew, *Plantae selectae*, Nuremberg, 1750–1773, tab. XXV.

LINNAEUS AND
THE FOUNDATION OF
MODERN BOTANY

FIG. 5.9. The plates in Johann Jacob Dillenius, *Hortus Elthamensis*, London, 1732, were used by Linnaeus for naming and describing plants. This work illustrates the plants in the garden at Eltham Palace, London, including this *Solanum* species, tab. CCLXXIV, p. 366.

Uppsala University, living comfortably in the house flanking the botanical garden (fig. 5.10). Linnaeus was an inspirational teacher, rapidly attracting pupils, among them Pehr Kalm (1716–1779), Pehr Osbeck (1723–1805), Daniel Solander (1733–1782) and Carl Peter Thunberg (1743–1828), all of whom would publish important botanical works and become known in their own right. The almost complete body of their work and many early editions can be studied in the Mertz Library today, including such key publications as Kalm's account of his North American travels in *Itinera priscorum Scandianorum in Americam* (fig. 5.11);[18] Osbeck's journey to China entitled

nations. One of his favorite students, Daniel Solander, traveled with Sir Joseph Banks and Captain James Cook on the legendary voyage of the *Endeavour* between 1768 and 1771. Linnaeus not only gave his students eternity by naming plants in their honor, but did so for many of his patrons and benefactors as well. Thus, he named

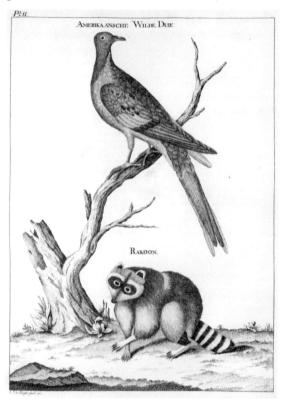

FIG. 5.11. A passenger pigeon and a raccoon described by Linnaeus' disciple Pehr Kalm in his popular *En resa til Norra America* or *Travels into North America*. First published in Stockholm in 1753, this illustration is from the Dutch edition, Utrecht, 1772, plate II.

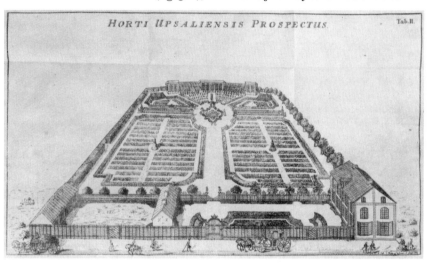

FIG. 5.10. In a rare copy of Linnaeus, *Hortus Upsaliensis/ quam...praesidio...Caroli Linnaei...*Thesis (M.D.), Uppsala, 1745, the author provides a perspective view of the Uppsala Botanical Garden with planting beds arranged according to the Linnaean system.

Dagbok öfwer en Ostindisk resa åren,[19] and many works by Thunberg. In addition to writing *Flora Japonica*[20] and *Flora Capensis*,[21] the first Floras of Japan and the Cape of Good Hope, Thunberg became professor of medicine in Uppsala, and, supervising a large number of students, kept alive the Linnaean tradition, after the death of Linnaeus in 1778.

Linnaeus recruited his favorite students as his "apostles" using them to expound his own ideas in their theses and sending them to explore the living world on his behalf.[22] They traveled as surgeons or pastors on board the Swedish merchant fleets and those of other voyaging

the American mountain laurel, *Kalmia latifolia* (fig. 5.12), after his student Pehr Kalm and the African genus *Cliffortia* after George Clifford.

In the year 1751 Linnaeus published his *Philosophia botanica* in Stockholm.[23] This work clearly demonstrates how Linnaeus first established modern botanical Latin in a standardized form, adopting a system of nomenclature in which each species of plant receives a name consisting of two terms, the

first term identifying the genus to which it belongs and the second the species itself. Much of this information was then brought together in his landmark *Species plantarum* of 1753 (fig. 5.13), considered the first modern "world Flora" and effective starting point of scientific binominal nomenclature.[24] Using his standardized binomial nomenclature *Species plantarum* displays relationships between plants and identifies no less than 5,900 different "species." In this work Linnaeus tried to name all the plants known to him, drawing together observations of living plants, dried specimens, and descriptions in books.[25] The various species are organized within 1,098 major groups or "genera" which are in turn grouped in "classes," based on the sexual parts of the flowers. The text layout helps the reader pick out the binomial names. *Species plantarum* combined not only information from Linnaeus' earlier publications, but also information taken from his students' recent studies on new plant species collected in North America and China, featuring in the travel accounts of Kalm and Osbeck.

Whenever he lacked access to living or dried specimens, Linnaeus used images already published in books to support his descriptions of new plant species. The avocado described by Linnaeus in *Species plantarum* as *Laurus persea* (now *Persea americana)* and originally published in Sir Hans Sloane's *A Voyage to the Islands of Madera...and Jamaica* (fig. 5.14),[26] is one of around hundred plants in this book for which the descriptions and accompanying illustrations serve as reference sources or "types."[27] Examples of other illustrations designated as "types," since they were later used for plant descriptions by Linnaeus, come from two important French publications, namely Louis Econches Feuillée, *Journal des observations physiques, mathématiques et botaniques* (1714–1725), [28] and Charles Plumier,

Traité des fougères de l'Amérique dating from 1705 (fig. 5.15).[29]

The usefulness of Linnaeus' new classification system and its practical application in identifying and naming newly discovered living organisms in what is aptly called the Age of Discovery, brought him worldwide academic

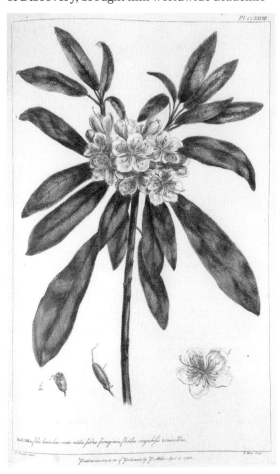

FIG. 5.12. *Kalmia latifolia*, in Philip Miller, *Figures of the Most Beautiful, Useful, and Uncommon Plants Described in The Gardeners Dictionary*, London, 1760. vol. 2, plate CCXXVIII. Pehr Kalm was commemorated by Linnaeus in the name he gave to the mountain laurel, *Kalmia*, one of the plants first described by Kalm on his travels through North America.

fame. He maintained a large international network of correspondents,[30] each eagerly awaiting the latest of his publications. These included Nikolaus Joseph Jacquin (1727–1817), working for Empress Maria Theresa in Vienna. Jacquin's work is notable for showing the early

CAROLI LINNÆI

S:æ R:giæ M:tis Sveciæ Archiatri; Medic. & Botan.
Profess. Upsal; Equitis aur. de Stella Polari;
nec non Acad. Imper. Monspel. Berol. Tolos.
Upsal. Stockh. Soc. & Paris. Coresp.

SPECIES
PLANTARUM,

EXHIBENTES

PLANTAS RITE COGNITAS,

AD

GENERA RELATAS,

CUM

Differentiis Specificis,
Nominibus Trivialibus,
Synonymis Selectis,
Locis Natalibus,
Secundum
SYSTEMA SEXUALE
DIGESTAS.

TOMUS I.

Cum Privilegio S. R. M:tis Sueciæ & S. R. M:tis Polonicæ ac Electoris Saxon.

HOLMIÆ,
Impensis LAURENTII SALVII.
1753.

STORMÄGTIGSTE ALLERNÄDIGSTE
KONUNG och DROTTNING
ADOLPH FRIDERIC,
LOVISA ULRICA,
SVERIGES GÖTHES OCH VENDES
KONUNG och DROTTNING!

FIG. 5.13 A–B. The first edition of Linnaeus' *Species plantarum*, published in Stockholm in 1753, was dedicated to King Adolph Frederik and Queen Louisa Ulrica of Sweden. This work was one of the first publications to use the binomial system for the naming of plants.

FIG. 5.14. Lacking an actual plant specimen, Linnaeus used the illustration of avocado in Sir Hans Sloane, *A Voyage to the Islands Madera...and Islands of America*, London, 1707–1725, vol. 2, tab. 222, fig. 2, as a type specimen to describe the species.

DRA MAJESTETER är jag
allerunderdånigst skyldig detta verk,
frukten af min mästa och bästa lef-
nad, det jag nu under EDRA
MAJESTETERS milda regering fått med
nögdt och roligt sinne fullborda.

Prunus racemosa, caudice non ramoso,
alato fraxini folio non crenato, fructu
rubro subdulci. *The maiden Plumb tree.*

adoption of Linnaeus' binomial nomenclature.[31] His beautifully illustrated folio book on the plants of the West Indies and South America[32] and the multivolume and magnificently illustrated publication on the flora of Austria[33] are excellent examples; they use Linnaean terminology throughout.

Johannes Gronovius' *Flora Virginica,* published between 1739 and 1743, was not only one of the earliest American Floras,[34] but also the first book that used the sexual system of

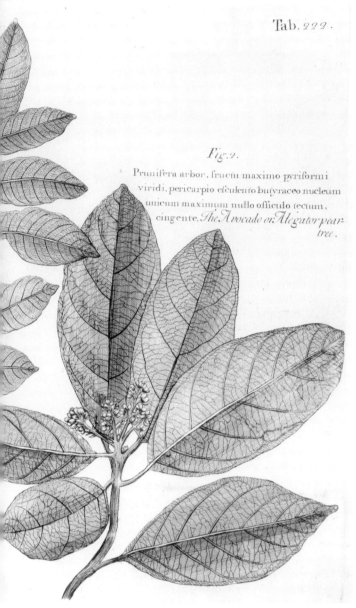

Tab. *222*.

Fig. 2.

Prunifera arbor, fructu maximo pyriformi
viridi, pericarpio esculento butyraceo nucleum
unicum maximum nullo officulo tectum,
cingente. *The Avocado or Alegator pear-
tree.*

116

Lingua Cervina scandens, cara folus minor.

Fr. C. Plumier Minimus B.R.D. se Se.

Fig 5.15. *Lingua cervina scandens*, in Charles Plumier, *Traité des fougères de l'Amérique*, Paris, 1705, tab. 116. Linnaeus used Plumier's work as a source for his own descriptions.

LINNAEUS AND
THE FOUNDATION OF
MODERN BOTANY

classification, apart from Linnaeus' own works.[35] The work was based on the plant collections of John Clayton, an early explorer of Virginia in the 1720s, after whom Linnaeus named the "miner's lettuce" *Claytonia perfolia*.[36] One of the first practicing Linnaean botanists in North America was John Bartram (1699–1777), whom Linnaeus in fact called the "greatest natural botanist in the world."[37] It was through correspondence with Bartram in Philadelphia and with Cadwallader Colden (1689–1776), Governor of New York,

that information on North American plants reached Linnaeus in Uppsala.[38] Both published accounts of natural history using the Linnaean method. Linnaeus also drew heavily on the work of the English naturalist and explorer of Virginia and Carolina, Mark Catesby (1682–1749), using many of his descriptions of American plants and animals from his *Natural History of Carolina, Florida and the Bahama Islands*.[39] A plant genus, namely the West Indies lily thorn or *Catesbaea spinosa* was chosen by Linnaeus to commemorate this remarkable explorer (fig. 5.16).[40]

It took quite some time for the Linnaean system for plant naming became fully accepted in England. Certain botanists applauded his simplified taxonomic system, others, including his own colleagues Peter Collinson and John

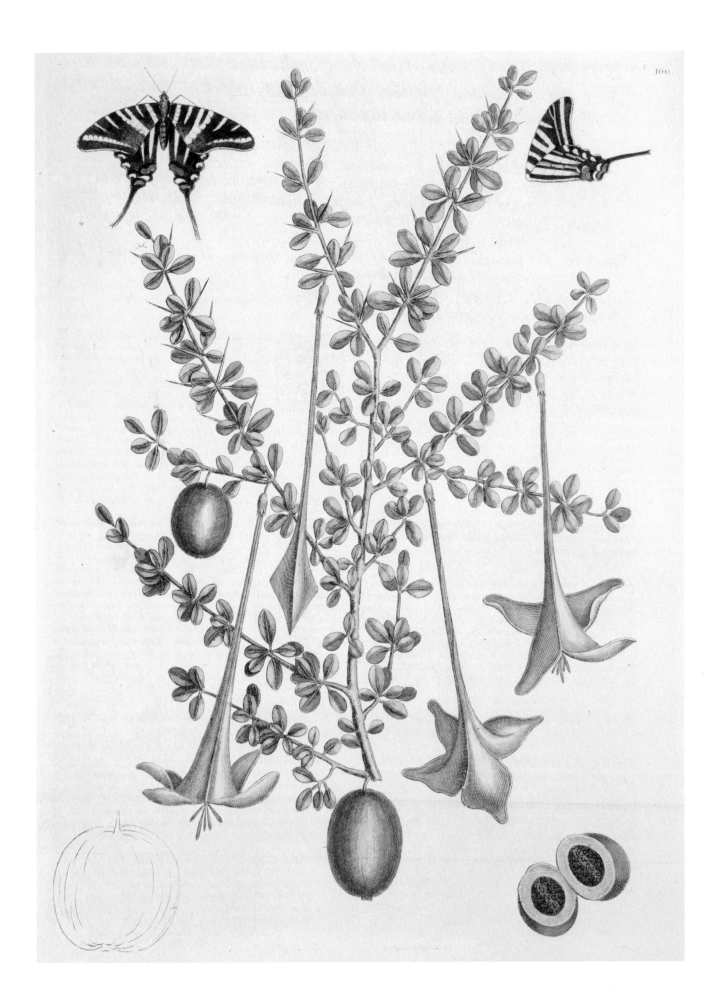

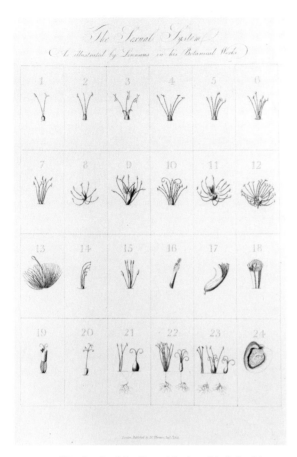

FIG. 5.17. "Synthesis of the Sexual System," in Robert J. Thornton, *New Illustration of the Sexual System of Carolus von Linnaeus...*, London, 1807, illustrates Linnaeus' system of dividing plants in classes, determined by the number of stamens in the flowers.

Ellis, complained about him changing the names of plants.[41] It was not until 1762 that William Hudson, by using binomial Latin names to identify genera and species in his *Flora Anglica*,[42] provided a format for the writing of Floras. This helped to establish widespread use of the Linnaean method in England. A generation later, Erasmus Darwin was still inspired by Linnaeus sexual system and the concept of the "loves of the plants" when writing his famous poem *The Botanic Garden* (1791).[43] In the same period, Robert John Thornton (1768–1837), a well-known English physician and botanist, published *The Temple of Flora*, a beautifully illustrated oversized folio to promote Linnaeus'

FIG. 5.16. *The Natural History of Carolina, Florida, and the Bahama Islands*, first published in London in 1731–1743 by the early explorer Mark Catesby. Linnaeus named the West Indies lily thorn or *Catesbaea spinosa*, shown in vol. 2, tab. 100, in Catesby's honor.

sexual system (fig. 5.17).[44] By contrast, John Hill (ca. 1714–1775), an apothecary and prolific writer, only hesitatingly accepted Linnaeus' ideas in his twenty-six volume self-published and self-illustrated work *The Vegetable System*.[45] Hill adopted Linnaean binomials from volume 2 onwards only, and in later volumes refused to use Linnaeus' system all together, preferring his own method of plant classification.[46] His patron was John Stuart, 3rd Earl of Bute, who had also expressed doubts about Linnaeus' sexual system and attempted to build a more natural system of classification, focusing on the detailed aspects of each plant, rather than only its flower.[47]

In mainland Europe, the erudite Swiss botanist-physician and poet, Albrecht von Haller (1709–1777), published accounts of the Swiss flora,[48] developing a classification system which was never widely used because of its complexity. Linnaeus' innovative short-hand method contrasted with Haller's intricate system that required a study in detail of the functioning of the entire plant rather than just looking at the flowers.[49] Other contemporary European botanists studied mosses, ferns and fungi, which, lacking visible flowers did not fit into Linnaeus' classification system. One of these specialists was the German botanist Johann Hedwig (1730–1799), who with his *Species muscorum frondosorum*[50] took botany into a different direction, publishing beautiful microscopic images that showed, for the first time, the cellular structure and details of the reproductive capsules of mosses.[51]

French scholars differed in their attitude to Linnaean concepts as well. Interestingly, Jean-Jacques Rousseau (1712–1778), the great Enlightenment philosopher of his time, declared that he was a pupil of Linnaeus, and published a beautiful guide to botany (fig. 5.18).[52] Professor Antoine Gouan (1733–1821) from the University of Montpellier, apart from maintaining a lively

FIG. 5.18. *Viola odorata*, in Jean Jacques Rousseau, *Lettres élémentaires sur la botanique*, Paris, 1789, vol. 2, plate XXIX. Declaring himself a student of Linnaeus, the great French philosopher published his *Lettres*, using the Linnaean system.

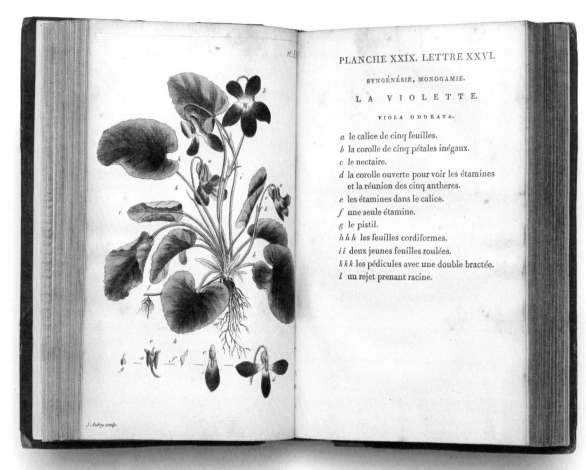

PLANCHE XXIX. LETTRE XXVI.

SYNGÉNÉSIE, MONOGAMIE.

LA VIOLETTE.

VIOLA ODORATA.

a le calice de cinq feuilles.
b la corolle de cinq pétales inégaux.
c le nectaire.
d la corolle ouverte pour voir les étamines et la réunion des cinq antheres.
e les étamines dans le calice.
f une seule étamine.
g le pistil.
h h h les feuilles cordiformes.
i i deux jeunes feuilles roulées.
k k k les pédicules avec une double bractée.
l un rejet prenant racine.

GROUNDBREAKING
WORKS ON BOTANICAL
DISCOVERIES

correspondence with Linnaeus, also used his methods. His catalog of the botanical garden of Montpellier was in fact the first French binomial publication.[53] Meanwhile, Bernard de Jussieu (1699–1777), whom Linnaeus had met on his brief visit to the *Jardin des Plantes* in Paris, continued using a pre-existing classification system first published by Joseph Pitton de Tournefort (1656–1708) in *Institutiones rei herbariae* (1700).[54] Unlike Linnaeus' system, it combined other features than only the sexual parts of the plant in an attempt to forward an all-inclusive "natural system" of classification, differentiating between trees, shrubs or herbaceous plants. The further development of such a "natural system" would have to wait till the time when the knowledge of the world's botanical realm was more widely available. Jussieu's younger protégés, Claude Richard (1754–1821) and Michel Adanson

(1727–1806), continued to use Tournefort's method and actively opposed Linnaean ideas in print. Adanson's *Familles des plantes* (1763)[55] identified fifty-eight major groups or "families" of plants and formed a precursor of a widely adopted natural system of classification that was eventually published by a younger member of the Jussieu family, Antoine-Laurent de Jussieu (1748–1836) in his *Genera plantarum* (1789).[56]

After the death of Linnaeus in 1778 and that of his son, Carl Linnaeus the Younger (1741–1783) five years later, there was no immediate successor to inherit his precious collections. Finally, it was James Edward Smith (1759–1828), then a medical student studying under the Professor John Hope (1725–1786) at Edinburgh University, who acquired all Linnaeus' biological collections, library, and manuscripts and brought them to England. Founding the Linnean

Society of London in 1788, he thus safeguarded Linnaeus' collections for posterity.[57] Smith wrote books on botany, all of them using the Linnaean system, helping to make it the methodology of choice in Britain. Among them is the elegant work *Exotic Botany*,[58] which includes some of the first published images of plants from Australia (fig. 5.19). Smith is also remembered for another important work, the rare *Flora Graeca*[59] (see fig. 3.20), which he edited and completed after the death of the original author, John Sibthorp (1758–1796).

By the middle of the nineteenth century there was sufficient worldwide knowledge of plants for the development of a more elaborate plant classification system based on the differing features of the whole plant, enabling them to be grouped into families with common elements. By this time George Bentham (1800–1884) and Joseph D. Hooker (1817–1911) in England, Stephan Endlicher (1804–1884) in Austria, John Torrey (1796–1873) and Asa Gray (1810–1888) in America, had with their worldwide contacts, developed plant classifications based on "natural systems," which, replacing Linnaeus' more rudimentary artificial system, would remain in use well into the twentieth century.[60]

Linnaeus' binomial system revolutionized the way in which knowledge of plant identities was shared and in doing so greatly advanced the discipline of botany from the early eighteenth century onward. The foundations for the science of botany lie in the three major innovations he introduced: the precise classification of plants, the binomial system of scientific naming, and the standardization of botanical terminology.[61] The last two of these innovations are still used in modern botanical naming today, indicating their timeless value. Linnaeus told us: "*Nomina si nescis, perit et cognitio rerum*,"[62] or, "If you do not know the names of things, the knowledge of them is lost, too"—a saying as true today as it was then.

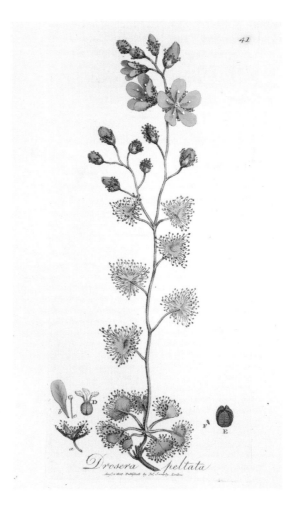

FIG. 5.19. Engraving of *Drosera peltata* or peltate sun dew, in James Edward Smith *Exotic Botany…and Scientific Descriptions*, London, 1804–1805, vol. 1, plate 41. Smith promoted the use of the Linnaean system in England, and was among the first to describe the newly discovered plants of Australia, like this insectivorous sun dew from New South Wales.

LINNAEUS AND
THE FOUNDATION OF
MODERN BOTANY

ENDNOTES

1. P. H. Oswald and C. D. Preston, *John Ray's Cambridge Catalogue (1660)* (London, 2011), 113–116. See also Josep L. Barona, "Clusius' exchange of botanical information with Spanish scholars," in *Carolus Clusius: Towards a Cultural History of a Renaissance Naturalist*, edited by Florike Egmond, Paul Hoftijzer, and Robert Visser (Amsterdam: Koninklijke Akademie van Wetenschappen, 2007), 99–116.

2. Olof Celsius, *Hierobotanicon; sive, De plantis Sacrae Scripturae…*(Upsaliae: Sumtu auctoris, 1745–1747). Olof's nephew, Anders Celsius, was responsible for the temperature scale that was reversed by Carl Linnaeus to the form still used today, with zero as freezing point.

3. Carl von Linné, *Flora Lapponica, exhibens plantas per Lapponiam crescents…*(Amstelaedami: Apud S. Schouten, 1737).

4. Adriaan van Royen, *Florae Leydensis prodromus…* (Lugduni Batavorum: Apud S. Luchtmans Academiae typographum, 1740). While van Royen refers to the sexual classification system of Linnaeus, listing it in his Preface as the fifth system, he uses his own system, which combines seed anatomy and flower

structure. The Mertz Library copy is of particular interest as it is filled with contemporary annotations by students citing Linnaeus' latest publication as "Linn h.Cliff."

5. Carl von Linné, *Caroli Linnaei...Systema naturae...*(Lugduni Batavorum: Apud Theodorum Haak, 1735). This first edition is not in the Mertz Library, but numerous other early editions, published in different countries between 1744 and 1796, are kept there.

6. When the 12th edition appeared in 1766–1768, the last edition published during Linnaeus' lifetime, *Systema naturae* had expanded from its original 11 pages to 2,300 pages, bound in three volumes.

7. Carl von Linné, *Caroli Linnaei...Fundamenta botanica...*(Amstelodami: Apud Salomonem Schouten, 1736). The Mertz Library has the 1741 augmented edition published by Salomon Schouten. The work was dedicated to Johannes Burman and Adrianus van Royen, Olof Rudbeck, Johan Jakob Dillenius and Antoine de Jussieu.

8. Carl von Linné, *Caroli Linnaei...Bibliotheca botanica...*(Amstelodami: Apud Salomonem Schouten, 1736). This work was also dedicated to Johan Burman: "Horto instructissimo Amstelodamensis."

9. Carl von Linné, *Caroli Linnaei...Critica botanica in qua nomina plantarum generica, specifica & variantia examini* (Lugduni Batavorum: Apud C. Wishoff, 1737).

10. Carl von Linné, *Caroli Linnaei...Genera plantarum...*(Lugduni Batavorum: Apud Conradum Wishoff, 1737).

11. Wilfrid Blunt, *The Compleat Naturalist, a Life of Linnaeus* (London: Frances Lincoln, 1971), 10.

12. For a complete overview of Linnaeus' letters and summaries of their content, see the *Linnaeus Correspondence website*, accessed February 9, 2013, http://www.c18.org, where all the letters are listed.

13. Carl von Linné, *Caroli Linnaei...Musa Cliffortiana florens Hartekampi...*(Lugduni Batavorum: 1736).

14. Carl von Linné, *Hortus Cliffortianus: plantas exhibens quas in hortis tam vivis quam siccis...*(Amstelaedami, 1737). This book is extremely rare. It was not published commercially and only a limited number of gift copies were printed.

15. Christopher Jacob Trew, *Plantae selectae* (Norimbergae, 1750–1773). This is one of many published works which Ehret illustrated for Trew, with rich holdings in the Mertz Library.

16. Johann Jacob Dillenius, *Hortus Elthamensis...*(Londini: Sumptibus auctoris, 1732).

17. Blunt, *Compleat Naturalist* (1971), 132–133, gives more information on Tessin and his relationship with Linnaeus.

18. All of the variant editions of this travel account are held in the Mertz Library. The best known contemporary ones are Pehr Kalm's *Itinera priscorum Scandianorum in Americam* (Aboæ: Impressit J. Merckell, 1757). His full account was published in Stockholm

in 1753–1761 as *En resa til Norra America*. An English translation by John Reinhold Forster entitled *Travels into America*, appeared ten years later.

19. Pehr Osbeck, *Dagbok öfwer en Ostindisk resa åren 1750, 1751, 1752* (Stockholm: Tryckt hos L. L. Grefing, 1757).

20. Carl Thunberg, *Flora Japonica: sistens plantas insularum Japonicarum secundum systema sexuale* (Lipsiae: In Bibliopolio I. G. Mülleriano, 1784).

21. Carl Thunberg, *Flora Capensis; sistens plantas promontorii Bonae Spei Africes* (Upsaliae: Litteris J. F. Edman, 1807–1813). The Mertz Library has rich holdings of Thunberg's works, important for the description of many new species of plants.

22. The theses of Linnaeus' pupils were published in *Amoenitates academicae, seu Dissertationes variae physicae, medicae, botanicae...*(Lugduni Batavorum, 1749). The content is regarded as part of the publications of Linnaeus and there are several editions in the Mertz Library.

23. Carl von Linné, *Caroli Linnaei...Philosophia botanica...*(Stockholmiae: Apud Godofr. Kiesewetter, 1751).

24. Carl von Linné, *Caroli Linnaei...Species plantarum...*(Holmiae: Impensis L. Salvii, 1753). The Mertz Library also holds later editions, including those published after Linnaeus' death. The facsimile of the 1753 edition, published in 1957 in two volumes by the Ray Society, has useful additional content by William T. Stearn and John L. Haller in the introduction and appendix. This edition was reissued in 2013 by the Ray Society (vols. 177 and 178), with updated supplements by Charlie E. Jarvis.

25. Charlie E. Jarvis, *Order out of Chaos: Linnaean Plant Names and Their Types* (London: Linnean Society of London in association with the Natural History Museum, 2007), 30.

26. Hans Sloane, *A Voyage to the Islands of Madera, Barbados, Nieves, S. Christopher and Jamaica...and Islands of America* (London: Printed by B. M. for the author, 1707–1725).

27. Jarvis, *Order out of Chaos*, 157.

28. Louis Feuillée, *Journal des observations physiques, mathématiques et botaniques...*(Paris, P. P. Giffart, 1714–1725).

29. Charles Plumier, *Traité des fougères de l'Amérique* (Paris: Imprimerie Royale, 1705). The Linnaean types have been identified by Charlie E. Jarvis, one of the Linnaean scholars that have unravelled the complex history behind plant names.

30. The Linnaean Correspondence website documents the exchange of letters between Linnaeus and his network of worldwide correspondents. See http://linnaeus.c18.net accessed November 29, 2012.

31. Frans A. Stafleu, *Linnaeus and the Linnaeans: The Spreading of Their Ideas in Systematic Botany, 1735–1789* (Utrecht: Oosthoek, 1971), 185.

32. Nikolaus Joseph Jacquin, *Selectarum stirpium Americanarum historia...*(Vindobonae: Ex Officina Krausiana, 1763).

33. Nikolaus Joseph Jacquin, *Florae Austriacae...*(Viennae: Typis Leopoldi Johannis Kaliwoda, 1773–1778).

34. Johannes Fredericus Gronovius, *Flora Virginica...* (Lugduni Batavorum: Apud Cornelium Haak, 1739–1743).

35. Stafleu, *Linnaeus and the Linnaeans*, 162.

36. Clayton's dried plant specimens are still held in the Natural History Museum in London. Linnaeus saw these collections, and used the species accounts in his own works. They can be seen and searched online, accessed February 07, 2013, http://www.nhm.ac.uk/research-curation/research/projects/clayton-herbarium/claytonialrg.html.

37. Edward Duyker, *Nature's Argonaut. Daniel Solander 1733–1782* (Melbourne: Miegunyah Press, 1988), 66.

38. Cadwallader Colden, *Plantae Coldenghamiae in provincia Noveboracensi Americes...*(Stockholmiae: s.n., 1749–1751).

39. Mark, Catesby, *The Natural History of Carolina, Florida, and the Bahama Islands...*(London: Printed at the expense of the author, 1731–1743).

40. Ibid., vol. 2, tab. 100.

41. William T. Stearn, *Three Prefaces on Linnaeus and Robert Brown* (Weinheim: J. Cramer, 1962), III, p. ii.

42. William Hudson, *Flora Anglica, exhibens plantas per Regnum Angliae sponte crescentes...*(Londini, Impensis auctoris, 1762). See also Stafleu, *Linnaeus and the Linnaeans*, 109–110.

43. Erasmus Darwin, *The Botanic Garden; A Poem, in Two Parts* (London: Printed for J. Johnson, 1791).

44. Robert John Thornton, *New Illustration of the Sexual System of Carolus von Linnaeus...and the Temple of Flora, or Garden of Nature* (London: T. Bensley, 1807).

45. John Hill, *The Vegetable System...*(London: Printed at the Expense of the Author, 1761–1775). See also Charlie E. Jarvis, "A Supplement to the Introduction by William Stearn," in *Carl Linnaeus, Species Plantarum, A Facsimile of the First Edition of 1753* (London: The Ray Society, 2013), S1.10–S.1.11.

46. Stafleu, *Linnaeus and the Linnaeans*, 210.

47. See Maureen H. Lazarus and Heather S. Pardoe, "Bute's Botanical Tables: Dictated by Nature" in *Archives of Natural History* 36, part 2 (2009), 277–298.

48. Albert von Haller, *Historia stirpium indigenarum Helvetiae inchoata* (Bernæ: Sumptibus Societatis typographicae, 1768).

49. Stafleu, *Linnaeus and the Linnaeans*, 246.

50. Johannes Hedwig, *Joannis Hedwig...species muscorum frondosorum...*(Parisiis: A. Koenig, 1801).

51. Johannes Hedwig, *Fundamentum historiae naturalis...* (Lipsiae: Apud S.I. Crucium, 1782).

52. Jean-Jacques Rousseau, *Lettres élémentaires sur la botanique* (Paris: Poinçot, 1789). See also the recently published work by Alexandra Cook, *Jean-Jacques Rousseau and Botany: the Salutary Science* (Oxford: Voltaire Foundation, 2012).

53. Antoine Gouan, *Hortus Regius Monspeliensis...* (Lugduni: Sumptibus fratrum de Tournes, 1762). See also Stafleu, *Linnaeus and the Linnaeans*, 110.

54. Joseph Pitton de Tournefort, *Tournefort Josephi Pitton aquisextiensis...Institutiones rei herbariae* (Parisiis: E Typographia Regia, 1719).

55. Michel Adanson, *Familles des plantes* (Paris: Vincent, 1763).

56. Antoine-Laurent de Jussieu, *Genera plantarum secundum ordines naturals disposita...*(Parisiis: Apud Viduam Herissant et Theophilum Barrois, 1789).

57. This organization curates the unique resource of the Linnaean Collections, much of which is now available through web-based resources, see for the Linnaean Collections online, accessed February 10, 2013: http://www.linnean.org/specimen-collections.

58. James Edward Smith, *Exotic Botany...*(London: Printed by R, Taylor, 1804–1805).

59. John Sibthorp, *Flora Graeca: sive, Plantarum rariorum historia, quas in provinciis aut insulis Graeciae legit...* (Londini: Typis Richardi Taylor, 1806–1840).

60. Various editions of the works of George Bentham & Joseph D. Hooker, *Genera plantarum ad exemplaria imprimum in herbariis Kewensibus septata definata* (Londini: Reeve, Williams & Norgate, 1862–1883), and that of Stephan L. Endlicher, *Genera plantarum secunda ordines naturales disposita* (Vienna: Apud Fridericum Beck, 1836–1841), provided the guidelines on classification which were used in most of the major floras, as well as the arranging of Herbaria collections until the early twentieth century. In America, John Lindley's work highlighted the use of the natural system, including his *An Introduction to the Natural System of Botany and Rural or Domestic Economy* (New York: G. & C. & H. Carvill, 1831), with an appendix by John Torrey: *Catalogue of North American Genera of Plants: Arranged According to the Orders of Lindley's Introduction to the Natural System of Botany* (New York: Sleight & Robinson, 1831).

61. Jarvis, *Order out of Chaos*, 1. Although the sexual system for plant classification has now been superseded by both natural and molecular systems, the continuity of the binomial system and the standardized methodology introduced by Linnaeus have facilitated exchange of information about the natural world, and still support biodiversity studies today.

62. Linnaeus, *Philosophia botanica* (1751), 158, under VII, Nomina.

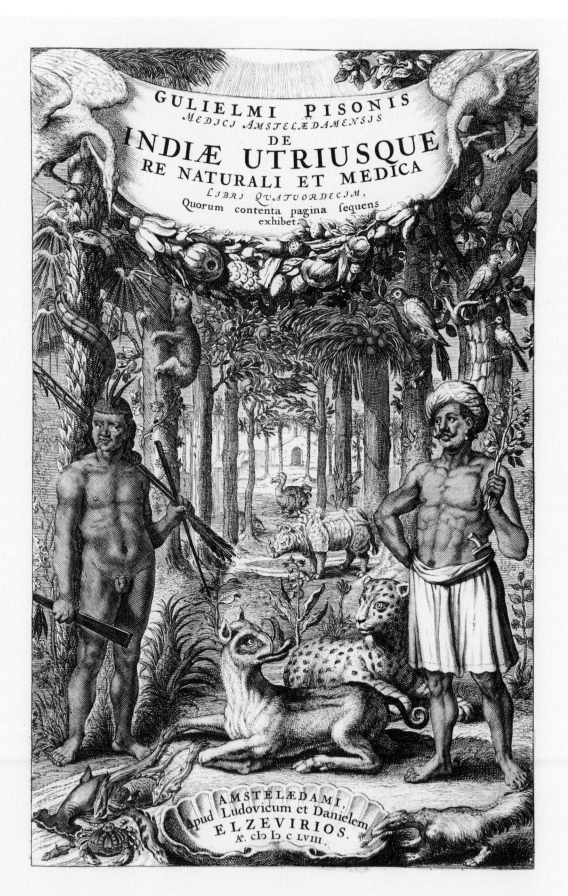

GULIELMI PISONIS
MEDICI AMSTELÆDAMENSIS
DE
INDIÆ UTRIUSQUE
RE NATURALI ET MEDICA
LIBRI QUATUORDECIM,
Quorum contenta pagina sequens
exhibet.

AMSTELÆDAMI,
Apud Ludovicum et Danielem
ELZEVIRIOS.
Aº. cɔ Iɔ c LVIII.

NEW WORLD EXPLORATIONS:
BRAZIL

H. WALTER LACK

The LuEsther T. Mertz Library houses a particularly rich collection of printed materials on the flora of South America starting from early reports in the sixteenth century to the present day. This chapter focuses on illustrated works on the vascular flora of Brazil published before 1906, the year *Flora Brasiliensis*,[1] the first Flora of this vast country, was finally completed. However, this contribution is selective and of course restricted to those works present in the Mertz Library. At the same time it highlights illustrations relevant to modern taxonomic research with an emphasis on those appearing in independently published works, setting the botanical exploration of Brazil into a broader context.

From a Western perspective the modern era began with the discovery of the Americas in 1492. Only two years later the Treaty of Tordesillas would divide the newly discovered lands in America, Africa, and Asia between the Crown of Portugal and the Crown of Castile (Spain) along a meridian 370 leagues west of the Cape Verde Islands. The lands to the east of this line would belong to Portugal and the lands to the west to Spain. The consequences of the agreement were far-reaching: for the next four centuries rivalry would reign between these two global colonial powers and both countries would become the principal gates of entry for all newly discovered goods from the overseas territories, including plants and animals. The subsequent decline of the Portuguese and Spanish political-economic strength made this territorial divide of the world obsolete, but it did hold sway in continental South America. Here the Treaty of Tordesillas was repeatedly modified resulting in an updated boundary between the two colonial empires largely coinciding with the border lines of modern Brazil; a country that not only occupies close to half the surface of South America, but is the fifth largest country on Earth.

Both Christopher Columbus and Pedro Álvares Cabral reportedly brought plant material home to Spain and Portugal, respectively. Columbus' botanical trophies were cobs of maize (*Zea mays*) and Cabral's specimens of brazilwood (*Caesalpinia echinata*). A map of Brazil showing the harvesting of this tree used for tanning and the preparation of red dye was made as early as 1518.[2] Brazilwood could not be cultivated in Europe, but maize became quickly established in the Old World. This initiated the (in)famous Columbian Exchange,

FIG. 6.1. Title page of the first printed work on the natural history of Brazil, including an extensive account of plant diversity in this country, from G. Piso, *De medicina Brasiliensi libri qvatvor...et Georgii Marcgravii de Liebstad Historiae rervm natvralivm Brasiliae libri octo*, Lvgdvn. Batavorvm [Leiden], 1648.

[133]

or Grand Exchange, the large-scale transfer of plants, animals, microorganisms and genes from the New to the Old World and vice versa that had enormous long-term consequences.

SPAIN VERSUS PORTUGAL IN SOUTH AMERICA

Spanish and Portuguese authorities were unwilling to share knowledge of their overseas possessions with other countries and restricted access to them to nationals from the home countries. As a result, information on plant life in their vast colonial empires would remain fragmentary at best, often confined to manuscripts kept in Spain and Portugal. In addition, there was often a considerable lapse of time between first report and first illustration available. Michele de Cuneo, one of Columbus' companions on the second voyage undertaken in 1493-1494, gave the first report of the pineapple (*Ananas sativus*), but the first illustration is found in a manuscript attributed to Gonzalo Fernández de Oviedo y Valdés and dated 1539-1546.[3] The same applies to the earliest illustrations of New World plants prepared on the basis of living specimens cultivated in Europe: they exist in manuscript form, among them illustrations of a pumpkin (*Cucurbita pepo*)[4] and of a flowering and fruiting maize plant.[5] Significantly older representations of maize cobs and pumpkins are located in the Loggia of Psyche in the Villa Farnesina in Rome, dated 1515-1517.[6]

Overall, Spain showed a slightly more liberal attitude towards foreign researchers and several non-Spanish naturalists were allowed to visit the Spanish colonies during the second half of the eighteenth century. Among them were three Vienna based botanists Nikolaus Joseph Jacquin (1727-1817),[7] Franz Boos (1753-1832),[8] Thaddaeus Haenke (1761-1816),[9] and Joseph Dombey (1742-1794) from France.[10] Also allowed

<div style="margin-left: 2em; font-variant: small-caps;">GROUNDBREAKING
WORKS ON BOTANICAL
DISCOVERIES</div>

FIG. 6.2. First printed illustration of genipa (*Genipa americana* L.). Anonymous woodcut based on A. Eckhout, p. 92 in G. Piso, *De medicina Brasiliensi libri qvatvor...et Georgii Marcgravii de Liebstad Historiae rervm natvralivm Brasiliae, libri octo*, Lvgdvn. Batavorvm [Leiden], 1648.

to enter were Alexander von Humboldt (1769-1859),[11] born in Berlin and based in Paris, and his companion explorer Aimé Bonpland (1773-1858). By contrast, non-Portuguese naturalists, among them Humboldt,[12] were not given permission to visit the Portuguese colony of Brazil. Portugal and Spain also differed when it comes to botany and publishing botanical explorations. Several important botanical expeditions were undertaken under the auspices of the Spanish Crown, but only a single one under the auspices of the Portuguese Crown. And whereas at least a start was made in the late eighteenth century in publishing the botanical results of one of the Spanish expeditions, this was not the case for the Portuguese expedition.

The proper botanical exploration of Brazil started during what could be called the Dutch interval, the period when the Dutch West India Company possessed extensive lands on the eastern coast of Brazil effectively forming a Dutch colony with Mauritsstad (now Recife) as its capital. The astronomer-naturalist Georg Marcgrave (1610–1644) collected important information on the natural history of this area, which was later published in Holland in two sumptuous works.[13] The first of these, entitled *De medicina Brasiliensi libri qvatvor…et Georgii Marcgravii de Liebstad Historiae rerum naturalium Brasiliae*, printed posthumously in Leiden in 1648 with Willem Piso as its author, has an iconic title page (fig. 6.1), giving an impression of the rich diversity of the flora and fauna of this part of the world. Furthermore, it contains the first plant illustrations from Brazil drawn from life with accurate descriptions. Among them was a wood-cut showing the genipa (*Genipa americana* L.) (fig. 6.2), based on a drawing by Albert Eckhout (ca. 1610–1665).[14] The second work, Piso's *De Indiae utriusque re naturali et medicina libri qvatvordecim*, printed in Amsterdam in 1658, effectively an enlarged edition of the first, comprises several more illustrations of native Brazilian plants. For more than a century these representations were the only printed images of the Brazilian plants true to nature. As such they were the only reliable source for Carl von Linné or Carolus Linnaeus (1707–1778) to base scientific names on, which he did when writing his *Species plantarum* published in 1753.

While none of the famous circumnavigations of the eighteenth century had a specific botanical focus, important botanical observations were nonetheless made during the landfalls. Specimens were gathered, studied, described, but only few were also published. Of the botanical novelties thus discovered, a climbing plant found in the vicinity of Rio de Janeiro was the most spectacular plant of all: the bougainvillea (*Bougainvillea spectabilis*).[15] Nowadays almost omnipresent in subtropical gardens, it was collected in 1767 by Philibert Commerson (1727–1773) and Jeanne Barret (1740–1807), two members of the first French circumnavigation on the *Étoile* and the *Boudeuse*, headed by Louis-Antoine de Bougainville. A year later this species was recorded in a watercolor by Sydney Parkinson (1745–1771),[16] member of the British circumnavigation on the *Endeavour*, headed by Lieutenant James Cook. The watercolor ended up in the collection of Sir Joseph Banks in London and would form the basis for the impressive engraving in *Banks' Florilegium*, published only in 1984, more than two centuries later (fig. 6.3). The herbarium specimens from the French circumnavigation were subsequently entrusted to Antoine Laurent de Jussieu (1748–1836) in Paris; one of them would form the basis of a copper engraving that was first published in 1791 in Jean-Baptiste de Lamarck's *Tableau encyclopédique et méthodique des trois règnes de la nature* (fig. 6.4).

When the first Russian circumnavigation headed by Adam Johann [Iwan Fjodorowitsch] Baron von Krusenstern[17] on the *Nadesha* and *Newa* and the second Russian circumnavigation headed by Otto [Otto Ewstawewitsch] von Kotzebue on the *Rurik* stopped on the Brazilian coast in 1803–1804 and 1815 respectively, significant botanical material was gathered.

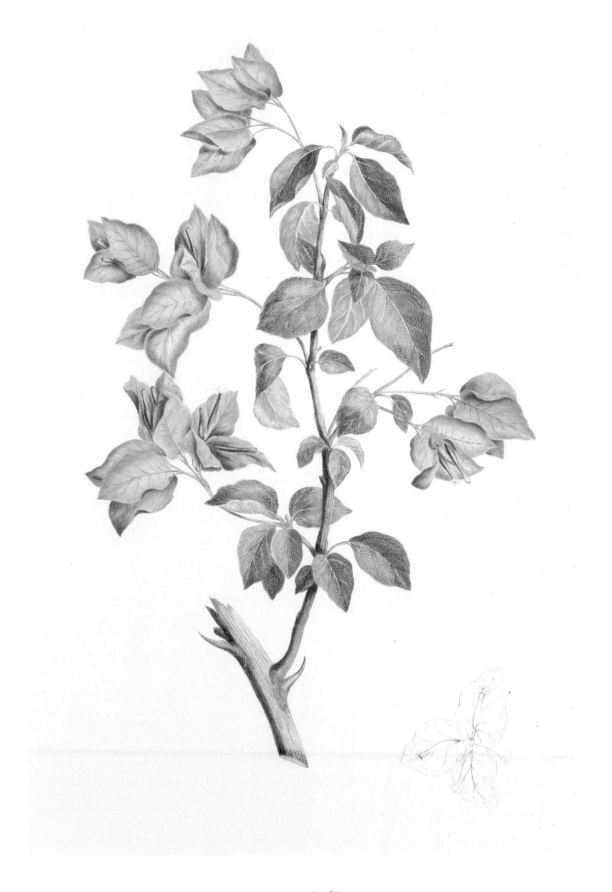

FIG. 6.3. Bougainvillea (*Bougainvillea spectabilis* Willd.), published more than two centuries after the drawing was prepared by S. Parkinson in Brazil. Color copper engraving based on S. Parkinson, tab. 355 in *Banks' Florilegium*, London, 1984. Copyright permission kindly granted by Alecto Historical Editions and The Trustees of the Natural History Museum, London.

Of the collections from the first voyage only the ferns, all from Isla de Santa Catarina (now called Florianópolis), were described and published under the title *Plantes receuillies pendant le voyage des russes autour du monde* in Tübingen in 1810, with Georg Heinrich [Grigori Iwanowitsch] Baron von Langsdorff (1774–1852) and Friedrich Ernst [Fjodor Bogdanowitsch] von Fischer (1782–1854) as co-authors.

PORTUGUESE, COLONIALS, AND CONSULS

Portugal was rightly considered one of Europe's unenlightened backwaters in the eighteenth century. Meanwhile the scientific study of plant life in Portugal and its Brazilian colony started only with Domenico Agostino Vandelli (1735–1818) from Padua, Professor of Natural History and Chemistry at Coimbra University, as well as co-founder of the botanical garden of that city. Vandelli's slim volume *Florae lusitanicae et Brasiliensis specimen* published in 1788 can be regarded as a late start. It lists a few hitherto unknown plants, describing and illustrating several new species from Brazil, such as the genus *Vellozia*, a shrub named after José Mariano da Conceição Velloso (1742–1811), a colonial and Franciscan friar, later based in Lisbon. His *Flora fluminensis* was the first work covering the complete vascular flora of a single, albeit small province of Brazil and was accompanied by an impressive series of lithographs. Complete sets of this Flora, including the one kept in the Mertz Library, contain a bibliography curiosity, namely two entirely different dedications, caused by the book's production delays: the first is to Maria I, in 1790 Queen Regnant of Portugal, the second to her grandson Pedro I (fig. 6.5), in 1831 Emperor of Brazil. Distribution of the first part of the text took place in 1829, its 1,640 illustrations were printed in Paris and distributed in 1831; the last part of the text appeared as late as 1881.[18]

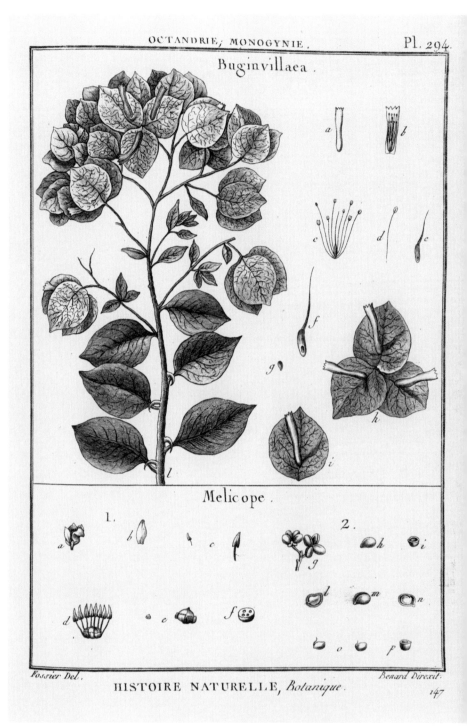

FIG. 6.4. First printed illustration of bougainvillea (*Bougainvillea spectabilis* Willd.) based on a specimen from the first circumnavigating expedition flying French colors, the generic name dedicated to its leader Louis-Antoine de Bougainville. Upper part of copper engraving based on Fossier, tab. 294 in J. B. P. A. de Monet de Lamarck, *Tableau encyclopédique et méthodique botanique*, vol. 2, Paris, 1792.

PETRO

NOMINE AC IMPERIO PRIMO

BRASILIENSIS IMPERII

PERPETUO DEFENSORE, IMO FUNDATORE,

SCIENTIARUM, ARTIUM, LITTERARUMQUE

PATRONO ET CULTORE

JUBENTE,

FLORA FLUMINENSIS

A' Fr. JOSEPHO MARIANO A CONCEPTIONE VELLOZO,

Ordinis Minorum

COLLECTA, DESCRIPTA, ET ELABORATA

ANNO M. D.CC. XC.

EX M. S. COD. IMPERIALIS BIBLIOTHECÆ ERUTA

NUNC PRIMO

EDITUR

FLUMINE JANUARIO.

A. D. M. DCCC. XXV.

IMPERII IV.

99614

FIG. 6.5. Dedication sheet, in *Flora fluminensis*, the first Flora covering a province of Brazil. J. M. da C. Velloso, *Florae fluminensis, seu descriptionum plantarum praefectura fluminensi sponte nascentium*, vol. 1, Rio de Janeiro, 1829.

During the early decades of the nineteenth century a few doctoral theses dealing with plant life in the colony of Brazil were submitted to Northern European universities, among which a small volume entitled *Plantarum Brasilium decas tertia* published in Uppsala in 1821. It had been defended with Carl Peter Thunberg in the chair and contained a colored engraving of the bromeliad *Billbergia amoena* (fig. 6.6). The plant had been collected by Laurin Westin, Swedish Consul in Rio de Janeiro and at that time a colleague of Langsdorff (see above), then the Russian Consul. Extensive plant material was collected by the latter and sent to the Imperial Botanical Garden in Saint Petersburg during his tenure, but did not result in an actual illustrated publication. In short, by 1820 only a tiny fraction of the extremely diverse vascular flora of Brazil had been collected, named, and published, largely coming from the vicinity of the Portuguese settlements on the coast.

A MARRIAGE WITH MANY CONSEQUENCES

This dearth of botanical information began to change radically with the marriage in 1817 of Pedro, Crown Prince of Portugal, and Leopoldine, Archduchess of Austria. "Leopoldine will ascend to one of the highest thrones in the world; then she may well botanize and collect minerals," was the enthusiastic comment of one of her uncles, Archduke Ludwig. Both the bride and her father, Franz I, Emperor of Austria, were well known for their interest in natural sciences and botany, with the latter spending considerable sums on his gardens and conservatories, documented in watercolors.[19] It is therefore hardly surprising that Franz I arranged for a large party of naturalists, gardeners, draughtsmen, and assistants to accompany his daughter to Rio de Janeiro to investigate both plant and animal life, as well as the mineralogical riches of the Portuguese colony. Via diplomatic channels all

collections were to be sent back to further enrich the Emperor's cabinets in Vienna, as well as the conservatories and menagerie in Schönbrunn, the summer residence of the Habsburg family.

The high profile of the Austrian Expedition to Brazil is evident from the fact that there were neither restrictions on the duration, nor the budget of the project.[20] Clemens Prince Metternich, Minister of State in Vienna, was entrusted with the supervision; Karl Ritter von Schreibers, Director of the combined Imperial Royal Natural History Cabinets in Vienna, with the organization of the undertaking. The long list of participants for the expedition included the naturalists Johann Emanuel Pohl (1782–1834), Johann Christan Mikan (1769–1844), Johann Natterer (1787–1843), and Heinrich Wilhelm Schott (1794–1865), all from the Austrian Empire. Three naturalists joined the team from Bavaria and Tuscany, Carl Friedrich Philipp von Martius (1794–1868), Johann Baptist Spix (1781–1826), and Giuseppe Raddi (1770–1829). This expedition was unique in that it enjoyed the full support from the Portuguese court and from the Austrian diplomatic mission, both based in Rio. At the same time the expedition was highly adventurous with participants travelling either together or independently, trying various routes to penetrate deep into virgin country. Several travelogues were published: by Martius with Spix as co-author, and by Pohl, by Mikan and by Schott, all together enabling a detailed reconstruction of the different exploration routes. Schreibers arranged for the printing of the official reports. Large quantities of collections arrived in Munich, Florence, and, notably, Vienna, where a Brazilian museum was founded in the center of the city. The publication of the botanical findings now started promptly, and was undertaken mostly in grand style, albeit in limited editions and in a rather uncoordinated way.

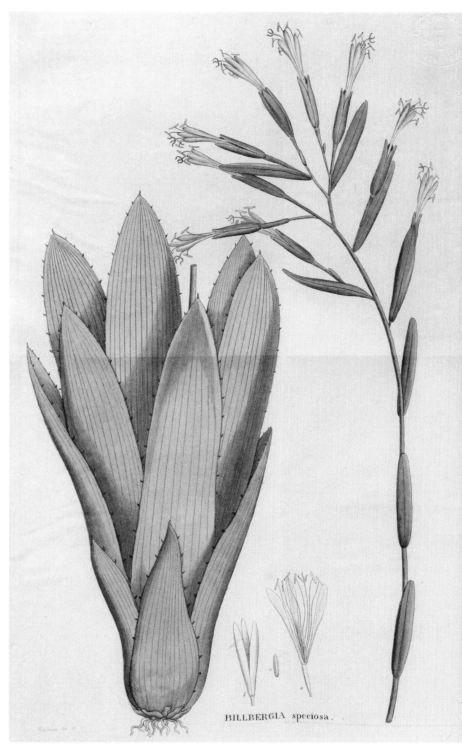

BILLBERGIA speciosa.

FIG. 6.6. First printed illustration of the bromeliad *Billbergia amoena* (Lodd. et al.) Lindl., the generic name dedicated to Gustaf Johan Billberg, naturalist in Stockholm. Colored copper engraving based on Sickman, tab. 1 in C. P. Thunberg, *Plantarum Brasiliensium decas tertia*, Upsaliae [Uppsala], 1821.

The first of these richly illustrated works to appear—reporting the botanical and zoological findings of the Austrian expedition to Brazil—was Mikan's *Delectus florae et faunae Brasiliensis*, published 1820–25 in Vienna. It contained among its lithographs an elegant rendering of a newly discovered plant, i.e., *Metternichia principis*, named in honor of the expedition's supervisor (fig. 6.7). Pohl's work *Plantarum Brasiliae icones*, published in Vienna a few years later,[21] is also full of eponyms: some plants are named after Franz I, his fourth wife Karolina Augusta, the Archdukes Ferdinand and Anton Victor. Sadly, having return to Vienna in ill health, Pohl died before his travelogue and

his *Plantarum Brasiliae icones* were completed. Remarkably, of the ninety-eight copies indicated in the list of subscribers accompanying this work, no less than twenty-seven were to go to members of European reigning families, and of these seventeen to the Habsburgs alone. Instead of publishing his findings in a book, Raddi decided to disseminate his findings in several scientific journals, which tended to be of limited circulation and contained illustrations of lesser quality. A copper engraving of the grass *Arundinella hispida* was included in

FIG. 6.7. First printed illustration of *Metternichia princeps* Mik., the generic name dedicated to Clemens Prince Metternich, Minister of State in Vienna. Lithograph based on anonymous drawing, unnumbered plate [tab. 13] in J. C. Mikan, *Delectus florae et faunae Brasiliensis*, Vindobonae, 1823.

FIG. 6.8. Illustration of the grass *Arundinella hispida* (Willd.) Kuntze. Copper engraving based on G. Nerici, tab.1, fig. 3 in G. Raddi, *Agrostografia Brasiliensis* published in *Atti de la Reale Accademia Lucchese di Scienze, Lettere ed Arti* 3: 331–383, Lucca,1823.

his "Agrostografia Brasiliensis," published in *Atti della Reale Accademia Lucchese di Scienze, Lettere ed Arti* (fig. 6.8). Finally, Schott collaborated with Stephan Endlicher (1804–1849), Professor of Botany at Vienna University, Director of the Botanical Garden and Head of the Imperial Royal Botanical Cabinet. Together they made some of their findings known in a slim volume of limited circulation entitled *Meletemata botanica*, published in Vienna in 1832. It included the description and illustration of a holoparasitic flowering plant from Brazil then incompletely understood, which they named *Lophophytum mirabile* (fig. 6.9).

Lophophytum mirabile

FIG. 6.9. First printed illustration of the holoparasitic *Lophophytum mirabile* Schott & Endl. Lithograph based on Zehner, tab. 1 in H. Schott, & S. Endlicher, *Meletemata botanica*, Vindobonae [Vienna], 1832.

CARL FRIEDRICH PHILIPP VON MARTIUS

Martius, the youngest naturalist of the expedition, on returning home to Munich was received in grand style and decorated by King Maximilian I Joseph. He was appointed second curator of the Royal Botanical Garden in the Bavarian Capital and elected full member of the Royal Bavarian Academy of Sciences. His career soon surged and in time he would become Professor of Botany at Munich University and Director of the Royal Botanical Garden. This meant that for the rest of his life Martius would have the luxury to concentrate on analyzing and working out details of the botanical exploration he had just undertaken, an advantage that would result in numerous copiously illustrated publications. Martius is probably best known for his *Historia naturalis palmarum*, dedicated to a single plant family that seems to have impressed him most: the palms.[22] This impressive folio publication appeared in installments and upon subscription. With a weight of around 60 pounds (28 kilos) and a book block measuring 23.5 × 17 inches (60 × 43 cm), it is an outstanding work of science and art combined. The second volume, appearing between 1823 and 1837 in Munich, contains descriptions and illustrations of palms from Brazil, among them *Leopoldina pulchra* (fig. 6.10), a genus dedicated to Archduchess Leopoldine. Again, the list of subscribers is most impressive, showing Martius' widespread connections with representatives of the European reigning houses of this period. Among them were Alexander I, Tsar of Russia; Willem III, King of the Netherlands; Friedrich Wilhelm III, King of Prussia; and Friedrich I August, King of Saxony. *Historia naturalis palmarum* became a much sought after work. This was partly due to the attractive manner in which the palm trees were portrayed, namely placed against the setting of a Brazilian landscape. It did not seem to matter that these landscapes were

added later in the Munich studio to enhance the palm studies themselves, carefully prepared after nature by Martius while in Brazil. Be that as it may, the famous author Johann Wolfgang von Goethe (1749–1832) evidently enjoyed this approach writing in his review: "in addition, abundantly detailed foregrounds acquaint the viewer more closely with the country's other plants and extreme luxuriant vegetation…it should also be added that the painterly eye and taste with which Mr von Martius combines the objects into an overall landscape merits the admiration of all those who look upon and judge the work from an artistic point of view."[23]

Martius was a great admirer of Alexander von Humboldt and the publications on plant material collected by Humboldt and Bonpland during their exploration of the Spanish colonies in the Americas. Among these works was the remarkable *Nova genera et species plantarum*, written by Carl Sigismund Kunth, published in Paris between 1816 and 1825 in seven large, sumptuously illustrated tomes, containing a total of seven hundred copper-engravings. Martius decided to imitate this grand model and also to copy its title when making his Brazilian collections known to the scientific community. His work comprised three folio-sized volumes with three hundred carefully executed lithographs. It included an impressive rendering of the newly discovered species *Clusia comans* (fig. 6.11).

BRAZIL OPENING UP

The arrival in Rio de Janeiro in 1807 of the royal family accompanied by members of the court, aristocracy, government and clergy, soon ended the exclusive relations of the colony with the Portuguese motherland. Harbors were opened to foreign nations and in 1815 the United Kingdom of Portugal, Brazil, and the Algarves was created. The declaration of independence of Brazil in 1822 led to an unprecedented influx of naturalists from many countries of Europe exploring the still largely unknown state and collecting plant material. Brazil had become fashionable and people from all strata of society made use of the new possibilities it offered. One of the first was Augustin de Saint-Hilaire (1779–1853), a French gentleman of private means, who had arrived in Brazil even before the Austrian expedition. Upon his return to France he produced several illustrated works, including *Florae Brasiliae meridionalis* published in Paris between 1824–1833, with a total of 192 lithographs, showing among others the recently discovered *Lafoensia nummularifolia* (fig. 6.12).

The list of naturalists from Central Europe is long and diverse–ranging from Maximilian Prince zu Wied-Neuwied (1782–1867)—a well-known botanical explorer and ethnographer known also for his subsequent expeditions through the American West—to Friedrich Sellow (1789–1831), a collector mainly active for institutions in the Kingdom of Prussia. On his return trip from Peru, the naturalist Eduard Friedrich Poeppig (1798–1868) passed through Brazil. Back in Leipzig, he published his botanical findings in another book entitled *Nova genera et species plantarum*,[24] a work done in collaboration with Endlicher; one of Poeppig's trophies was *Mendoncia multiflora* (fig. 6.13) illustrated in a lithograph on the basis of his drawing now in the Natural History Museum in Vienna.[25]

Meanwhile, up north in Denmark, Eugen Warming (1841–1924), Professor of Botany at Copenhagen University, followed another approach to publishing the results of his travels to Brazil. They appeared in the years 1867 to 1894 in a long list of papers printed in the journal *Videnskabelige Meddelelser fra den Naturhistoriske Forening i Kjøbnhavn*. They contain a series of lithographs, which portray several plants and plant parts in one single

LEOPOLDINIA pulchra.

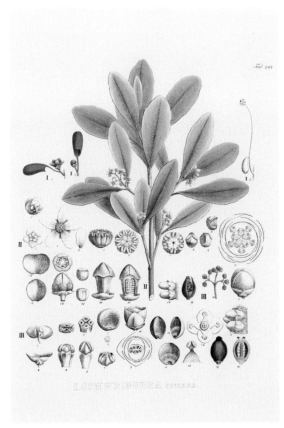

LASCHEWINGOELEA comans.

LAFOENSIA nummularifolia

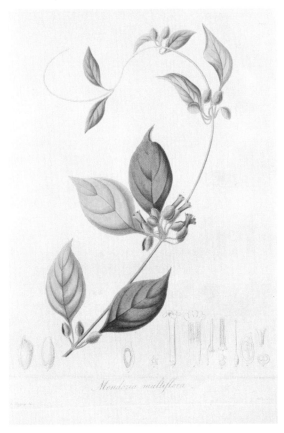

Mendoncia multiflora

FIG. 6.10. First printed illustration of the palm *Leopoldinia pulchra* Mart., the generic name dedicated to Archduchess Leopoldine, later Empress of Brazil. Colored lithograph based on anonymous drawing, tab. 53, fig. 1–15 in C. F. P. von Martius, *Historia naturalis palmarum*, vol. 2, Monachii [Munich], 1824.

FIG. 6.11. First printed illustration of *Clusia comans* (Mart.) Pipoly, the generic name dedicated to Carolus Clusius, prefect of the Botanical Garden in Leiden. Colored lithograph based on anonymous drawing, tab. 297, fig. II, 1–18 in C. F. P. von Martius, *Nova genera et species plantarum*, vol. 3, Monachii [Munich], 1832.

FIG. 6.12. First printed illustration of *Lafoensia nummularifolia* A. St.–Hil., the generic name dedicated to João Carlos de Bragança, Duke de Lafões, first President of the Academy of Sciences in Lisbon. Copper engraving based on E. Delile, tab. 190 in A. de Saint-Hilaire, *Flora Brasiliae meridionalis*, vol. 3, Parisiis [Paris], 1833.

FIG. 6.13. First printed illustration of *Mendoncia multiflora* Poepp. & Endl., the generic name dedicated to Cardinal José (II) Francisco Miguel António de Mendonça, Patriarch of Lisbon. Colored copper engraving based on E. Poeppig, tab. 208 in E. Poeppig & S. Endlicher, *Nova genera et species plantarum*, vol. 3, Lipsiae [Leipzig], 1840.

FIG. 6.14. Illustration of the bladderwort *Utricularia olivacea* Wright ex Griseb. Lithograph based on anonymous drawing, figures in upper part of tab. 2 in E. Warming, *Symbolae ad floram Brasiliae centralis cognoscendam*, pars 17, published in *Videnskabelige Meddelelser fra den Naturhistoriske Forening i Kjøbnhavn* ser. 3, 1874, pp. 439–459.

plate, thereby foreshadowing the modern arrangement of botanical illustrations (fig. 6.14).

Interest in the flora of Brazil and the publication of illustrated works in large format continued to flourish in Vienna under the long reign of Emperor Franz Joseph I. Among such publications was Heinrich Wawra's [Jindřich Blažej Vávra] remarkable *Botanische Ergebnisse*, a large folio describing the botanical results of his Brazilian sojourn in 1859–60. In it can be found a representation of *Memora imperatoris-maximiliani* (fig. 6.15), its epithet a tribute to Archduke Maximilian, the later Emperor of Mexico, the key figure of the expedition and a younger brother of Franz Joseph I. Notably left out of Wawra's work were the aroids. There was a special reason: they were entrusted to Schott, the great specialist for this plant family, who had participated in the great Austrian Expedition. Schott, then the Director of the Imperial Gardens in Vienna, produced an in-depth account based on the living collections of aroids gathered by the party of the Archduke and later cultivated in the conservatories of Schönbrunn; unfortunately he did not live to see it published. Subsequently work on this publication was transferred to Theodor Kotschy (1813–1866), then to Siegfried Reissek (1819–1871), and finally to Eduard Fenzl (1808–1879). All three were staff members of the Imperial Royal Botanical Cabinet, subsequently part of the Imperial Royal Court Natural History Museum in Vienna and all three would die in short succession, leaving the work to be completed by Johann Peyritsch (1835–1889). Peyritsch, Professor of Botany and Director of the Botanical Garden at Innsbruck University, finally published this impressive collaborative work in 1879 in Vienna under the title *Aroideae Maximilianae*. The colored lithograph of *Anthurium gladiifolium* (fig. 6.16) was based on such a cultivated specimen. In 1873 Wawra (1831–1887) had accompanied two

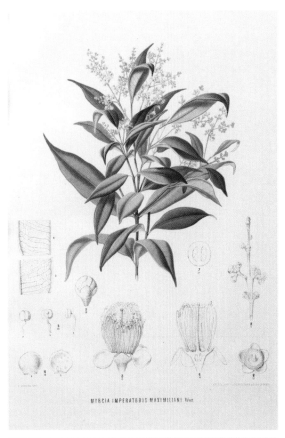

FIG. 6.15. First printed illustration of *Memora imperatoris-maximiliani* (Wawra) A. H. Gentry, the specific epithet commemorating Archduke Maximilian, Emperor of Mexico. Colored lithograph based on J. Seboth, tab. 10 in H. Wawra von Fernsee, *Botanische Ergebnisse*, Vienna, 1866.

NEW WORLD
EXPLORATIONS:
BRAZIL

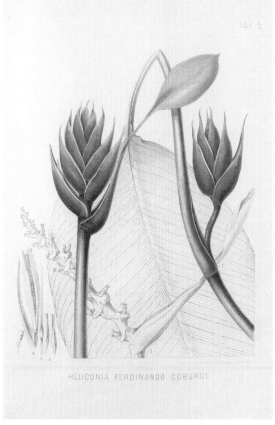

FIG. 6.17. Illustration of highly ornamental *Heliconia episcopalis* Vell. Colored lithograph based on anonymous drawing, tab. 5 in H. Wawra von Fernsee, *Itinera principum S. Coburgi*, vol. 2, Vienna, 1888.

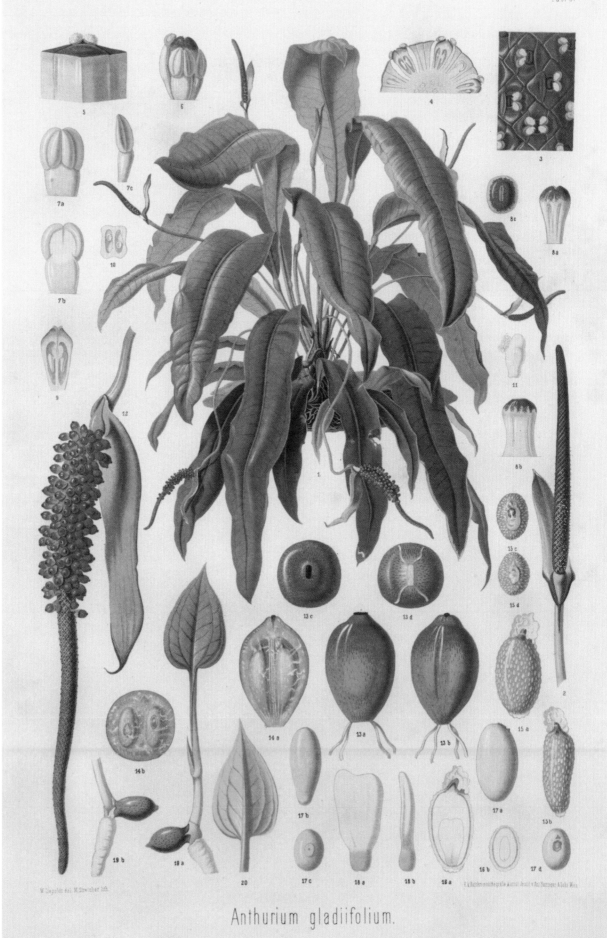

Anthurium gladiifolium.

FIG. 6.16. First printed illustration of the aroid *Anthurium gladiifolium* Schott. Colored lithograph based on W. Liepoldt, tab. 9, in J. J. Peyritsch, *Aroideae Maximilianae*, Vienna, 1879.

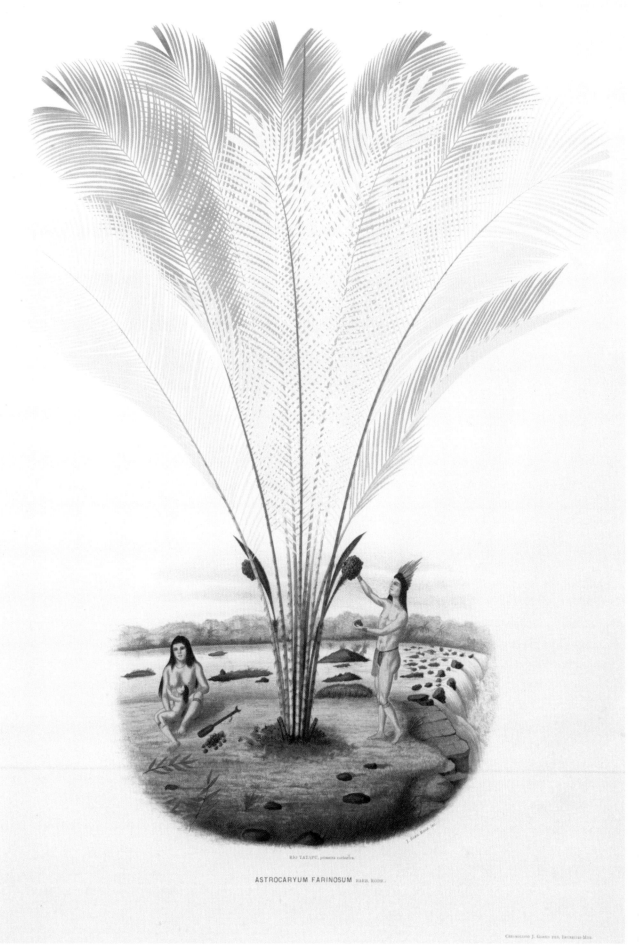

RIO YATAPU, primeira cathedra.

ASTROCARYUM FARINOSUM BARB. RODR.

CHROMOLITHO J. GOFFIN FILS, BRUXELLES-MIDI.

NEW WORLD
EXPLORATIONS:
BRAZIL

FIG. 6.18. First printed
illustration of the palm
Astrocaryum farinosum
Barb. Rodr. Color lithograph
based on J. Barbosa
Rodrigues, tab. 77, in
J. Barbosa Rodrigues, *Sertum
Palmarum Brasiliensium*,
vol. 2, Brussels, 1903.

princes of the Sachsen-Coburg-Saalfeld-Koháry family to Brazil. Again plants were collected, brought back to Vienna, and published by Wawra in yet another large-sized work entitled *Itinera principum S. Coburgi*. The work contained a colored lithograph of *Heliconia episcopalis* (fig. 6.17), a spectacular plant with a scientific name coined by Velloso. During this period no other illustrated work of similar format and caliber was produced by Brazilian botanists, with one single exception: the splendid *Sertum Palmarum Brasiliensium* published in Brussels in 1903 by João Barbosa Rodrigues (1842–1909). He was Director of the Botanical Garden in Rio de Janeiro and possessed an in-depth knowledge of orchids and palms. He dedicated his magnum opus to the palm family, describing among his new species the recently discovered *Astrocaryum farinosum* (fig. 6.18).

THE GREAT SYNTHESIS

Many expeditions to Brazil were to be undertaken during the nineteenth century. The opening up of Brazil had made the botanical riches of this huge country accessible to the scientific community with the consequence of vast collections of plant material leaving Brazil and arriving in the centers of learning in Europe. Right from the beginning the new plant acquisitions and the published records referring to them had been scattered and therefore it was soon felt desirable to bring all sources together and aim at a great synthesis. A first attempt was started by Martius with the publication of his *Flora Brasiliensis seu enumeratio plantarum* published in Stuttgart in octavo format with but two installments issued in 1829 and 1833, both devoid of illustrations; this project failed. Considerable input for the putting together of this work had been given by Christian Gottfried Daniel Nees von Esenbeck (1776–1858), Professor

of Botany and Director of the Botanical Garden at Bonn University. The follow-up project initiated and planned by Martius and Endlicher— both experts at pulling strings for such a grandiose undertaking—was much more successful. Endlicher for one, needed little effort to gather the necessary funds, due to his weekly meetings to discuss botanical issues personally with Ferdinand I, Emperor of Austria.[26]

In the end, three crowned heads of state were prepared to support the folio-sized *Flora Brasiliensis* and agreed to have their names in print on the title page of all 130 installments of the great work (fig. 6.19)—Ferdinand I, the eldest son of Franz I; Ludwig I, King of Bavaria, the brother of Karoline Augusta; and Pedro II, Emperor of Brazil, the son of Pedro I and Archduchess Leopoldine. The title page also explicitly states "cura Musei C. R. Pal. Vindobonensis auctore Steph. Endlicher successore Ed. Fenzl condidum" [care of the Imperial Royal Court Museum in Vienna and founded by Steph. Endlicher with Eduard Fenzl as successor], thereby stressing the central role of the Vienna collections in this imperial endeavor. However, very substantial collections from Brazil also arrived at the Royal Botanical Garden and Museum in Berlin, where the later editors of *Flora Brasiliensis* would work. The financial arrangements for this project have not yet been fully elucidated, although it is clear that Ferdinand I contributed annually significant sums to *Flora Brasiliensis*.[27]

More relevant to science than the financial support from the three crowns, was the modern approach envisaged by Martius and Endlicher in publishing the various botanical materials. It was clear to them right from the beginning that no single person would be able to deal with the immense diversity of the Brazilian vascular plants. As founders of the project they devised a well-considered plan to the

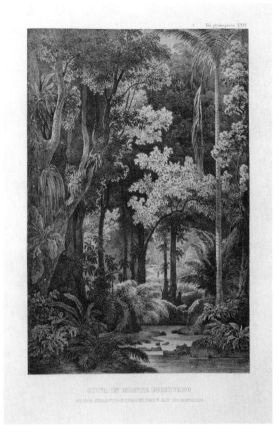

FIG. 6.19 A–B. Title page and folio XXIV of the last installment of the *Flora Brasiliensis*, forming the index for the great Flora. C. F. P. von Martius, A. G. Eichler, and I. Urban (eds.), *Flora Brasiliensis*, vol. 1 (1), Monachii [Munich], 1906.

divide of the work among various specialists, irrespective of national borders. This resulted in the first great Flora ever produced involving international cooperation with contributions coming from all parts of Europe. Although in the end more printed pages came from botanists in the Kingdom of Prussia than from any other country, the largest single contribution came from the Kingdom of Belgium. It was the account of orchids written by Alfred Cogniaux (1841–1916) describing no less than 1,765 species. His mammoth treatment of this family comprised the description of 131 new species. Broken down by the sheer number of pages, Carl Schumann (1851–1904) of the Royal Botanical Garden and Museum in Berlin was the second most

important contributor to the *Flora Brasiliensis*, followed by Johann Müller Argoviensis (1828–1896), Professor of Botany at Geneva University and Director of the Botanical Garden, and John Baker (1834–1920), Keeper of the herbarium at the Royal Botanic Gardens at Kew. However, all four and also many the other contributors had ever been to Brazil. They based their accounts largely on herbarium specimens, and the few, usually deplorable living plants which survived in conservatories.

Right from the start, Martius and Endlicher had envisaged an illustrated Flora. To diminish high costs for such a publication, they decided to use uncolored lithographs only, to carefully select the species illustrated, and to choose a

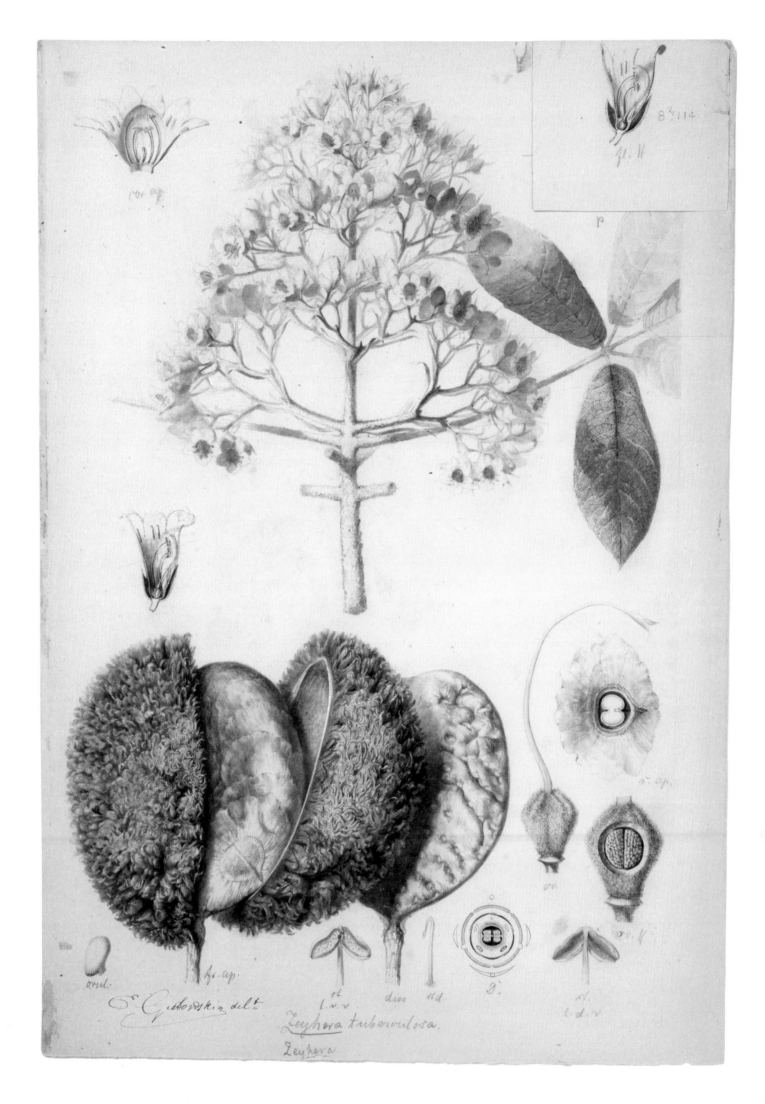

8?.114

E. Gibbordskiz delt.

Zeyhera tuberculosa.

Zeyhera

printer in Leipzig, a traditional center for book production and trade. Organized and diligent as they were, they never could have foreseen the incredible slow pace at which the project would proceed. Ultimately the work took sixty-six years to complete. Three scientific editors were responsible for *Flora Brasiliensis*. The first of all was Martius, followed by his private assistant August Wilhelm Eichler (1839–1887),[28] later Professor of Botany at Berlin University and Director of the Royal Botanical Garden and Museum there, and finally the latter's collaborator Ignatz [Ignatius] Urban (1848–1931), later the Vice Director of that institution. The share of the three successive editors of this immense publication was not exactly equal: Martius was in charge of installments 1–46, Eichler handled 47–99, and Urban 100–130. They also differed in the number of pages they contributed as authors to the great Flora. Eichler wrote 866 columns (see below), Urban 522, and Martius 438. When in 1906 Urban compiled the index volume of the great work comprising fifteen volumes, he counted 20,733 columns of text equaling about 10,367 pages of folio size, plus 3,811 lithographs illustrating no less than 6,246 species, i.e., about a third of the species treated in *Flora Brasiliensis*. Surprisingly, Urban sent more than three hundred original pencil drawings and annotated page proofs by exchange to The New York Botanical Garden in ca. 1914, which are now kept in the Mertz Library.[29] They provide an unusual opportunity

FIG. 6.20. Anonymous drawing of *Zeyheria tuberculosa* (Vell.) Bureau ex B. Verl., sent in ca. 1914 as part of an exchange agreement from the Royal Botanic Garden and Botanical Museum Berlin-Dahlem to New York. The generic name is dedicated to Johann Michael Zeyher, a widely traveled plant collector. Anonymous drawing forming the basis for the lithograph published as tab. 114 in C. F. P. von Martius, *Flora Brasiliensis*, vol. 8 (2), Monachii [Munich], 1897. Art and Illustration Collection, 38–279.

to see the interaction of authors and illustrators, particularly when the pencil drawings, e.g., of *Zeyheria tuberculosa* (fig. 6.20) and the proofs are compared with the final published version.

Upon its completion in 1906 *Flora Brasiliensis* was the largest Flora then written and a monument of its own dealing with a staggering 19,433 species of vascular plants. At the same time the work, while essential, comprised nothing but the very basic, synthesized knowledge of the contributors at the moment of finishing the accounts. After 1906 the scientific community continued to study plant life in Brazil, a country known for its mega-biodiversity. So far no one has taken up the challenge to start a new Flora. What is available, however, is a modern catalog entitled *Catálogo de plantas e fungos de Brasil*,[30] a checklist enumerating over 32,364 species of vascular plants; an increase of 12,931 species in the intervening 104 years. This work shows what plant taxonomy in a tropical country really is—both an ending synthesis and the stone of Sisyphus. Yet, botanical research will go on and continue to draw from the remarkable endeavor of those intrepid naturalists, who through the centuries have laid the foundation for our understanding of the flora of Brazil.

EPILOGUE

The literature on the botanical exploration of Brazil until 1906 is immense, with numerous studies on the various projects. The older literature has been covered admirably in the register volume forming the final part of *Flora Brasiliensis*,[31] a treatment which continues to be indispensable. The more modern literature is dealt with in the standard bibliography in the field.[32] Recently a brief, but excellent synopsis has been published in Portuguese and English.[33] Because of the implications to other branches of science, notably zoology, mineralogy, and

ethnology, and the outstanding quantity and quality of material brought back to Vienna and Munich, the Austrian expedition to Brazil has been repeatedly studied, with a biography of Natterer containing a comprehensive list of references of the most recent studies.[34]

The plant names employed in the captions reflect the current state of botanical knowledge, whereas those appearing on the plates are the botanical names that were accepted by the authors when their publication appeared.

ACKNOWLEDGMENTS

J. Crompton (Salisbury), S. Dressler (Frankfurt), K. Grotz, E. Lack, and E. von Raab-Straube (all Berlin) have kindly read a draft version of this text.

ENDNOTES

1. C. F. P. von Martius, ed., *Flora Brasiliensis. Enumeratio plantarum in Brasilia hactenus detectarum quas suis aliorumque botanicorum studiis descriptas et methodo naturali digestas partim icone illustratas* 1–15, (Monachii, Lipsiae: apud R. Oldenbourg in comm., 1840–1906).

2. Y. T. Roche, A. Presotto and F. Cavalheiro, "The Representation of *Caesalpinia echinata* (brazilwood) in Sixteenth and Seventeenth-century Maps," *Anais da Academia Brasileira de Ciências* 79, no. 4 (2007): 751–765. In the end "pau brasil" (*Caesalpinia echinata*) gave its name to the territory discovered by Cabral with the earlier denomination Ilha da Vera Cruz being replaced by Brazil. See M. Kraus, "Entdeckung und Kolonialisierung Brasiliens," in M. Kraus and H. Ottomeyer, eds., *Novos Mundos— Neue Welten: Portugal und das Zeitalter der Entdeckungen* (Berlin: Deutsches Historisches Museum, 2007), 115–127.

3. Compiled probably in Santo Domingo and later finished in Spain, now in Real Academia de la Historia in Madrid. See K. A. Myers, *Fernández de Oviedo's Chronicle of America: A New History for a New World* (Austin, TX: University of Texas Press, 2007).

4. Reported from the *Grandes Heures d'Anne de Bretagne*, now in the Bibliothèque Nationale in Paris. See H. S. Paris, M. C. Daunay, M. Pitrat and J. Janick, "First known image of *Cucurbita* in Europe, 1503–1508," *Annals of Botany* 98, no. 1 (2006): 41–47.

5. Located in the Codex Fuchs, now in Österreichische Nationalbibliothek in Vienna. See B. Baumann, H. Baumann and S. Baumann-Schleihauf, *Die Kräuterbuchhandschrift des Leonhart Fuchs* (Stuttgart: Ulmer, 2001).

6. J. Janick and G. Caneva, "The First Images of Maize in Europe," *Maydica* 50, no. 1 (2005): 71–80.

7. F. A. Stafleu, "Jacquin, European Botanist," in *Nicolai Josephi Jacquin Selectarum stirpium Americanarum historia* (New York: Hafner Publishing Co., 1971), F 7–F 17.

8. H. Lindorf, "Notices on the Austrian Expedition in a Venezuelan Document Dated 1787 and Comments on Botanical Names Linked to the Collections," *Acta Botanica Venezuelica* 27, no. 1 (2004): 57–64.

9. M. V. Ibáñez Montoya, *La expedición Malaspina*, Tomo 4, Trabajos científicos y correspondencia de Tadeo Haenke (Madrid: Ministerio de Defensa: Museo Naval: Lunwerg Ed., 1992).

10. A. R. Steele, *Flowers for the King: The Expedition of Ruiz and Pavon and the Flora of Peru* (Durham, North Carolina: Duke University Press, 1964).

11. H. W. Lack, *Alexander von Humboldt und die botanische Erforschung Amerikas* (Munich, New York: Prestel, 2009).

12. E. Kalwa, "Alexander von Humboldt, die Entdeckungsgeschichte Brasiliens und die brasilianische Geschichtsschreibung des 19. Jahrhunderts," in M. Zeuske and B. Schröter, eds., *Alexander von Humboldt und das neue Geschichtsbild von Lateinamerika* (Leipzig: Leipziger Universitätsverlag, 1992), 61–79.

13. P. J. P. Whitehead, "The Biography of Georg Marcgraf (1610–1643/44) by his Brother Christian, Translated by James Petiver," *Journal of the Society for the Bibliography of Natural History* 9, no. 3 (1979): 301–314.

14. Dutch painter who accompanied Governor Johan Maurits von Nassau-Siegen to Brazil; illustrations now in the Biblioteka Jagiellońska in Cracow. See P. J. P. Whitehead, "The original drawings of the Historia Naturalis Brasiliae of Piso and Marcgrave (1648)," *Journal of the Society for the Bibliography of Natural History* 7, no. 4 (1976): 409–422.

15. H. W. Lack, "The Discovery, Naming and Typification of *Bougainvillea spectabilis* (*Nyctaginaceae*)," *Willdenowia* 42, no. 1 (2012): 117–126.

16. H. C. de Lima, L. B. Kury and M. Barretto, *Sydney Parkinson. Ilustrações botânicas de espécies brasileiras na expedição de James Cook 1768–1769* (Rio de Janeiro: Andrea Jacobsson, 2012).

17. L. A. Šur, ed., *Materialy ekspedicii akademika Grigorija Ivanovica Langsdorfa v Braziliju v 1821–1829, gg.* (Leningrad: Izd. Nauka, 1973).

18. J. P. P. Carauta, "A data efetiva de publicação de 'Flora Fluminensis,'" *Vellozia* 7 (1969): 26–33. See also J. P. P. Carauta, "The Text of Vellozo's Flora Fluminensis and its Effective Date of Publication," *Taxon* 22, no. 2/3 (1973): 281–284.

19. H. W. Lack, *Florilegium imperiale. Botanische Schätze für Kaiser Franz I. von Österreich* (Munich: Prestel, 2006).

20. The extensive published record is summarized e.g., in K. Schmutzer, "Der Liebe zur Natur halber: Johann Natterers Reisen in Brasilien 1817–1836," *Österreichische Akademie der Wissenschaften, Veröffentlichungen der Kommission für Geschichte der Naturwissenschaften, Mathematik und Medizin* 64 (2011).

21. H. W. Lack, "Pohls Plantarum Brasiliae icones et descriptiones," *Zandera* 1, no. 1 (1982): 3–7; no. 2 (1982): 13–20.

22. H. W. Lack, *Carl Friedrich Philipp von Martius. The Book of Palms—Das Buch der Palmen—Le Livre des palmiers* (Cologne: Taschen, 2010).

23. Cited in Lack, *The Book of Palms*, 10, 16, 22.

24. W. Morawetz and M. Rösner, eds., *Eduard Friedrich Poeppig 1798–1868: Gelehrter und Naturforscher in Südamerika* (Leipzig: Universität Leipzig Institut für Botanik, 1998).

25. C. Riedl-Dorn, "Eduard Poeppigs Briefe an Stephan L. Endlicher und seine Bilder im Naturhistorischen Museum in Wien," in Morawetz et al., eds., *Eduard Poeppig*, 109.

26. Riedl-Dorn, Briefe, 87.

27. C. Riedl-Dorn, "Die Grüne Welt der Habsburger: zur Ausstellung auf Schloß Artstetten 1. April bis 2. November 1989," in *Veröffentlichungen aus dem Naturhistorischen Museum Wien*, N. F. 23 (1989), 75.

28. H. W. Lack, "August Wilhelm Eichler (1839–1887)," *Willdenowia* 18, no. 1 (1988): 5–18.

29. Anonymous, "Accessions," *Journal of The New York Botanical Garden* 15 (1914): 65–68. B. G. Callery, "Collecting Collections: Building the Library of The New York Botanical Garden," *Brittonia* 47, no. 1 (1995): 44–56.

30. R. C. Forzza et al. (eds.), *Catálogo de plantas e fungos do Brasil* 1–2 (Rio de Janeiro: Jardim Botânico do Rio de Janeiro, Jakobsson Estudio, 2010).

31. I. Urban, "Vitae itineraque collectorum botanicorum, notae collaboratorum biographicae, florae Brasiliensis ratio edendi chronologia, systema, index familiarum," in C. F. P. von Martius, ed., *Flora Brasiliensis. Enumeratio plantarum in Brasilia hactenus detectarum quas suis aliorumque botanicorum studiis descriptas et methodo naturali digestas partim icone illustratas* (1) (Monachii, Lipsiae: Apud R. Oldenbourg in comm., 1906).

32. F. A. Stafleu and R. S. Cowan, *Taxonomic Literature: A Selective Guide to Botanical Publications and Collections with Dates, Commentaries and Types*, 2nd ed. (Utrecht: Bohn, Scheltema and Holkema, 1976–1988); F. A. Stafleu and E. A. Mennega, *A Selective Guide to Botanical Publications and Collections with Dates, Commentaries and Types*, ed. 2, Supplements 1–8 (Königstein: Koeltz Scientific Books, 1992–2009); L. J. Dorr, and D. H. Nicolson, *A Selective Guide to Botanical Publications and Collections with Dates, Commentaries and Types*, ed. 2, Supplements 7–8 (Ruggell: A. R. Gantner Verlag, 2008–2009).

33. L. Kury and M. R. Sá, "Flora brasileira, um percurso histórico," in A. C. I. Martins, ed., *Flora Brasileira: história, arte & ciência* (Rio de Janeiro: Casa da Palavra, 2009), 18–67.

34. Schmutzer, *Der Liebe zur Natur halber*, passim.

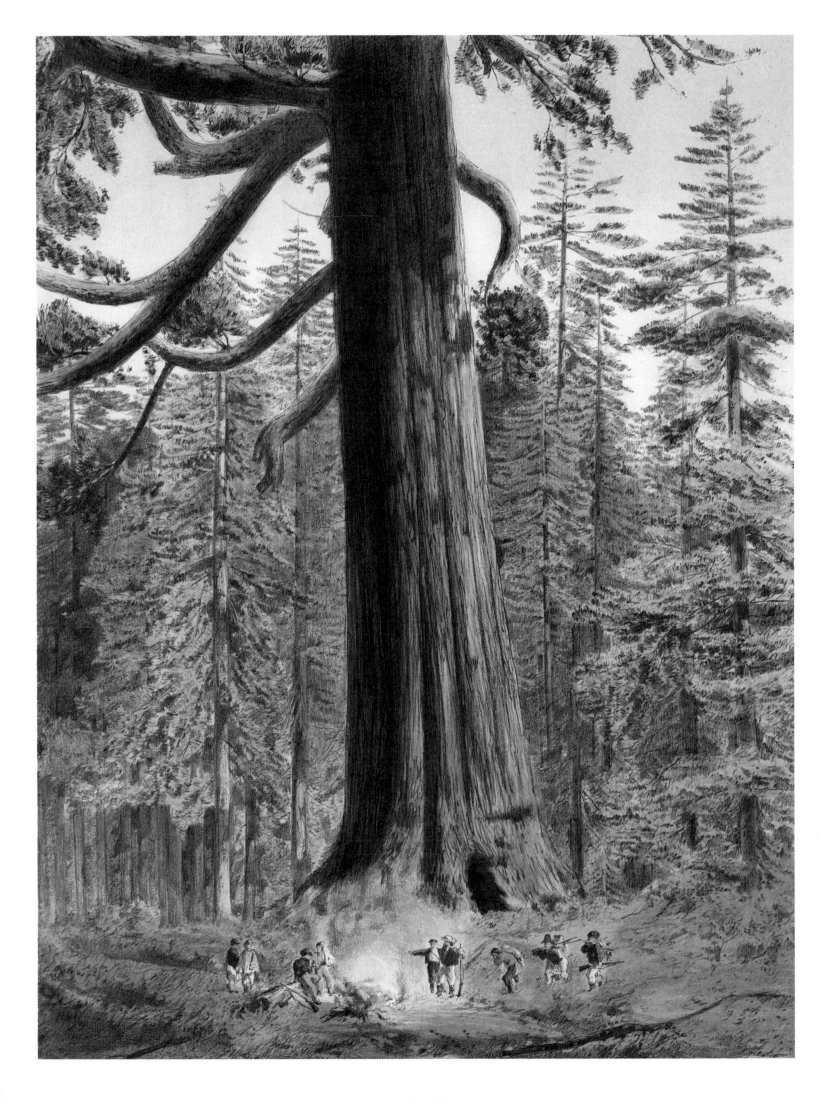

CREATING A NORTH AMERICAN FLORA

ELIZABETH S. EUSTIS
WITH DAVID ANDREWS

The first dedicated publication of North American plants appeared in 1635, the work of Parisian botanist Jacques Philippe Cornut, who described specimens available to him in France (fig. 7.1).[1] The last North American Flora written entirely overseas was completed by British botanist William Jackson Hooker in 1840.[2] For almost two centuries, North American botany remained largely the domain of colonial powers competing for mastery of the continent's territory and resources. Long after the American Revolution, European field botanists continued to roam the continent, often working on behalf of their governments. Since territorial claims were based to a great extent on prior exploration and the right of discovery, many scientific expeditions and botanical publications were politically significant as well as intellectually and economically motivated. Lacking the necessary resources of libraries, herbaria, sophisticated instruments, and financial support, Americans too continued

to send their botanical discoveries to established European authorities for classification, naming, description, and publication. Benjamin Franklin and Thomas Jefferson, among others, advocated greater engagement by Americans in writing their own natural history, urging the post-Revolutionary generation to prove that liberty "is the great parent of science and virtue."[3]

Half a century later, the efforts of numerous individual botanizers coalesced in a descriptive Flora, North American in content, authorship, and publication, catalyzed by John Torrey (1796–1873) (fig. 7.2), and written by him with his rising former student and assistant, Asa Gray (1810–1888). Torrey's library, papers, and herbarium—even his vasculum (collecting case)—the carefully preserved archive of a culminating era in American botanical history, passed to The New York Botanical Garden soon after its founding (fig. 7.3). This chapter places the importance of that collection in the context of early efforts to forge a collaborative network of local and itinerant botanists, followed by the first effective organization of centralized systematic botany in the United States, and the enormous task of introducing the botanical riches of a vast continent at their moment of maximum discovery.

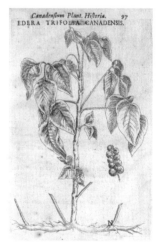

FIG. 7.1. *Edera trifolia canadensis* or poison ivy, made an appearance in the first book of North American plants, *Canadensium plantarum* by Jacques Philippe Cornut, written and published in Paris in 1635, p. 97. This species was introduced into European gardens as an ornamental exotic before its less appealing qualities were experienced.

FIG. 7.13. *Sequoia wellingtonia*, in Edward Ravenscroft, *Pinetum Britannicum*, Edinburgh, 1884, vol. 3, plate 37. After discovery of the giant redwood was reported in 1852, this magnificent species, now named *Sequoiadendron giganteum* for the Native American inventor of Cherokee syllabary, was first called *Wellingtonia* for the Duke of Wellington, while Americans referred to it as *Washingtonia*.

American publication of American plants began in 1785 with the first volume of *Memoirs* by the Boston-based American Academy of Arts and Sciences. "An Account of some of the vegetable Productions, naturally growing in this Part of America, botanically arranged" by Rev. Manasseh Cutler (1742–1823), described native plants of New England and their uses.[4] In that same year, John Bartram's first cousin, Humphry Marshall (1722–1801), produced *Arbustrum Americanum: the American Grove,* the first botanical book written by an American and published in the United States. Marshall asserted that "the Science of Botany…is an object which not only merits the attention and encouragement of every patriotic and liberal mind, but undoubtedly deserves a place amongst the first of useful pursuits."[5]

Americans and Europeans both were exploring the continent and recording their newly discovered species. Philadelphia Quaker William Bartram (1739–1823) accompanied his father, John (1699–1777), on plant hunting expeditions as a boy, and later spent four years of immersion with Indian tribes as far south as Florida and as far west as the Mississippi River, describing numerous plant species for the first time in a famous account of his travels (fig. 7.4).[6] French botanist André Michaux (1746–1802) and his son, François-André Michaux (1770–1855), were sent by King Louis XVI to collect the useful and beautiful plants of North America for introduction into French horticulture. Their books, published in Paris and illustrated by

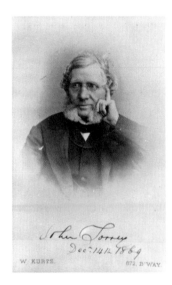

FIG. 7.2. Photograph of John Torrey, dated Dec. 14, 1869, by William Kurz, a leading innovator of studio photography. This image portrays John Torrey as an eminent, pensive botanist, at the age of 73.

FIG. 7.3. The books and papers of John Torrey, including his correspondence with explorers and botanists, as well as herbarium specimens, reside in The New York Botanical Garden. Among them is an ornate vasculum decorated with his name as a presentation piece.

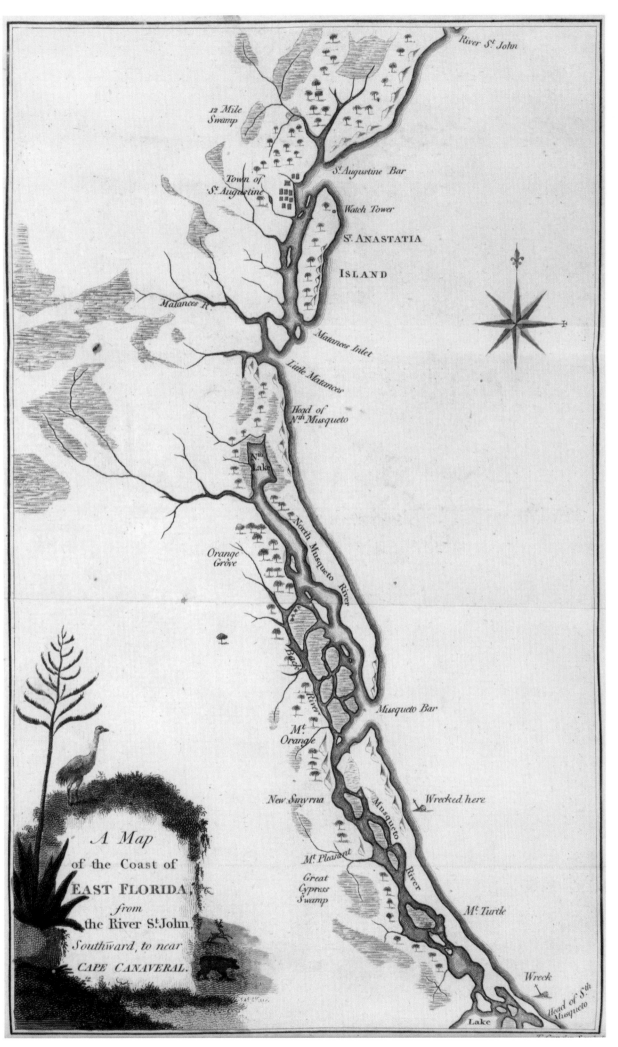

Watch Tower

St. ANASTATIA

ISLAND

12 Mile
Swamp

St. Augustine Bar

Town of
St. Augustine

River St. John

Matances R.

Matances Inlet

Little Matances

Head of
Nth Musqueto

Nth
Lake

Orange
Grove

North Musqueto River

Beach River

Mt
Orange

New Smyrna

Musqueto Bar

Wrecked here

Mt Pleasant

Musqueto River

Great
Cypress
Swamp

Mt Turtle

A Map
of the Coast of
EAST FLORIDA,
from
the River St. John,
Southward, to near
CAPE CANAVERAL.

Wreck

Lake

Head of Sth
Musqueto

FIG. 7.4. "A Map of the Coast
of East Florida from the River
St. John Southward near to
Cape Canaveral," by T. Conder,
illustrates William Bartram's
description of his four-year
exploration, published
as *Travels through North &
South Carolina, Georgia,
East & West Florida* in 1791.
This famous account was
closely studied by European
romantics imagining life
in the American wilderness.

Pl. 59.

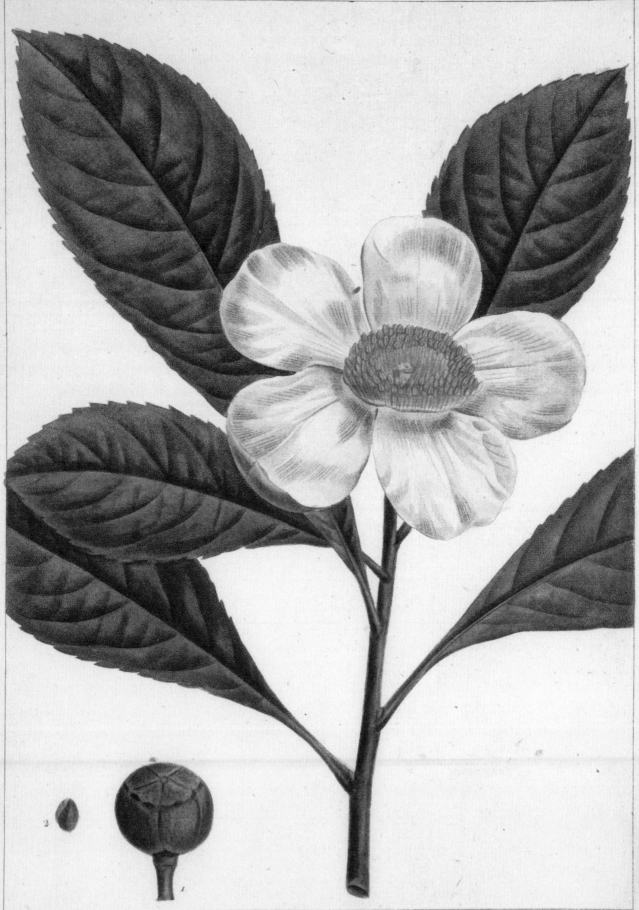

P. J. Redouté del.

Gabriel sculp.

Franklinia.

Gordonia pubescens.

Pierre-Joseph Redouté (1759–1840) were far
more splendid than any publication in America
at the time. The complete collection of Michaux
editions at the Mertz Library includes the first
United States imprint of *The North American
Sylva*, which appeared in Philadelphia in six
volumes from 1841 to 1849 (fig. 7.5). To the
descriptions and fine color plates of the 1803
French publication, this edition added Thomas
Nuttall's more recently discovered species
from the Rocky Mountains, Oregon Territory,
and California.[7]

Lutheran minister Henry Muhlenberg
(1753–1815) of Lancaster, Pennsylvania, led the
first effort to forge a collaborative network of
American botanists, each contributing local
studies towards a national Flora. His *Catalogus
plantarum Americae Septentrionalis* was used
by younger botanists to guide the formation
of their own herbaria, as evidenced by heavily
underlined copies once owned by Lewis von
Schweinitz and John Torrey now located in the
Mertz Library.[8]

Muhlenberg designated Dr. Benjamin Smith
Barton of Philadelphia (1766–1815) as the best
synthesizer of a descriptive and comprehensive
North American Flora. Barton taught natural
history, botany, and *materia medica* at the
University of Pennsylvania. His *Elements of
Botany* of 1803 was not only the first botanical
textbook with an American imprint, but also
more thoroughly illustrated than most American
books at that time, primarily from drawings
by William Bartram.[9] Barton himself invested
independently in the first extensive travels
sponsored by an American to focus primarily
on botany, sending the German gardener-
botanist Frederick Pursh (1774–1820) from
Philadelphia to North Carolina in 1806 and then
north as far as Vermont in 1807. After Pursh
left his employment, Barton trained a young
English enthusiast, Thomas Nuttall (1786–1859),

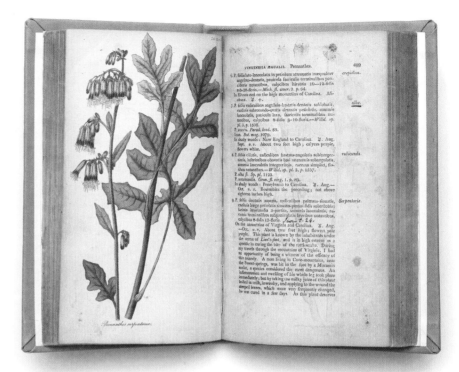

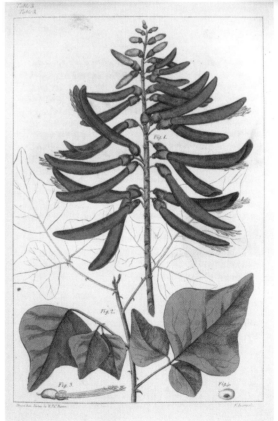

FIG. 7.6. *Prenanthes serpentaria* or lion's-foot was first published in 1814 by Frederick Pursh in his fundamental *Flora Americae Septentrionalis*, vol. 2, p. 499, the first North American Flora to catalog species all across the continent. A native of the mountains of Virginia and Carolina, it was vividly described by Pursh as a cure for snakebite.

FIG. 7.7. *Erythrina herbacea* or coral tree, in William P.C. Barton, *A Flora of North America*, 1820, vol. 1, tab. 3. This specimen was nursed through the winter in Bartram's Garden outside Philadelphia, and meticulously drawn and hand-colored by the author and his wife.

FIG. 7.5. *Franklinia gordonia pubescens*, in André and François-André Michaux, *North American Sylva*, Philadelphia, 1841–1849. Discovered by botanist John Bartram in Georgia in 1765, this plant was named for revolutionary patriot-scientist Benjamin Franklin. Pierre-Joseph Redouté drew its portrait, which appeared in vol. 1, plate 59, of the work's first American edition.

for botanical fieldwork and sent him out on collecting trips from Savannah to the Great Lakes and the West—where his travels continued far beyond the planned itinerary—from 1809 to 1811. Before his departure, Nuttall signed a contract restricting his observations for Barton's use exclusively and his collections for Barton and himself alone.[10]

As the practitioner with the most advanced botanical and horticultural education of anyone working in the United States at the time, Frederick Pursh continued to assist leading figures with the important botanical enterprises of the day, including classification of botanical collections from the first federal exploratory survey, the Lewis and Clark Expedition.[11] Meriwether Lewis, who planned to publish his discoveries himself, asked Pursh to assist him by drawing and describing them. But when, after many delays and scant support, Pursh left Philadelphia to run the new Elgin Botanic Garden in New York, he took away with him his drawings and records as well as portions of many Lewis and Clark specimens. In 1811, with war on the horizon, he sailed for England with his collection. There he worked with libraries and herbaria surpassing any such resources in America, and with the equally incomparable patronage of botanical enthusiast Aylmer Lambert, who was in the midst of publishing his own monograph on the genus *Pinus*, including recently discovered species from North America.[12]

In 1814 Frederick Pursh produced his *Flora Americae Septentrionalis* (fig. 7.6), the first Flora of North America to span the continent, nearly doubling the number of species recorded by André Michaux eleven years earlier.[13] His was the first published account of the Pacific Northwestern flora, based on 124 species from the Lewis and Clark expedition. Acclaim for this achievement accompanied condemnation of Pursh for preempting the important discoveries

of other plant collectors and for publishing in London as the United States fought to limit continuing British imperial influence in the American hemisphere.

The War of 1812 was followed by an era of intensive scientific inquiry in the United States. As numerous local Floras (thoroughly represented in the Mertz Library) reached publication, Amos Eaton (1776–1842) single-handedly set out to broaden botanical interest and education through the first popular lectures on the subject in America, as well as innovative academic courses. In 1817, he published his *Manual of Botany for the Northern and Middle States*, a simplified text written in English, unlike the Latin of more scientific botanical books. This became the best-selling popular botany through eight expanding editions over the next thirty years. By his own efforts and through the work of his follower Almira Hart Lincoln Phelps (1793–1884), he greatly increased public support for the natural sciences and also advanced the teaching of botany to women and girls.[14]

Meanwhile, the death of Benjamin Barton freed Thomas Nuttall from his contractual restrictions, enabling him to publish his *Genera of North American Plants* in 1818. Nuttall expanded and corrected earlier works based on his own direct observations and collections during the most wide-ranging American field studies by any botanical explorer—from Florida and the Great Lakes to Oregon and California. Moreover, he returned to the United States to accomplish this, making it the second Flora to be published in North America.[15] An American Flora written by an American remained an elusive goal, however. Benjamin Barton's nephew and student, William P. C. Barton (1786–1856), succeeded him as professor of botany and natural history at the University of Pennsylvania, inheriting his uncle's unfulfilled mission. In 1820 he opened his *A Flora of North*

America (fig. 7.7) with another call for American botanical writers "to penetrate the recesses of our territory" in order to further national economic and medical interests:

> North American botany has hitherto owed its greatest accessions to the learning and enterprize of foreign botanists, who have devoted themselves to this alluring subject, under the liberal patronage of transatlantic governments.... That spirit of independence, however, which forms the basis of character in a true American, has discovered its determination to emancipate itself from scientific subjugation to foreign countries.... [16]

Barton further emphasized that his book had been published and its plates printed entirely in the United States.

JOHN TORREY'S WORK: "FOR THE HONOR OF OUR COUNTRY AND THE ADVANCEMENT OF BOTANICAL SCIENCE" [17]

Among the most important collections at The New York Botanical Garden are the books, incoming correspondence, and herbarium of John Torrey, the senior figure in American botany during the period of Western exploration prior to the Civil War. He was praised for furthering his research "for the Honor of our Country and the Advancement of Botanical Science." [18] Torrey was first inspired to pursue botany by Amos Eaton during Eaton's confinement—resulting from the disarray of his business affairs—in a prison where Torrey's father was the fiscal agent. While still a medical student in New York, in 1817 at the age of twenty, he was named curator for the new Lyceum of Natural History (today the New York Academy

FIG. 7.8. A manuscript calendar of flower sightings by the young medical student John Torrey, his *Calendarium Florae* records the species he collected on botanizing excursions in the vicinity of New York City in 1818 and 1820.

of Sciences), one of the seminal associations fostering the early development of the natural sciences in the United States (fig. 7.8). From that time onward he solicited collections of plants, and by 1821 he could report, "All the botanists here send me everything they collect...." Torrey's first published work was *A Catalogue of Plants Growing Spontaneously within Thirty Miles of the City of New York*. After launching the *Annals* of the Lyceum in 1823, one of the earliest vehicles for taxonomic publication in America, he was elected President the following year. [19]

When the United States government began to include civilian scientists in federal exploratory expeditions, they were unpaid and expected to provide their own equipment. Lacking independent means, Torrey could not afford to join the cadre of scientists led by Major Stephen Harriman Long when they set out from Saint Louis to explore the upper Missouri River in 1819, a mission redirected to the Rocky Mountains and the Spanish boundary in 1820. Consequently, the first person to fulfill an assignment as botanist for a U.S. expedition was Dr. Edwin James (1797–1861), who had studied with Torrey and eventually appealed to him to classify the specimens collected en route. The botanical discoveries of this expedition captivated Torrey's interest in the Western Flora and initiated his role as the "closet botanist" living with libraries and herbaria who could

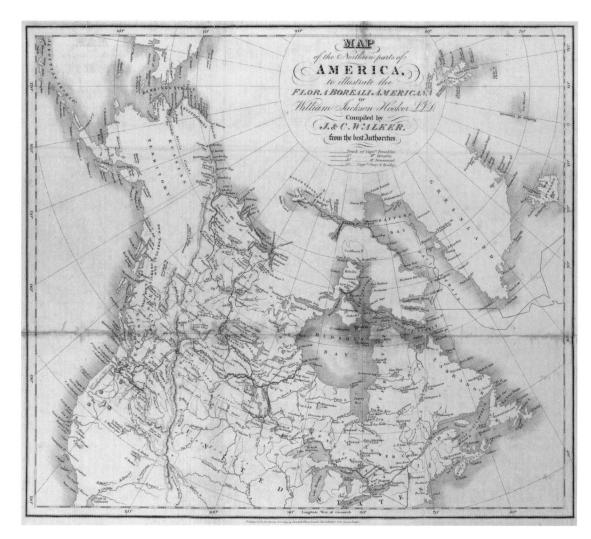

analyze, classify, name, describe, and publish the specimens collected by field botanists.

Torrey took up the continuing challenge of producing a North American Flora, expanding from the local level to begin a regional *Flora of the Middle and Northern Sections of the United States*, planned to complement a Southern work in progress by Stephen Elliott (1771–1830).[20] This prompted his collegial correspondent British botanist William Jackson Hooker to inform him that he himself was working on a Flora of the British possessions in North America, including the Pacific Northwest and the Rocky Mountains.[21] Torrey's personal copy of Hooker's work, now in the Mertz Library, is annotated and the itineraries of several key botanical

explorations in North America and Canada are highlighted on the accompanying map (fig. 7.9).

Torrey's first attempt to create an American Flora would remain incomplete largely because the prevailing approach to plant classification was in the process of upheaval. Despite reluctance to overthrow the established Linnaean system, progressive botanists embraced a new "Natural System" analyzing additional parts of the plant for more accurate identification. In an 1823 letter to John Torrey, Moravian-American botanist Lewis David von Schweinitz exclaimed, "my head almost runs crazy with the astonishing effects of a perfectly new (at least to me) analytical method of distinguishing the plants of a numerous genus,

by analytical tables, which if well executed, cannot fail of determining the species."[22] In 1826 Torrey converted to the new method with his *Account of a Collection of Plants from the Rocky Mountains and Adjacent Countries* introducing the nearly 500 previously undescribed taxa discovered by Edwin James.[23] Five years later he added a new *Catalogue of North American Genera* to the American edition of John Lindley's *Introduction to the Natural System of Botany*, further promoting its acceptance in the United States.[24] Also in 1836 he was appointed botanist to the State of New York with responsibility for writing a state Flora.[25]

By this time Torrey's influence as the leading botanist in America had become apparent. In the course of his career, well over sixteen species would be named for him, and no fewer than four introductions were in contention for the genus name *Torreya*.[26] In 1830 he began to correspond and exchange specimens with Asa Gray whom he finally met in 1832. By the following year, Gray was his virtual apprentice, living at Torrey's home, collecting plants for him, and later rearranging Torrey's herbarium. Torrey and Gray became collaborators on the major projects of mid-century American botany, including coordinated publication of new plant discoveries and creation of a comprehensive, rigorously systematic American Flora. From 1838 to 1843, they completed six of the intended seven parts of their *Flora of North America*, largely achieving the synthesis once envisioned by Henry Muhlenberg, correcting and integrating previously scattered herbarium records and published descriptions along with newly classified discoveries.[27]

Efforts to bring systematic order to American taxonomy on the national scale became an increasingly formidable undertaking as publication of the Torrey and Gray *Flora* coincided with accelerated exploration of the American West. By the 1840s, expansionists such as Senator Thomas Hart Benton of Missouri and President James Polk invoked "Manifest Destiny" to assert a transcontinental nation as the obvious intention of Divine Will. Supporting their campaign to extend the boundaries of the United States from coast to coast were exploratory surveys by a new branch of the Army called the Corps of Topographical Engineers. Their expeditions mapped the territory, seeking transportation routes and determining boundaries while employing civilian scientists to describe its natural history. The resulting inundation of new plant discoveries expanded *Flora of North America* far beyond its original concept.[28]

French scientist and map-maker Joseph Nicolas Nicollet (1786–1843) exemplified a higher level of commitment to botanical discovery while leading a survey of the area between the Upper Mississippi and Missouri Rivers sponsored by the Topographical Corps. At his own expense Nicollet employed Dresden-born botanist Karl Andreas Geyer (1809–1853) to accompany the expedition. Together they trained John Charles Frémont (1813–1890), a young second lieutenant in the Corps and the son-in-law of Thomas Hart Benton—Geyer teaching Frémont the importance of collecting and preparing fine botanical specimens.[29] Nicollet then sent their specimens to Torrey with a letter saying, "It is with full confidence and trust that I send the whole to you, with the earnest request to make it as good as possible

GROUNDBREAKING
WORKS ON BOTANICAL
DISCOVERIES

for the benefit of science, should it prove to be of some important accession to your very valuable Flora &c...you will confer upon me a great favor, if you can give me a Catalogue of the collection...." [30]

Frémont in turn wrote to Torrey in 1842 as he embarked on the first of his five expeditions across the West. Their correspondence would continue for over a decade, accompanied by herbarium specimens and a few sketches (fig. 7.10), preserved at The New York Botanical Garden. During arduous journeys over 20,000 miles Frémont collected over 1,000 plant specimens, yielding 167 new species and 19 new genera, including one named after him by Torrey. Among Torrey's reports of these discoveries is *Plantae Frémontianae* of 1853 describing plants collected by Frémont in California during the transition from Mexican rule to U.S. statehood.[31]

Meanwhile, federal investment in scientific exploration escalated dramatically but sporadically with the United States Exploring Expedition led by Commander Charles Wilkes from 1838 to 1842, its first international venture of this kind. Congress attempted to declare the intellectual independence of the nation by mandating that its "scientifics" should all be Americans, aspiring to the prestige of contributing to international science in a world of imperial powers, while also advancing the American whale fishery and the expansion of trade.

At the time, Great Britain and the United States were contending to claim the Oregon Country, which extended from the Pacific Northwest coast to the Rocky Mountains. Not coincidentally, the Wilkes Expedition sent a party overland from Puget Sound to San Francisco on a detour from their circumnavigation of the Pacific Ocean (fig. 7.11). As they traveled, William Hooker completed his Flora of British North America, including the Oregon territory—the last of the North American Floras written by a botanist overseas working with plant materials transported across the Atlantic.

The Wilkes Expedition marks a turning point in American understanding of the importance of botany as a profession and of sustained commitment to its funding. An overwhelming return of 50,000 herbarium specimens, seeds of 684 species, and live plants of 254 species deluged the capitol city, eventually launching the National Herbarium (initially organized by John Torrey) and the United States Botanic Garden. But inadequacies of both funding and training for preparing scientific reports frustrated its participants, stalled and reduced the impact of their discoveries, and negated the determination to employ American scientists only. Wilkes persevered for thirty years to achieve publication of twenty-one volumes and nine atlases, having enlisted eight botanists of various nationalities to write the botanical reports.[32] John Torrey agreed to catalog the collections from Oregon and California, a project that would continue for the rest of his life, culminating in the posthumously published *Phanerogamia of the Pacific Coast of North America*. Asa Gray

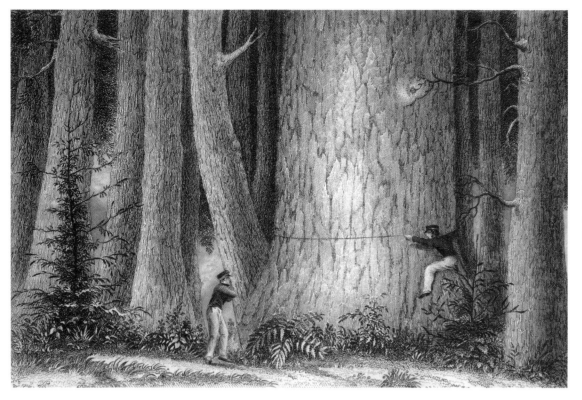

FIG. 7.11. Pine Forest, Oregon, in Charles Wilkes, *Narrative of the United States Exploring Expedition*, 1845, vol. V, opp. p. 116. Expedition artist Joseph Drayton illustrates topographers measuring a giant tree in a "pine forest," now more accurately identified as a grove of *Picea sitchensis* or Sitka spruce and *Pseudotsuga menziesii* or Douglas fir. The largest tree shown here was 39 feet 6 inches in circumference and approximately 250 feet high.

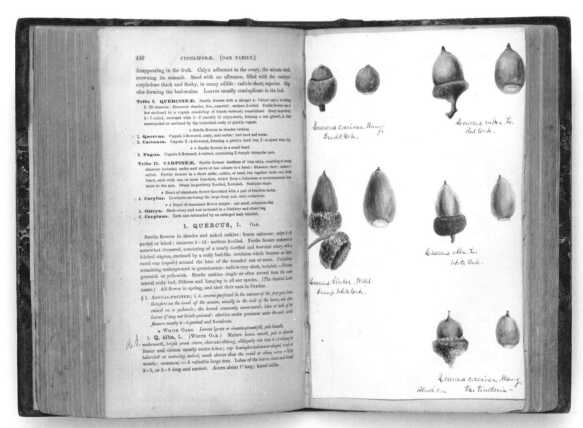

FIG. 7.12. Botanist William Whitman Bailey heavily annotated his 1868 copy of the ubiquitous *Manual of the Botany of the Northern United States* by Asa Gray, with marginalia and drawings, including this study of various acorns.

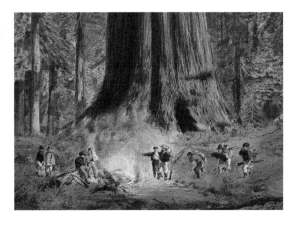

FIG. 7.13. *Sequoia wellingtonia*, in Edward Ravenscroft, *Pinetum Britannicum*, Edinburgh, 1884, vol. 3, plate 37 (detail).

took on the exotic Flora on condition that he be supported for a year of European study and consultation.[33]

In 1842 Gray became Professor of Botany at Harvard University, the first full-time position dedicated entirely to that science at an American institution.[34] Departing from New York removed him from close contact with Torrey, but propelled him to a position of authority at a time of enormous intellectual ferment in the sciences. It spurred him to create the second important herbarium in the United States at Harvard and accelerated his writing of textbooks at various levels. His *Manual of the Botany of the Northern United States* alone, first published in 1848 and dedicated to John Torrey, "established modern systematic American botany as a definitely organized science" and made it accessible to any interested reader. It evolved through eight editions in innumerable imprints over the following century, used by professionals and amateurs alike. One copy now in the Mertz Library, annotated and extra-illustrated by William W. Bailey, exemplifies its use as a botanist's working reference (fig. 7.12).[35]

By 1850 John Torrey and Asa Gray shared in stature as the leaders and national coordinators of American taxonomy during its most dynamic era of expansion and innovation.

THE BOTANICAL REPRESENTATION OF AMERICA

Throughout the first half of the nineteenth century, all of the most compelling printed images of American botanical specimens were published in Europe. Even later, no American illustrator could compete with the splendor of the giant sequoia in Edward Ravenscroft's *Pinetum Britannicum*, which absorbed this Californian species as a British tree and attached to it the botanically invalid name of an English military hero (fig. 7.13).

In 1845 Gray was introduced to the young artist Isaac Sprague (1811–1895), recently returned from assisting John James Audubon on an expedition to Missouri, and taught him how to study botanical specimens under a microscope and draw them accurately. Sprague brought a new level of precise visual representation to American botanical publication, satisfying a long-standing ambition to commission high-quality illustrations made in America for "a *national* work"—"national" in this context assimilating resident German-born artists and botanists as Americans (fig. 7.14 A–B).[36] Gray credited his artist with scientific abilities beyond drawing, and botanical illustration soon attained a new prominence in his work (fig. 7.15).[37]

Artists began to provide a new visual dimension to published reports of the exploratory expeditions. John Torrey and Asa Gray recommended Charles C. Parry and Charles Wright respectively as botanists for a survey of the new Mexican boundary by the Corps of Topographical Engineers led by Major William H. Emory in 1854. Torrey also recommended the Prussian topographical artist, surveyor, and naturalist Arthur Schott (1814–1875). Schott had previously illustrated Torrey's botanical appendix to Howard Stansbury's

FIG. 7.14 A–B. *Asclepias macrophylla* by Isaac Sprague, drawn for John Torrey's botanical report on specimens collected during exploration of a possible railroad route to the Pacific Ocean along the 35th parallel. The original drawing, Art and Illustration Collection 70 (left), corresponds with the lithograph (right), published in the Pacific Railroad Surveys, vol. V, 1855.

Exploration and Survey of the Valley of the Great Salt Lake of Utah, the original drawings for which are in the Botanical Art Collection of the Mertz Library.[38]

Schott wrote a letter to Torrey in 1855, conserved in The New York Botanical Garden's Archives, commenting on the excitement generated by the cacti, "the most striking features" among the indigenous plants, "which deserve more special attention on account of their being almost new in the representation of landscapes."[39] Never before had cacti been seen in profusion by artists, and those present celebrated their unique opportunity to present them to the public, most dramatically in a large frontispiece from a field sketch by Heinrich Balduin Möllhausen (fig. 7.16). When the botanical results of the Mexican Boundary Survey were published in Torrey's "Botany of the Boundary" in 1858, Dr. George Engelmann's (1809–1884) supplement on the cacti added seventy-five superb botanical studies drawn

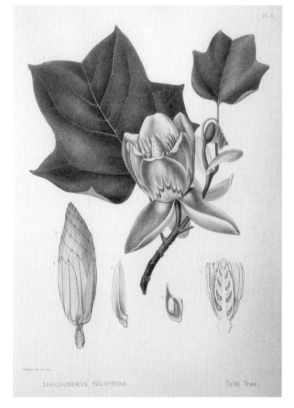

LIRIODENDRON TULIPIFERA. Tulip Tree.

FIG. 7.15. (left) *Liriodendron tulipifera* or tulip tree, by Isaac Sprague, published in Asa Gray's *Plates Prepared Between 1849 and 1850 to Accompany a Report on the Forest Trees of North America*, Washington, 1891, plate 8. Sprague's abilities contributed to a new prominence of botanical illustration in American publications.

FIG. 7.16. (p. 168) "View along the Gila," in George Engelmann's "Cactaceae of the Boundary," in the *Report on the United States and Mexican Boundary Survey*, 1859, vol. 2, opp. p. 78. The artist Heinrich Balduin Möllhausen drew this scene near the Colorado River showing an imposing saguaro cactus— now *Carnegiea gigantea*.

FIG. 7.17. (p. 169) Cactus species of the genus *Mammillaria*, one of the seventy-five illustrations provided by Paulus Roetter for George Engelmann's "Cactaceae of the Boundary," in *Report on the United States and Mexican Boundary Survey*, 1859, vol. 2, plate 9.

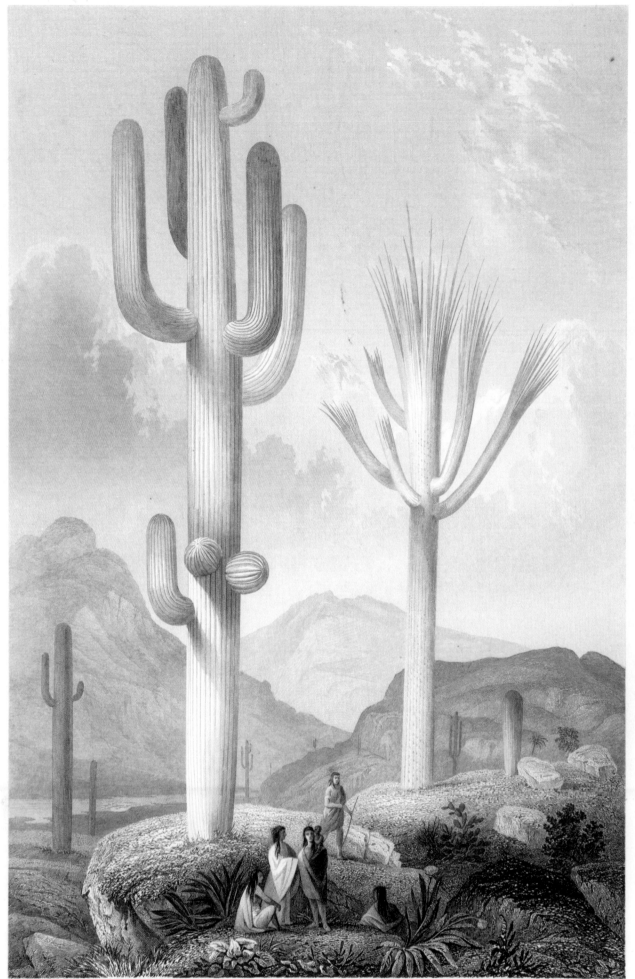

P. Roetter del. Rebuffet sc.

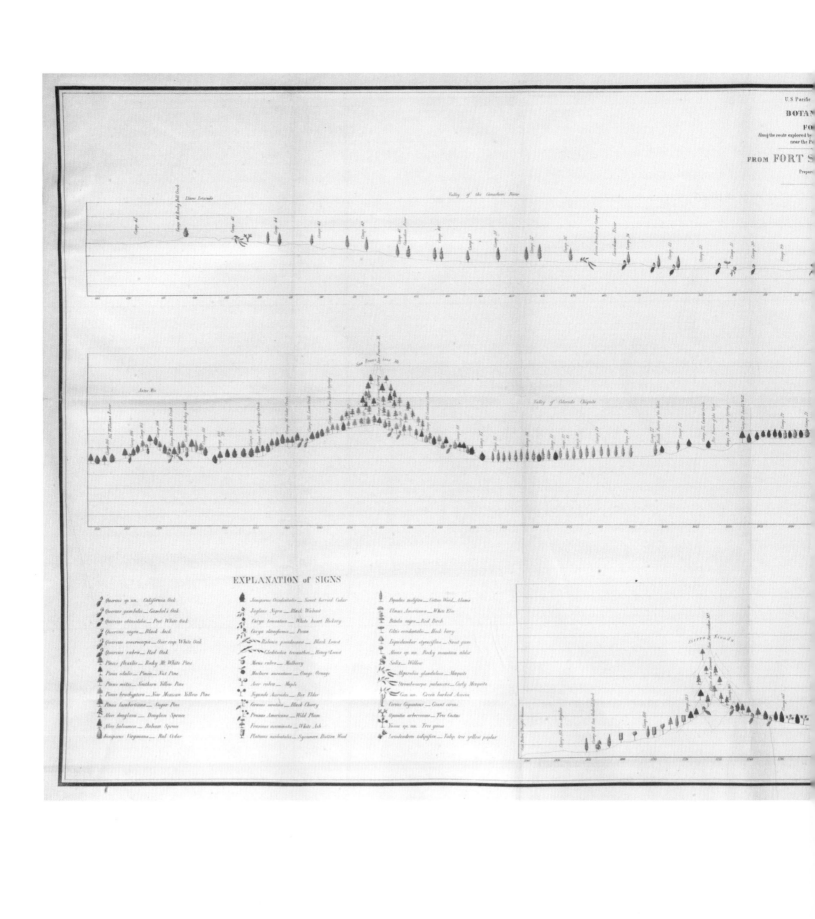

U.S Pacific

BOTAN...

FO...

Along the route explored by...
near the Po...

FROM FORT S...

Prepar...

EXPLANATION of SIGNS

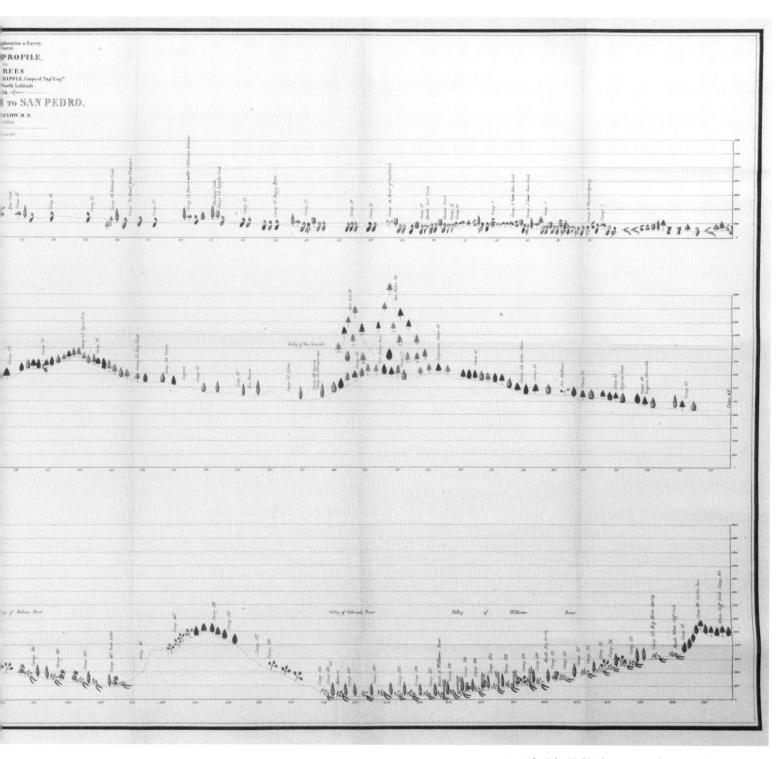

FIG. 7.18. John M. Bigelow prepared an innovative "Botanical Profile representing the Forest Trees Along the Route...," in his report, *Description of Forest Trees*, published in *United States Pacific Railroad Exploration and Survey,* 1856. This large sheet is printed in three bands that could be cut and attached to show the geographical sequence of tree species and their altitudes from right to left.

FIG. 7.19. As botanist for the U. S. Geological Exploration of the Fortieth Parallel, William Whitman Bailey kept a *Diary of a Journey in California and Nevada, 1867–1868*, providing an account of his remarkable expedition, which is illustrated by his own drawings and by some of the first photographs of the American West.

by Paulus Roetter (1806–1894) from collected specimens (fig. 7.17).

From 1853 to 1854, a series of expeditions known as the Pacific Railroad Surveys explored alternative routes across the West for a transcontinental railway. The journey led by Lieutenant Amiel W. Whipple along the 35th parallel from Arkansas to Los Angeles produced the most botanically interesting results, classified by Torrey in the final report (fig. 7.18). John M. Bigelow (1804–1878), one of twelve scientists accompanying the Whipple Expedition, created a profile representing the distribution of forty-two kinds of trees along the route. This extraordinary chart exemplifies interest in the new field of plant geography and demonstrates the pervasive influence of its originator Alexander von Humboldt, who first correlated tree species with altitude and devised new styles of mapping their distribution.[40]

One of the last government expeditions was the United States Geological Exploration of the Fortieth Parallel under Clarence King from 1867 to 1868. William Whitman Bailey (1843–1914), the first official botanist for the King expedition and later the first professor of botany at Brown University, wrote a manuscript diary full of description and anecdote now located in the Mertz Library, illustrated with his own drawings and with a few of the earliest photographs of the American West, taken by the expedition photographer Timothy H. O'Sullivan (fig. 7.19).[41]

FLORA ACCOMPLISHED

John Torrey died in 1873, acclaimed as the great taxonomist of North American botanical discovery; author of thousands of new species; founder of one of the most important herbaria in the country at Columbia College—now at The New York Botanical Garden—and a formative influence on those of Harvard University and the Smithsonian Institution; a developer of the science programs and advisor to many colleges, universities, and scientific organizations; mentor and friend of the first generations of professional botanists in the United States, most notably Asa Gray. In the same year, Gray retired from teaching, carrying on at Harvard with his essential theoretical contributions and with the Flora of North America in his role as the central national clearinghouse of botanical classification and publication. Their joint mission, to organize and classify for science the flora of a vast continent, was accomplished to the extent possible at that time.

With the establishment of The New York Botanical Garden soon after, its first director, Nathaniel Lord Britton (1859–1934), made the Garden an important center of ongoing taxonomic research. With Addison Brown (1830–1913), Britton launched a new attempt to integrate regional studies into the first fully *illustrated* comprehensive survey of the American flora from Virginia northward, including Canada, published from 1896 to 1898.[42] By 1901, while The New York Botanical Garden sponsored explorations focusing on new areas of the United States, Britton and the

Garden began to prepare the first Flora since Torrey and Gray to encompass all of North America, reclassified according to the American Code.[43] In 1930 Henry A. Gleason, Head Curator of The New York Botanical Garden, revised Britton's and Brown's publication. Working with Garden scientist Arthur Cronquist, Gleason also produced *Manual of Vascular Plants of Northeastern United States and Adjacent Canada*.[44] Leading botanists continued to produce an encompassing series of regional Floras conducted throughout the twentieth and into the twenty-first century.[45] After explorations and research that extended over a period of forty years, Arthur Cronquist, Noel Holmgren, Patricia Holmgren, and other collaborators completed the six-volume *Intermountain Flora*, published in 2012.[46] Related work continues with the discovery of new species, rapidly changing habitats, and new understandings of molecular relationships. As informed understanding of ecosystems becomes increasingly important in the preservation of biodiversity, ongoing endeavors have achieved a scale and synthesis of detailed knowledge surpassing the most ambitious visions of early American botanists, even the aspirations of John Torrey and Asa Gray.

ENDNOTES

1. Jacques Philippe Cornut, *Canadensium plantarum* (Paris: Simon le Moyne, 1635). All of the primary sources cited in this chapter can be found in the Mertz Library, many of them in multiple editions.

2. William Jackson Hooker, *Flora Boreali-Americana; Or, The Botany of the Northern Parts of British America...*, 2 vols. (London: H.G. Bohn, [1829]–1840). The copy presented by Hooker to John Torrey is located in the Mertz Library.

3. Jefferson's exhortation is quoted in John C. Greene, *American Science in the Age of Jefferson* (Ames: Iowa State University Press, 1984), 253.

4. Manasseh Cutler, "An Account of Some of the Vegetable Productions, Naturally Growing in this part of America, Botanically Arranged," *Memoirs of the American Academy of Arts and Sciences*, vol. 1 (1785), 396–493.

5. Humphry Marshall, *Arbustrum Americanum: the American Grove...*(Philadelphia: printed by Joseph Crukshank, 1785), v–vii. David Andrews has given to the Mertz Library a collection of uncut sheets of pages from this work.

6. William Bartram, *Travels through North and South Carolina, Georgia, East and West Florida...*(Philadelphia: Printed by James & Johnson, 1791).

7. François-André Michaux, *The North American Sylva; or, A Description of the Forest Trees of the United States, Canada, and Nova Scotia, Considered Particularly with Respect to their Use in the Arts, and their Introduction into Commerce...*(Philadelphia: J. Dobson, 1841–1849). David Andrews Collection.

8. Henry Muhlenberg, *Catalogus plantarum Americae Septentrionalis* (Lancaster, PA: William Hamilton for the author, 1813). The Mertz Library has Lewis von Schweinitz's copy, also John Torrey's copy of the 1818 edition, inscribed "Those species which are underlined are in the Herbarium of J.T." James A. Mears, "Some Sources of the Herbarium of Henry Muhlenberg," *Proceedings of the American Philosophical Society* 122, no. 3 (June 9, 1978), 155, states the priority of this herbarium, now located at the Academy of Natural Sciences in Philadelphia.

9. Benjamin Smith Barton, *Elements of Botany*, 2 vols. (Philadelphia: for the author, 1803). The definitive monograph on Barton is Joseph and Nesta Ewan, *Benjamin Smith Barton, Naturalist and Physician in Jeffersonian America* (St. Louis: Missouri Botanical Garden Press, 2007).

10. Jeannette E. Graustein, *Thomas Nuttall Naturalist: Explorations in America 1808–1841* (Cambridge: Harvard University Press, 1967), 18–19, 38–39.

11. Joseph Ewan, "Frederick Pursh, 1774–1820, and his Botanical Associates," *Proceedings of the American Philosophical Society* 96, no. 5 (October 1952), 599–628.

12. Aylmer Bourke Lambert, *A Description of the Genus Pinus*, 2 vols. (London: T. Bensley for J. White, 1803 and 1824).

13. Frederick Pursh, *Flora Americae Septentrionalis, or, A Systematic Arrangement and Description of the Plants of North America...*, 2 vols. (London: Printed for White, Cochrane, and Co., 1814). Of the five copies in the Mertz Library, copy one belonged to John Torrey and has his annotations; copies 2 and 5 have hand-colored plates.

14. Ethel M. McAllister, *Amos Eaton, Scientist and Educator, 1776–1842* (Philadelphia: University of Pennsylvania Press, 1941), 212–262, on Eaton's botanical work. The Mertz Library has all eight editions of Eaton's *Manual of Botany*; as well as his

other botanical books. Almira Hart Lincoln Phelps'
Familiar Lectures on Botany, the textbook intended
especially for girls, exists in twenty-six (!) imprints
on the Mertz shelves. Emanuel D. Rudolph, "Almira
Hart Lincoln Phelps...and the Spread of Botany in
Nineteenth Century America," *American Journal of
Botany* 71, no. 8 (1984): 1161–1167.

15. Thomas Nuttall, *The Genera of North American Plants
and a Catalogue of the Species, to the Year 1817*, 2
vols. (Philadelphia: Printed for the Author by D. Heartt,
1818). Graustein, 120–128. According to Graustein, this
"landmark in American botany initiat[ed] the shift of
the study of North American plants from the eastern
hemisphere to the western.... It surpassed Michaux's
Flora and in quality far outranked Pursh's." The Mertz
Library has every volume published by Nuttall in its
original edition with the original paper boards in the
David Andrews Collection.

16. William P.C. Barton, *A Flora of North America*, 3 vols.
(Philadelphia: M. Carey & Sons, 1820–1823), v–ix. The
Mertz Library has the only known copy of vol. 1 in its 12
original parts, beginning in August 1820.

17. Quotation from a review of John Torrey, *A Flora of the
Middle and Northern Sections of the United States*, in
The American Journal of Science and Arts 7 (1824), 192.

18. A finding aid posted on line at library.nybg.org/
finding_guide/archv/torrey_ppf.html, outlines Torrey's
incoming correspondence in the Archives, including
leaders and botanists of U.S. exploratory expeditions.
Torrey's herbarium, including many contributions
from collectors such as Henry Muhlenberg, was also
transferred to The New York Botanical Garden.

19. John Torrey, *A Catalogue of Plants Growing Sponta-
neously within Thirty Miles of the City of New York*
(Albany: printed by Websters and Skinners for the
Lyceum of Natural History of New York, 1819). The eight
copies of this work located in the Mertz Library include
John Torrey's own interleaved and annotated volume.
Torrey's letter to Amos Eaton is quoted in Andrew
D. Rodgers, *John Torrey, a Story of North American
Botany* (Princeton, 1942; reprinted New York: Hafner,
1965), 24–25. Rodgers also cites Torrey's letter to
Lewis von Schweinitz of 1821. On John Torrey's work
with the Lyceum of Natural History, see Simon Baatz,
*Knowledge, Culture, and Science in the Metropolis:
the New York Academy of Sciences, 1817–1970*
(New York: The New York Academy of Sciences, 1990),
25–29, 35–36. The Mertz Library has a complete run
of the *Annals of the Lyceum of Natural History of
New York*, 1824–1877.

20. John Torrey, *A Flora of the Northern and Middle
Sections of the United States...*, (New York: Swords,
1824). Stephen Elliott, *A Sketch of the Botany of
South-Carolina and Georgia* (Charleston: J. Hoff, 1816–
1821, 1824). Elliott dedicated his book to the memory
of Henry Muhlenberg. The deliberate relationship
between these works was mentioned by Asa Gray in
his obituary of Torrey, *American Journal of Science
and Arts*, (June 1873), 5, 30.

21. Hooker to Torrey, September 9, 1824; Archives NYBG,
Torrey Papers, Folder 5.20: "American Botanical intel-
ligence will now be more valuable to me than ever:
because...[Dr. Richardson] & myself have the intention
of publishing a Flora of the British possessions & of
the Arctic regions of N. America.... I have been the
means of sending two Botanists from Scotland to the
N.W. coast of America. They are on their way to the
mouth of the Columbia, where one will return over-
land...[while the other will] spend 2 years among the
rocky mountains...."

22. Lewis David von Schweinitz to Torrey, September
21, 1823; Archives NYBG, Torrey Papers, Folder 7.31.
Schweinitz was the close friend and collaborator of
Torrey's earlier career.

23. John Torrey's paper on James' Rocky Mountain plants
was read to the Lyceum of Natural History on Decem-
ber 11, 1826 and published in the following *Annals*.

24. John Lindley, *An Introduction to the Natural System
of Botany...*(New York: G. & C. & H. Carvill, 1831). John
Torrey, *Catalogue of North American Genera of Plants:
Arranged according to the Orders of Lindley's Intro-
duction to the Natural System of Botany...*(New York:
Sleight & Robinson, 1831).

25. John Torrey, *A Flora of the State of New-York* (Albany:
Carroll and Cook, printers to the Assembly, 1843).

26. Rodgers, 1942/1965, 78–86, 309.

27. John Torrey and Asa Gray, *A Flora of North America...
Arranged According to the Natural System* (New York,
London, and Paris: Wiley & Putnam [etc.], 1838–1843).

28. On the history of the United States exploratory expe-
ditions, see William H. Goetzmann, *Army Exploration
in the American West, 1803–1863* (New Haven: Yale
University Press, 1959; Lincoln: University of Nebraska
Press, 1979). See also Susan Delano McKelvey,
*Botanical Exploration of the Trans-Mississippi West
1790–1850* (Jamaica Plain: Arnold Arboretum, 1955).

29. Stanley L. Welsh, *John Charles Frémont, Botanical
Explorer* (St. Louis: Missouri Botanical Garden Press,
1998), 13–17. See also Donald D. Jackson and Mary L.
Spence, eds., *The Expeditions of John Charles Frémont*,
vols. 1–3 (Urbana: University of Illinois Press, 1970).
James L. Reveal, *Gentle Conquest: the Botanical
Discovery of North America* (Washington, DC: Library
of Congress and Starwood, 1992), 124.

30. Joseph Nicollet to John Torrey, February 18, 1841,
Archives NYBG, Torrey Papers, Folder 6.51. Torrey's
report was appended to J.N. Nicolet, *Report Intended
to Illustrate a Map of the Hydrographical Basin of the
Upper Mississippi River* (Washington: Blair and Rives
for the U.S. House of Representatives, 1845), 143–165.

31. John Charles Frémont to John Torrey, November 16,
1842, Archives NYBG, Torrey Papers, Folder 4.12. John
Torrey, *Plantae Frémontianae, or, Descriptions of
Plants Collected by Col. J.C. Frémont in California*
(Washington City: Smithsonian Institution, 1853).

32. Charles Wilkes, *Narrative of the United States Exploring Expedition*, 5 vols. and an atlas (Philadelphia: Lea & Blanchard, 1845). The three published botanical volumes are also present at the Mertz Library. Eight letters from Charles Wilkes to John Torrey, 1847–1858 are contained in Folder 8.18 of the Torrey Papers, Archives NYBG.

33. Richard H. Eyde, "Expedition Botany: the Making of a New Profession, in Herman J. Viola and Carolyn Margolis, eds., *Magnificent Voyagers: the U.S. Exploring Expedition, 1838–1842* (Washington, D.C.: Smithsonian Institution Press, 1985), 25–41. The definitive biography of Gray is A. Hunter Dupree, *Asa Gray, 1810–1888* (Cambridge: Harvard University Press, 1959; revised edition Baltimore: The Johns Hopkins University Press, 1988), 185–196. John Torrey, *Phanerogamia of the Pacific Coast of North America* (Philadelphia: C. Sherman, 1862, 1874).

34. Dupree 1959, 110–114 ff., called Gray the first American to support himself as a full-time professional botanist. Torrey had to work outside of botany throughout his adult life for an income, first as a doctor, then as a professor of chemistry and assayer of the Mint.

35. Asa Gray, *A Manual of Botany of the Northern United States* (Boston: J. Munroe, 1848). The Mertz Library holds nineteen nineteenth-century imprints of this title. On the importance of this book, see Rodgers 1942/1965, 209. William W. Bailey's copy of the 1868 edition also contains a note from Asa Gray to Bailey congratulating him on his marriage.

36. "The engravings could be done cheaply in France, but this would not be creditable to us in managing a *national* work...it must be altogether American." Torrey letter to Charles W. Short, October 1831; quoted in Rodgers 1942, 100. Emanuel D. Rudolph, "Isaac Sprague, 'Delineator and Naturalist,'" *Journal of the History of Biology* 23, no 1 (1990), 91–126. Dupree 1959, 166–168.

37. Asa Gray and Isaac Sprague, *Genera Florae Americae Boreali-Orientalis Illustrata...*, 2 vols. (Boston: James Munroe; New York and London: John Wiley, 1848–1849), and the only much later published, *Plates Prepared Between...1849...1850 to Accompany a Report on the Forest Trees of North America* (Washington: Smithsonian Institution, 1891).

38. Emory's frequent letters to John Torrey over ten years beginning in 1847 are located in the Torrey papers, Folder 4.1 and have been digitized and posted on line via the Library's catalog. Schott's drawings for this report are in Collection 70 (Pacific Railroad Reports) of the Botanical Art Collection. Howard Stansbury et al., *Exploration and Survey of the Valley of the Great Salt Lake of Utah...*, (Philadelphia: Lippincott, Grambo & Co., 1852), 383–397; also the official Washington printing the following year. Parry's descriptive letters to Torrey from 1846 to 1868, including his experiences with the Mexican Boundary Survey, have been posted online by the Mertz Library.

39. Letter from Arthur Schott to John Torrey [1855]; Archives NYBG, Torrey Papers, Folder 7.29. For a thorough discussion of Schott's contributions to the Emory Expedition, see "Arthur Schott, Marking the Mexican Boundary," in Robin Kelsey, *Archive Style: Photographs and Illustrations for U.S. Surveys, 1850–1890* (Berkeley: University of California Press, 2007), 19–72.

40. John M. Bigelow, "Botanical Profile Representing the Forest Trees Along the Route Explored by Lieut. A. W. Whipple, Corps of Topl. Engrs. near the Parallel of 35° north latitude, 1853–1854, from Fort Smith to San Pedro," in *Reports of Explorations and Surveys, to Ascertain the most Practicable and Economical Route for a Railroad from the Mississippi River to the Pacific Ocean...*, vol. 4: "Report on the Botany of the Expedition" (Washington, DC, [1857]), between pp. 26–27. John Torrey, "Descriptions of the General Botanical Collections," *idem.*, vol. 4, 59–161 and 25 plates.

41. William Whitman Bailey, "Diary of a Journey in California and Nevada, 1867–1868," manuscript in the Rare Book Room. Bailey's correspondence from 1867 to 1904 is also located in the Mertz Library.

42. Nathaniel Lord Britton and Addison Brown, *An Illustrated Flora of the Northern United States...*, 3 vols. (New York: Charles Scribner, 1896–1898). A revision by Henry A. Gleason was first published in 1952.

43. Nathaniel L. Britton et al., *North American Flora*, 34 vols., 1905–1957. On the gestation of this North American Flora, see Gleason, "The Scientific Work of Nathaniel Lord Britton," *Proceedings of the American Philosophical Society* 104, no. 2 (April 19, 1960): 222–223.

44. Henry A. Gleason, *Manual of Vascular Plants of Northeastern United States and Adjacent Canada* (Princeton, NJ: Van Nostrand [1963]).

45. Other authors who, in addition to Britton, Brown and Gleason, contributed significantly to the history of regional American Floras include Axel Rydberg (1860–1931), John Kunkel Small (1869–1938), and David D. Keck. Several important researchers who co-published with Arthur Cronquist (1919–1992), were Charles Leo Hitchcock (1902–1986), Marion Ownbey (1910–1974), and J. W. Thompson (1890–1978).

46. Arthur Cronquist et al., *Intermountain Flora: Vascular Plants of the Intermountain West, U.S.A.*, 6 vols. (New York: The New York Botanical Garden Press, 1972–2012). The illustrations made for this publication are deposited in the Art and Illustration Collection of the Mertz Library.

CELEBRATED

The remarkable development of America's own vision

WORKS ON

for landscape design, gardening tradition, botany, horticulture,

AMERICAN

and horticultural commerce, from the early Republic

GARDENING

through the early twentieth century, is expressed in books,

AND

nursery catalogs, diaries, and correspondence.

HORTICULTURE

Engraved vignette on the title page, in Humphry Repton,
*The Landscape Gardening and Landscape Architecture of the
Late Humphry Repton, Esq...,* by J. C. Loudon, London, 1840.

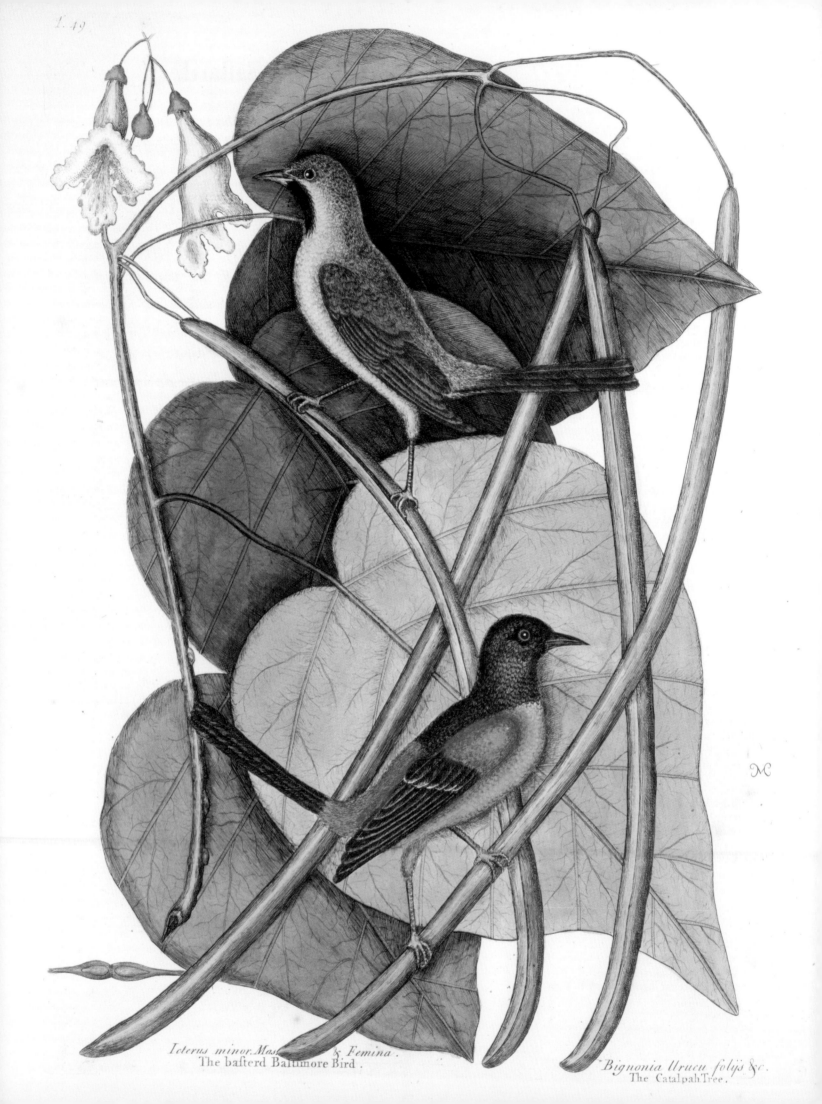

T. 49

Icterus minor. Mas & *Femina* .
The basterd Baltimore Bird .

Bignonia Urucu folijs &c.
The Catalpah Tree .

EARLY AMERICAN HORTICULTURAL TRADITIONS: GARDENING WITH PLANTS FROM THE NEW WORLD

MARK LAIRD

During the last decades of the eighteenth century, colonial traditions slowly gave way to the creation of a new Republic. A selection of books and documents from the LuEsther T. Mertz Library provides the opportunity to tell the story of reciprocal relationships between Old World and New World botany-*cum*-horticulture in this period through the study of natural histories, nurseries, botanical gardens, and horticultural societies. By looking at the early natural histories of America, especially those by Mark Catesby (1683–1749), André Michaux (1746–1802), and François-André Michaux (1770–1855), it becomes clear how the introduction of American plants to Europe changed the nature of landscape gardening in England, with explorations having an equally profound effect on the nursery trade and horticultural activities in the early Republic.

From the early nineteenth century onward, American-born researchers began producing their own botanical and horticultural books, thereby breaking a long tradition of foreigners being the primary writers on New World botany and horticulture (see chapter 7).[1] Within the new Republic, the American scientific community's autonomy from the Old World was also being defined anew: through medico-botanical activities undertaken at the Elgin Botanic Garden, established in New York City in 1801 by the noted physician David Hosack (1769–1835), and through the New York Horticultural Society, founded in 1818.[2] During that period, the first important American nurseries of the Bartram family in Philadelphia and the Prince family on Long Island, New York—both established in the eighteenth century—were still thriving. By 1826, the notable Scottish garden architect John Claudius Loudon (1783–1843) acknowledged the remarkable advances in botany and horticulture in the New World in his *Gardener's Magazine*:

> At one time the country was chiefly known by the investigations of Europeans; but now there are the native names of Hosack, Elliot, Nuttall, Torrey, Barton, Bigelow, and others, all of which deserve honourable mention for their exertions in the protection or prosecution of native botanical investigations, and some of whom are held in high estimation even among Europeans. There is also a horticultural society established in New York.[3]

Clearly North America was taking its place in "Garden Botany" alongside Europe as a source and promoter of "botanical wealth."

FIG. 8.2. Colored engraving of *Catalpa bignonioides*, in Mark Catesby, *Natural History of Carolina, Florida and the Bahama Islands*, London, 1729–1747, vol. 1, plate 49. The *Catalpa*, introduced from South Carolina in the early 1720s, was one of Mark Catesby's most successful acclimatized "exotics" for English gardening.

EARLY NATURAL HISTORIES OF AMERICA AND EUROPEAN "ARBOREOMANIA"

An influx of exotic plants had occurred in the seventeenth century throughout Europe, due to world-wide mercantile expansion. Yet it was not until the early eighteenth century that more sophisticated hot houses allowed for the cultivation of succulents and tropical species in botanical gardens, such as those displayed in the "theatre" of Chelsea Physic Garden in London (fig. 8.1). These garden theatres attempted to present a complete assortment of the floras of the known world, including the new American continent.[4] From the mid-seventeenth century onward, a succession of naturalists had contributed to the knowledge of New World botany. From England, John Tradescant and his son made voyages to Virginia in 1637, 1642, and 1654; their *Musæum Tradescantianum* of 1656 lists the rarities collected there.[5] In 1678, John Banister reached Virginia, and, by 1686, John Ray's *Historia plantarum* began to reflect expanding botanical studies.[6] During the 1680s, John Banister sent plants to Henry Compton, Bishop of London, who cultivated these prized "exotics" in his Fulham garden.[7] Among them was *Magnolia virginiana*, the first *Magnolia* to be cultivated in Europe. By the 1690s, *virtuosi* at the Temple Coffee House in London were informally dispersing such newly introduced exotics. Wider distribution through the nursery trade occurred a few decades later.[8]

A catalyst for the increased interest in New World plants, was the publication of Mark Catesby's *Natural History* (1729–1747), represented by no less than five copies in the Mertz Library.[9] Catesby had already traveled to Virginia in 1712, but it was the 1722 to 1726 voyage which began in Charleston, South Carolina, that resulted in a new era of botanical exploration in that colony. The impact on gardening in England was profound and led, among other things, to shrubberies—eventually called "American gardens." These were "theatres" or display plantations of acclimatized woody plants, especially ericaceous plants such as *Rhododendron* and *Kalmia*. The impact of Catesby's introductions is epitomized by the one *Catalpa bignonioides* that grew in the Prince of Wales' Carlton House garden in London in the mid-1730s (fig. 8.2). This thirteen-foot specimen cost a fortune at three guineas, but *Catalpa* soon became widely affordable through nurseries. By 1755 nurseryman John Williamson supplied English landscape gardener Lancelot "Capability" Brown at Petworth, Sussex, with three *Catalpa*, costing only 1s 6d each.[10] Among late eighteenth- and early nineteenth-century references to American trees in England is an account by the author and farmer William Cobbett (1763–1835). He describes the beautiful plantation of American trees round his Oxfordshire homestead: "the seeds of which were sent me, at my request, from Pennsylvania in 1806, and some of which [are] now nearly forty feet high."[11]

A mania for Catesby's American exotics is best illustrated by the introduction to England and acclimatization therein of *Magnolia grandiflora*.[12] This European "Arboreomania,"[13] pursued by the Duke of Richmond and Lord Petre among others, was further promoted by new collectors of American plants, including John Clayton, and Johan Frederik Gronovius,

CELEBRATED WORKS
ON AMERICAN
GARDENING AND
HORTICULTURE

FIG. 8.1. "The Upright of the Greenhouse and Stoves," an engraving of the Chelsea Physic Garden, in Philip Miller, *Gardeners Dictionary*, 1st ed., London, 1731. The ground plan of the two-story structure, flanked by stoves for succulents and tropical plants, shows an arrangement of potted exotics in a "theatre" of four quarters.

who published *Flora Virginica* from 1739 to 1743.[14] But it was the owners of the great Philadelphia nursery, John Bartram (1699–1777) and his son William (1739–1823), who consolidated the commercial export of woody plants through Peter Collinson (1694–1768) in London. Their role was extended by royal prerogative at the Royal Botanic Gardens at Kew until the Revolution.[15] William Prince's New York nursery served a local clientele interested primarily in fruit-growing and viticulture and was thus in no way a competitor for the overseas market in American woody species.[16] After the Revolution, new initiatives came from France. André Michaux—trained as a botanist by Bernard de Jussieu (1699–1777), and having worked with Jean Baptiste de Lamarck (1744–1829)—was sent to America in 1785 by the French government to collect species useful in food or medicine. Michaux wrote in dismay from New York in 1786: "One cannot count on nurserymen here as in Europe where one finds the products of distant lands gathered together in a garden. There are no informed people here, not even amateurs. There is only one nurseryman [William Prince], noted for pears and apples."[17] Hence, in 1786, a nursery garden for native plants was established by the Michaux in New Jersey, on a branch of the Hackensack River from where, over the next ten years, thousands of trees were shipped back to France.

A second nursery was established at Charleston, South Carolina, in fall 1786.[18] It remained under François-André's care until 1790. From Charleston, the Michaux traveled to northern Florida in 1788 and to the Bahamas in 1789, with the elder Michaux also venturing into Canada. Plans to explore the American West faltered, and it was left to the legendary explorers Lewis and Clark under Thomas Jefferson's instructions to realize between 1804 and 1806 what might have been the ultimate

Michaux legacy. The remarkable Michaux legacy *in print*, however, is abundantly represented in the Mertz Library, which has indeed the most complete set of published materials anywhere: twenty-six titles and editions of a total of thirty-nine listed in Ian MacPhail's *André & François-André Michaux*.[19] In his *Natural History*, Mark Catesby had advanced the argument that color was essential to natural history illustration. Yet the expense of hand-coloring proved a difficulty in financing his work. The twenty species and sixteen varieties of oak in André Michaux's *Histoire des chênes de l'Amérique,* were featured in impressive black-and-white engravings (fig. 8.3).[20] This study of the genus *Quercus* in eastern North America was first published in 1801.[21] Of the thirty-six engravings, thirty-two are from drawings by the artist Pierre-Joseph Redouté (1759–1840), the remaining by his brother, Henri-Joseph (1766–1852). By the time François-André Michaux's first volume of *Histoire des arbres forestiers de l'Amérique Septentrionale* appeared in Paris in 1810, however, it had colored illustrations.[22] The color plates were printed by a new technique known as stipple engraving—using tiny dots rather than lines—a process perfected by Redouté to help build tonality, as is clearly visible in a print of the Bartram oak, named after John Bartram (fig. 8.4).[23]

EARLY NURSERIES IN AMERICA

The nursery profession in America was already flourishing in Boston by 1719,[24] but it was John Bartram who established the first American nursery of great distinction in Philadelphia in 1728. He was first in a line of four generations who worked in the family business in Kingsessing, Philadelphia, from the early eighteenth up to mid-nineteenth century. When the nursery closed, the garden with its surviving

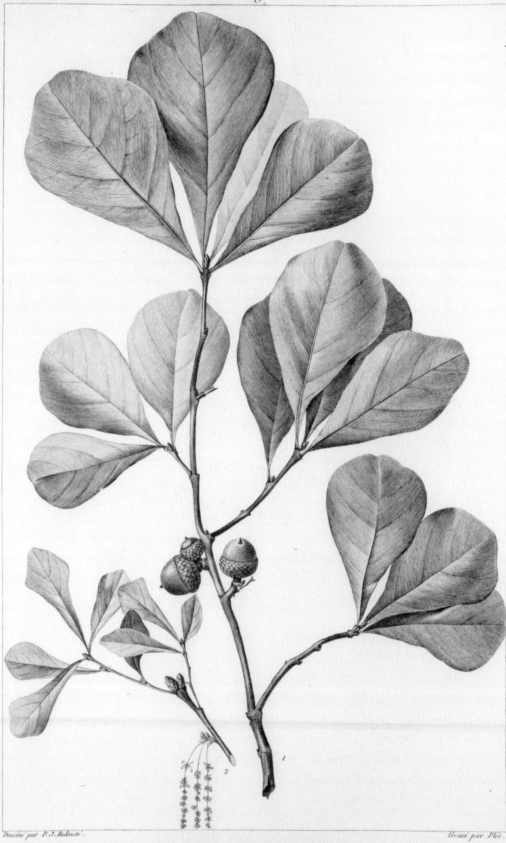

Dessiné par P. J. Redouté. Gravé par Plée.

QUERCUS aquatica.

FIG. 8.3. *Quercus aquatica* or water oak, engraved by Auguste Plée after a drawing by Pierre-Joseph Redouté, in André Michaux, *Histoire des chênes de l'Amérique*, Paris, 1801. This oak, shown in plate 19, proved to be rarely grown in English gardens.

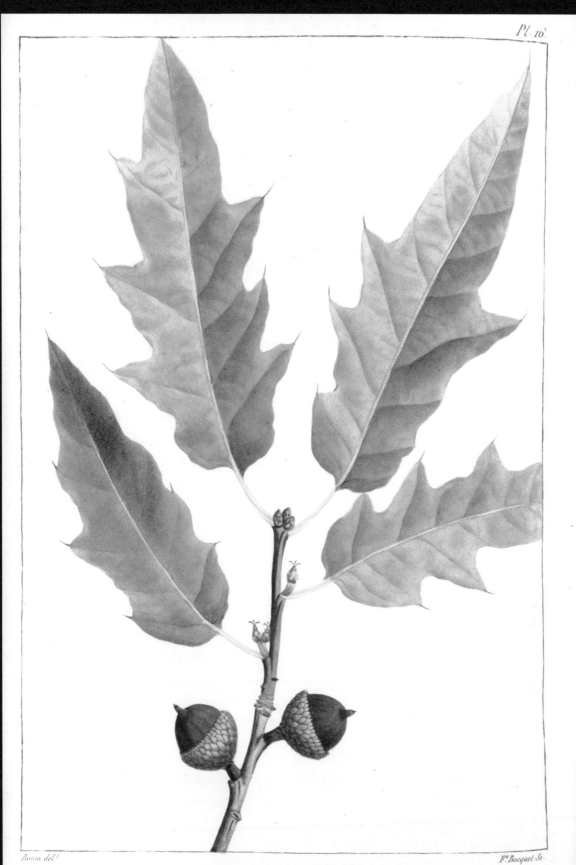

Pl. 16.

Bossa del.

F.º Bocquet Sc.

QUERCUS heterophilla.

Bartram's Oak.

FIG. 8.4. *Quercus heterophylla* named "Bartram's Oak," in François-André Michaux, *Histoire des arbres forestiers de l'Amérique Septentrionale*, Paris, 1810–1813, vol. 2, plate 16. Michaux found the species in a "field belonging to Mr. Bartram." William Bartram gave him young shoots to preserve the species in public gardens of the early Republic.

trees, notably a huge swamp cypress, continued to attract visitors (fig. 8.5). The Bartrams made their living through the exchange of plants and natural history specimens with collectors around the world, particularly Peter Collinson in London, thus expanding what Mark Catesby had initiated. While lists of Bartram export plants survive from the 1750s to 1760s, and copies of his *Observations* (1751) are in the Library,[25] the *Catalogue* of 1783, issued by Bartram's sons, is key to establishing what American species they grew and sold. Over two hundred were itemized, a total that serves as a benchmark in relationship to other nurseries, especially William Prince's New York nursery, and to later published Bartram catalogs. For example, William Bartram's 1807 *Catalogue of Trees, Shrubs, and Herbaceous Plants, Indigenous to the United States of America* lists more than 1,500 species—1,057 natives and 482 exotics—suggesting how botanical collections overlapped with stock for commercial sale.[26] William Bartram's boxed collection of forty-five "curious" species of 1792 included plants discovered on his southern explorations that were publicized in his *Travels through North and South Carolina, Georgia, East & West Florida* (fig. 8.6).

The Mertz Library holds a comprehensive collection of books and manuscripts by William Prince Jr. (1766–1842) and his son William Robert Prince (1795–1869), who maintained the family nursery originally established in 1737 at Flushing, Long Island by William Prince Sr. (1725–1802). In the 1750s the garden opened as a commercial venture, referred to in catalogs and newspaper advertisements as "*The Linnaean Botanic Garden and Nurseries, William Prince & Sons, Proprietors.*" An anonymous report of 1767 recorded: "For sale at William Princes nursery, Flushing, a great variety of fruit trees, such as apple, plum, peach, nectarine, cherry, apricot, and pear."[27] The many catalog publications,

FIG. 8.5. *Taxodium distichum* or swamp cypress, in *The Horticulturist and Journal of Rural Art and Rural Taste*, vol. 10, 1855, p. 372. The old cypress was said to have grown to maturity in Bartram's Garden at Kingsessing, Philadelphia in 1855 and was reported to be 125-feet tall, with a circumference of 20 feet.

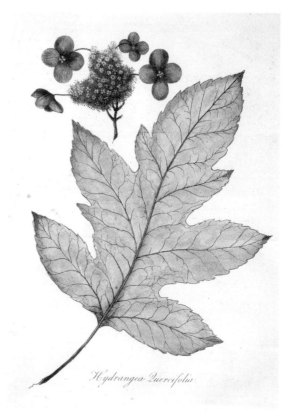

Hydrangea Quercifolia

FIG. 8.6. *Hydrangea quercifolia*, in William Bartram, *Travels through North and South Carolina, Georgia, East & West Florida, etc.*, Philadelphia, 1791, plate 6. Bartram likely had no living plants of *H. quercifolia* in Philadelphia before receipt of a Michaux shipment in spring 1791. *H. quercifolia* was introduced to English gardens in 1803.

selling greenhouse plants, shrubs, vines, herbaceous plants, and bulbous roots, started in 1777 and would continue uninterrupted into the 1840s. In the 21st edition of the *Catalogue of Fruit and Ornamental Trees and Plants* of 1822, William Prince Jr. proudly explained how far their enterprise had come since their father began ornamenting his private garden with a few trees. They had seized lucrative opportunities to develop the "first extensive fruit collection in America."[28] In *A Short Treatise on Horticulture* of 1828, Prince further promoted his business,[29] which Benjamin Prince had defined in 1822 as an ordering of merchandise: "we keep as correct a book as any one in the mercantile line, in which each square is recorded, with its boundaries; and each row has its different variety."[30] The

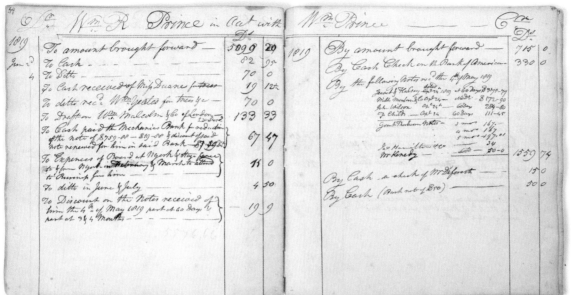

Prince Account Book, 1815 onward (fig. 8.7),
points to the operating methods pursued with
notable clients in New York, as well as abroad,
including William Malcolm of the renowned
Kennington nursery in London.

The Prince catalogs are organized to
showcase fruit trees, and "Indigenous Vegetable
productions of our own country generally,"
but also with a view to medicine. The medical-
botanical connection is borne out by the actual
use of the Prince catalogs within the medical
establishment of the day. In fact, Prince's 1820
*Catalogue of American Indigenous Trees, Plants,
and Seeds* in the Mertz Library first belonged to
the pre-eminent botanist and physician Samuel
Mitchill (1764–1841), who personally received
this inscribed copy from William Robert Prince
(fig. 8.8 A–B). It would later become part of
John Torrey's (1796–1873) collection. Mitchill
taught chemistry, botany, and natural history
at Columbia College from 1792 to 1801, and
was founding editor of the *Medical Repository*,
the first medical journal in the United States.
The medico-botanical-*cum*-horticultural links
among the Prince nursery, Columbia College and
David Hosack's Elgin Botanic Garden mark out
these distinct New York initiatives of the early

Republic. By contrast, Bartram's study of nature
in Philadelphia was a revolutionary way to grow
plants by natural habitats, and the emphasis was
on the export of natives as "exotics."[31]

The well-known botanists Benjamin Barton
(1766–1815) and Jacob Bigelow (1786–1879)
were among the first to make a significant
contribution to the development of the medical
sciences, producing publications that invariably
belonged to the "History of Botany" curricula
at American universities. David Hosack's 1795
Syllabus of the Course of Lectures on Botany
for Medical Students at Columbia College,
otherwise largely based on European titles, lists
all their works.[32]

As Hosack's writings indicate, medicinal
plants were still stocked along with culinary
and ornamental trees, and flowering and
greenhouse plants. Yet the section "Medicinal
and Culinary Exotics" amounts to a listing of
dozens of edible plants with a few apothecary
species thrown in, perhaps implying a decline of
"physic" plants with the rise of comestible and
ornamental plants. A combined look at Hosack's
and Prince's publications of the 1820s indicates,
therefore, the increased focus on ornamental
horticulture or floriculture. The Prince's rose

Image of pages 18–19 of *Hortus Marybonensis*:

Page 18 — PENTANDRIA MONOGYNIA.

2 Canadense, — Canadian
3 Appendiculatum,

LYSIMACHIA, — LOOSE STRIFE.
1 stricta, — bulb-bearing
2 Thyrsiflora, — Thyrse-flowered
3 nummularia, — Money-wort
4 nemorum, — grove
5 Ephemerum, — Willow-leaved
6 vulgaris, — common
7 quadrifolia, — four-leaved
8 ciliata, — ciliated
angustifolia, — narrow-leaved
10 punctata, — Spotted-leaved
dubia, — purple-flowered

ANAGALLIS, — PIMPERNEL
1 tenella, — creeping

SPIGELIA, — WORM-GRASS
1 Marilandica, — perenniel

PYXIDANTHERA, — PYXIDANTHERA
Barbulata, — barbed

PLUMBAGO, — LEAD-WORT
1 Europæa, — European

PHLOX, — LYCHNIDEA
1 Paniculata, — Panicled
2 undulata, — waved
3 acuminata, — Lyon's
4 suaveolens, — white-flowered
5 maculata, — Spot-stalked
6 intermedia, — intermediate
7 Pyramidalis, — Pyramidal
8 pilosa, — pilose
9 amæna, — fine-red
10 Carolina, — Carolina

Page 19 — PENTANDRIA MONOGYNIA.

11 Suffruticosa, — Suffruticose
12 glaberrima, — Red-flowering
13 divaricata, — divarecated
14 ovata, — oval-leaved
15 Stolonifera, — Stoloniferous
16 subulata, — awl-shaped
17 setacea, — bristly

CONVOLVULUS, — BIND-WEED.
1 arvensis, — corn
2 Sepium — Bear-bind
Scammonia, — Scammony
4 Althæoides, — Silky-leaved
5 Bryonifolius, — Bryony-leaved
6 lineatus, — dwarf
Soldanella, — Sea
Cantabrica, — Flax-leaved
1 Panduratus, — Virginian
Candicans, — Tenassee

POLEMONEUM, — GREEK VALERIAN.
1 cœruleum, — Blue
2 Sibiricum, — Siberian
3 repens. — creeping

JASSIONE, — SHEEP'S-SCABIOUS.
1 Perennis, — Perennial

CAMPANULA, — BELL-FLOWER.
1 Azurea, — azure
2 Sibirica, — Siberian
3 Alliariæfolia, — Alliaria-leaved
4 rotundifolia, — round-leaved
5 Pyramidalis, — Pyramidal
6 Trachellioides,
7 Lilifolia, — Lily-leaved
8 Carpatica, — carpatian

FIG. 8.9. In *Hortus Marybonensis*, London, 1819, pp. 18–19, Thomas Jenkins lists seventeen species of the North American genus *Phlox*. Peter Collinson grew the white-flowered *Phlox suaveolens*, ca. 1766, and by 1776, it was featured in a collage by Mrs. Delany.

selection, for example, amounted to 160 types and an additional ten "everblooming" varieties derived from the China rose. Surprisingly, the stock of native plants fell short of what was being offered by equivalent nurseries in the Old World. The rare catalog *Hortus Marybonensis*, published in London in 1819 by nurseryman Thomas Jenkins (fig. 8.9), itemizes seventeen species of the American genus *Phlox* in his Marylebone nursery, as compared to only five that were grown at the Prince Nursery in Flushing, and a handful in David Hosack's Elgin Botanic Garden. Interestingly, among *Phlox* cultivated in Marylebone were *Phlox divaricata*, collected by John Bartram, and *Phlox carolina*, associated with Mark Catesby.[33] The Marylebone catalog also has an unusual section entitled "aquatic and bog plants," including *Menyanthes trifoliata* and *Hottonia palustris*—native English moisture-loving plants that William Curtis (1746–1799) had profiled in *Flora Londinensis*.[34] The native English *Grass of Parnassus* was in stock together with its American cousin.[35] This

FIG. 8.10. *Magnolia fraseri*, in *Curtis's Botanical Magazine*, London, 1809, vol. 30, plate 1206. When William Bartram sent his cousin Humphry Marshall a box of plants for European clients in 1792, a single "*Magnolia auriculata M. fraseri*," was among the forty-five "curious" species.

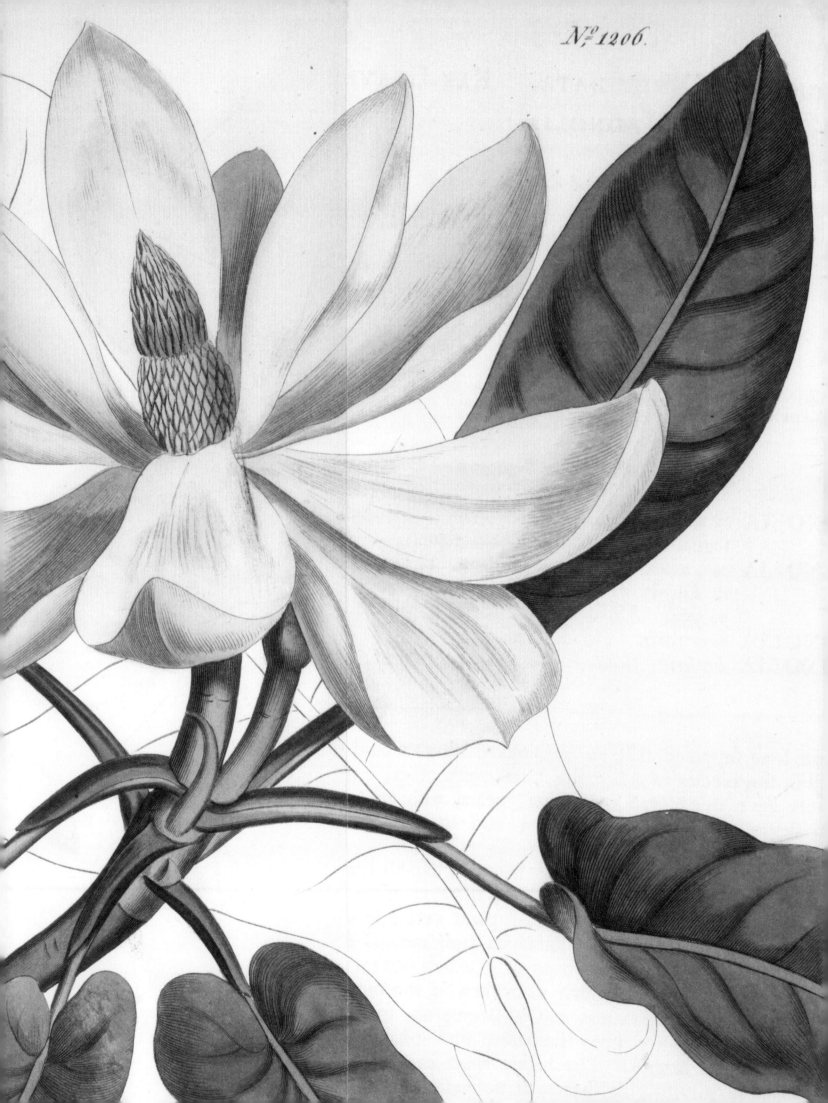

combined cultivation of English and American plants indicates a specialization occurring in English gardening and landscape design in the decades around the turn of the century—the period of landscape gardeners Humphry Repton (1752–1818) and John Claudius Loudon. Such in-depth specialization had not yet developed in America.[36] The rise of horticulture, with the founding of the Horticultural Society of London in 1804, and the status in England of the "American Garden" among dozens of specialized gardens, meant that North American plants had an economic cachet denied them in their own country until at least mid-century.

America continued in this way to play a lead role as an exporter of "exotics," while the rise of exotic horticulture in the New World meant importing from Europe and Asia. The 1828 Bartram *Periodical Catalogue of Fruit and Ornamental Trees* issued by Robert Carr (who, having married John Bartram Jr.'s daughter, Ann, co-managed the business), is dominated by greenhouse plants and fruit trees and has a fair selection of ornamental flowers too.[37] On the other hand, the Bartram/Carr catalog of 1831, entitled *Periodical Catalogue of American Trees, Shrubs, Plants, and Seeds,* is impressive for its natives, offering no less than fourteen hundred varieties of American plants and was aimed at the export market. Exchange rates were listed: American dollars against French francs, Dutch guilders, British sterling, as well as a number of Saxon and Prussian currencies. The catalog's naming of these American native plants showed a high level of botanical expertise, following the important standard works of the day–those by André and François-André Michaux, Thomas Nuttall (1786–1859), John Torrey, and Frederick Pursh (1774–1820). At the same time, Carr retained a residual respect for the Bartram family's own collecting heritage, leading to a preference for maintaining the name authority

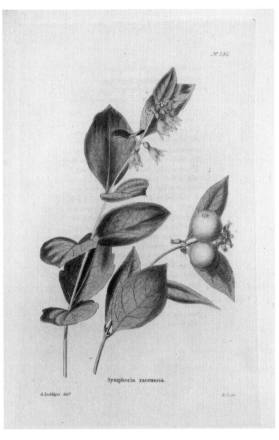

FIG. 8.11. *Symphoria racemosa* or common snowberry, in Loddiges, *The Botanical Cabinet*, London, 1818, vol. 3, no. 230. *Symphoricarpos albus* var. *laevigatus*, which became a mainstay of English gardens of the nineteenth century, was sent to Conrad Loddiges' nursery, in London in spring 1817 by Robert Carr from Bartram's Garden.

of *Bartram* over *Walter*. For example, *Magnolia auriculata* Bartr. (Bartram) was used in the 1831 catalog, rather than *Magnolia fraseri* Walt., (named by Thomas Walter after the English collector John Fraser), which was William Curtis' preferred nomenclature (fig. 8.10).[38] Remarkably, the Bartram nursery also grew plants brought back by the Lewis and Clark expedition to the Pacific Northwest. These included *Symphoricarpos albus* var. *laevigatus*, which, discovered in 1805, made its way into the Prince Nursery in New York and a decade later into Conrad Loddiges' London nursery (fig. 8.11).[39]

In 1801, on the spot where Rockefeller Center now stands, Dr. David Hosack, whose portrait is kept in the Mertz Library (fig. 8.12), established New York's first botanical garden. Named after his father's birthplace of Elgin in Scotland, the Elgin Botanic Garden was set up to instruct medical students at Columbia College. Born in New York City in 1769 and educated at Columbia, Princeton, and University of Pennsylvania, Hosack also studied medicine and botany in Edinburgh, and learned directly from William Curtis, making daily visits to Curtis' Brompton Botanic Garden in London in 1793. In 1794 Hosack returned to New York, bringing with him his herbarium, which included duplicate specimens from the great Linnaean herbarium of James Edward Smith (1759–1828).[40] A year later Hosack published *Syllabus of the Course Lectures on Botany* for Columbia College. Reissued in 1814 and 1824, his syllabus began by dividing "Natural History" into six categories and ended with the literature making up a "History of Botany," followed by a comparison of the systems of Linnaeus and Antoine Laurent de Jussieu.[41] Distinguishing itself from William Prince's commercial "Linnaean Botanic Garden," the Elgin Botanic Garden was a scientific center, as Hosack himself stressed in his 1806 account of the Elgin Garden: "A primary object of attention in this establishment will be to collect and cultivate the native plants of this country, especially such as possess medicinal properties, or are otherwise useful."[42] William Curtis' London Botanic Garden at Lambeth (1779–1789), which specialized in British natives and agricultural crops, was a significant forerunner of the Brompton Botanic Garden in London, where Hosack had studied.[43] At Lambeth, creating a kind of "living museum," Curtis shifted from physic or apothecary gardening to the virtues of

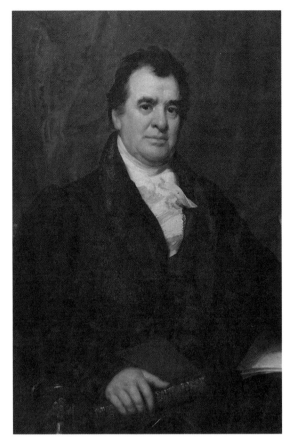

FIG. 8.12. David Hosack (1769–1835), in a portrait signed and dated by the artists Samuel Waldo and William Jewett in 1831. The well-known physician and fourth president of the New York Horticultural Society is seated with a book in his study. Oil on canvas, 42 × 32 inches. Art and Illustration Collection.

what he had called in *Flora Londinensis* "Rural Oeconomy." Thus, when Hosack described the Elgin Botanic Garden in 1806, he emphasized ornamental and utilitarian functions beyond those of *pure* medicine: "The establishment of a Botanic Garden in the United States, as a repository of native plants, and as subservient to medicine, agriculture, and the arts, is doubtless an object of great importance."[44] Here at the Elgin Botanic Garden and in early American botanical gardens in general—those founded at Harvard, Yale, Princeton, and at the University of Pennsylvania—scientific, agricultural, and ornamental interests were inextricably linked to notions of national economy.[45] The

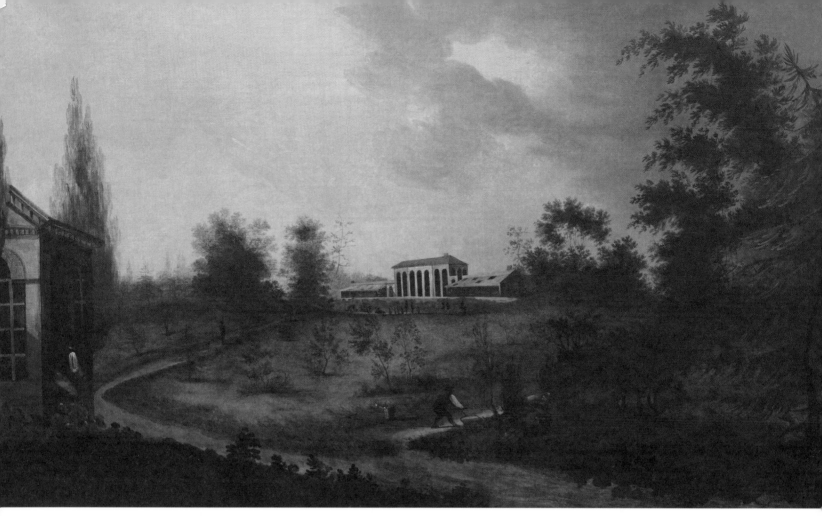

distinguishing characteristic of botanical studies, repeatedly emphasized by American scientists, educators and public figures, was "accessibility."[46] Hosack's 1806 account of the Elgin Botanic Garden is brought to life by a handsome painting in the Mertz Library (fig. 8.13). It depicts a conservatory building and hot-houses, which command, like a Palladian villa, the center-ground of a picturesque layout, which was described as follows in a contemporary account:

> In the year 1801 I purchased, of the Corporation of the city of New York, twenty acres of ground; the greater part of which is now in cultivation. Since that time, a Conservatory, for the more hardy green-house plants, has been built; in addition to which, two Hot-Houses are now erecting for the preservation of those plants which require a greater

FIG. 8.13. *The Elgin Botanic Garden*, ca. 1815. Standing on the spot of what today is Rockefeller Center, the grounds were divided into various compartments for the instruction of students of medical botany. In the greenhouse at the center, a considerable number of rare exotics and plants from the Old World were cultivated. Oil on canvas, 27 × 39 inches. Art and Illustration Collection.

> degree of heat. The grounds will be arranged in a manner the best adapted to the different kinds of plants, and the whole enclosed by a belt of forest trees and shrubs, native and exotic.[47]

Architecturally, the complex recalls Philip Miller's eighteenth-century greenhouse structures at Chelsea Physic Garden (see fig. 8.1). Yet the irregular grounds, winding paths, specimen shrubs on the lawn, and enclosing belt are more on the model of the Royal Botanic Gardens, Kew than the Chelsea Physic Garden, albeit at a fraction of the size. Since there is no plan of the Elgin Botanic Garden, the exact

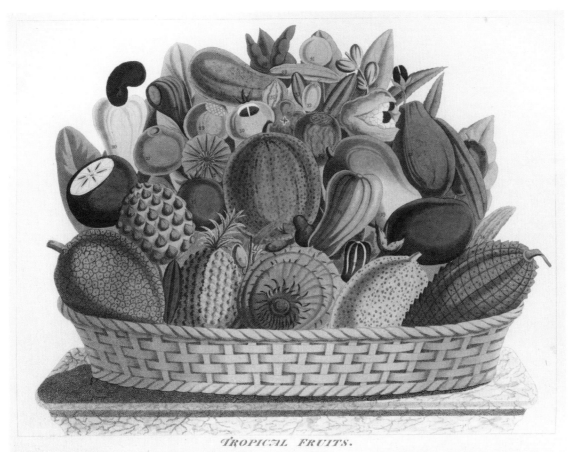

TROPICAL FRUITS.

FIG. 8.14. "Tropical Fruits," frontispiece, in William J. Titford, *Sketches Towards a Hortus Botanicus Americanus*, London, 1811. A Jamaica-born, British-trained physician, Titford studied with David Hosack at the Elgin Botanic Garden while preparing this book.

EARLY AMERICAN
HORTICULTURAL
TRADITIONS

layout of the grounds and disposition of the planting beds cannot be determined, nor is it clear whether Hosack copied geometric features from the American and English botanical gardens known to him.[48] When it comes to the garden's plantings, Hosack's *Catalogue of Plants Contained in the Botanic Garden at Elgin* of 1806 and 1811 point to the relatively modest scale of collecting: a mere couple of thousand species. By comparison, William Curtis' Lambeth Garden presented 6,000 plants in the same period.[49]

Despite the relatively small numbers of species listed by Hosack, the catalogs of the Elgin Botanic Garden suggest he was tapped into both New and Old World networks of collecting, with plants arriving in New York from Philadelphia and London. Species recently discovered by William Bartram and shipped to

Philadelphia by André Michaux in 1791 show up in Hosack's work with a variety of scientific name authorities listed. For example, John Fraser had introduced *Aesculus parviflora* to Britain by 1785, but Hosack listed *Aesculus parviflora* Walt. under the common name "long-spiked horse chestnut." Similarly, *Magnolia fraseri*, native to the southeastern United States, arrived in Britain in 1786, but in Hosack's catalog it was simply entered under "Carolina."[50] Some plants in Hosack's catalog must have come from abroad, thus forming part of the larger, reciprocal horticultural exchange: the "purple Magnolia *of China*" is itemized in the Elgin catalog, referring to an Asian variety most likely imported via London.[51]

Another source of Hosack's plants, beyond London-based nurserymen, was Frederick

CELEBRATED WORKS

ON AMERICAN

GARDENING AND

HORTICULTURE

Pursh, a German-born botanist (see chapter 7). Having worked at William Hamilton's estate of Woodlands and for Benjamin Smith Barton, Pursh left Philadelphia in 1806 for the Elgin Botanic Garden, bringing with him—without the permission of his patron—seeds and cuttings of several new plants from the Meriwether Lewis expeditions through the Pacific Northwest. Pursh's *Flora Americae Septentrionalis*, published in 1813 in London,[52] offered to his English readers some species newly discovered in the Pacific Northwest and along America's East Coast.[53] In 1811 William J. Titford, one of Hosack's young botanists in residence in the Elgin Botanic Garden, published *Sketches Towards a Hortus Botanicus Americanus* illustrating some of the exotic plants grown in the garden (fig. 8.14).[54] That same year, Hosack turned to the Legislature

for its support: he was in debt, despite his robust annual income of $11,600. The Elgin Botanic Garden was sold to the State of New York, ratified in a deed signed by District Attorney Cadwallader D. Colden. The state granted the land to Columbia College, but, having acquired the land primarily for speculative purposes, the grounds were not maintained and by 1817, with only the greenhouses standing, the Botanic Garden ceased to exist. Thomas Jefferson's proposal of a gift to Hosack in 1818, consisting of a box of non-American seeds from the *Jardin des Plantes* in Paris "for the use of the Botanical garden of N. York," came too late.[55] While the gates of the Elgin Botanic Garden closed forever, others, most notably those of the New York Horticultural Society, opened, furthering botany and horticulture in the region.

In 1818 a group of horticulturists, gardeners, and nurserymen, "all Scotchmen," as it happens,[56] gathered in a Broadway inn to found the New York Horticultural Society.[57] Incorporated in spring 1822, the Society resolved that a committee of seven members be set up. This Inspecting Committee, consisting of prominent New Yorkers such as John R. Murray, John McNab, William Wilson, Martin Hoffman, Peter Schermerhorn, Thomas Hogg, and Michael Floy, was "appointed to meet weekly to receive and examine all exhibitions during the Summer Season."[58] The Inspecting Committee's records are extensive, and the colorful flavor of the reports can be conveyed in one sample page from the 1822 Minutes (fig. 8.15). The Horticultural Society thus launched a regular schedule of fruit, vegetable, and flower shows that were to foster a fellowship of all ranks of society with an interest in horticulture, despite the associations of other horticultural societies (and notably the Massachusetts Horticultural Society) with notions of elite "cultivation."[59]

Unlike most other such institutions, and despite its status as a learned society, the New York Horticultural Society boasted a diverse membership that crossed class lines in a mutual enthusiasm for horticulture. Estate owners and gardeners, presidents and laymen, professors and painters could be counted among its members. Thus, in 1824, corresponding and honorary membership was extended to Thomas Jefferson, John Adams, William Hooker, Asher B. Durand, and Benjamin Silliman.

In 1822 Peter Schermerhorn proposed that David Hosack acquire membership. Hosack became the Society's president only a few years later. In this function, in addition to making important contributions to the botanical-medical field, he would promote horticulture

smile at the turn, in which is an equal proportion of philosophy and humour. He who has no wealth, has no credit; he who has not an obedient wife, has no repose; he who has no offspring, has no strength; he who has no kindred, has no supporters; and he who has none of these—*lives free from every care.*

WM. PRINCE, Proprietor of Linnæan Garden near New-York, offers to the public his very extensive collection of the choicest fruits, which have been selected with the greatest care from the most celebrated establishments throughout the world, and to which very large additions have recently been made. The assortment of Ornamental Trees, Shrubs and Plants, is very extensive. Also, Hyacinths, Tulips, and other Bulbous Flowers. Above 1900 species of Green House Plants comprising the most rare and splendid kinds. In the collection are above 500 varieties of Roses, including 54 varieties of China Roses, and 9 of Moss Roses. Also, about 10,000 thrifty Grape Vines, of the finest European kinds. The new catalogues for 1825, are just published and may be obtained of Joseph Bridge, No. 25, Court-street, Boston, and orders through him will meet prompt attention. Sept. 30

Fruit and Ornamental Trees, &c.

FOR SALE, at the Kenrick Place, near the Brighton Post Office. The Nurseries have been much extended, & besides a variety of English Cherries, Pears, Apricots, &c. contain many thousands of grafted Apple trees of su-

FIG. 8.16. Advertisements in *The New England Farmer and Horticultural Journal*, p. 112. On September 20, 1825, William Prince "Proprietor of Linnaean Garden near New York" announced that the "new catalogues for 1825 are just published." He offered the public "his very extensive collection of the choicest fruits" from around the world.

EARLY AMERICAN
HORTICULTURAL
TRADITIONS

in New York, including fruit growing as part of husbandry. Access to a substantial husbandry literature in the Mertz Library, beginning with *The New England Farmer* of 1797, demonstrates what resources the New York Horticultural Society drew upon in annual fruit, flower, and vegetable displays. Under the same title of *The New England Farmer*, a periodical was published from 1822. Among the advertisements from the 1825–1826 issues of *The New England Farmer*, several point to the abundance of fruit-growing and availability of excellent produce,[60] including an advertisement placed by the Prince family nursery (fig. 8.16).[61]

Competitive fruit growing was apparent during the Horticultural Society's heyday of the

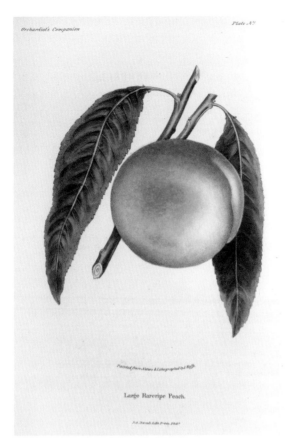

Large Rareripe Peach.

FIG. 8.17. "Large Rareripe Peach," in *The Orchardist's Companion*, vol. 1, Philadelphia, 1841, A. Hoffy, editor: "Mr Prince writes...That, this choice and beautiful variety was raised by the grandfather of the author, from the stone of the Red Rareripe, and was transmitted by the present William Prince, a few years after our revolution, to Mr. William Forsyth," in London.

1820s. Each anniversary dinner presented an opportunity to assert the social status of the Society as a learned society, while also enjoying the jolly atmosphere of Florists' Feasts of the past.[62] The President's address, alluding to the "unprecedented drought of the past season," boosted pride in the skill and industry of the members. After the regular toasts to the Constitution and Laws of the United States, and to the social refinement of "Horticulture, Nature's handmaid," toasts were extended to all, from The Horticultural Society of London to "Sir J. Edward Smith, the distinguished President of the Linnaean [sic] Society of London."[63]

The eighth-anniversary exhibition of 1826 was attended by "numerous ladies," yet the anniversary dinner was for the male membership only.[64] The press reported: "Early in the day the doors were thrown open to such ladies and gentlemen as take an interest in the improvement and advancement of horticulture." Then, significantly, the doors were gently closed to women. The final toast of the evening was from Mr. William Wilson, who came up with a suggestive formulation: to "American Horticulture, her sap [*sic*, corrected in pencil to "tap"] root, has penetrated to the most congenial soil to a depth secure from the bad effects of superficial vicissitudes. Success to her rising stem."[65] And rise it did: by 1829 a press publication reported positively on the state of horticulture in New York,[66] with vegetable- and fruit growing at a high degree of perfection— as contemporary images of ripe fruits in *The Orchardist's Companion* demonstrate (fig. 8.17).[67] Landscape gardening, however, lagged behind and would have to wait for the impetus given by landscape-theorists such as Andrew Jackson Downing (see chapter 9).[68]

In the 1836 issue of *Gardener's Magazine*, under "Obituaries," the death in 1835 of "Dr. Hosack of New York" followed shortly after the notice of the French botanist Antoine Laurent de Jussieu's death. This was a critical year in the fortunes of the New York Horticultural Society. Although the prospects were set fare for renewal—with John Torrey as a new President and with new appointments to the Committee of Asa Gray and Andrew Jackson Downing—decline continued and was compounded by the economic contraction of the late 1830s. A bitter letter written in 1837 by a member of the Society and addressed to Charles Hovey, editor of the popular *Magazine of Horticulture and Botany*, sums up the mood. In his jeremiad, the member blamed New Yorkers for being "eat up with avarice and

immorality."[69] He claimed that attempts to display horticulture had met with failure because of citizens being "so engaged in the engrossing of fictitious wealth, that they had no time to admire the beauties of nature, except so far as building lots…were concerned."[70] An empty wealth, based on real estate speculation, had trumped the "botanical wealth" that John Loudon believed was North America's special destiny.

AMATEUR BOTANY AND THE "AMERICAN GARDEN" IN THE OLD WORLD

When Robert Carr issued the catalog of American species for sale at the "Bartram Botanic Garden" in 1831, he appended the 1830 Report of the Committee of the Pennsylvania Horticultural Society. The committee gave Carr "much credit" and "praise" for the flourishing state of the garden.[71] It entirely overlooked Ann Bartram's contribution through a botanical acumen that Scottish horticulturist Alexander Gordon described in 1837 as a "passionate fondness." He added: "Mrs. Carr's botanical acquirements place her in the very first rank among American botanists."[72] Sixty years later, much had changed in North American botany and horticulture. By 1889—the year that the Torrey Botanical Club began its push to establish The New York Botanical Garden—forty-three percent of an active membership of that Club was female.[73] In Europe, women had been active in amateur botanizing since the late seventeenth- and early eighteenth century. Jean-Jacques Rousseau helped popularize Linnaeus for "Flora's daughters;"[74] and, in the Library's English translations of Rousseau's work by Thomas Martyn, which originally belonged to Dr. Hosack, Linnaean systems were made accessible to all amateurs (fig 8.18).[75] Thus, in the world of amateur botany in England, women and men were now joining forces, as is

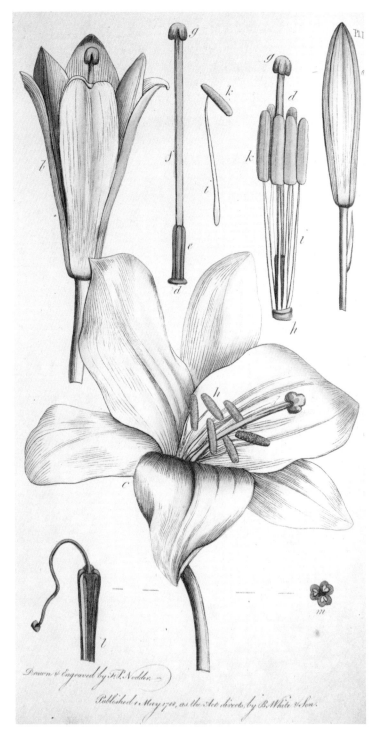

FIG. 8.18. *Lilium candidum*, in Thomas Martyn, *Thirty-eight Plates, with Explanations: Intended to Illustrate Linnaeus's System of Vegetables*, London, 1799, plate 1. The English key to the plate made the Latin of Linnaean botany intelligible to all: *a* shows the flower in bud, while *b* is the corolla expanding; the pistil, germ, style, stigma, stamens, filaments, and anthers are shown at *d* to *k*.

The illustration contains the following labels:

Illustration of the parts of Fructification in vegetables

A Pistil its Stigma

its Style

Germ

1

2

Apex or Anther

Pollen Dust or Farina

its Filament

A Stamen

The Germ advanced to a Pericarp which is here a Capsule.

White Lily expanded.

a Calix with the corolla removed.

b. The petals of the corolla

c. Stamens.

d. The pistil.

THE LADY'S AND GENTLEMAN'S Botanical Pocket Book; adapted to Withering's Arrangement of BRITISH PLANTS. Intended to facilitate and promote the Study of Indigenous Botany. By William Mavor L.L.D.

Flora dispensing her favours.

London Printed for Vernor & Hood, Poultry.

FIG. 8.19. Frontispiece and title page, in William Fordyce Mavor, *The Lady's and Gentleman's Botanical Pocket Book, Adapted to Withering's Arrangement of British Plants*, London, 1800." The illustration of a dissected flower includes the key: "White Lily expanded—a Calix with the corolla removed."

also clear from William Fordyce Mavor's book, entitled *The Lady's and Gentleman's Botanical Pocket Book* of 1800 (fig. 8.19).[76]

Linnaean botany was not just a vogue among gentlewomen, however, it was also edifying for the artisan gardener. The Mertz Library holds a unique manuscript by Robert Elliot, the same person who in 1832 published a letter "On the Culture of Pelargoniums" in Loudon's *Gardener's Magazine*.[77] The manuscript entitled *Specimen's of Plants, Chiefly Drawn from Nature*, dates from 1815 and shows the legacy

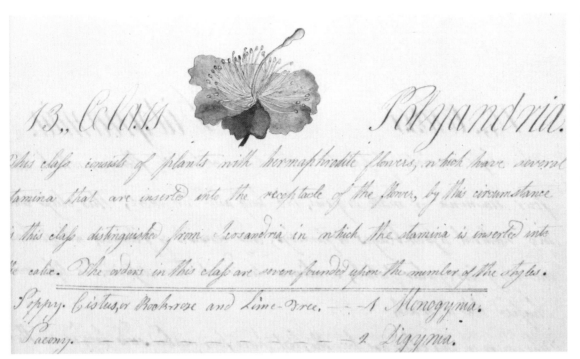

FIG. 8.20. Manuscript page, in Robert Elliot's album *Specimen's of Plants, Chiefly Drawn from Nature*, 1815, p. 16, illustrating "Class 13 Polyandria." Elliot has studiously copied from some Linnaean authority: "This class consists of plants with hermaphrodite flowers," including the orders of flowers such as poppy, peony, larkspur, ragwort, columbine, and anemone.

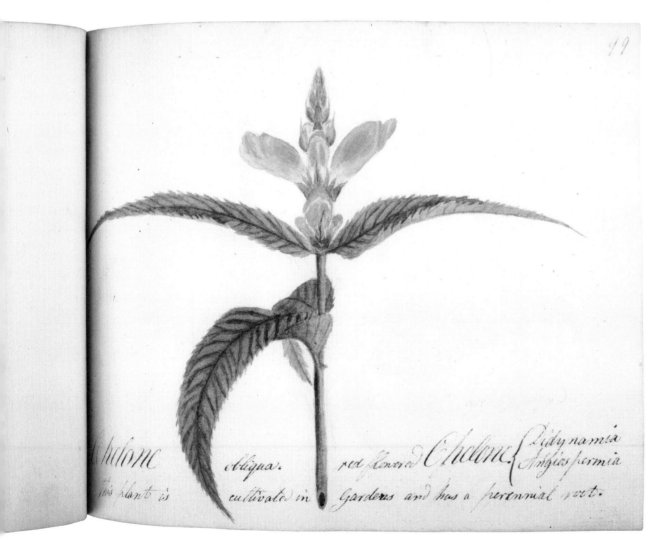

FIG. 8.21. *Chelone oblique,* in Robert Elliot's album *Specimen's of Plants, Chiefly Drawn from Nature*, 1815, p. 99. First introduced to England from North America in 1752, this late-blooming "turtlehead" was noted by Elliot as "red flowered," growing from its "perennial root," and contributed to a lengthened flowering season in English gardens.

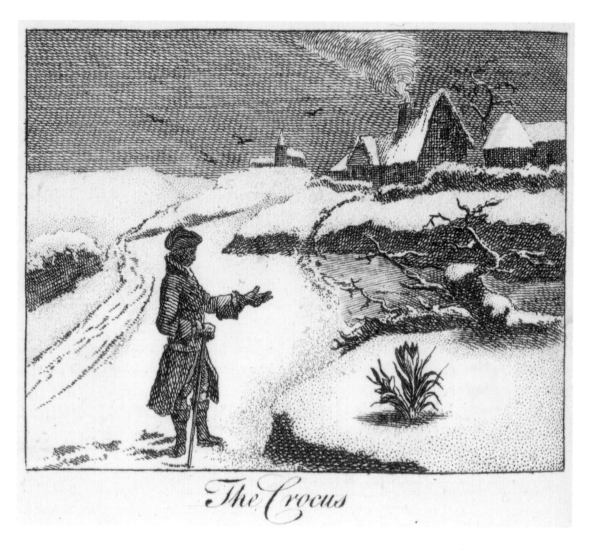

FIG. 8.22. "The Crocus," in *Fables of Flowers for the Female Sex*, London, 1773, p. 59, written for the Princess Royal by an anonymous author [John Huddlestone Wynne], influenced Thornton's plate "The Snowdrop" in *Temple of Flora*, depicting snowdrops and crocuses in a winter landscape. The supporting poem includes the lines: "In these bleak months, why dost thou chuse/ T'adorn a waste of snow?"

The Crocus

of Linnaeus.[78] The opening pages feature plants "Arranged according to Linneus' [*sic*] System" (fig. 8.20). Elliot wrote in the Introduction: "The design I had in mind in beginning with this work was merely as an assistant in studying Botany." The manuscript also gives a good snapshot of what was being grown by a skilled gardener in one provincial garden in England: Rose-hill in Cumberland, owned by William Hartley. Referring also to his American plants, Elliot states: "The plants of many of the orders are natives of forieng [*sic*] Countrys and easey to be met with here" (fig. 8.21).[79]

Thomas Martyn, the translator of Rousseau's *Lettres*, also played a seminal role in the

generation of a work that is significant in the history of female botanical art. His lectures helped introduce Robert John Thornton (1768–1837) to botany while this young doctor was at Guy's Hospital. With studies completed in 1797, Thornton advertised his three-volume folio book, *The New Illustration of the Sexual System of Linnaeus*, which is important for its gendered iconography and connections with

FIG. 8.23. American bog plants, in Robert Thornton, *The Temple of Flora*, London, 1807, featuring "Fetid Pothos" or skunk cabbage, pitcher plant, and Venus' flytrap. First grown in England in special tanks or "swamp" areas of botanical gardens, such bog plants were being accommodated in specialized "American Gardens" by 1800.

Pl. 12

LILIUM CANADENSE.

Drawn by Mrs E. Bury, Liverpool.

Engraved Printed, & Coloured by R. Havell.

contemporary sentimental literature (fig. 8.22).[80] Particularly significant is the third and final part of the book, entitled *Temple of Flora*, which contains thirty-one plates, eight of which depict American plants with several others alluding to the American Republic. They show images that involve themes of gender and sexuality, metamorphic cycles, as well as iconographies of empire and political instability, whereby the importance of North America, the lost colonies, is always implicit.[81] Whatever the symbolism of Thornton's plate of American bog plants—featuring Venus' flytrap with its gendered and sexual associations—such depictions are also significant for indicating connection with contemporary botanical literature. Publications such as Thomas Jenkins' list of "aquatic and bog plants" in the Marylebone gardens, directly helped inspire the vogue for the "American Garden" in England (fig. 8.23).[82]

The vogue for the "American Garden" is also clearly apparent in the Mertz Library's two copies of *A Selection of Hexandrian Plants*, a monograph that appeared in London from 1831 to 1834. At twenty-three inches high, it is among the largest botanical works ever published. The drawings are by "Mrs. Edward Bury" (Priscilla Susan Falkner Bury) of Liverpool, with engravings by Robert Havell, best known as the interpreter of John Audubon's work. The North American *Lilium canadense* (fig. 8.24) is featured in one plate with reference to Michaux. Without explicitly mentioning an "American Garden" (a north-facing bog garden), the text states that the lily was placed "in a border of bog-earth, shaded by high hedge." Thus "American Gardens" were the epitome of New World-*in-*

Old World: the fruits of the labors of Catesby, the Bartrams, Collinson, the Michaux, Curtis, and Jenkins.[83] Despite the rhetoric of 1837—how New York and the New York Horticultural Society had been eaten up with the "engrossing of fictitious wealth"—America's "botanical wealth," which Loudon thought unparalleled, was yielding, and would continue to yield remarkable returns in Europe.

FIG. 8.24. *Lilium canadense*, in Priscilla Susan Falkner Bury, *A Selection of Hexandrian Plants*, London, 1831–1834, plate 12. Grown in the "Liverpool Botanic Garden, in a border of bog-earth," this American lily, which Michaux observed in the wild with typically three flowers, was producing up to twelve flowers in cultivation, with colors varying by cultivar.

ENDNOTES

<div class="sidebar">
CELEBRATED WORKS
ON AMERICAN
GARDENING AND
HORTICULTURE
</div>

1. For this history, see James L. Reveal, *Gentle Conquest: The Botanical Discovery of North America with Illustrations from the Library of Congress* (Washington, DC: Starwood Publishers, 1992).

2. This Society, which existed from 1818 to 1844, was a precursor to the later "Horticultural Society of New York," founded in 1900 and incorporated in 1902.

3. John Claudius Loudon, "The Gardener's Magazine and Register of Rural and Domestic Improvment," 1 (1826), 52–53.

4. Mark Laird, "Greenhouse Technologies and Horticulture: the 1st Duchess of Beaufort's Badminton Florilegium (1703–05) and J. J. Dillenius's *Hortus Elthamensis* (1732)," and Jan Woudstra, "'Much Better Contrived and Built then Any Other in England:' Stoves and Other Structures for the Cultivation of Exotic Plants at Hampton Court Palace, 1689–1702," in *Technology and the Garden*, eds. Michael G. Lee and Kenneth I. Helphand (Washington, DC: Dumbarton Oaks, 2014), 55–107.

5. *Musæum Tradescantianum: Or, A Collection of Rarities. Preserved at South-Lambeth neer London* (London: Printed by John Grismond, 1656).

6. John Ray, *Historia plantarum generalis* (London: S. Smith & B. Walford, 1686–1704).

7. Mark Laird, "Exotics and Botanical Illustration," in *Sir John Vanbrugh and Landscape Architecture in Baroque England 1690–1730*, eds. Christopher Ridgway & Robert Williams (Stroud, Gloucestershire: Sutton Publishing, 2000), 95–97.

8. Margaret Riley, "The Club at the Temple Coffee House," Appendix to Mark Laird, "The Congenial Climate of Coffeehouse Horticulture: The *Historia plantarum rariorum* and the *Catalogus plantarum*," in *The Art of Natural History: Illustrated Treatises and Botanical Paintings, 1400–1850*, eds. Therese O'Malley and Amy R. W. Meyers (New Haven and London: Yale University Press, 2008), 252–259. See also Margaret Riley's D. Phil. thesis, "*Procurers of Plants and Encouragers of Gardening:*" *William and James Sherard, and Charles du Bois, Case Studies in Late Seventeenth- and Early Eighteenth-Century Botanical and Horticultural Patronage* (University of Buckingham, 2011), 36–78.

9. The first one hundred plates were produced between 1729 and 1732, though the first volume title page bears the date 1731. Catesby presented to the Royal Society the parts that make up the second volume between 1734/35 and 1743, with the Appendix in 1747, though the title page bears the date 1743; there are two copies of the very fine 1754 edition, one in beautiful morocco leather binding, and the edition of 1771.

10. Mark Laird, "From Callicarpa to Catalpa: The Impact of Mark Catesby's Plant Introductions on English Gardens of the Eighteenth Century," in *Empire's Nature: Mark Catesby's New World Vision*, eds. Amy R. W. Meyers and Margaret Beck Pritchard (Chapel Hill and London: University of North Carolina Press, 1998), p. 223.

11. William Cobbett, *A Year's Residence in the United States of America; Treating of the Face of the Country, the Climate, the Soil, the Products, the Mode of Cultivating the Land* (New York: Printed for the author by Clayton and Kingsland, 1818), Preface, V.

12. This is discussed in detail in Mark Laird, "Mark Catesby's Plant Introductions and English Gardens of the Eighteenth Century," in *The Curious Mister Catesby: A "Truly Ingenius" Naturalist Explores New Worlds*, eds. David J. Elliot and E. Charles Nelson (Athens, GA: The University of Georgia Press, 2015) [forthcoming].

13. Lisa L. Ford, "A World of Uses: Philadelphia's Contributions to Useful Knowledge in François-André Michaux's North American Sylva," in *Knowing Nature: Art and Science in Philadelphia 1740–1840*, ed. Amy R. W. Meyers (New Haven and London: Yale University Press, 2011), 289.

14. Johannes Fredericus Gronovius and John Clayton, *Flora Virginica, exhibens plantas quas v.c. Johannes Clayton in Virginia observavit atque collegit* (Lugduni Batavorum, Apud Cornelium Haak, 1739–1743).

15. See again Reveal, *Gentle Conquest*, chapters III and IV. See also Joel Fry, "America's 'Ancient Garden:' The Bartram Botanic Garden, 1728–1850," in *Knowing Nature*, 60–95, and Mark Laird, "This Other Eden: The American Connection in Georgian Pleasure Grounds, from Shrubbery and Menagerie to Aviary and Flower Garden," in *Knowing Nature*, notably 116–118.

16. William Robert Prince, *A Treatise on the Vine; Embracing its History from the Earliest Ages to the Present Day, with Descriptions of Above two Hundred Foreign and Eighty American Varieties; By William Robert Prince, aided by William Prince* (New York: J. & J. Swords, 1830).

17. Quoted in Fry, "America's 'Ancient Garden,'" *Knowing Nature*, 81.

18. Ibid., 81.

19. Ian MacPhail, *André & François-André Michaux* (Lisle, IL: The Morton Arboretum, 1981). See also above, chapter 1, note 71.

20. André Michaux, *Histoire des chênes de l'Amérique; ou, Descriptions et figures de toutes les espèces et variétés de chênes de l'Amérique Septentrionale, considérées sous les rapports de la botanique, de leur culture et de leur usage* (Paris, Impr. de Crapelet, 1801).

21. There are fine copies of this work in the David Andrews Collection in the Mertz Library.

22. François-André Michaux, *Historie des noyers de l'Amérique Septentrionale, considérées principalement sous les rapports de leur usage dans les arts et de leur introduction dans le commerce* (Paris: De l'Imprimerie de L. Haussmann et d'Hautel, 1810–1813).

23. Redouté used this color-printing process in a few works including his famous *Les Liliacées* (Paris, Chez l'auteur, Impr. de Didot jeune, an X, 1802–[1816]). Various colors of printing ink were applied to the engraved copper plate with cloth daubers. After printing, the printed sheet would be further colored by hand. Inking by this method required much more skill than with ordinary engraving, but the colors varied less from print to print, and the final hand-coloring was much simplified, because the color printing already defined so much of the outline and shading. For further reading, see James N. Green, "Hand-Coloring versus Color Printing: Early-Nineteenth-Century Natural History Color-Plate Books," in *Knowing Nature*, 262. See Wilfrid Blunt and William T. Stearn, *The Art of Botanical Illustration* (Woodbridge, Suffolk: Antique Collectors Club Ltd, 1994), 204–205, for a discussion of precedents for stipple engraving and its techniques.

24. Therese O'Malley, *Keywords in American Landscape Design* (New Haven and London: Yale University Press, 2010), "Nursery," 434. See also Peter Benes, "Horticultural Importers and Nurserymen in Boston 1719–1770," in *Plants and People: Annual Proceedings of the Dublin Seminar for New England Folklife*, ed. Peter Benes (Boston: MA: Boston University, 1995), 38–53.

25. John Bartram, *Observations on the Inhabitants, Climate, Soil, Rivers, Productions, Animals, and Other Matters Worthy of Notice* (London: Printed for J. Whiston and B. White, 1751).

26. Fry, "America's 'Ancient Garden,'" in *Knowing Nature*, 85.

27. O'Malley, *Keywords*, 434–436.

28. William Prince, *Catalogue of Fruit and Ornamental Trees and Plants, Bulbous Flower Roots, Green-house Plants, &c. &c., Cultivated at the Linnaean Botanic Garden* (New York: Swords, 1822), preface.

29. William Prince, *A Short Treatise on Horticulture: Embracing Descriptions of a Great Variety of Fruit and Ornamental Trees and Shrubs, Grape Vines, Bulbous Flowers, Greenhouse Trees and Plants, &c., Nearly All of Which Are at Present Comprised in the Collection of the Linnaean Botanic Garden, at Flushing, near New-York* (New York, Printed by T. and J. Swords, 1828). Cf. Elizabeth Eustis' essay "The Horticultural Enterprise," following in this volume. See also O'Malley, *Keywords*, 40.

30. O'Malley, *Keywords*, 436.

31. Cf. Therese O'Malley, "Art and Science in the Design of Botanic Gardens, 1730–1830," in *Garden History: Issues, Approaches, Methods*, ed. John Dixon Hunt (Washington, DC: Dumbarton Oaks, 1992), 282.

32. David Hosack, *Syllabus of the Course of Lectures on Botany, Delivered in Columbia College* (New York: Printed by J. Childs, 1795).

33. For the background to *Phlox* species, cf. Laird, "Congenial Climate," *Art of Natural History*, 241–247.

34. Thomas Jenkins, *Hortus Marybonensis, or A Catalogue of Hardy Herbaceous Plants, Deciduous & Evergreen Shrubs, Forest & Fruit Trees, to Which is Added, a List of Aquatic and Bog Plants* (London: Printed for and Sold by the Proprietor, 1819), 154.

35. Ibid., 156.

36. See Mark Laird, "Plantings," in *A Cultural History of Gardens in the Age of Empire*, ed. Sonja Dümpelmann, vol. 5 of *A Cultural History of Gardens*, general eds. John Dixon Hunt and Michael Leslie (London: Bloomsbury, 2013), 69–89.

37. Robert Carr, *Periodical Catalogue of Fruit and Ornamental Trees and Shrubs, Green House Plants, &c., Cultivated and For Sale at Bartram's Botanic Garden, Kingsessing. Robert Carr, Proprietor* (Philadelphia: Russell and Martien, 1828).

38. Ibid., 80–81.

39. The Bartram nursery, most surprisingly, also offered mosses, algae, and fungi for sale in the 1831 catalog, indicating the integration of natural-history collecting with horticultural/botanical collecting, equivalent to the Old-World lineage of medico-botany that extends from the Temple Coffee House group to William Curtis. For further reading, see Laird, "Congenial Climate," in *Art of Natural History*, and *A Natural History of English Gardening, 1650–1800* (New Haven and London: Yale University Press, 2015) [forthcoming]. See also Fry, "America's 'Ancient Garden,'" in *Knowing Nature*, 87. Cf.the 1822 Prince *Catalogue* under "Symphoria racemosa."

40. See Christine Chapman Robbins, *David Hosack's Herbarium and its Linnaean Specimens* (Philadelphia, PA: American Philosophical Society, 1960).

41. David Hosack, *Syllabus of the Course of Lectures on Botany Delivered in Columbia College in 1795* (New York: Printed by J. Childs, 1795), and later editions.

42. David Hosack, *A Catalogue of Plants Contained in the Botanic Garden at Elgin, in the Vicinity of New-York, Established in 1801* (New York: Printed by T. & J. Swords, 1806), 3–6, esp. 4. The 1811 edition is entitled *Hortus Elginensis: Or a Catalogue of Plants, Indigenous and Exotic, Cultivated in the Elgin Botanic Garden*. See also O'Malley, *Keywords*, 150.

43. Graham Gibberd, "The Location of William Curtis' London Botanic Garden in Lambeth," *Garden History* 13, no. 1 (Spring 1985), 9–16. See also William Hugh Curtis, *William Curtis, 1746–1799, Fellow of the Linnean Society, Botanist and Entomologist* (Winchester, Warren and Son Ltd., 1941).

44. Hosack, *A Catalogue of Plants*, 3.

45. See Therese O'Malley, "'Your Garden Must Be a Museum to You': Early American Botanic Gardens," in *Art and Science in America: Issues of Representation*, ed. Amy R. W. Meyers (San Marino, CA: Huntington Library, 1998), 40.

46. Ibid., 38–39.

47. Hosack, *A Catalogue of Plants*, 3–4.

48. Representations of these gardens are reproduced together in O'Malley, *Keywords*, "Botanic Garden," 146–154.

49. The first edition of *Hortus Kewensis* (1789) listed 5,600 species, a number that had doubled by 1810–13 to 11,000 species, as various editions indicate. See Ray Desmond, *The History of the Royal Botanic Gardens Kew* (London, 1995), 107.

50. Hosack, *Hortus Elginensis*, 2 ff.

51. The species Curtis had named *M. purpurea* is now known as *Magnolia liliflora* Desr. It was introduced to London from Japan by 1791, and first illustrated in Curtis' *Botanical Magazine* in 1792.

52. Frederick Pursh, *Flora Americae Septentrionalis; or, A Systematic Arrangement and Description of the Plants of North America* (London: Printed for White, Cochrane, and Co., 1814).

53. Reveal, *Gentle Conquest*, 71–74: *Gautheria shallon*, for example, as well as *Chelone lyonii*.

54. Reveal, *Gentle Conquest*, 74.

55. O'Malley, *Keywords*, 151.

56. Minutes of the New York Horticultural Society, Letter to Robert Manning dated 1872, looking back to 1818.

57. The commencement of the Society is dated 29 September 1818.

58. Minutes of the New York Horticultural Society, May 28, 1822.

59. See James S. Ackerman, "On Public Landscape Design Before the Civil War, 1830–1860," in Therese O'Malley and Marc Treib, eds., *Regional Garden Design in the United States* (Washington, DC: Dumbarton Oaks, 1995), 191–207.

60. *New England Farmer*, September 30, 1825, 103, and November 4, 1825, 120, and April 14, 1826, 303.

61. Ibid., March 26, 1825, 271, and May 5, 1826, 328.

62. Minutes of the New York Horticultural Society, 1825, 79. At the 1825 dinner event Dr. Hosack donated twelve very fine bunches of the "White Muscaline." Floriculture was on display, too: "The flowers for the decoration of the room and tables were furnished from the gardens of Mr. Floy, Mr. Hogg and Mr. Curr."

63. Ibid., 1825, 79. Mr. Kennersly proposed the final toasts of the evening: "May we rise in health, dine in friendship, crack a bottle in mirth, and sup with the goddess of contentment." Mr. André Parmentier, proprietor of the new nursery garden in Brooklyn, added a last toast to "The fair sex," quoting the lines: "The world was sad, the garden was wild,/And man, the *gardener*, sigh'd, till woman smil'd."

64. Minutes of the New York Horticultural Society, 1826, 91.

65. Ibid., 1826, 91.

66. Ibid., 1829. Press Report of the Visiting Committee of the Society describing the "actual state of Gardening in this State," in the year 1828.

67. *The Orchardist's Companion: a Quarterly Journal, Devoted to the History, Character, Properties, Modes of Cultivation, and All Other Matters Appertaining to the Fruits of the United States* (Philadelphia: A. Hoffy, 1841–[1842]).

68. Minutes of the New York Horticultural Society, 1829, 143. "Landscape Gardening," was in its "infancy" and needed nurturing: "It is the legitimate province of our Society to accelerate the progress of improvement in this respect." While Loudon trumpeted one advance after another in his "Progress of Gardening" in Britain, the Republic had to wait for Downing's 1841 *Treatise* for significant steps in American landscape gardening, according to *Gardener's Magazine*, 1836, 637, "Gardening and Rural Improvements in Foreign Countries," where Loudon writes: "gardening, in common with every other description of rural improvement, is making rapid progress." Cf. also Therese O'Malley, "From Practice to Theory: The Emerging Profession of Landscape Gardening in Early Nineteenth-Century America," in *Botanical Progress, Horticultural Innovation and Cultural Changes*, eds. Michel Conan and W. John Kress (Washington, DC: Dumbarton Oaks, 2007), 223–237.

69. Peter Mickulas, "Cultivating the Big Apple: The New York Horticultural Society, Nineteenth-Century New York Botany, and The New York Botanical Garden," *New York History* 83, no. 1 (Winter 2002), 34.

70. Ibid., 35.

71. Carr, *Periodical Catalogue of American Trees*, 84.

72. Fry, "America's 'Ancient Garden,'" in *Knowing Nature*, 87; Alexander Gordon, "Bartram Botanic Garden," *Genesee Farmer* 7, no. 28 (1837), 220.

73. Two female members were medical doctors, and Emily L. Gregory was one of only seventeen female American botanists to receive a doctorate during the nineteenth century. Significantly, her degree was granted in 1886 in Zürich, Switzerland. See Mickulas, "Cultivating the Big Apple," *New York History*, 53.

74. Ann B. Shteir, *Cultivating Women, Cultivating Science: Flora's Daughters and Botany in England 1760–1860* (Baltimore: The Johns Hopkins University Press, 1996), 19–20.

75. Thomas Martyn, *Thirty-eight Plates, with Explanations: Intended to Illustrate Linnaeus' System of Vegetables* (London: J. White, 1799), plate 1.

76. William F. Mavor, *The Lady's and Gentleman's Botanical Pocket Book, Adapted to Withering's Arrangement of British Plants* (London: Vernor & Hood [1800]). The original owner of the copy kept at the Mertz Library has made numerous hand-written entries, ranging in date and location. Under the genus *Erica*, the observations extend from 1815 to 1829, all within the owner's home-base of Surrey. Other genera were noted further afield to the north or west of Britain.

77. Elliot's letter was published in John Claudius Loudon, *Gardener's Magazine*, February 1832, 162–164.

78. *Specimen's of Plants, Chiefly Drawn from Nature. With a Short Account of the Place of Growth, and Time of Flowering, of each Plant. Arranged According to Linneus' [sic] System, by Robert Elliot, Gardner to Milham Hartley Esqr. Rose-hill*, 1815 [manuscript].

79. Elliot, *Specimen's of Plants*, Introduction, 2.

80. Robert Thornton, *New Illustration of the Sexual System of Carolus von Linnaeus: Comprehending an Elucidation of the Several Parts of the Fructification; a Prize Dissertation on the Sexes of Plants...and the Temple of Flora, or Garden of Nature* (London: T. Bensley, 1807). The plate entitled "Flora Dispensing her Favours on the Earth," designed by Maria Cosway, is an excellent example of mythical womanhood drawn by a woman. Other illustrations drew upon themes and images from contemporary sentimental literature, including *Fables of Flowers, For the Female Sex* (London: Printed for G. Riley and sold by J. Wilkie, 1773).

81. Reference to North America is implicit, yet in the context of the still-possessed colonies, including "British North America" (Canada, home of the Loyalists). Cited with the permission of the author: Miranda Mollendorf, "Dissertation Prospectus: The World in a Book: Robert John Thornton's Temple of Flora 1799–1812," Harvard University, 2010–2013.

82. E. Charles Nelson, *Aphrodite's Mousetrap: a Biography of Venus' Flytrap, with Facsimiles of an Original Pamphlet and the Manuscripts of John Ellis, F.R.S.* (Aberystwyth, Wales: Boethius Press in Association with Bentham-Moxon Trust and the Linnean Society, 1990).

83. Mark Laird, "American Garden," in *Chicago Botanic Garden Encyclopedia of Gardens: History and Design*, ed. Candice A. Shoemaker (Chicago and London: Fitzroy Dearborn Publishers, 2001), vol. 1, 39–41.

TOWARD AN AMERICAN LANDSCAPE THEORY

JUDITH K. MAJOR

In the preface to *Fruits and Fruit-Trees of America* (1845), Andrew Jackson Downing described himself as "a man born on the banks of one of the noblest and most fruitful rivers in America…whose best days have been spent in gardens and orchards."[1] During his brief life, Downing was to become not only one of America's most respected pomologists, but also a renowned horticulturist, landscape gardener, and garden theorist.[2] Born on October 31, 1815 in Newburgh, New York, Downing lived his entire life in this village on the west bank of the Hudson River sixty miles north of New York City. He thus worked in the type of landscape that he recommended to his readers—where nature assisted in the creation of comely homes and gardens. The Hudson Highlands form a strikingly picturesque setting where steep bluffs edge both sides of the river (fig. 9.1). These surroundings were a profound influence on Downing, who promoted an American version of the British picturesque landscape style. In doing

so, he influenced the direction of landscape design throughout the second half of the nineteenth century.

Although there were plenty of British works on landscape gardening, they were predicated upon a climate, society, income, and cost of labor wholly different from those in the United States, and Downing recognized "a great want of something…felt in this country and great groping in the dark in the absence of it."[3] This need for native-born books was concisely explained by Downing: "No two languages can be more different than the gardening tongues of England and America."[4] The Collection of the LuEsther T. Mertz Library holds a rich variety of American publications that played a role in differentiating and defining American from British landscape gardening.

The Archives also include letters from Downing to the well-known botanist John Torrey (1796–1873) that offer a fresh approach to studying Downing's life and body of work. He was seventeen in 1833 when he wrote a deferential letter to Torrey: "I…cannot express my gratification at the commencement of a correspondence with one who holds such a prominent place among the friends of science in America." Over the next nineteen years,

FIG. 9.7. Scottish plant collector David Douglas was the first to extensively explore the American West Coast where he collected seeds of the majestic Douglas fir or *Abies douglasii*, here shown as a specimen in a domesticated landscape, in Edward Ravenscroft, *Pinetum Britannicum*, Edinburgh, 1884, vol. 2, plate 17.

FIG. 9.2. Portrait of Andrew Jackson Downing, signed by Calvert Vaux to John Torrey in 1865. To commemorate their mutual friend and colleague, Torrey named a genus native to California *Downingia* in his honor. Vertical File.

Downing matured from a fledgling nurseryman-horticulturist to an established author, editor, and landscape gardener. Letters reveal his fascination with both exotic and native plants and his increasingly warm friendships with Torrey and the botanist Asa Gray, who both played a key role in the creation of an American Flora (see chapter 7). The letters also show the importance of the Hudson River as a means of travel and communication between New York and the villages and estates along its length (fig. 9.2).[5]

In 1837 Downing wrote to Torrey that he was gathering material for a volume, "on the beauty, utility & advantage of foreign and indigenous forest trees considered chiefly in relation to Landscape Gardening and the improvement

FIG. 9.1. Majestic view over the Hudson River near Newburgh, NY, in a print by Hermann Meyer, ca. 1855. Many residences with extensive gardens were laid out along the river throughout the nineteenth century, with steamboats offering easy access to New York City. Art and Illustration Collection.

of Country Residences."[6] Ultimately, Downing published three different books to address these subjects: *A Treatise on the Theory and Practice of Landscape Gardening Adapted to North America* (1841), *Cottage Residences...Adapted to North America* (1842), and *The Architecture of Country Houses* (1850).[7]

For a young country anxious to justify itself, the native-born *Treatise* proved that Americans were ready to enjoy a civilized society. The embellishment of house and garden was turned

into a patriotic act as Downing forged a bond between landscape gardening and popular issues of the period, including the love of rural life and the ideals of domesticity and stability. His three editions of the *Treatise* reflected Downing's highest aspirations—to guide country gentlemen in the creation of ideal homes and extensive pleasure grounds.[8]

Borrowing concepts from the Old World—especially Britain—the *Treatise* addressed landscape gardening as a fine art. Two landscape expressions in the natural style—the "Beautiful" and the "Picturesque"—were the subject of numerous works and often acrimonious debates in eighteenth-century Britain and formed the foundation of Downing's American theory. Beginning with Edmund Burke's *Origin of our Ideas of the Sublime and Beautiful* (1757) and followed by Uvedale Price's *An Essay on the Picturesque* (1794) the two terms were defined by opposing characteristics that Downing assigned to the appropriate American landscapes (fig. 9.3).[9]

Downing favored the "Picturesque" over the "Beautiful" for aesthetic and practical reasons. He spelled out the advantages of the "Picturesque" in a suitable location such as the naturally wild and bold character of his native Hudson Highlands. With much effect and little art, the raw materials of wood, water, and surface could be economically appropriated. He was careful to explain, however, that in scenery that was naturally flowing in outline, proprietors were obliged to heighten that expression by the refinements of the "Beautiful" mode.

Downing was particularly indebted to the Scottish-born landscape gardener John Claudius Loudon (see chapter 8), who sought to change the long-held notion that the object of landscape gardening was to copy nature. Art should be recognized everywhere in the landscape, Loudon proclaimed, especially in

Fig. 12 Landscape Gardening, in the Graceful School.

Fig 13. Landscape Gardening, in the Picturesque School.

FIG. 9.3. The "Beautiful" and the "Picturesque," in Downing, *A Treatise on the Theory and Practice of Landscape Gardening*, New York, 1844, opp. p. 54, showing how qualities called "Beautiful" were diametrically opposed to the "Picturesque" characteristics of the landscape.

FIG. 9.4. Plan and section of the Derby Arboretum, in John Claudius Loudon, *Derby Arboretum*, London, 1840, p. 175. The author describes the arboretum's collection of trees and shrubs as one of the most extensive ever planted, and "named with a degree of correctness scarcely to be found in any other garden."

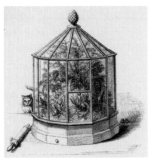

FIG. 9.5. A "Wardian case," a small glass parlor that would keep plants in good condition during long overseas voyages, as depicted in Nathaniel Bagshaw Ward, *On the Growth of Plants in Closely Glazed Cases*, London, 1852, p. 35.

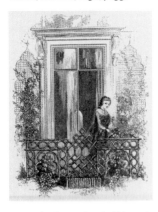

FIG. 9.6. Engraving, in Edward Sprague Rand Jr., *Flowers for the Parlor and Garden*, Boston, 1863, p. 224, showing a woman practicing balcony gardening. Rand considered the love of flowers "an almost holy thing."

the predominance of exotic trees, shrubs, and plants over indigenous ones. He developed an alternative landscape style called the "Gardenesque" that took into consideration the beauty of every individual tree and shrub as a specimen. This style benefited from the thousands of rare plants imported into Britain as new colonial accessions and overseas trade treaties opened up unknown areas of the world: the Royal Botanic Gardens at Kew and Loudon's Derby Arboretum (fig. 9.4), as well as many aristocratic estates, displayed these riches on their grounds.[10]

A remarkable invention called the Wardian case eased the importation of young trees and shrubs from distant countries. An accidental discovery in 1829 by the London physician and amateur naturalist Nathaniel Bagshaw Ward (1791–1868) led to its development as a practical method of transporting live specimens during long sea voyages. In 1834 Downing read about this innovation in a foreign horticultural magazine, and he eagerly described the

workings of this "curious thing" in a postscript to Torrey: "It is the cultivation of plants in close glazed boxes without the admission of or supply of water!" The idea occurred to Downing that the invention could also be used as a decorative feature for the home: "you might have a pretty & most curious rock-work in miniature…&the seeds of some of the most beautiful ferns planted among them" (fig. 9.5).[11]

The popular English author Shirley Hibberd (1825–1890) devoted a whole chapter to the Wardian case in *Rustic Adornments for Homes of Taste* (1856), while *Flowers for the Parlor and Garden* (1863) by Edward Sprague Rand Jr. (1834–1897) offered advice to Americans on stocking and managing this parlor accessory. Rand warned his female audience not to follow English practices because the plants would get chilled by the American winter if the case was built in a window. He also wrote about balcony gardening, reminding his readers that it is the sun and not the winter's cold that kills many of the plants (fig. 9.6). The remedy was simple: protect from the winter's sun.[12]

This difference in climate was one of the major reasons that British treatises on gardening were unreliable for readers across the ocean. From practices in the flower and the vegetable garden to the method of transplanting trees, Downing noted that the bad words of English gardening were damp and lack of sunshine, those of America, drought and hot sunshine.[13] Although he considered the lawn as one of the most enduring sources of beauty in landscape gardening, Downing admitted in his popular journal *The Horticulturist and Journal of Rural Art and Rural Taste. Devoted to Horticulture, Landscape Gardening, Rural Architecture, Botany, Pomology, Entomology, Rural Economy, &c.* that unlike the moist and humid conditions of Britain, the dry and hot American summers do not favor lawns.[14] Yet later writers on

landscape architecture continued to promote the lawn, and despite the unsuitable conditions, the perfect green lawn would reach cult status in America.

In July 1850 Downing embarked on his first and only trip abroad to acquire first-hand knowledge of England and France; he also gained a fresh understanding of his own country's worth. Touring the grounds of grand estates while in England, Downing proudly noted the specimens and collections of indigenous American plants: the Douglas firs at Chatsworth and at Dropmore and the rich masses of rhododendrons, azaleas, and kalmias in the "American" garden at Woburn Abbey (fig. 9.7). Downing also met the English architect Calvert Vaux (1824–1895) in London, and Vaux elected to return to the United States with him—a decision of great import for the future of American landscape architecture.[15]

After his sojourn abroad, Downing slowly came to the realization that the adoption of Loudon's notion that the natural style could be acknowledged as art only through the use of numerous exotic plants (i.e., the "Gardenesque")—made little practical or aesthetic sense in a country so rich in indigenous trees and shrubs as America. He became convinced that improvers could use native trees to realize landscape gardening in the highest sense of the term: Americans merely had to take a tree out of the forest and cultivate it in good soil on an open lawn. Downing pointed to a fifty-year-old elm planted in the midst of a smooth lawn: its symmetrical form with its long graceful branches in the shape of an antique vase was nothing like its wild counterpart (fig. 9.8).[16]

Downing was not the sole author attempting to teach Americans to appreciate their native trees. He could rely on books such as *The American Forest, or, Uncle Philip's*

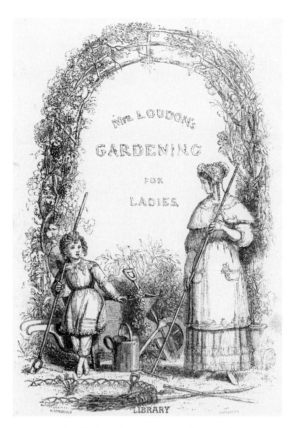

FIG. 9.10. Frontispiece, in Jane Loudon, *Practical Instructions in Gardening for Ladies*, London, 1841, showing a mother and child with gardening tools. Admiring the English author and her work, Downing helped to prepare her publication for the American market.

Conversations with the Children about the Trees of America (1834). According to Uncle Philip, the oak is the grandest and the most useful of trees, and he related to his young audience that the best wood and sweetest acorns come from the white oak (fig. 9.9). Like Downing, the author hoped, "it will not be deemed time misspent to have taken some pains to acquaint [children] with the wealth and beauty of those magnificent forests which spread over the broad surface of our dear country."[17]

At this time, children were reared on conversation books such as *The American Forest*; botany and gardening were believed to be ideally suited to children (as well as to ladies) As Uncle Philip wisely noted, "I have often been struck by the fact that children seldom become

The Oak.

FIG. 9.9. Oak tree, in Uncle Philip [Francis Hawks], *The American Forest*, New York, 1868, p. 19, illustrating Downing's belief that there were "no grander or more superb trees, than our American Oaks." Compared to the smaller number in Britain and France, North America could boast no less than forty different species.

FIG. 9.8. (next spread) View of elm trees in New Haven, Connecticut, ca. 1845, known in Downing's time as "the City of Elms." Print after a drawing by Alexander Jackson Davis, the artist and architect who delineated many of the illustrations in Downing's works. Art and Illustration Collection.

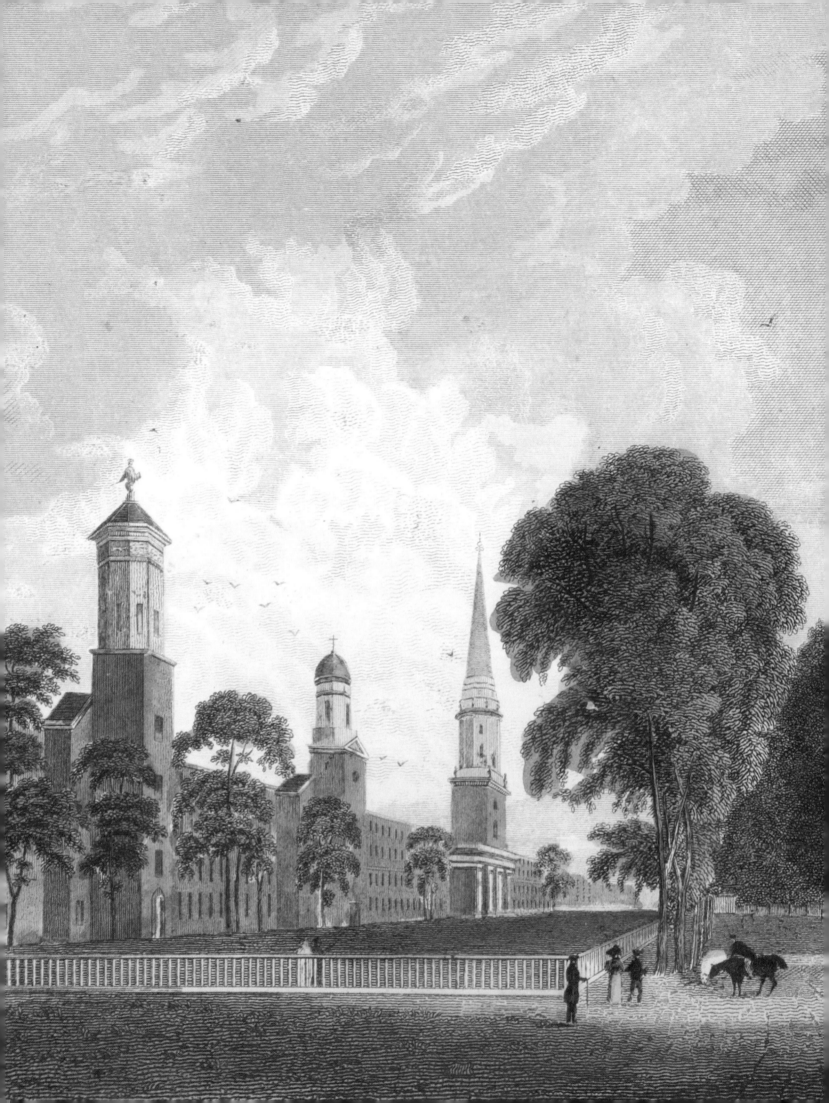

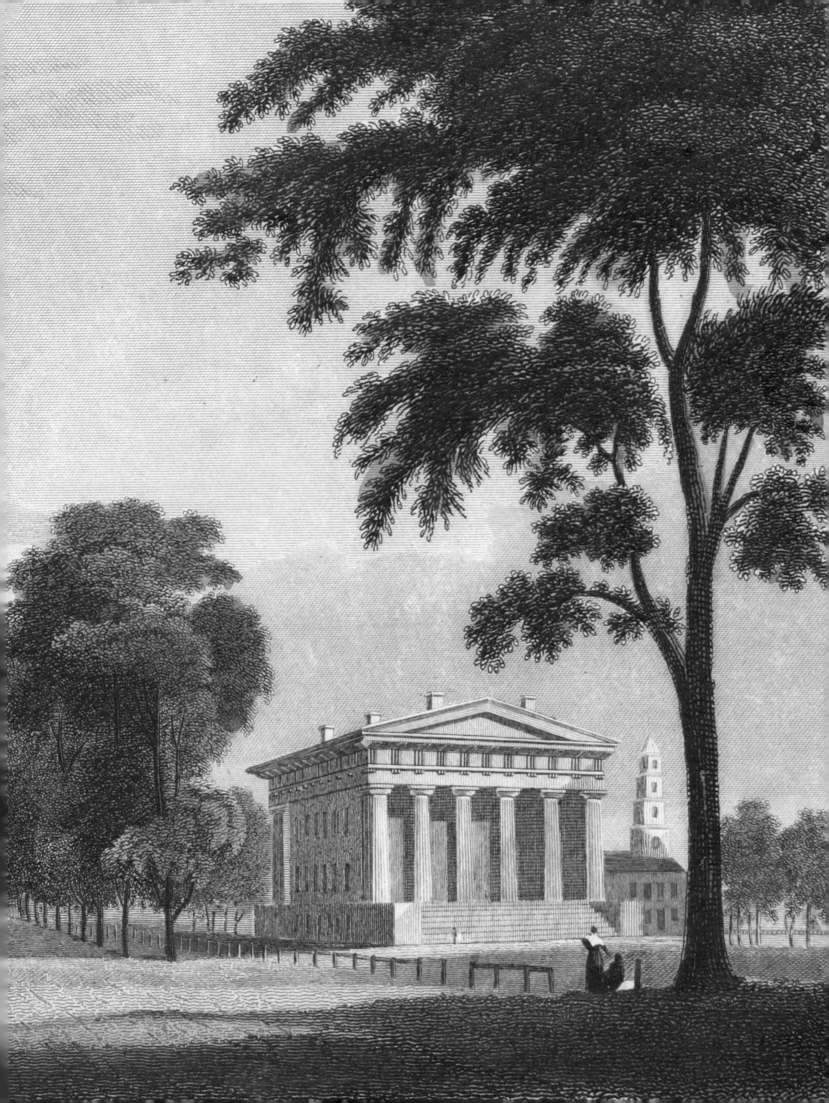

FIG. 9.11. Surrounded by flowers, ladies arrange nosegays, as depicted in Peter Parley, *The Garden, Familiar Instructions For the Laying Out and Management of a Flower Garden*, Philadelphia, 1869, opp. p. 115.

CELEBRATED WORKS

ON AMERICAN

GARDENING AND

HORTICULTURE

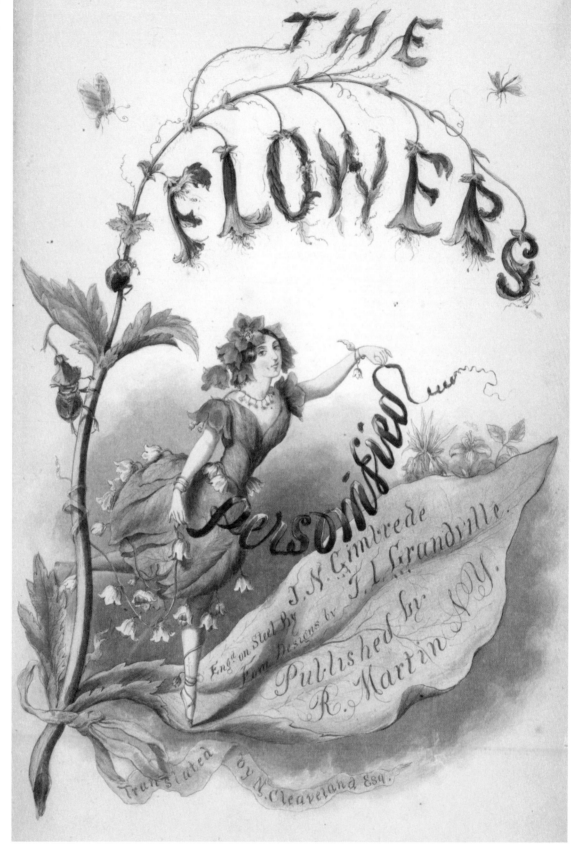

FIG. 9.12. Title page, in *The Flowers Personified*, a translation of J.J. Grandville, *Les Fleurs animées*, New York, 1849. Colorful illustrations convey the personality assigned to each flower by the Victorian language of flowers. The columbine, for example, expresses folly, the yellow daylily coquetry.

weary of having their attention directed to the objects of nature."[18] One way that Downing's interest in the education of children expressed itself was in the design of an ideal schoolhouse—full of light and air and surrounded by nature. Such schools would positively affect a child's character.[19]

Carrying these ideas over to the realm of the American home, Downing fully believed that good houses with lovely gardens and fruitful orchards effected a moral improvement in human nature, and that ladies were the natural mistresses of the art of embellishment.[20] He was therefore delighted in 1834 to note the publication of John Lindley's *Ladies' Botany*,[21] and John Torrey's intent to bring it to the attention of an American audience.[22] And in fact, Downing would become personally instrumental in bringing out an American edition of Mrs. Jane Loudon's *Gardening for Ladies; and Companion to the Flower-Garden* in 1843. His preface to this book stated that he sought to increase a taste for gardening among his own "fair country-women,"—an occupation that he believed would directly improve their health.[23] Downing's trip abroad would boost his conviction in the benefits of exercise when he witnessed first-hand that English women of rank did not lead a life of drawing room languor but one full of active duties, and he repeatedly admonished his countrywomen to work and walk outdoors more often.[24]

The works of Jane C. Webb Loudon (1807–1858) were written in a clear and simple style that Downing found particularly commendable, and he hoped that *Gardening for Ladies* would attract both novices and amateurs who had little practical experience (fig. 9.10). There were few Americans, he observed in the preface, who did not have to "begin at the beginning," and few who did not desire simple and elementary instruction. Downing added a number of notes to the book that were necessary because of the differences in climate; one was a reminder that the camellia would not endure the open air in winters north of the Carolinas.[25]

Jane Loudon wrote her major work *Botany for Ladies* (1842) as an alternative to John Lindley's *Ladies' Botany*. Remembering her own struggle to learn botany, she recognized that women needed a book that contained more elemental information and that was more easily understood. She also turned away from the familiar format of an earlier generation. No longer narrated by a maternal voice or in a domestic setting, her text was written in the first person, which was meant to invite women readers into botanical study. The decision reflected Mrs. Loudon's pedagogical ideas about girls' education in botany—rather than mothers, specialists trained as botany teachers should be in charge.[26]

With Mrs. Loudon's advanced ideas on women and their potential, one may ask whether she approved of Downing's tenor in *The Horticulturist* as he expressly courted his female readers. In "A Talk with Flora and Pomona," the deity of the garden, Flora, shared her wisdom with Downing and counseled that floral designs were best performed under the direction "of the more tasteful eyes of ladies."[27] Downing was not the only one to expect ladies to take care of the realm of flowers—at the time, other male writers concurred that without flowers and female smiles, men were merely savages.[28] In "On the Drapery of Cottages and Gardens," Downing remarked: "Men are so stupid…that if the majority of them had their own way there would neither be a ringlet, nor a ruffle…nor a nosegay, left in the world." He asked the aid of the ladies in "dressing, embellishing, and decorating" the outside of country cottages and homes (fig. 9.11).[29]

Jean-Baptiste Alphonse Karr (1808–1890), a

CELEBRATED WORKS
ON AMERICAN
GARDENING AND
HORTICULTURE

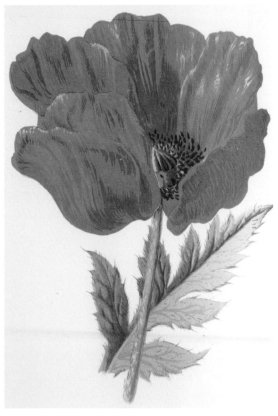

French journalist and novelist who also indulged in a love of floriculture, wrote the introduction to *The Flowers Personified: Being a Translation of Grandville's "Les Fleurs Animées"* (1849). Today Karr's introduction is seen as a work of Victorian social satire, as he implores ladies to take pity on the poor flowers laid at their feet: "Will you not remember that they are severed from their parent stems; that they have been brought to you that you may see them die, and inhale their last fragrant sighs."[30] The volume's fifty-four plates offer hand-colored engravings of floral maidens in the guise of her designated flower (fig. 9.12).

In addition to *Rustic Adornments for Homes of Taste,* Shirley Hibberd was also the author of the five-volume *Familiar Garden Flowers* (1879–1887), which has equally colorful, but less fanciful plates as *Les Fleurs animées.* Each volume contains approximately forty "familiar" flowers (fig. 9.13 A–B).[31] Referred to as the father of amateur gardening, Hibberd was the ideal person to convince amateurs that the skills of horticulture could be learned by anyone. In many aspects, Downing's life and career were similar to Hibberd's; both were authors and editors in horticulture who wrote from personal experience and carried out trials on a variety of flowers and fruits. The two men believed that the garden was an artificial creation, not a copy of nature, and both professed to write for an audience with moderate means.

Downing spun a dream of the ideal country residence in the *Treatise* only to realize that it was unattainable for all but a few Americans. The starting ground for an American theory and practice rested in *The Horticulturist,* which set its sights on more modest aspirations: "a cottage embosomed in shrubbery, a little park filled with a few fine trees, a lawn kept short by a flock of favorite sheep."[32] Downing increasingly advocated simplicity and frugality linked with

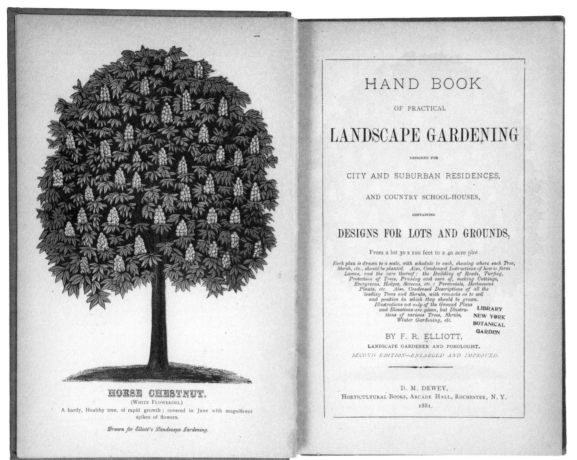

FIG. 9.14. A flowering horse chestnut (*Aesculus hippocastanum*), as depicted on the title page, in *Hand Book of Practical Landscape Gardening*, Rochester, New York, 1881, by F.R. Elliott, landscape gardener and pomologist.

TOWARD AN
AMERICAN LANDSCAPE
THEORY

making the best use of the country's existing natural landscape–most particularly its native vegetation.[33] Downing condemned nurseries that did not stock the native tulip tree, sassafras, and black gum, and while praising the unrivaled beauty of these trees he also offered practical reasons for their superiority. All of them were freer from insect attacks than imported trees, he wrote, and they remained unaffected by the summer sun, which burned the leaves of what Downing referred to as the "Asiatic" horse-chestnut (fig. 9.14).[34]

The first number of *The Horticulturist* appeared in July 1846. The new journal under the editorship of Downing began publication fully ten years after he first discussed the idea for such a periodical with John Torrey. In 1836 Torrey had introduced Downing to W. J. Hooker's *Companion to the Botanical Magazine*

and commented that a similar publication would be beneficial in America.[35]

As the full title indicated, a great percentage of *The Horticulturist* was devoted to practical subjects; much space was given to the discussion and illustration of hundreds of new and improved varieties of fruit and to pomological reform. As author of the regularly reprinted *Fruits and Fruit-Trees of America* (1845), it is not surprising that Downing made frequent references to fruits and fruit trees ranging from cherries to pear trees; at times, a letter to Torrey was accompanied by a box of fruit for him to enjoy with his wife. Downing wrote *Fruits and Fruit-Trees* (fig. 9.15), which he described to a friend as "digested descriptions of fruits,"[36] because he felt that everything previously published on the subject was full of errors. The Mertz Library has several earlier works on American fruit trees

including *The American Orchardist* (1822) by the physician James Thacher (1754–1844), which the author introduced as a "little practical treatise… for the information and encouragement of our farmers."[37]

Over the course of his editorship of *The Horticulturist*, Downing's inclination leaned increasingly toward moderation and simplicity, as study, professional practice, travel, and access to information and opinions from the far reaches of the United States and its territories gave him the confidence to modify his theory and practice of landscape gardening. It became vividly apparent to Downing that societal, economic, and climatic differences made English books on landscape gardening useless in America. There was a vast disparity in the availability of land and labor: in the Old World, land was scarce and there was of a division of labor that provided access to domestic services. In America, land was plentiful and with the opportunities for westward movement, even expensive domestic labor was difficult to find. Everything, Downing stressed, called for "a mint of money," because labor was always costly in America: "servants are so time-serving in this country, where intelligent labor finds independent channels for itself."[38]

It is not surprising that two examples of what Downing called America's "rural gems" were relatively modest compared to the grand estates that he visited abroad. Hyde Park and Montgomery Place were located on the Hudson River and both began with an excellent patrimony from nature: existing streams, native woods, and varied undulating grounds. Their new plantations, roads, walks, and architectural features, including bridges, seats, pavilions, and a large greenhouse/conservatory were all tastefully designed and sited.

In the summer of 1834, Downing planned a visit to Hyde Park and asked Torrey for a letter of introduction to its owner, the physician and botanist Dr. David Hosack (see chapter 8).[39] Since 1828 Hosack had been improving his Hudson River estate, a seven-hundred-acre site north of Poughkeepsie, with the help of the Belgian nurseryman and landscape gardener André Parmentier (1780–1830). Downing lauded Hyde Park as "one of the finest specimens of the modern [i.e., natural] style of Landscape Gardening in America," and took advantage of his earlier personal inspection to describe how art heightened the natural charms of the site (fig. 9.16).[40] Hosack's villa was situated on a ridge overlooking the Hudson, and Parmentier created a broad sloping lawn down to the river to make the house visible to passers-by traveling by steamboat. James Thacher (author of the earlier mentioned *The American Orchardist*), stopped by Hyde Park on an excursion down the Hudson. Admiringly, he described the stone bridge that took the approach drive over a rapid stream emerging from the milldams above to fall in a cascade: "the winding of the road, the varied surface of the ground, the bridge, and the falling of the water, continually vary the prospect and render it a never tiring scene."[41] Parmentier planted a grove of Lombardy poplars and magnolias native to Appalachia, and Hosack also had a greenhouse built to house his collection of citrus trees and tropical plants.[42]

Parmentier called for the reinstatement of nature in a brief essay on "Landscapes and Picturesque Gardens," published in Thomas G. Fessenden's *New American Gardener* (1828). Writing that it was ridiculous to apply the rules of architecture to the embellishment of gardens, he extolled those individuals who preferred "to walk in a plantation irregular and picturesque, rather than in those straight and monotonous alleys, bordered with mournful box, the resort of noxious insects."[43] Hosack's villa and its grounds and embellishments closely paralleled Parmentier's design advice in this essay.

FIG. 9.16. View of Hyde Park, after a sketch by Downing's colleague Alexander Jackson Davis, illustrating improvements to the grounds by landscape gardener André Parmentier. A. J. Downing, *A Treatise on the Theory and Practice of Landscape Gardening*, New York, 1844, opp. p. 34.

FIG. 9.15. Among many varieties published in *Fruits and Fruit-Trees of America*, New York, 1850, p. 378, Downing especially lauded the Dix pear: "The Dix is, unquestionably, a fruit of the highest excellence…juicy, rich, sugary, melting and delicious, with a slight perfume. The original tree… stands in the garden of Madam Dix, Boston. It bore for the first time in 1826."

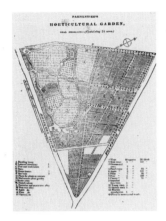

FIG. 9.17. André Parmentier's Horticultural Garden in Brooklyn, illustrated in *The New England Farmer*, Oct. 3, 1828, p. 84, was essentially a commercial nursery and contained a great variety of trees and plants—useful and ornamental, indigenous and exotic—including varieties introduced into America for the first time.

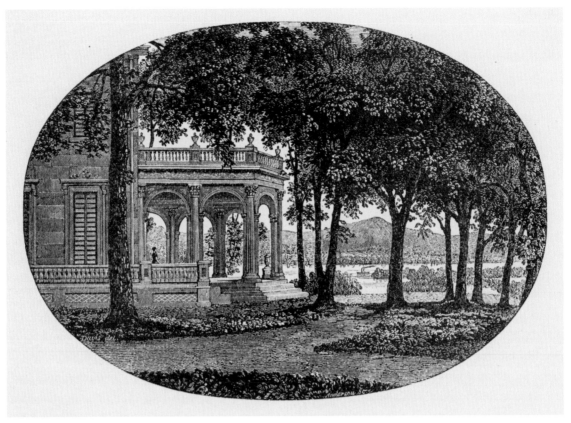

FIG. 9.18. This view of Montgomery Place in *The Horticulturist*, vol. 2, Oct. 1847, opp. 183, illustrates Downing's admiration for the place evident in his description: "So great is the variety of scenery [at Montgomery Place], caused by the leafy woods, thickets and bosquets, that one may pass days and even weeks here, and not thoroughly explore all its fine points."

André Parmentier belonged to a celebrated family of Belgian horticulturists. In his native city of Enghien (or Edingen), south of Brussels, Parmentier received training in landscape gardening under the guidance of his brother. Soon after immigrating to America in 1824, he was asked by Hosack to be the superintendent of the Elgin Botanic Garden, America's first botanical garden. Parmentier decided instead to establish his own horticultural and botanic garden on a twenty-four-acre site in Brooklyn (fig. 9.17). In an 1828 article reprinted in *The New England Farmer*, the author described the transformation of the original site: "In the short space of three years one of the most stony, rugged, sterile pieces of ground on the whole Island which seemed to bid defiance to the labours of man, [is] now stored with the most luxuriant fruit and blooming with the most beautiful flowers."[44]

In 1893 the Curator of the Royal Botanic

Gardens at Kew, George Nicholson (1847–1908), visited Hyde Park after two months of studying America's native woody vegetation. Although it had been over sixty years since Parmentier designed the grounds, Nicholson recognized the beauty of the designed setting: "From the natural terrace near the house with a distant view of the Catskills, and to the north splendid river scenery, the eye ranges over wide stretches of turf bordered by noble trees." All those interested in landscape gardening, he wrote, should explore this place to learn a lesson on how to treat the foreground to fine distant views. He described a grove of beeches and the many

specimens on the estate, ranging from a ginkgo with a thirty-six-inch-diameter trunk to the finest pitch pine that he had ever seen.[45]

The other rural gem, the 380-acre Montgomery Place, was devoted largely to pleasure grounds and ornamental gardens (fig. 9.18).[46] Bounded on the west by the Hudson, a broad undulating lawn looked over the water to the Catskill Mountains. The estate had been passed down to Louise Davezac Livingston (1781–1860) and her daughter Cora Livingston Barton (1806–1873).[47] After 1845 Downing became increasingly involved with the landscape improvements being carried out by this pair.[48] In that year he suggested design changes for the flower garden when it became necessary to diminish its size, while assuring Mrs. Livingston that he had "the greatest confidence" in her judgment and taste.[49] A year later he expressed delight that the great charms of Montgomery Place were to be enhanced by an arboretum: "How few persons there are yet in this country who know any thing of the individual beauty of even our own forest trees."[50] Downing also admired the estate's free-standing conservatory, where delicate plants and large citrus trees grew until they were brought out in summer.

Forty-five years later, Charles Eliot (1859–1897) described Montgomery Place in *Garden and Forest*, and his father subsequently reprinted the article in *Charles Eliot: Landscape Architect* (1902). Where once the flower garden and conservatory stood, there was "a simple but well-framed lawn," and only a few scattered specimens remained from the well-stocked arboretum so admired by Downing. What had not changed was the broad panorama of the Hudson River to the west backed by the bold outline of the Catskills. Eliot quoted Downing: "Morning and noon the shade [of the Catskills] only varies from softer to deeper blue. But the hour of sunset is the magical

time for the fantasies of the color-genii of these mountains."[51]

Two factors stimulated the burst of enthusiasm for glasshouses in the mid- to late-nineteenth-century garden. First, the repeal in 1847 of the Federal Direct Tax law that took into account the number and size of windows, and second, a sharp increase in gardening literature that kindled a taste for this type of architectural structure in the garden.[52] A year after the repeal of the glass tax, Downing enticed his readers to "open this little glazed door… [on] a little miniature tropical scene, separated from the outer frost-world only by a few panes of glass." He knew that his readers with "money in their purses" could enjoy the luxury of greenhouses and conservatories filled with rare and beautiful exotic plants. But Downing also offered instructions, a plan, and a section for a small greenhouse that could be attached to a parlor (fig. 9.19). The structure was particularly light and airy and every plant was within reach. He spelled out how to keep the little place warm in the winter, protect it from the hot sun in the summer, and how to bring in a supply of water.[53]

This type of small attached greenhouse would have been a good addition to the "Cottage in the English, or Rural Gothic Style," Design II in Downing's *Cottage Residences* (1842). The entrance façade of this "Picturesque" cottage on a one-and-a-quarter-acre site looked toward a prospect and was a mile from a country town (fig. 9.20). The cottage boasted a veranda—of great utility in America's hot summers, but scarcely necessary in England because of the damp climate. A portion of the grounds was laid out as a lawn, shrubbery, and flower garden "in the picturesque manner," and the rest was devoted to a fruit and vegetable garden. As advised in Downing's *Treatise,* spiry-topped trees were planted to harmonize with the gothic architecture of the cottage.[54]

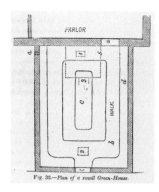

FIG. 9.19. Plan and section of a small greenhouse, in A. J. Downing, "A Chapter on Green-Houses," *The Horticulturist,* vol. 3, Dec. 1848, p. 259. In the instructions Downing explains the arrangement of the water supply and how to keep the place warm in winter and protected during the hot summer months.

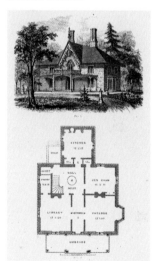

FIG. 9.20. Plan and perspective view of a "Cottage in the English, or Rural Gothic Style," as illustrated in Downing, *Cottage Residences,* New York, 1842, opp. p. 50. Rather than the bay window projecting from the parlor, a small greenhouse could be attached.

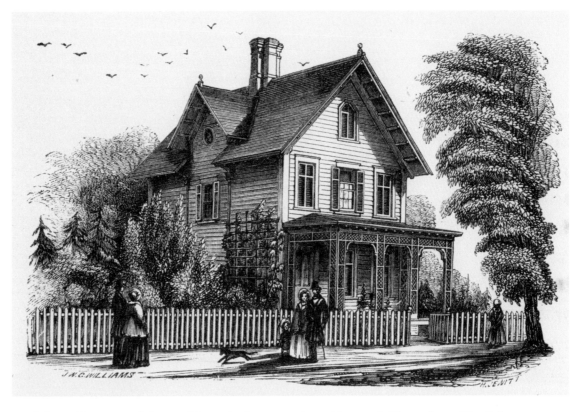

Calvert Vaux carried forward Downing's
ideas on American landscape gardening and
rural architecture after his partner's death on
July 28, 1852, when the Hudson River steamboat
Henry Clay caught fire and sank. Vaux recalled
his partner's "great desire—Public Pleasure
grounds *every where,*" to express on a grand
scale what he considered the national/natural
style in landscape gardening, remedying
the country's lack of a national garden and
promoting an American taste for public
pleasure grounds. Downing's vision for the
Public Grounds in Washington, DC, which he
was working on at his death, would be realized
in the city he so eloquently championed in *The
Horticulturist* editorial "The New-York Park."
The 1858 "Greensward Plan" for Central Park
was designed by Calvert Vaux—the English
architect whom Downing brought to America—
and Frederick Law Olmsted (1822–1903)—the
gentleman farmer whose queries to the editor
appeared in *The Horticulturist*. Until the

1870s, Vaux and Olmsted would collaborate on
landscape projects throughout the country in
cities including Chicago, Boston, and Buffalo,
carrying forward the experiment in public park
design initiated by Downing.

In 1857, the same year as the design
competition for Central Park, Vaux brought
out *Villas and Cottages: A Series of Designs
Prepared for Execution in the United States*. Like
Downing, Vaux wrote about accommodating
designs to, "the soil, the length of day, the wants
of the people, [and] the habit and form of the
government" in America. Vaux also agreed with
Downing that the improvement of the village
school house and its surroundings was one of
the most powerful forces that could be applied
toward bettering rural buildings in general.[55]
Vaux did not supply ground plans for his designs
as in *Cottage Residences*, but vignettes give
a sense of the siting. "Design No. 1: A Simple
Suburban Cottage," was for a plumber on a
twenty-five-foot lot in Newburgh, New York

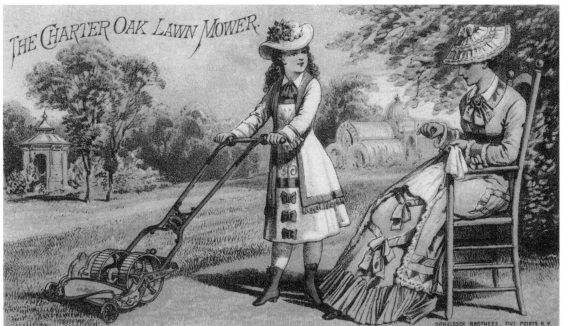

THE CHARTER OAK LAWN MOWER.

DONALDSON BROTHERS, FIVE POINTS, N.Y.

TOWARD AN
AMERICAN LANDSCAPE
THEORY

(fig. 9.21). A veranda was attached to the front of a simple rectangular structure. Vaux suggested that if there were any young girls in the family, the parlor could be enlivened by a hanging basket of flowers.

Vaux and Olmsted dissolved their partnership in 1872, and a few years later Olmsted established a formal working relationship with Jacob Weidenmann (1829–1893), a Swiss-born landscape architect working in Connecticut. Weidenmann's first book, *Beautifying Country Homes: A Handbook of Landscape Gardening* (1870), had already been published. "Within the last ten years," Weidenmann noted in the preface, "the popular taste has wonderfully advanced, and the want of a brief work of instruction in Landscape Architecture has been greatly felt." Downing had died in 1852 and although Olmsted wrote numerous articles, reports, and encyclopedia entries, he never wrote a book on the subject. Weidenmann believed that all Americans could "make their country homes attractive and lovely, and enjoy the beauties of nature about their own house."[56]

Like Olmsted and Horace William Shaler Cleveland (1814–1900), who practiced in the Midwest, Weidenmann believed that designers in their field should be known as "landscape architects," not as "landscape gardeners." Olmsted thought this title "more discriminating" and that using "landscape architect" prepared clients for dealing with him as a professional. Cleveland wrote in 1873 that most of his clients in the Midwest believed that landscape gardening was solely a decorative art.[57]

Weidenmann's *Beautifying Country Homes* has two sections: the first lays out practical general rules and principles applicable to any style of grounds and residences. Weidenmann optimistically assumed that the landscape architect would be called in at the beginning of the project to help situate the house and to advise on drainage, road construction, and the grading of roads and walks. Only at that point would he direct the planting, dressing, and seeding of the lawns, and the planting of trees and shrubs. Weidenmann also attempted to answer every client's central question: what will the improvements cost and what will

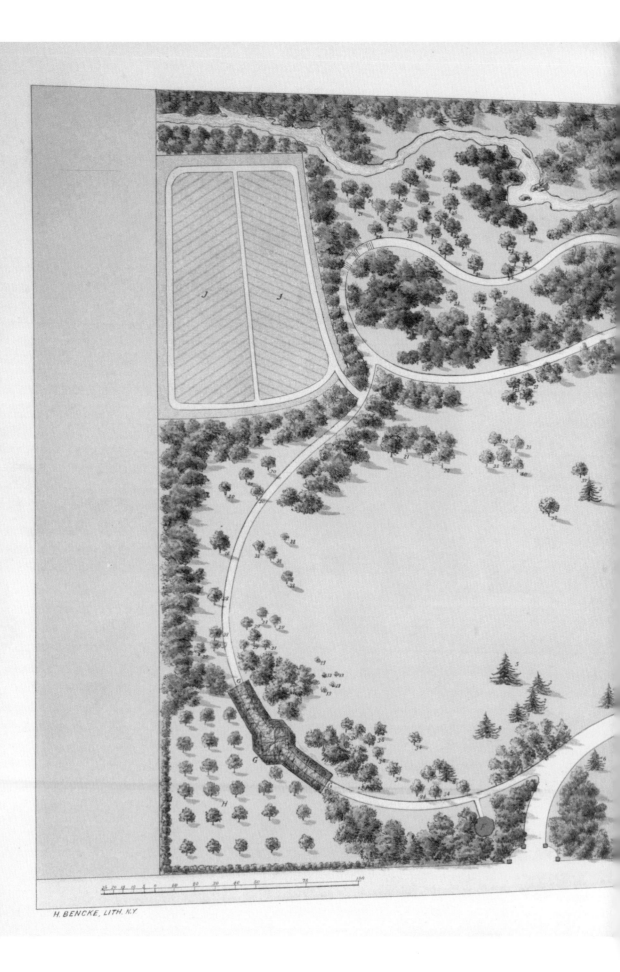

FIG. 9.23. Garden layout, in J. Weidenmann, *Beautifying Country Homes*, New York, 1870, plate XXII, illustrates the residence of Morris K. Jesup, Esq., situated on the Hudson River near Irvington, NY. Designed and executed by Ignatz A. Pilat, the five-acre site accommodated a picturesque ravine and beautiful undulating lawns, gentle sloping down to and offering grand views over the river.

H. BENCKE, LITH, N.Y.

TOWARD AN
AMERICAN LANDSCAPE
THEORY

be the yearly expense of keeping the grounds in good order?

As mentioned earlier, Downing admitted in *The Horticulturist* that the hot, sunny American summer does not favor the type of fine lawns that thrive under British conditions, yet writers on landscape architecture continued to promote the lawn. Weidenmann devoted a section to lawns, observing that this landscape element formed the basis of ornamental pleasure grounds and was of great importance. He recommended the use of a lawnmower to save labor:[58] a No. 2 hand-machine required two men and mowed three quarters of an acre per day—a much different portrayal from that shown in nursery catalogs and trade cards from the 1880s onward in which an elegantly dressed young girl pushes one of the new lightweight lawnmowers (fig. 9.22).[59]

Part two of *Beautifying Country Homes* offers twenty-four colored plates of "Plans of Improved Places," including country homes, country seats, and suburban residences on sites ranging from 1½ to 10 acres and houses on small city lots. All were existing projects designed by landscape architects—Weidenmann considered completed work more valuable than "any fancy drawings or designs."[60] He briefly described the grounds of each place and listed their principal trees and shrubs. A project designed and executed by the Austrian-born gardener Ignatz A. Pilat (1820–1870) for the Hudson River residence of the New York financier Morris K. Jesup (1830–1908) is illustrated in plate XXII (fig. 9.23).[61] Pilat was a friend of Olmsted's and served as head gardener of Central Park beginning in 1857, the year he conducted a plant survey of the Central Park site.

A contemporary of Olmsted, Eliot, and Weidenmann, Mariana Griswold Van Rensselaer (1851–1934), was not a practitioner but a critic writing about landscape gardening (a term she preferred over landscape architecture) in

periodicals such as *Century, American Architect and Building News,* and *Garden and Forest.* She worked closely with Olmsted who admired her ability to explain his nascent profession to architects, aspiring landscape architects, gardeners, clients, and public and private users of designed landscapes. Like Olmsted, she considered the landscape architect an artist, and he wrote to her that "the interpretation of artists to the public" was her mission.[62]

Van Rensselaer's *Art Out-of-Doors: Hints on Good Taste in Gardening* (1893) was a recasting of and additions to six years of her articles and editorials. It was neither a do-it-yourself manual nor a practical treatise for artists and students: she simply wished "to say a friendly word to the public on behalf of gardening as an art." Jane Loudon would have approved of the chapter "A Word for Books," in which Van Rensselaer wrote that no helper was as good as a botanical handbook to develop a love for nature.[63]

In an 1896 editorial for *Garden and Forest,* Van Rensselaer carried forward Downing's idea that there was a vast difference between England and America in regard to the practice of landscape gardening. She noted two important ways that the nations differed: the price of labor and the climate. Van Rensselaer wrote: "In England labor is cheap; in America it is very dear." And America's climate—"almost arctic in winter, and almost tropical in summer"—would not permit American women to work in the garden like their British counterparts.[64]

How to Plan the Home Grounds (1899) by the landscape architect Samuel Parsons Jr. (1844–1923) reiterated that America's gardens should "talk our language…[and should be made] in the way of our day and country."[65] Parsons had been Vaux's partner and they were responsible for selecting the site of The New York Botanical Garden (see chapter 11). Parsons had also acted as New York City superintendent of parks—

therefore, it is no surprise that he dedicated the book to Vaux and to William A. Stiles (1837–1897), the managing editor of *Garden and Forest*, who had argued for maintaining the integrity of the original Greensward plan for Central Park.

The purpose of Parson's book was set forth in the preface: to offer simple basic principles for making all home grounds beautiful—whether a small yard or a great country estate. His articles in *Scribner's Magazine* often addressed lawns, and in *How to Plan the Home Grounds* he reserved a chapter for the lawn, which he considered next in importance to the house: "the very heart of the landscape picture lies within the tender green space." He admitted that there was still much to be accomplished in developing vigorous varieties of well-known grass seed that would endure drought and shade.[66]

In 1899 Samuel Parsons Jr. was one of eleven founding members of the American Society of Landscape Architecture that included the sons of Frederick Law Olmsted and Calvert Vaux. The century thus ended with the founding of a professional organization that dedicated itself to "the public health, safety, and welfare and recognition and protection of the land and its resources."[67] Missing from this Society's code of ethics was any reference to "nature" or to "beauty" in any guise, and there was no attempt to link landscape architecture to the fine arts as Olmsted and his colleagues had done. Half a century had passed since Downing's *Treatise* declared that American horticulture and landscape gardening could not advance without understanding the nation's native language of gardening. A language of gardening had become a language of professionalization. All was not left behind, however. Twentieth-century landscape architects were able to benefit from and to be inspired by the amateur naturalists, inventors, plant collectors, botanists, nurserymen, horticulturists, gentleman farmers, gardeners, landscape gardeners, architects, journalists, authors, and critics who had shaped a rich American tradition. In an exchange with the Old World through correspondence, periodicals, and books, Americans adopted, adapted, or rejected ideas and practices as the nation moved toward an indigenous theory of landscape architecture.

TOWARD AN
AMERICAN LANDSCAPE
THEORY

ENDNOTES

The author has written a full-length study of Downing's theory and practice of landscape gardening: *To Live in the New World: A. J. Downing and American Landscape Gardening* (Cambridge and London: MIT Press, 1997). She has also published: *Mariana Griswold Van Rensselaer: A Landscape Critic in the Gilded Age* (Charlottesville and London: University of Virginia Press, 2013). See also Judith K. Major, "Downing, Andrew Jackson." 137–138. In *The Oxford Companion to the Garden*, ed. Patrick Taylor (Oxford & New York: Oxford University Press, 2006); and Judith K. Major, "Downing, Andrew Jackson 1815–1852: United States Landscape Gardener and Horticulturist," 1: 384–387; and "Wardian Case," 3: 1417–1418. In *Chicago Botanic Garden Encyclopedia of Gardens: History and Design*, ed. Candice A. Shoemaker, 3 vols. (Chicago and London: Fitzroy Dearborn Publishers, 2001).

All writings from *The Horticulturist* are by Andrew Jackson Downing.

1. The quotation is from the opening line of the preface to A. J. Downing, *The Fruits and Fruit-Trees of America* (New York and London: Wiley and Putnam, 1845)]. The Mertz Library has ten editions of A. J. Downing, *Fruits and Fruit-Trees of America* ranging from 1845 to 1900.

2. Evidence of Downing as a respected pomologist can be found in Charles Darwin, *On the Origin of Species by Means of Natural Selection* (London: John Murray, 1859), 85. When Darwin wrote about natural selection in *Origin of Species* he cited Downing's findings on the curculio, a type of weevil that affected certain varieties of fruit. The Mertz Library's first edition of *Origin of Species* is one of 1,250 copies, all of which were sold on November 24, 1859, the day of publication. The Mertz Library has an extensive collection of Darwiniana. As late as 1875, D. M. Dewey, who provided nurserymen plates of fruit, flowers, and ornamental trees, referred to Downing's *Fruits and Fruit-Trees* as the country's most reliable work. See D. M. Dewey, *Dewey's Colored Fruits and Flowers* (Rochester, NY: D. W. Dewey, 1875).

3. Downing to Torrey, 9 November 1837. Archives NYBG, Torrey Papers.

4. "American versus British Horticulture," *The Horticulturist and Journal of Rural Art and Rural Taste* 5 (September 1850): 249–250.

5. A. J. Downing to John Torrey, 28 August 1833, Archives NYBG, Torrey Papers. An informal lending arrangement with Torrey allowed Downing to stay current with the latest books and journals such as John Lindley's *Ladies' Botany, or, A familiar introduction to the study of the natural system of botany* and the *Gardeners' Chronicle* and William Jackson Hooker's The *Journal of Botany*. Through this means, he learned of new inventions such as the Wardian case, and kept track of botanical explorers including David Douglas and Thomas Nuttall. The Mertz Library has 107 various editions of John Lindley's and 87 of William Jackson Hooker's works; In March 1836, Downing wrote to Torrey: "The direct communication with the city has been so long interrupted that the appetite for any news in the scientific way is quite keen...the fields are yet covered with nearly a foot of snow and the Hudson is still closed...you may venture to come out to the country for a botanical ramble by the first of July at least!" Downing to Torrey, 28 March 1836, Archives NYBG, Torrey Papers.

6. Downing to Torrey, 9 November 1837, Archives NYBG, Torrey Papers.

7. The Mertz Library has the 1841, 1844, 1849, 1854, 1859, 1865, 1967, and 1991 editions of A. J. Downing's *A Treatise on the Theory and Practice of Landscape Gardening Adapted to North America*; the 1842, 1844, and 1853 editions of *Cottage Residences... Adapted to North America*, and the 1850 and 1853 editions of *The Architecture of Country Houses*. Downing mentions a letter from John Claudius Loudon, the first solid proof of communication between the American novice and his British mentor. See Downing to Torrey, 3 December 1842, Archives NYBG, Torrey

CELEBRATED WORKS ON AMERICAN GARDENING AND HORTICULTURE

Papers; Later letters tell of his thriving practice and the success of *Cottage Residences* (1842) and of the *Horticulturist*, a weekly journal that he edited from 1846 until his death in 1852.

8. For details of the changes among the editions, see Part I: "Landscape Gardening as a Fine Art," in the author's *To Live in the New World*, 7–97.

9. The Mertz Library has a collection of important eighteenth- and early nineteenth-century British and French books on aesthetic theory and the "natural" style in landscape gardening: Edmund Burke, *A Philosophical Enquiry into the Origin of our Ideas of the Sublime and Beautiful*, 3rd ed. (1761); George Mason, *An Essay on Design in Gardening* (1768); Thomas Whately, *Observations on Modern Gardening* (1770); William Mason, *The English Garden: a poem* (1772–1781); Uvedale Price, *An Essay on the Picturesque* (1794); Horace Walpole, *Essai sur l'art des jardins modernes* (1785); Humphry Repton, *Sketches and Hints on Landscape Gardening* (1794) and *Observations on the Theory and Practice of Landscape Gardening* (1803); René Louis Girardin, *De la composition des paysages* (1777) and the English translation: *An Essay on Landscape* (1783); Jacques Delille, *Les Jardins: poëme* (1801) and the English translation: *The Gardens, a Poem* (1798).

10. Loudon presented his most fully developed concept of the "Gardenesque" in *The Suburban Gardener, and Villa Companion* (1838) and in the 8-volume *Arboretum et Fruticetum Britannicum* (1838). Also see J. C. Loudon, *The Derby Arboretum* (London: Longman, Orme, Brown, Green, and Longmans, 1840).

11. Downing to Torrey, 28 July 1834, Archives NYBG, Torrey Papers. In the Mertz Library, see N. B. Ward, *On the Growth of Plants in Closely Glazed Cases* (London: J. Van Voorst, 1842).

12. Shirley Hibberd, *Rustic Adornments for Homes of Taste* (London: Groombridge and Sons, 1856; reprint, London: Century in association with the National Trust, 1987), 141; Edward Sprague Rand Jr., *Flowers for the Parlor and Garden* (Boston: J. E. Tilton & Company, 1863), 237, 225.

13. "American versus British Horticulture," *Horticulturist* 5 (September 1850): 250,

14. "A Chapter on Lawns," *Horticulturist* 1 (November 1846): 202.

15. See the series "Mr. Downing's Letters from England," *Horticulturist* 5 (September 1850): 153–160; (November 1850): 217–224; *Horticulturist* 6 (February 1851): 83–86; (March 1851): 137–141; (June 1851): 281–286.

16. The white oak with nothing to interfere with its expansion is also quite different from the same tree shut up in a forest. And in North America, the white oak was only one of the forty-four indigenous kinds of oak trees that had been described by the early nineteenth century.

17. Uncle Philip [Francis L. Hawks], *The American Forest; or Uncle Philip's Conversations with the Children about the Trees of America* (New York: Harper & Brothers, 1834), 27–28, 7.

18. Ibid., 7.

19. "A Chapter on School-Houses," *Horticulturist* 2 (March 1848): 394–95. For schoolhouses, also see in the Mertz Library, F. R. [Franklin Reuben] Elliott, *Handbook of Practical Landscape Gardening Designed for City and Suburban Residences* (Rochester, NY: D. M. Dewey, 1881).

20. For these beliefs, see "On the Moral Influence of Good Houses," *Horticulturist* 2 (February 1848): 346; and "On the Drapery of Cottages and Gardens," *Horticulturist* 3 (February 1849); 353.

21. John Lindley, *Ladies' Botany, or, A Familiar Introduction to the Study of the Natural System of Botany* (London: J. Ridgway, 1834–1837).

22. Downing to Torrey, 29 December 1834, Archives NYBG, Torrey Papers.

23. Mrs. [Jane] Loudon, *Gardening for Ladies; and Companion to the Flower-Garden*, edited by A. J. Downing (New York: Wiley & Putnam, 1843), iii–iv.

24. For example, see "Mr. Downing's Letters from England," *Horticulturist* 6 (March 1851): 140–141.

25. Ann B. Shteir, in her study of the contributions of nineteenth-century British women to the field of botany, writes that Jane Loudon helped "her readers cross over into scientific study." Like Downing, Mrs. Loudon wanted to bring more women into botanical study. Shteir points out that Loudon turned away from the Linnaean sexual system—an impediment to teaching botany to girls—to the natural system, which helped realize her ambition of incorporating botany into the common curriculum for girls. See *Cultivating Woman, Cultivating Science: Flora's Daughters and Botany in England, 1760 to 1860* (Baltimore & London: The Johns Hopkins University Press, 1996), 221.

26. The Mertz Library has Mrs. Jane Loudon, *Botany for Ladies* (London, J. Murray, 1842).

27. "A Talk with Flora and Pomona," *Horticulturist* 2 (September 1847): 108.

28. For other contemporary opinions on ladies and flowers, see Henry Meigs, *An Address, on the Subject of Agriculture and Horticulture, Delivered in the Church of the Messiah, on Thursday, October 9th, 1845* (New York: James Van Norden & Co., 1845), 8; see also Solon Robinson, "Advice to Western Immigrants," in *Solon Robinson: Pioneer and Agriculturist; Selected Writings*, ed. Herbert Anthony Kellar, vol. 1: 1825–1845 (Indianapolis: Indiana Historical Bureau, 1936), 520.

29. "On the Drapery of Cottages and Gardens," *Horticulturist* 3 (February 1849): 353.

30. *The Flowers Personified: Being a Translation of Grandville's "Les Fleurs Animées,"* introduction by Alphonse Karr; trans. N. Cleaveland (New York: R. Martin, 1849), vol. 1, 6; For social satire comment, see Anna Laurent, "Art + Botany: J.J. Grandville's Les Fleurs Animées." March 24, 2011. http://www.gardendesign.com/ideas/art-botany-les-fleurs-animes (accessed 21 November 2012); The Mertz Library has two editions of the French version: J.J. Grandville, *Les Fleurs animées* (1847 and 1867). Two editions of Karr's *A Tour Round My Garden* (1855 and an undated one) are also in the Library's Collection.

31. Shirley Hibberd, *Familiar Garden Flowers*, 5 vols. (London, Paris, New York, Toronto and Melbourne: Cassell and Company, 1879–1887).

32. "On the Mistakes of Citizens in Country Life," *Horticulturist* 3 (January 1849): 309.

33. "The Neglected American Plants," *Horticulturist* 6 (May 1851): 201–203.

34. "A Few Hints on Landscape Gardening," *Horticulturist* 6 (November 1851): 489–91.

35. Downing to Torrey, 28 March 1836, Archives NYBG, Torrey Papers; W.J. Hooker's *Companion to the Botanical Magazine* is in the collection of the Mertz Library. Luther Tucker, the proprietor of the New York agricultural journal *The Cultivator*, secured Downing's services at a time when his popular volumes had become part of many household libraries. In the fall of 1842, Downing told Torrey that his *Cottage Residences* had "succeeded beyond any expectations," and reported a flourishing practice in "*professional landscape gardening...on the 'European plan' and at nearly the European prices.*" Downing to Torrey, 8 October 1842, Archives NYBG, Torrey Papers; Downing wrote to Torrey: "We print 3000 [of my Horticultural Journal] & it is increasing every day & seems to be doing much good in exactly the right quarter." Downing to Torrey, 16 March 1847, Archives NYBG, Torrey Papers.

36. Downing to John Jay Smith, 11 Aug. 1843, Smith Manuscript Collection, Library Company of Philadelphia on deposit at the Historical Society of Pennsylvania, Philadelphia.

37. James Thacher, *The American Orchardist* (Boston: Joseph W. Ingraham, 1822), iii. Others in the Mertz collection include William Kenrick, *The New American Orchardist*, (Boston: Carter, Hendee and Russell, Odiorne, 1833) and Edward Sayers, *The American Fruit Companion*, 2nd ed. (Boston: Weeks, Jordan, 1839).

38. "On the Mistakes of Citizens in Country Life," *Horticulturist* 3 (January 1849): 307.

39. Downing to Torrey, 28 July 1834, Archives NYBG, Torrey Papers. Downing was "anxious to get a moment's peep at a book or two" in Hosack's library, and wrote that he had already exchanged plants with Hosack's gardener the previous spring.

40. Downing, *Treatise* (1841), 22.

41. James Thacher, "An Excursion on the Hudson," *The New England Farmer* 9 (December 3, 1830): 156, reprinted in Therese O'Malley, *Keywords in American Landscape Design* (New Haven and London: Center for Advanced Study in the Visual Arts, National Gallery of Art, in association with Yale University Press, 2010), 176.

42. On the emulation of the Marquis de Girardin's design, see Philip J. Pauly, *Fruits and Plains: The Horticultural Transformation of America* (Cambridge & London: Harvard University Press, 2007), 168.

43. André Parmentier, "Landscapes and Picturesque Gardens," in Thomas G. Fessenden, *The New American Gardener* (Boston: J.B. Russell, 1828), 185. The Mertz Library has the 1837, 1845, and 1850 editions of *The New American Gardener*.

44. "Parmentier's Horticultural Garden," *The New England Farmer* 6 (October 3, 1828): 84; Information about Parmentier can be found in several issues of the *Brooklyn Botanic Garden Record*: vol. 11 (October 1922): 115–18; vol. 12 (October 1923): 119–25; and vol. 15 (January 1926): 10–16.

45. *Bulletin of Miscellaneous Information (Royal Gardens, Kew)*, vol. 1894, no. 86 (February 1894): 65–66. http://www.jstor.org/stable/4118331 (accessed 4 December 2012); Hyde Park is now the Vanderbilt Mansion National Historic Site in Hyde Park, New York. http://tclf.org/landscapes/vanderbilt-estate-hyde-park (accessed 7 May 2012).

46. The site was originally a 242-acre farm; Downing states that Montgomery Place is 400 acres; Charles Eliot writes that the site is 300 acres; the official Montgomery Place Web site gives the size as 380 acres. Downing first wrote about Montgomery Place in "A Visit to Montgomery Place," *Horticulturist* 2 (October 1847): 153–60; Downing abridged this editorial to describe Montgomery Place in Downing, *Treatise* (1849), 47–49.

47. In 1802 Janet Livingston Montgomery, widow of the American Revolutionary War hero General Richard Montgomery, purchased what was a 242-acre farm and began building a mansion and landscaping the site. Upon her death in 1828, her brother Edward Livingston inherited but was unable to spend much time at his country home because of his positions as United States Minister to France and Secretary of State under Andrew Jackson. On his return to the US in 1835, inspired by the gardens and estates of England and France, he began an extensive reworking of the landscape. With his unexpected death in 1836, the improvements came to a halt until his widow Louise Livingston and their daughter Cora Livingston Barton began to carry out their own plans. This is the point when A.J. Downing came into their lives. See Jacquetta M. Haley, ed., *Pleasure Grounds: Andrew Jackson Downing and Montgomery Place* (Tarrytown, NY: Sleepy Hollow Press, 1988), 11–13.

48. These two women exemplify what Therese O'Malley sees as early practitioners of the discipline of landscape gardening: "Women, as the most avid consumers of the literature of rural affairs [were] deeply engaged in the domestic realm where garden theory and practice predominated." See Therese O'Malley, "From Practice to Theory: The Emerging Profession of Landscape Gardening in Early Nineteenth-Century America," in Michel Conan and W. John Kress, eds., *Botanical Progress, Horticultural Innovations and Cultural Changes* (Washington, DC: Dumbarton Oaks, 2007), 237, fn53.

49. A. J. Downing to Louise Livingston [28 October 1845]. Sleepy Hollow Restorations, Tarrytown, New York; reprinted in Haley, ed., *Pleasure Grounds*, 30.

50. Downing to Thomas P. Barton, 31 December 1846, reprinted in Haley, 33.

51. Charles Eliot, "Some Old American Country Seats V–Montgomery Place," *Garden and Forest* 3 (March 19, 1890): 139. The essay is reprinted in [Charles William Eliot], *Charles Eliot: Landscape Architect* (Boston and New York: Houghton, Mifflin and Company and Cambridge: The Riverside Press, 1902), 253–56. The Mertz Library has the 1902 and 1903 editions; Downing quotation from "A Visit to Montgomery Place," *Horticulturist* 2 (October 1847): 155. Montgomery Place, Annandale-On-Hudson, New York, is now a National Historic Landmark and a property of Historic Hudson Valley.

52. For the factors that stimulated the enthusiasm for glasshouses, see Therese O'Malley, *Glasshouses: The Architecture of Light and Air* (Bronx, NY: The New York Botanical Garden, 2005), 26.

53. Downing, "A Chapter on Green-Houses," *Horticulturist* 3 (December 1848): 257–59; In writing about greenhouses, Shirley Hibberd reinforced the climactic differences between the two nations: "The briefness of the British summer and the frequent interruptions to out-door enjoyment, occasioned by adverse weather, render the well-kept plant house a place of most agreeable resort at every season of the year." See Shirley Hibberd, *The Amateur's Greenhouse and Conservatory* (London: Groombridge and Sons, 1873), 1.

54. Downing, *Cottage Residences*, 3rd ed. (New York and London: Wiley and Putnam, 1847), 42–52.

55. Calvert Vaux, *Villas and Cottages: a Series of Designs Prepared for Execution in the United States* (New York: Harper & Brothers, 1857), 32. The Mertz Library also has the 1864 edition and the Dover reprint of 1970.

56. Jacob Weidenmann, *Beautifying Country Homes: A Handbook of Landscape Gardening. Illustrated by Plans of Places Already Improved* (New York: Orange Judd and Company, 1870), preface.

57. Olmsted expressed this opinion in a letter to Charles Eliot, 28 October, 1886, Frederick Law Olmsted Papers, Library of Congress. Cf. H. W. S. Cleveland, *Landscape Architecture: As Applied to the Wants of the West* (Chicago: Jansen, McClurg, & Co., 1873), 5. The Mertz Library has the 1965 reprint.

58. Weidenmann, *Beautifying Country Homes*, 8, 37.

59. Trade card printed in Hartford ca. 1879.

60. Weidenmann, *Beautifying Country Homes*, unnumbered page accompanying plate I.

61. See Plate XXII and the accompanying text in Weidenmann. The Mertz Library has Charles Rawolle and Ignatz A. Pilat, *Catalogue of Plants Gathered in August and September, 1857 in the Terrain of the Central Park. Part First* (New York: M. W. Siebert, Steam Job Printer, 1857).

62. F. L. Olmsted to Mariana Griswold Van Rensselaer, 11 August 1886. Frederick Law Olmsted Papers, Library of Congress. See the author's *Mariana Griswold Van Rensselaer: A Landscape Critic in the Gilded Age* (Charlottesville and London: University of Virginia Press, 2013).

63. Mrs. Schuyler Van Rensselaer, *Art Out-of-Doors: Hints on Good Taste in Gardening* (New York: Charles Scribner's Sons, 1893); For "friendly word" see p. vii; for botanical handbook, see p. 325. The editorials and articles came from *American Architect and Building News*, *The Century Illustrated Monthly Magazine*, and *Garden and Forest*. The Mertz Library has two editions of *Art Out-of-Doors* (1893 and 1959).

64. Mariana Griswold Van Rensselaer, "English Gardens Unsuitable for America," *Garden and Forest* 9 (July 15, 1896): 281–282.

65. S. Parsons Jr., *How to Plan the Home Grounds* (New York: Doubleday & McClure Co., 1899), 57.

66. Ibid., 45–46.

67. See ASLA code of professional ethics at http://www.asla.org/ContentDetail.aspx?id=4276&RMenuId=8&PageTitle=Leadership (accessed March 5, 2013).

TOWARD AN

AMERICAN LANDSCAPE

THEORY

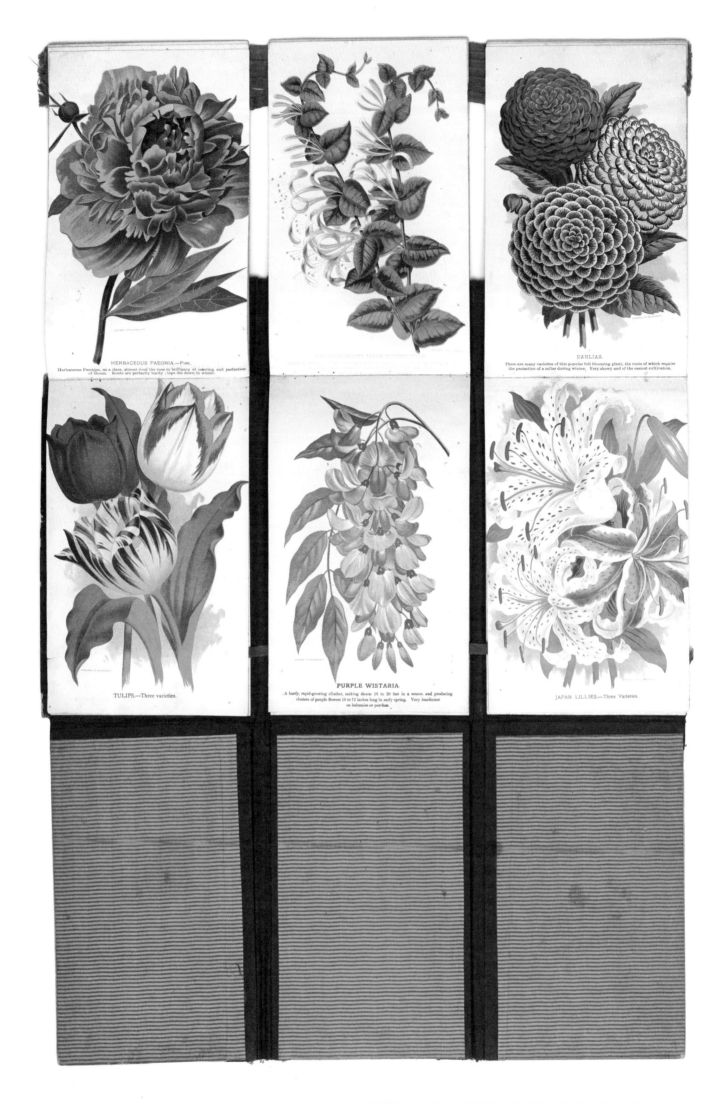

HERBACEOUS PAEONIA.—PINK.

Herbaceous Paeonias, as a class, almost rival the rose in brilliancy of coloring and perfection of bloom. Roots are perfectly hardy; tops die down in winter.

DAHLIAS.

There are many varieties of this popular fall blooming plant, the roots of which require the protection of a cellar during winter. Very showy and of the easiest cultivation.

TULIPS.—Three varieties.

PURPLE WISTARIA.

A hardy, rapid-growing climber, making shoots 15 to 20 feet in a season, and producing clusters of purple flowers 10 to 12 inches long in early spring. Very handsome on balconies or porches.

JAPAN LILLIES.—Three Varieties.

THE HORTICULTURAL ENTERPRISE: MARKETS, MAIL, AND MEDIA IN NINETEENTH-CENTURY AMERICA

ELIZABETH S. EUSTIS

In the late nineteenth century, intense rivalry between the leading American seed companies stimulated the publication of expansive, richly illustrated catalogs proclaiming the wonders of gargantuan vegetables and brilliant floral displays. Declarations of honest dealing in superior seeds were supported by pictures of large fields and efficient operations in new offices and warehouses. By 1892, fifteen years after extending his father's lumber business into the seed trade, William Henry Maule could boast of six stories of activity in his new warehouse in the center of Philadelphia. His anonymous artist imitated sectional views inside mercantile buildings to show every stage of activity from storing seed potatoes in the basement, to sorting and mailing orders, to packing seeds, to seed cleaning in the attic (fig. 10.1).[1] Enclosing this description and 136 densely designed pages of plants for sale were the paper covers of the catalog, blazing with colorful testing gardens, greenhouses, and portraits of enticing cultivars (fig. 10.2).

Maule's mail-order catalog culminates a long evolution in the selling of plants and seeds. At the beginning of the nineteenth century, farmers and gardeners saved and exchanged their own seed, while an emergent American seed and nursery trade centered on the major port cities of the Atlantic coast. Seed farms were small, cultivated by horse power and harvested by manual flailing. Advertising of plant materials for sale was sporadic and terse.[2] When the first independent American agricultural journal appeared in 1819, the columns of its last pages contained just a few short notices placed by various merchants announcing the arrival in port of seeds, roots, and tools for sale.[3] With notable exceptions such as the Bartrams and William Prince (see chapter 8), few merchants devoted their business entirely to horticulture, and most of their distribution was local or regional.

The Collections of the LuEsther T. Mertz Library document a transformation in growing, processing, and marketing an expanding array of plant materials in nineteenth-century America. The assemblage of related books is virtually complete, with most of the important titles held in multiple editions.[4] The Mertz Library is also an important repository of American print history and especially of color printing as it developed in close connection with botanical and horticultural publication, moving from natural history to fine art, to popular illustration, to trade catalogs. This chapter will focus primarily on two essential

FIG. 10.12. This example of a nurseryman's specimen book belonged to agent A. S. Chadbourne of Hallowell, Maine, in 1892. Some tree agents' plates were strapped together as flexible portfolios allowing skillful juxtapositions to entice farmer and homeowner.

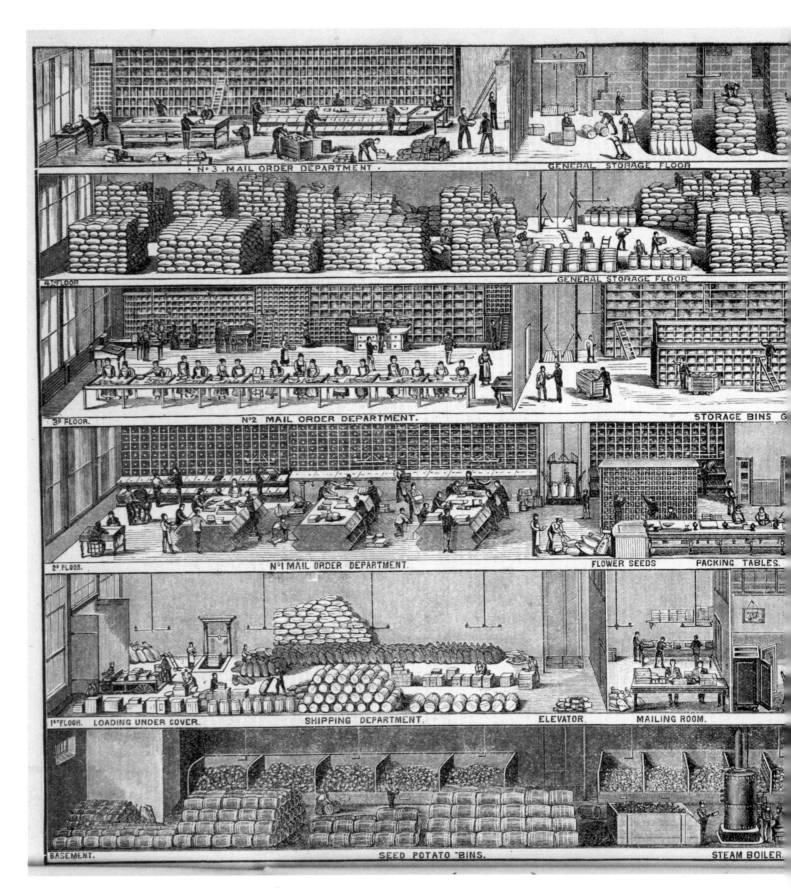

FIG. 10.1. This cross-section of a seed warehouse, in William Henry
Maule, *Maule's Seed Catalogue for 1892*, p. 3, displays a modern system
of mail-order operations in the style of contemporary factory views.

SEED CLEANING DEPARTMENT

N SEEDS IN PACKETS.

OFFICE N° 5

· PACKING TABLES ·

N°3 MANAGER'S OFFICE.

GENERAL OFFICES. N°1

GENERAL STORAGE.

vehicles for the early commercial development of American horticulture: the nurseryman's specimen book used by traveling tree agents, and the seed catalog—which precipitated mail-order marketing in America.

EARLY PUBLICATIONS

Bernard M'Mahon of Philadelphia published the first American seed catalog in booklet form in 1804. The oldest catalog in the Mertz Library soon followed, circa 1807, listing seeds, books, tools, and fifty varieties of gooseberry plants offered for sale by M'Mahon.[5] The first seed merchant based in New York City, Grant Thorburn, started his seed store with $15 in 1804 and saw a seed catalog—imported from London—for the first time the following year. By 1821, his own catalogs were published in pamphlet form, occasionally decorated with the first illustration so far discovered in an American seed catalog, a vignette of an unidentified glasshouse (fig. 10.3). His 1825 and 1838 catalogs list species and cultivar names in English, Latin, and French, with prices by the ounce or the quart, minimal horticultural instructions, time of harvest, and a recommended list of seeds to fill one acre with crops.[6]

Thomas Hogg's 1834 catalog is an especially well-conserved example of these early publications, with lists in columns of Latin names uninterrupted by any description or indication of prices. Hogg appealed to the botanophile plant collector who would read its Latin nomenclature as a demonstration of his seriousness of purpose.[7]

During the first quarter of the nineteenth century, Shaker communities became the most trusted American source of seeds and important innovators in consumer-friendly marketing. They guarded the purity of their stock, introduced small labeled packages of seed instead of barrels and cloth bags, and conducted

a mail order business. They also started a system of "commission boxes," supplying country stores with wooden boxes of fresh seed packets every spring and removing them in summer with any unsold contents. Commercial seed traders adopted similar practices beginning in the 1830s and 1840s, driving Shaker communities out of the business by the 1880s with aggressive new marketing tactics.[8]

Throughout the first half of the nineteenth century, however, a shortage of cheap paper, the high cost of printing, and the difficulties of illustration and color reproduction limited the extent and style of advertising and publication by nurserymen and seed traders. Paper shortages began to ease in the 1830s, but a catalog still represented an extraordinary investment. As late as 1846, William Robert Prince wrote, as proof of the superiority of his business, that the cost of publishing his catalog was $1,000.[9] No one published regular annual listings until the 1840s. Words were kept to a minimum, and illustrations remained sparse into the 1850s.[10]

A few seed sellers began to write manuals on horticulture, if for no other reason than to defend their profession from the accusations of customers who failed to nurture their seeds properly. Before commercial seed catalogs offered many instructions, Thomas Bridgeman, a market gardener, seedsman, and florist in New York, published *The Young Gardener's Assistant* in 1829 with the following introduction:

> The object of this little work is to enable our respectable seedsmen…to afford instructions at a trifling expense to such of their customers, as may not have a regular gardener, and thereby save themselves the blame of those who may not give their seeds a fair trial, for want of knowing how to dispose of them in the ground.[11]

FIG. 10.2. Back and front covers of *Maule's Seed Catalogue for 1892*. By the 1890s, vivid color and competitive portrayal of plants and modern facilities, such as this seed farm near Philadelphia, captivated readers of the major seed-house catalogs.

Bridgeman's manual remained in print for decades, the first in a long line of American books about growing flowers, fruits, and vegetables, most of which emerged from the commercial sector.[12]

The first American book dedicated to growing flowers was published without illustrations in 1828 by two seed merchants of Boston and New York. Its author, Roland J. Green, addressed a primarily female audience:

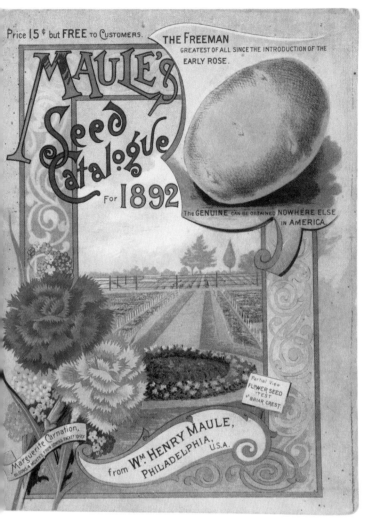

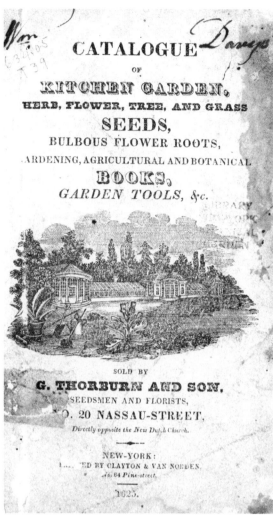

FIG. 10.3. Title page of Grant Thorburn and Son, *Catalogue of Kitchen Garden, Herb, Flower, Tree, and Grass Seeds*, New York, 1825. The first-known illustration in an American seed catalog was this vignette of a greenhouse, which decorated Grant Thorburn's lists in the 1820s.

Should the agriculturist have no taste for ornamental gardening, yet such is the laudable taste of the fair daughters of America, at the present day, that, there are but comparatively few that do not take an interest in a flower garden.... The cultivation of flowers, is an appropriate amusement for young ladies. It teaches neatness, cultivates a correct taste, and furnishes the mind with many pleasing ideas.... [Their colors harmonize] with the heart susceptible to the noblest impressions—and with spotless innocence.[13]

For a man, on the other hand, flower gardening was presented by Bridgeman as a means of maintaining "his station in society as becomes a rational and intelligent being, instead of sinking himself, as too many do, below the meanest of the mean, by spending his time in dissipation and vice."[14] Floriculture as a sign of refinement and an alternative to drinking or depression would remain a running theme throughout the century.

While floricultural books were issued by seed sellers, ladies (and a few gentlemen) composed a language of flowers, associating each species with a message enabling rhetorical interpretation of a bouquet. Addressing an audience of "fair and intelligent readers,"

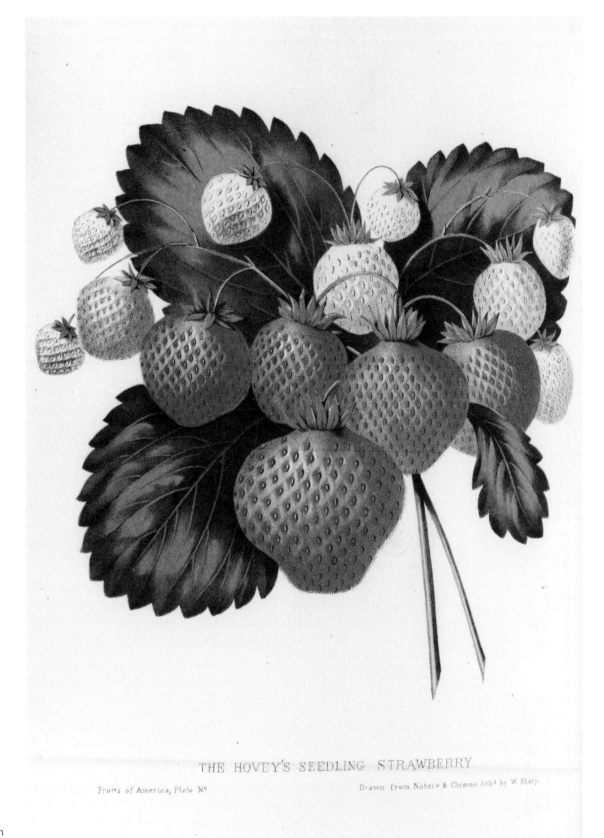

THE HOVEY'S SEEDLING STRAWBERRY.

Fruits of America, Plate No.

Drawn from Nature & Chromo lithd by W. Sharp

FIG. 10.4. Hovey's "Seedling Strawberry" was the first successful result of the American fruit hybridizing and a best-selling strawberry variety for decades. In 1852 Charles Hovey featured it prominently in his *The Fruits of America*, the first American book fully illustrated with chromolithographs.

numerous authors aspired to convey some introductory knowledge of botany through conventional romanticism, literary expressions of gentility, and artistically informative plates.[15] A mid-century taste for lavish gift books included at least fifty illustrated volumes related to flowers or the language of flowers, embellished by new techniques of color production in print.[16]

PRINTING PLANTS: FROM SCIENTIFIC ILLUSTRATION TO ADVERTISING MEDIUM

Until the 1840s, the usual method of applying color to printed images in America involved painting by hand. Because color plays a vital role in botanical description, the possibility of printing consistent coloration was of particular interest to doctors and natural scientists, and American color-plate books before the Civil War focused to a great extent on botany.[17]

When William Sharp introduced the multi-colored printing process of chromolithography to America in 1841, his work was quickly recognized by horticulturists as a solution to the urgent problem of identifying varieties of fruit.[18] From 1847 to 1851, he illustrated *The Fruits of America*, the first major American book with exclusively chromolithographic plates, written by nurseryman Charles Hovey (fig. 10.4).[19] Not

FIG. 10.5. *Victoria regia* was considered the most beautiful flower in the world, inspiring artists in England and America to new advances in printed botanical portraiture. Its "Intermediate Stages of Bloom" were magnificently depicted by William Sharp, in John Fisk Allen, *Victoria Regia; or, the Great Water Lily of America*, Boston, 1854.

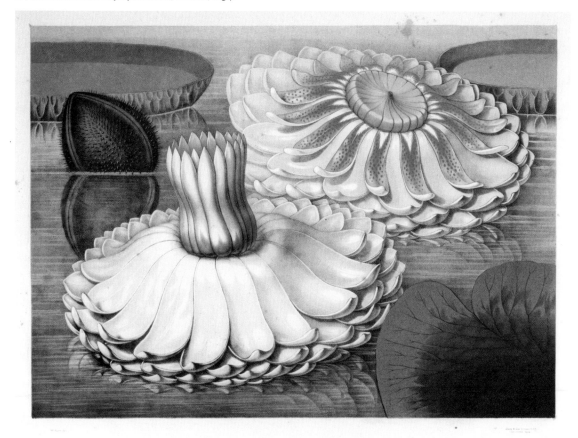

FIG. 10.6. (p. 240) Chromolithography became affordable by 1876, when trade cards burst upon the scene at the Philadelphia Centennial Exposition. By 1880 Jerome B. Rice & Co. was delighting the public with a series of cards featuring "Vegetable People." Archives NYBG, Mastrantonio Collection.

FIG. 10.7. (p. 241) Advertising proliferated along with advertising agencies and commercial public relations campaigns. Colorful posters as well as small cards and illustrated catalogs proclaimed the superiority of Rice's seeds. Archives NYBG, Mastrantonio Collection.

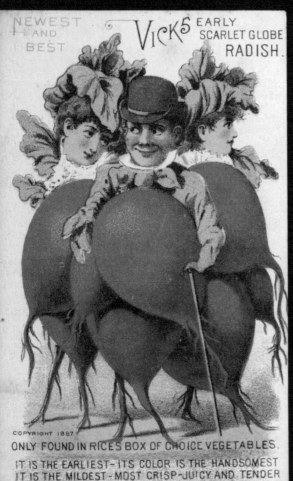

NEWEST AND BEST

VICK'S EARLY SCARLET GLOBE RADISH.

COPYRIGHT 1887

ONLY FOUND IN RICES BOX OF CHOICE VEGETABLES.
IT IS THE EARLIEST—ITS COLOR IS THE HANDSOMEST
IT IS THE MILDEST—MOST CRISP-JUICY AND TENDER
THE MARKET AS WELL AS PRIVATE GARDENERS.
FAVORITE TRY IT OVER

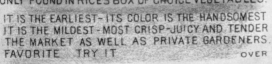

RICE'S SEEDS

WE ARE AMERICAN WONDERS WE ARE THE EARLIEST BEST.
Copyright 1885

GROWN & PUT UP BY
JEROME B. RICE & CO.
CAMBRIDGE VALLEY CAMBRIDGE, N.Y.
SEED GARDENS,

RICE'S SEEDS

EVERYBODY LIKES RADISHES DON'T THEY CHARLEY
Copyright 1885

GROWN & PUT UP BY
JEROME B. RICE & CO.
CAMBRIDGE VALLEY CAMBRIDGE, N.Y.
SEED GARDENS,

THE MIKADO OR TURNER HYBRID TOMATO.

ONLY FOUND IN RICES BOX OF CHOICE VEGETABLES

COPYRIGHT 1887

OLD FAVORITES MUST TAKE A BACK SEAT
MIKADO IS ONE OF THE EARLIEST AND OF THE LARGEST
SIZE. PERFECTLY SOLID AND OF UNSURPASSED QUALITY.
THE EARLIEST TOMATOES ARE PRODUCED BY USING OUR
NORTHERN GROWN SEED. OVER.

HANSON

The Best Lettuce in the World.

I SEND OUT THIS

HANSON LETTUCE SEED

in the firm belief that if you give it a fair trial you will pronounce it the finest, most delicate, and the LARGEST LETTUCE you ever saw.

Our cut shows a sectional part, the head being cut through the center. A comparatively new variety, introduced by Col. Hanson, of Maryland. The heads are of very large size, deliciously sweet, tender and crisp, even to the outer leaves. Heads weigh two and a half to three pounds, and measure about one and a half feet in diameter. Color, green outside and white within; free from any bitter or unpleasant taste. Not recommended for forcing, but has no superior for family use.

FOUND ONLY IN

RICE'S BOX OF CHOICE VEGETABLES

GROWN BY JEROME B. RICE AT THE CAMBRIDGE VALLEY SEED GARDENS.
CAMBRIDGE, N.Y.

coincidentally, Hovey had introduced the first named variety of any fruit produced in North America by intentional cross-fertilization, launching strawberry culture as a profitable enterprise and making himself a rich man.[20] New recognition of the commercial potential of hybridizing heightened the importance of publicizing accurate portraits of a cultivar.[21]

The high point of botanical portraiture in America followed in 1854, when Sharp printed six studies of the *Victoria regia* water lily, reputed to be the most beautiful flowering species in the world (fig. 10.5).[22] These color-blended chromolithographs presented both floriculture and printmaking as fine arts and laid the foundation for enthusiastic reproduction of ornamental botanical novelties in color.

In 1876 the Philadelphia Centennial Exposition exhibited chromolithography as an artistic medium while also popularizing the chromolithographic trade card as a collectable form of advertisement. Until newspapers and magazines relaxed their resistance to

advertising in the 1890s, trade cards, catalogs, and posters provided most of the publicity for seeds and other garden-related products (figs. 10.6 and 10.7).[23] A trade card provided by seed distributor William H. Reid of Rochester during the 1880s, for example, listed seeds and their prices on the back while allowing the retail storekeeper to stamp his name and location on the front (fig. 10.8). This engaging image illustrates one of the 20,000 colorfully branded display boxes that his warehouse shipped annually to country stores, each box containing about 200 lithographed packets of imported flower seeds (fig. 10.9).[24]

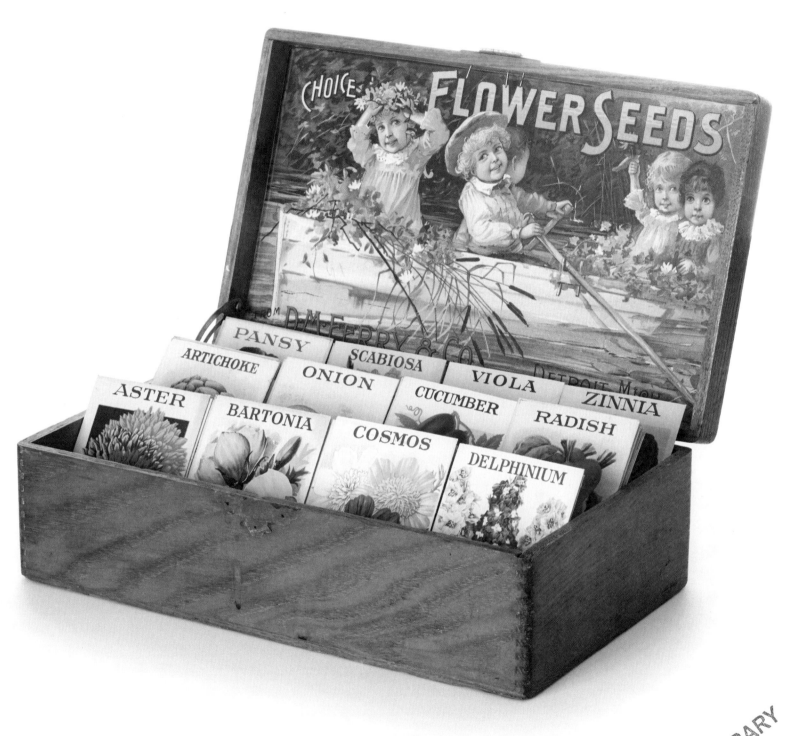

FIG. 10.9. Chromolithography decorated many of the boxes
in which seeds were delivered and displayed for sale. Some
of the most appealing were made for D. M. Ferry & Co. of
Detroit, such as this example printed in New York in 1893.
Archives NYBG, Mastrantonio Collection.

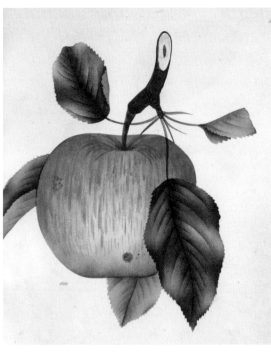

Fig. 10.10 A–B. This early hand-painted "Red Astrachan Apple" (top) in [Paintings of Fruits], ca. 1848–1852, is attributed to Joseph Prestele, who introduced the nurseryman's specimen plate into American commerce around 1850. His flawed fruit was imitated in commercial plant portraits as an emblem of honest salesmanship, as in this plate (below) in D. M. Dewey, *Dewey's Colored Fruits and Flowers*, Rochester, NY, ca. 1875.

CREATING A RURAL MARKET: TREE AGENTS AND THE NURSERY TRADE

While horticultural publishing and advertising were still in their early stages, thousands of traveling tree salesmen fanned out across the country to reach rural customers. From the 1840s until after the Civil War, Rochester was the hub of the American nursery trade, best positioned to transport live plants long distances via the Erie Canal, new railroads, and the Great Lakes. Rochester profited from at least an eight-day advantage over the Atlantic port cities in supplying the rapidly growing western market—a crucial difference in shipping live plant materials.[25]

Of the thirty nurseries and 150 nurserymen in the Rochester area, the leading business was owned by George Ellwanger and Patrick Barry at their Mount Hope Botanical and Pomological Garden. From seven acres in 1841 their land expanded to 400 acres with six acres under glass in 1856, as Ellwanger and Barry pioneered nation-wide marketing by hundreds of trained traveling sales agents.[26] By the 1850s, a tree agent could tempt farmers and homeowners with hand-colored pictures of luscious fruits. Colorful plant portraits serving this purpose made their first American appearance in the work of Bavarian artist Joseph Prestele (1796–1867), who moved to a utopian colony of mystical Protestants near Buffalo in 1843.[27] In Munich he had previously enjoyed a successful career as a botanical illustrator until his radical religious views were punished by the withdrawal of royal patronage.[28]

FIG. 10.11. The popularity of commercial color prints of fruits led to elaborate parlor editions such as this one with a title page, printed for leading fruit-plate merchant Dellon Marcus Dewey of Rochester, NY, ca. 1865, by the prominent lithography firm of E. B. & E. C. Kellogg in Hartford, CT.

THE
Specimen Book
OF
FRUITS, FLOWERS
AND
ORNAMENTAL TREES.

Carefully Drawn and Colored from Nature,

FOR THE USE OF
NURSERYMEN.

ROCHESTER, N.Y.
PUBLISHED BY
D. M. DEWEY, Age.

Lith. of E.B. & E.C. Kellogg.

Hartford, Conn.

ONE ACRE FAMILY FRUIT GARDEN.

This plan (essentially) showing the number and variety of fruit trees and vines, with proper distances, etc., for planting one acre, was made by John J. Thomas, and is highly approved.

No.		No.	
1—10 Plums, }	- - - - - Alternately.	8—15 Grape Vines, - - 1 row, 15 feet apart.	
5 Quinces, }	1 row, 20 feet, 13 feet in the row.	9—100 Raspberries, - - 1 row on side.	
2— 8 Cherries, 1 row, 25 feet, 26 feet in the row.		10 { 500 Strawberries, - - - 1 row on end.	
3—16 Apples, 2 rows, 40 feet, 26 feet in the row.		{ ☞ Can be changed and put among the trees.	
4—16 Standard Pears, }	26 ft. in row (alternately).	11—50 Blackberries, - 1 row, 4 feet on side.	
29 Dwarf Pears, }	3 rows, 40 ft., 13 ft. in row.	Can be kept clean with horse plow and cultivator.	
5—48 Peach Trees, 3 rows, 60 feet, 13 feet in row.		132 Fruit Trees, 255 Vines and Berries, 500 Straw-	
6—45 Currants, - - - 1 row, 4 feet apart.		berries—quite sufficient fruit for a large family,	
7—45 Gooseberries, - - 1 row, 4 feet apart.		and will generally leave a handsome surplus to sell.	

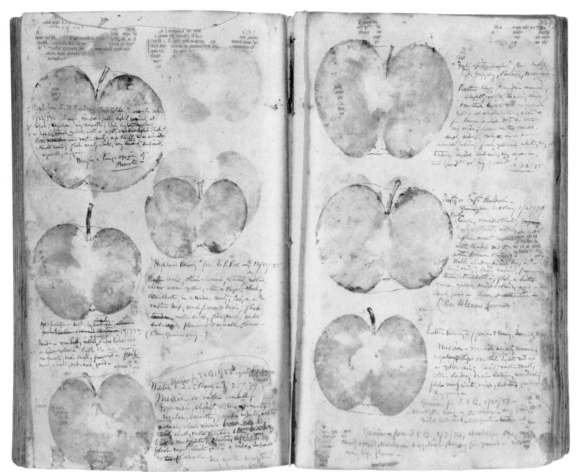

FIG. 10.14. John Jacobs
Thomas kept a notebook from
1837 until 1892 recording
approximately 367 apples,
203 pears, 14 cherries,
8 plums, 2 grapes, and 1 quince.
With some entries torn
away and others added over
the course of his lifetime,
this evolving manuscript
informed the expanding
editions of his popular manual
on fruit-growing.

THE HORTICULTURAL
ENTERPRISE

Prestele began to sell fruit and flower plates to the American nursery trade around 1848 or 1849, while he was also providing more detailed botanical lithographs to Asa Gray, John Torrey, and the Massachusetts Horticultural Society.[29] Ellwanger and Barry purchased as many as 3,500 of his pictorial specimens to be bound together as catalogs for their travelling agents, and others followed suit.[30] Despite the new promotional function of these images, Prestele's strict adherence to honesty prevented him from disguising imperfections in his models. The moral transparency implied by his prominent focus on an occasional flaw was later imitated by commercial publishers (fig. 10.10 A–B). Although a blemish may seem counter-intuitive as a selling point, it could effectively rebut accusations that such plates were unrealistically idealized. The deceitful peddler was a familiar stereotype, and tree agents had to contend with widespread suspicion of travelling salesman as seductive swindlers exaggerating the merits of their products and their ability to deliver high-quality goods. In nurseryman's specimen books prominent flaws signified honest portrayal of natural specimens.[31]

Despite the success of his prototypes, Prestele's original role was soon forgotten. Following his departure for Iowa in 1858, others distributed and copied his work without attribution. Dellon Marcus Dewey (1819–1889), a bookseller and publisher in Rochester, became the most successful producer of nurserymen's fruit plates, later claiming that he himself had invented them. Dewey aggressively expanded the number and marketing of such images,

hiring thirty artists by his own account to stencil and paint portraits of named varieties available for sale, and soon adding a less expensive line of printed specimens to accelerate his production. The Hartford lithography firm of Edmund Burke Kellogg and Elijah Chapman Kellogg—sometime collaborators with Dewey—imitated Prestele's prototypes and provided an elaborate title page for a fancy gift edition of fruit plates (fig. 10.11).[32] In 1873, Dewey developed a more practical pocket edition that could be bound as a book or strapped together as a flexible portfolio opening in various directions (fig. 10.12). He encouraged occasional rebinding in order to replace worn plates and to reflect changes in the available nursery stock. In 1859–1860 he listed more than 300 selections, in 1871 over 1,500, and by the time of his retirement in 1888 he offered about 3,000 varietal portraits.[33]

Often bound with the specimen plates was a plan for a family orchard designed by John Jacobs Thomas, one of the best-known American authorities on fruit trees (fig. 10.13). A notebook stamped with imprints from inked sections of nearly 600 varieties of fruit annotated with manuscript observations on the name, source, date, appearance, texture, and taste of each variety provides a unique record of Thomas' research (fig. 10.14).[34] Based on these observations, Thomas wrote one of the most important fruit books of the century, *The American Fruit Culturist*, which expanded from a small paper manual in 1846 through nineteen editions during his lifetime to a 600-page treatise with over 500 illustrations.[35]

Thomas taught the American public that they could provide fruits for both family and market throughout the year. His revised editions reflect a revolution in both horticulture and food preservation, adding instructions for "preserving fruit by artificial means" after the invention of the air-tight Mason jar in 1858 made

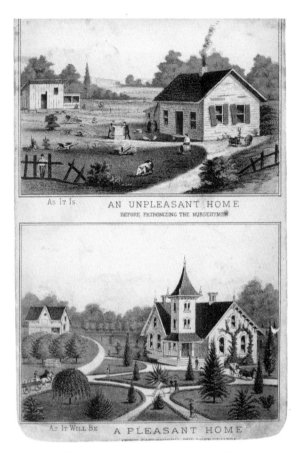

FIG. 10.15. D. M. Dewey's parable for the use of traveling fruit-tree salesmen compared a pleasant and unpleasant home in *The Nurseryman's Specimen Book of American Horticulture*, ca. 1870, to demonstrate that beauty and prosperity would reward an enlightened investor in fruit trees, unlike the sloth of a more backward farmer.

canning practical in the home kitchen. He also urged farmers to reap the profits of much larger orchards by distributing fruits via steamship and the new railroads. All of these changes increased the demand for nurserymen's trees.

Dewey offered one plate with contrasting views of "An Unpleasant Home Before Patronizing the Nurserymen," and "A Pleasant Home After Patronizing the Tree Dealers" (fig. 10.15). Printed on the back is a formulaic sales pitch, "The Parable of Jones and Brown," deploring backward Farmer Brown, who set his dog on a tree peddler and drove him away. Brown's more enlightened neighbor, Mr. Jones, instead recognizes the tree peddler as a

"philanthropist" and plants an orchard, enabling him to sell fruit, build a fine new house, and beautify its grounds with specimen trees. Jones finally urges Brown to "repent" and buy trees from the next passing tree agent.[36]

By the early 1870s, free-ranging tree agents were said to be responsible for nearly three quarters of all sales of American nursery stock, continuing at their height through the 1880s.[37] Dewey's attendant success in selling nurserymen's plates inspired others to enter the market, and Rochester also became a center for the production of all kinds of illustration related to the nursery and seed trades.[38]

At present, the Mertz Library has twenty-one bound collections of nurserymen's specimen plates. They represent the horticultural aspect of an era when peddlers of all kinds of consumer goods were introducing a new market culture into the American countryside.[39] Peddlers broadcast the idea that the status of a buyer and his family could be raised by the purchase of commodities signifying affluence and refinement, while also improving the communal level of civilization. Despite widespread concern about unscrupulous swindlers and their "humbug," the better tree agents disseminated enthusiasm for horticulture along with a new diversity of species and cultivars. Their fruits and ornamental plants transformed the rural landscape while providing a real improvement in the standard of living through both monetary profit and an enriched food supply.

SELLING SEEDS:
THE ORIGINS OF MAIL ORDER

The expansion of transportation networks, reliable shipping systems, and low prices for printing and mailing catalyzed a national market served by trade catalogs and diminished reliance on traveling salesmen. While a proliferation

of nurseries across the continent reduced the need for tree agents, merchants selling easily transportable seeds via mail orders especially benefited from the accelerating development of the United States Postal Service.

The oldest seed company in the nation was founded by David Landreth in Philadelphia in 1784. His son David Landreth II published the first American floral magazine in 1832, a short-lived journal with hand-colored lithographs, too rarefied and expensive given the limited market of affluent American horticulturists at the time.[40] In 1847 David the younger established the first large American seed farm; and in the same year he introduced *Landreth's Rural Register and Almanac*, a more cheaply produced small annual booklet that combined the functions of catalog and horticultural guide—unprecedented at the time.[41] Landreth's began manufacturing farm machinery for sale in 1853 and in 1872 became the first farm in Pennsylvania to deploy a steam-powered tractor, enabling them to accomplish "within an hour the labor of a well-conditioned team for an entire day" (fig. 10.16).[42] By 1879 they covered 1,574 acres of the 7,000 acres devoted to seed production in the United States.[43]

The total area of American seed farms increased rapidly to 169,850 acres in 1890, with 96,000 of those acres in active cultivation, propelled by new machinery and new delivery systems spanning the continent.[44]

In 1863 the Post Office revolutionized the seed-selling business with a new classification system assigning low rates to instructive periodicals as second class mail and to seeds as third class mail.[45] Twelve years later, Philadelphia seedsman Robert Buist wrote: "Since this regulation went into effect, this trade has so rapidly increased as to occasion us to establish a separate department in our store for the execution of all such orders."[46] Montgomery Ward's first one-page list of general merchandise distributed

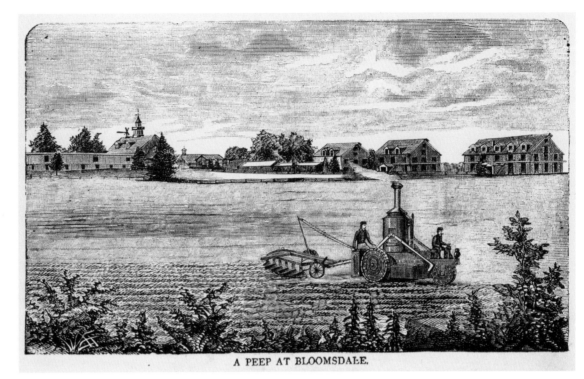

A PEEP AT BLOOMSDALE.

to farmers' cooperatives in 1872 usually serves as the point of departure for histories of mail order.[47] But seed merchants preceded him in the 1860s with repeated explanations to their customers of basic necessities such as providing their name and address to complete the unaccustomed transaction.

In 1879 modified postal regulations determined that a publication was eligible for cheap second class mail only if it appeared regularly with a date and place of issue and contained information useful to a list of subscribers. This created an irresistible temptation to send advertising through the mail in periodical form and codified the publication of informative seed catalogs as dated periodicals claiming large circulations.[48] Their authors extolled the seed catalogs as indispensible references—a "treatise" in at least one case—and alleged that they were not advertising.[49]

In this changing climate, astute seed merchants discovered the potential of mail order by incremental experience. One leading

example, Scottish immigrant Peter Henderson (1823–1890), started out working for seedsman Grant Thorburn and nursery florist Robert Buist. As a newly independent market gardener and nurseryman, he auctioned many of his live plants daily. By 1862 he was selling them through a catalog supplemented by newspaper advertising. In 1866 he wrote the first American manual on market gardening, *Gardening for Profit*, followed by the first book on commercial flower production, *Practical Floriculture*, in 1868.[50] These books inspired and guided a boom in commercial gardening. One year after stating that his business was primarily wholesale delivery to retailers, in 1870 Henderson noted that a recent sideline in seed selling was expanding far more rapidly than expected. The following year he established a seed department that became one of the largest American seed houses, personally writing most of its catalog and advertising for many years.[51]

As early as 1850, horticultural writer and clergyman Henry Ward Beecher warned beginning gardeners to beware of the seductions of the horticultural marketplace:

> We protest against floral spendthrifts, floral dissipation, and all flower-mongers....they will be entrapped by sounding names in seed-stores, and made wild by pompous catalogs from florists and seedsmen.[52]

But the pompous catalogs of Beecher's day pale by comparison with the extravagance that followed. Escalating investment in mail-order operations coincided with a surge of pictorialism in American publications of all kinds during the last three decades of the century. Illustrated gazettes and magazines, which first became popular in the 1850s, generated a new corps of commercial artists and printmakers who turned their talents to advertising. In seed catalogs, figures of plants became more numerous for the practical purpose of identification as well as commercial allure, occasionally filling a page by 1860.[53] As processes such as chromolithography and electrotyping became increasingly affordable, captivating imagery became an essential element in selling products.[54]

Color made a first tentative appearance in the seed catalog in the 1850s and took hold as a competitive innovation immediately after the Civil War, during the mid-1860s. Horticultural historian Ulysses P. Hedrick called Benjamin K. Bliss the first person to establish a primarily mail-order seed business and the first to introduce color to the catalog in 1853.[55] He was certainly one of the foremost early innovators in seed catalog design, closely followed by James Vick, who started out as a print compositor before gravitating into seed production and

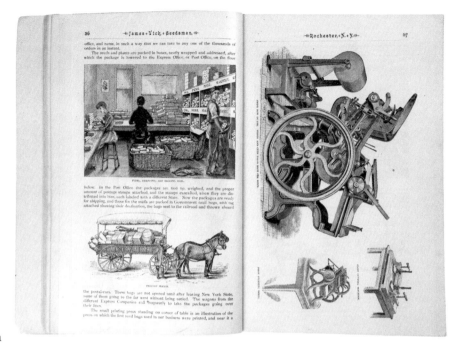

horticultural journalism. Uniquely prepared to deploy innovative print technologies and graphic design in the selling of seeds, Vick invested heavily in the machinery of printing and packaging (fig. 10.17). He was also one of the few seed growers to employ artists full-time in season to draw flowers in his gardens for publication.[56] In 1864 Vick repeatedly advertised the addition of color to his catalog–narrowly preceding competitors such as Henry A. Dreer and Joseph Breck.[57] Three years later he offered a floral chromolithograph as a premium for the first time, issued separately as a parlor print "to aid in the development of floral taste."[58]

Bliss moved his business to New York City in 1867, the same year that he adopted the venerable form of the folding plate from luxurious book production to illustrate his catalog with a fancy black-and-white frontispiece naming the floral varieties in a bouquet. His autumn catalog featured the earliest example so far discovered of chromolithography as the color process in a horticultural catalog. One of the earliest multicolor prints in the Mertz Library catalog collection is his 1869 folding

FIG. 10.17. James Vick invested heavily in publishing catalogs to promote sales of his merchandise, employing artists to draw illustrations of printing, packing, and shipping operations as seen here in *Vick's Illustrated Monthly Magazine and Floral Guide*, 1887, pp. 36–37.

FIG. 10.18. Chromo-lithograph of *Lilium auratum*, in Benjamin Bliss, *Descriptive Catalogue of a Choice Collection of Vegetable, Agricultural and Flower Seeds*, 1869, featuring a folding plate with one of the first color prints. This seed merchant was an early innovator in mail order and seed catalog design.

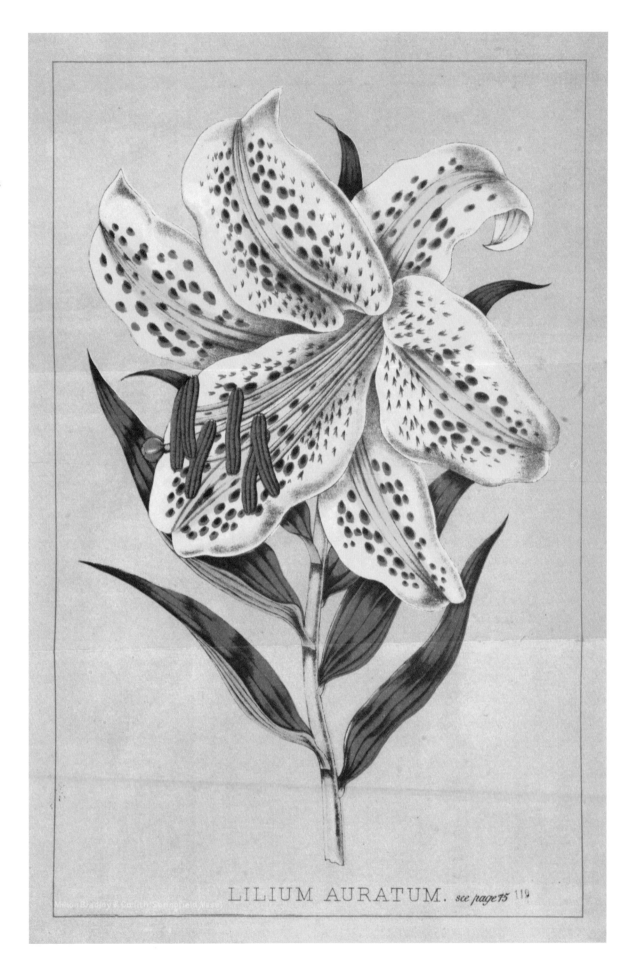

LILIUM AURATUM. *see page* 15 119

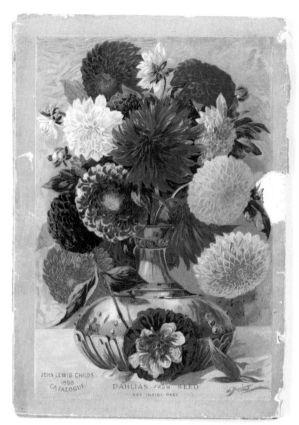

FIG. 10.19. Bouquet of "Dahlias From Seed," back cover of John Lewis Childs' catalog *New Rare & Beautiful Flowers*, 1888, by the German-trained artist William Momberger, who raised the standard of artistic seed catalog design in the 1870s and 1880s.

FIG. 10.20. Albert Blanc was a successful commercial artist, offering thousands of horticultural illustrations at low prices. His view of Peter Henderson's trial grounds in Jersey City in Henderson's *Manual of Everything for the Garden*, 1884, p. 26, anticipates the still-not-erected Statue of Liberty behind rows of cabbage varieties.

frontispiece of the recently imported Japan lily (fig. 10.18).[59] Bliss proceeded to set a new standard in the artistic quality of seed catalog images during the 1870s, hiring respected artist William Momberger (fig. 10.19) to design many of his pages and commissioning advanced commercial printmakers such as Milton Bradley (later famous for publishing colorful board games) to saturate his plates with color.

Briggs & Brother may have been the first to cover their catalog with a chromolithograph in 1873. The recently heightened commercial importance of graphic design is indicated by their professed pride in their "Magnificent Catalogue" as "a sample of the combinated elegance to which paper, type and ink can be brought"—"the

finest work of the sort ever issued on this continent or in Europe."[60] One of the leading horticultural artists, Albert Blanc, an immigrant from Antwerp, established his own horticultural engraving and electrotyping business in 1885, which "practically revolutionized" the seed trade. Electrotypes were copper casts made from engravings, which could be used for long runs of cheap publications, "enabling any seedsman to illustrate his catalog at comparatively little expense."[61] Blanc listed thousands of floral and horticultural figures for sale and offered to illustrate "any desirable novelties at a bargain." He was also commissioned to produce views of nurseries and their operations (figs. 10.20 and 10.25).

Seed catalogs reached their flamboyant peak in the 1880s and 1890s as the rotary press and other technological improvements made it possible to publish thick booklets, illustrated throughout and bound with chromolithographed covers and plates (fig. 10.21). The appropriation of chromolithography for commercial purposes repelled art critics, but delighted consumers. It remained the preferred embellishment of seed catalogs until color photography began to displace it around 1896.[62]

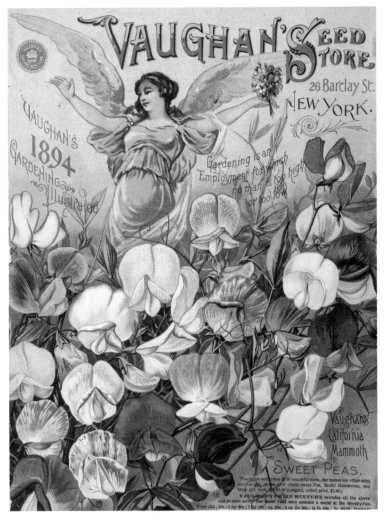

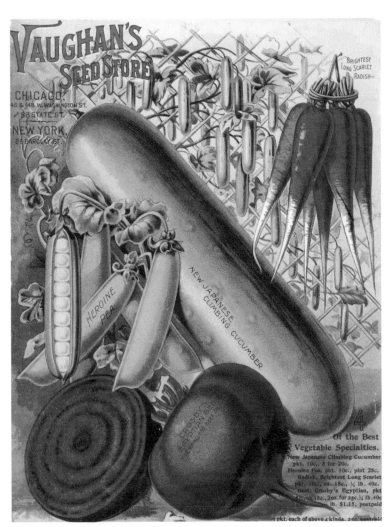

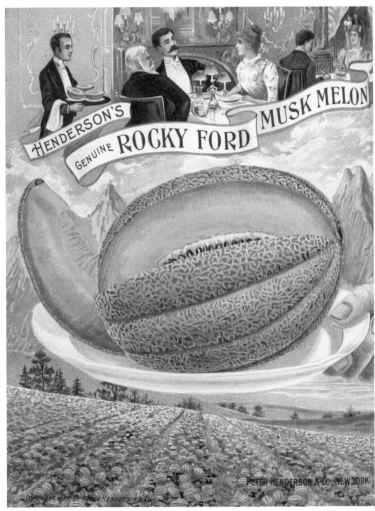

CORPORATE HORTICULTURE
AND ITS IMAGE

Seed dealers began to incorporate around the 1870s, as corporate charters became widely available mechanisms for raising capital by selling shares, enabling investment and expansion. The growth of a national market increased competition to engage the potential purchaser, at the same time that it lengthened the distance between supplier and buyer. Producers of all kinds of goods hustled to assert their competence and integrity as well as the consistently high quality and good value of their merchandise. After the first federal trademark protection law was passed in 1870, a new emphasis on branding appeared in seed catalogs and packaging, assuring the quality of a product.[63]

Competition brought about lower prices as well as marketing gimmicks such as cash prizes, seed premiums, money-back guarantees, discounts for group orders, free booklets and inexpensive parlor prints. With vigorous expansion came competing claims to be the best, the biggest, the first, the most efficient, with the highest quality control, the most rapid and correct fulfillment of orders, and the most modern facilities. Among those companies claiming to be the largest were Landreth (1874), Buist (1875), Ferry (1875), Childs (1888), and Burpee (by 1895). Conflicting assertions of supremacy became so flagrant that one of the contenders, Peter Henderson, himself concluded "that buyers of Seeds must often become puzzled to know at whose doors they can most advantageously place their patronage."[64]

A long-standing tendency to give exaggerated names to new varieties of seed accelerated into the frenzied promotion of grandiose novelties around the 1880s and 1890s (fig. 10.22). Valuable new plant introductions had to emerge from a

FIG. 10.22. For *Maule's Seed Catalogue*, 1885, p. 5, Albert Blanc drew two farmers, prosperous and poor, celebrating the certified testimonial that Maule's profitable "Ironclad" watermelon could grow to a weight of over 95 pounds.

plethora of discardable discoveries presented with indiscriminate acclaim. Joseph Harris, an influential seedsman, writer, and editor who had studied agricultural chemistry at Rothamsted Experimental Station in England before arriving in Rochester in 1849, advocated careful testing and seed selection before introducing a new variety.[65] W. Atlee Burpee expanded this approach at Fordhook Farms after 1888, seeking out and testing thousands of varieties of seed to produce popular new introductions such as "Iceberg" lettuce.[66]

Although their statistics were self-serving, the catalogs provide some measure of the tremendous growth of the industry during

FIG. 10.21 A–D. The height of dazzling chromolithography in the seed catalog was reached in the late 1880s and 1890s, immediately before color photography became a practical advertising medium. Vaughan's seed catalog of 1894 and Henderson's of 1899 represent this culmination of arresting cover art and interior plates.

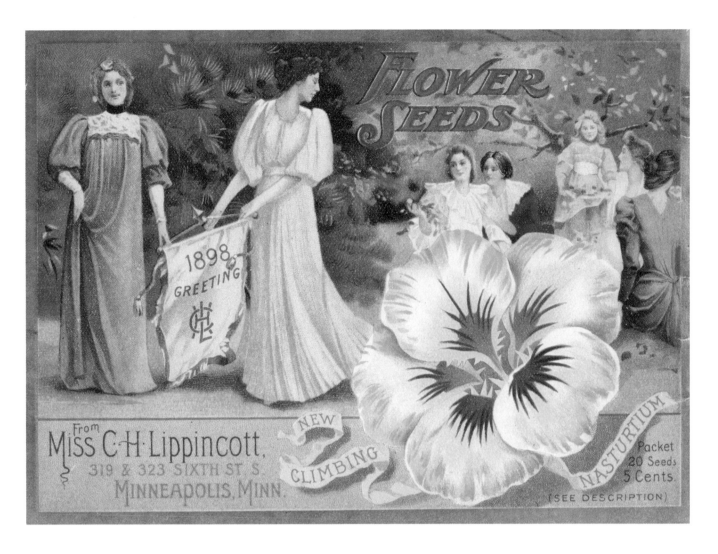

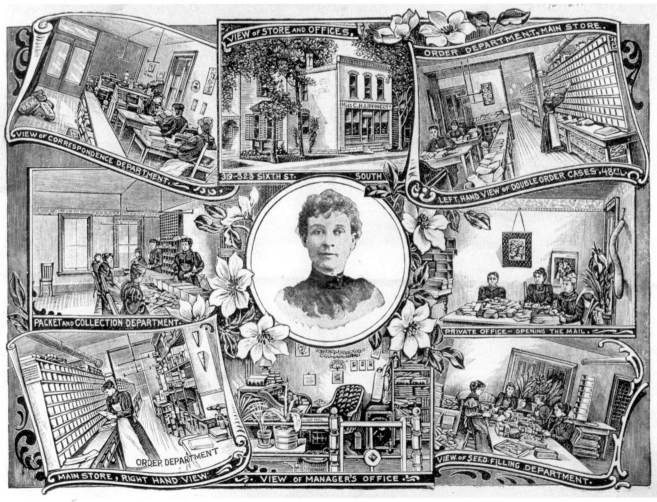

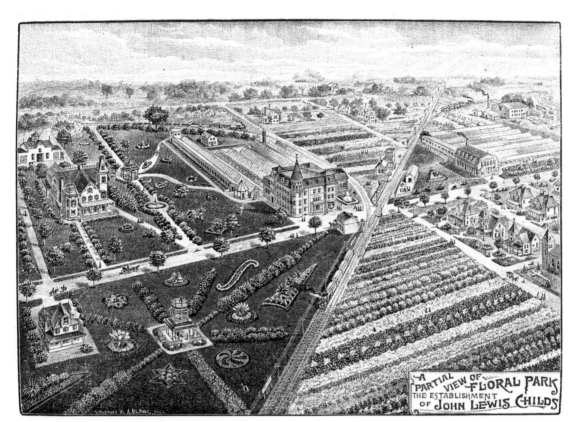

FIG. 10.24. A bird's-eye view, in John Lewis Childs' catalog, 1891, p. 4, illustrates his modern physical plant, including a belvedere, railroad, post office, and model village. His business integrated every function from seed growing, to display gardens, to packaging, advertising, horticultural instruction, sales, and distribution.

THE HORTICULTURAL
ENTERPRISE

the last quarter of the century. In 1875, Robert Buist proudly claimed that 100 orders daily on average in season made his "the largest seed establishment in this country."[67] But that number sounds negligible by comparison to James Vick's prior announcement of 1–2,000 mail orders daily in his busy season.[68] By 1888 D. M. Ferry & Co. reported sending out 750,000 copies of their catalog, in addition to supplying 100,000 shops across the country with display boxes of seed packets for sale (see fig. 10.9).[69] A few years later, Burpee declared "5100 cash retail orders received in one day."[70] And in 1898, Childs proclaimed that he issued 1.5 million catalogs annually, one of several merchant growers warranting a large post office and a railroad station on his premises.[71]

At the same time that they grew, energetic proprietors cultivated a strong sense of personal connection with their distant customers, drifting from real familiarity into a fiction of public relations. At the extreme of personal involvement, Peter Henderson is said to have answered at least 175,000 letters in the course of his career and remained available for random consultation "at the Greenhouses till 12 M., and at his office in New York from 1 to 3 p.m."[72] Dexter M. Ferry, on the other hand, took a more modern approach to public relations, with the placement of flattering stories vaguely commending him for the reception of his business into the American home:

> The peculiarly intimate, almost domestic relationship which the house of D. M. Ferry & Co. bears to the average home is what makes the reputation of the business, and the name of Mr. Ferry so widely known....[73]

Many catalogs invited readers to visit the seed farms, shops, and display gardens, even the business operations, of a seed company. For

those who could not make the trip, various types of illustration conveyed the superiority of the enterprise. Philadelphian rivals Robert Buist and David Landreth introduced views of their greenhouses and city stores as early as the 1850s.[74]

In 1873 a new kind of prospect representing the seed farm as industrial enterprise began to appear in the catalogs, influenced by the style of illustrated atlases popular at the time.[75] Bloomsdale appeared that year in Landreth's catalog (see fig. 10.16) and very similarly one year later in a book called *Pennsylvania Illustrated*, which referred to Landreth's not as a rustic farm, but as "prominent among the many industrial enterprises of Pennsylvania."[76] Bucolic landscape views of his seed farm illustrated James Vick's magazine and catalog, but such images of idyllic tranquility were greatly outnumbered by scenes of industrialized horticultural processes.[77]

In 1876, Dexter Morse Ferry embarked on a series showing work on his seed farm outside Detroit, beginning with the 6:45 a.m. roll-call of his laborers. Two years after incorporating in 1879, Ferry added views of the operations inside his "new mammoth seed store and warehouse" in the city, as well as new scenes of German immigrant women laboring under the close supervision of male overseers, while better dressed women carried out the office work of the mail order department.[78] One entrepreneur, Miss Carrie H. Lippincott, staffed her business in Minneapolis entirely with women. She appealed to her clientele by countering masculine claims of market dominance with traditionally feminine associations, from the diminutive size and pastel coloration of her catalog (which was called "dainty" by one reviewer), to the floral frame of her own portrait presiding over vignettes of her homelike office (fig. 10.23 A–B).[79]

Contenders for biggest-and-best status, on the other hand, tended to imitate the bird's-eye view of a manufacturing complex to capture their scale and complexity in a single prospect.[80] After the Dingee & Conard Company introduced a system of mass-producing roses that could supply a new popular demand for the species on a national scale, they published a dramatic new vista looking down over their enormous range of seventy glasshouses. This factory-style composition visually identified a nursery business with the heavy capital investment and enormous capacity of modern industry.[81]

The pictorial culmination of a completely integrated horticultural infrastructure appears in a bird's-eye view of John Lewis Childs' establishment in 1888, one year after he had succeeded in changing the name of his Long Island location from East Hinsdale to Floral Park (fig. 10.24). Artist Albert Blanc depicted the fields, greenhouses and warehouse of "the largest [business] of its kind in the world" with a new post office built to handle daily tons of mail and a railroad station on Childs' land in the foreground with its new name spelled out in flowers, further embellished by his mansion, display gardens, tree-lined avenue and observatory.[82]

During the course of the nineteenth century, the primary model of horticultural commerce in America evolved from a seasonal sideline, to a business personally run with a minimum of publicity by the self-employed owner of a nursery, to a national market served through itinerant agents selling trees and shrubs, to a large mail order corporation advertising widely and shipping directly to customers while also publishing a separate wholesale catalog. The largest companies to emerge from the competitive free-for-all of the late nineteenth century dominated mail-order sales for the next hundred years, expanding to a scale unimaginable by their founders. By the 1990s,

the Park Seed Company, for example, was mailing 13 million catalogs yearly; and today sales of vegetable seeds alone total about $5 billion annually.[83] But horticulture remained a sector that encouraged innumerable small ventures as well as a few behemoths.

Representing over 5,000 companies, the 58,000 (and counting) items in the Nursery and Seed Trade Catalog Collection of the Mertz Library document the continuing vitality of generation after generation of new horticultural enterprises as well as the longevity of some of the oldest firms. Known as a resource informing botanical history and nomenclature, historic garden restoration and historic revival design, as well as scholarship in the field of landscape history, the Mertz Library is also an important repository of American print history and, as this essay briefly demonstrates, a cutting-edge sector of nineteenth-century American enterprise.

ENDNOTES

Unless consultation in another collection is noted, all primary sources cited in these notes are part of the Mertz Library collections, frequently in multiple editions.

1. Maule entered the seed business in Philadelphia in 1877. According to his obituary in *Printers' Ink* 84 (1913): 35, "...his advertising developed into one of the longest continuous campaigns in the country. Mr. Maule is credited with having originated the big catalogue now used by so many seed houses." Closely comparable sectional views of factories were published during the 1870s. See Sally Pierce and Catharina Slautterback, *Boston Lithography, 1825–1880* (Boston: The Boston Athenaeum, 1991), 119, no. 121.

2. A. J. Pieters, "Seed Selling, Seed Growing, and Seed Testing," in *Yearbook of the Department of Agriculture* (Washington, DC, 1900), 550, citing as the earliest known record of seeds for sale an advertisement by a bookseller in the Newport, RI *Mercury* of 1763 announcing the arrival of garden seeds from London.

3. The Mertz Library holds a complete run of the *American Farmer*, ed. John Stuart Skinner (Baltimore: printed for John S. Skinner by J. Robinson, 1819–1834); as well as its successor series to 1871.

4. Liberty Hyde Bailey, "List of American horticultural books," in *The Standard Cyclopedia of Horticulture*, revised edition (New York: Macmillan, 1942) 2, 1523–1562. See also Elisabeth Woodburn, "Addendum of Books Published from 1861–1920," in Ulysses P. Hedrick, *History of Horticulture in America to 1860* (Portland, OR: Timber Press, 1988), 515–581.

5. John T. Fitzpatrick, "An Overview of American Nursery and Seed Catalogues, 1771–1832," in *Plants and People*, (Boston: Boston University, 1996), 152–162. On the early American nursery and seed business see Bailey, "Horticulture," in *Standard Cyclopedia* 2, 1516–1518. Bernard M'Mahon, *Catalogue* (Philadelphia: William Duance, [ca. 1807]).

6. Grant Thorburn's catalog of 1827, held by the Massachusetts Horticultural Society, offers more details than his brief account of the start of his business in *Forty Years' Residence in America* (Boston: Russell, Odiorne, & Metcalf; Philadelphia: Marshall, Clark & Co.; and New York: Monson Bancroft, 1834), 73–77. At the Mertz Library see Thorburn, *Catalogue* (New York: George P. Scott and Co., 1838), ii.

7. Thomas Hogg, *Catalogue* (New York: G. P. Scott & Co., 1834).

8. Margaret Sommer, *The Shaker Garden Seed Industry*, published M. A. thesis, University of Maine (Orono, 1966), 10–16, 26–27, 32, 36. Galen Beale and Mary Rose Boswell, *The Earth Shall Blossom: Shaker Herbs and Gardening* (Woodstock, VT: Countryman Press, 1991), 35–44.

9. William R. Prince, "Prevarication and Falsehood," letter to the editor, *Prairie Farmer* 6 (September 1846), 281.

10. On the evolution of printing as it affected American newspaper and magazine publication, see Frank L. Mott, *American Journalism, A History: 1690–1960*, 3rd edition (New York: Macmillan, 1962), 203–204, 314–316, 401–402, 497–498.

11. This introduction is repeated in the enlarged fourth edition (one of ten editions in the Mertz Library): Thomas Bridgeman, *The Young Gardener's Assistant* (New York: Booth & Smith, 1833), v. Bridgeman's related titles on growing flowers, fruits, and vegetables are also held in numerous editions.

12. Elisabeth Woodburn concluded that nurserymen "wrote all but a few of the gardening books from the earliest through the middle of the nineteenth century." See her "Horticultural Heritage: The Influence of U.S. Nurserymen," in *Agricultural Literature: Proud Heritage—Future Promise*, ed. Alan E. Fusonie and Leila P. Moran (Washington, DC: National Agricultural Library, 1975), 109–141.

13. Roland Green, *A Treatise on the Cultivation of Ornamental Flowers* (Boston: John B. Russell and New York: G. Thorburn & Son, 1828), 5. Woodburn identifies this as the first American book on flower gardening in "Horticultural Heritage," 125.

14. Thomas Bridgeman, *The Florist's Guide*, rev. ed. (New York, 1847), 3–5.

15. The form of address comes from Lucy Hooper, *The Lady's Book of Flowers and Poetry* (New York: J. Riker, 1842), 10.

16. Katherine Martinez, "'Messengers of Love, Tokens of Friendship'...," in Gerald W. R. Ward, ed., *The American Illustrated Book in the Nineteenth Century* (Winterthur, DE: Winterthur Museum, and Charlottesville, VA: University Press of Virginia, 1987), 93–97, discusses the role of beautiful and improving books in the virtuous American home. The Mertz Library holds numerous American and European titles related to the language of flowers.

17. William S. Reese, *Stamped with a National Character: Nineteenth Century American Color Plate Books*, exhibition catalogue (New York: The Grolier Club, 1999), 38–47.

18. Bettina A. Norton, "William Sharp: Accomplished Lithographer," in *Art and Commerce: American Prints of the Nineteenth Century* (Boston: Museum of Fine Arts and Charlottesville: University Press of Virginia, 1978), 50–75.

19. Charles Mason Hovey, *The Fruits of America* (Boston: Little, Brown, and Hovey, issued in installments 1847–1856, and in two volumes 1851–1856, with an incomplete third volume in 1859). The publisher's dummy containing signatures of subscribers was given to the Mertz Library by David L. Andrews. Reese, *Stamped*, 18, 45, calls this the first American book illustrated with chromolithographs based on the date of its first installment.

20. Hovey crossed six varieties of strawberry in 1834 and introduced "Hovey's Seedling" in 1838. Stevenson W. Fletcher, *The Strawberry in North America* (New York: Macmillan, 1917), 22, 27: "The introduction of the Hovey marked the emancipation of our horticulture from that of the Old World, and the beginning of North American plant breeding." Noel Kingsbury, *Hybrid: The History and Science of Plant Breeding* (Chicago: University of Chicago Press, 2009), 135–138, adds that "strawberry fever" reigned from about 1859 to 1870, yielding 1,362 named strawberry varieties in the United States by 1925. See also Daniel J. Kevles, "Fruit Nationalism—Horticulture in the United States from the Revolution to the First Centennial," in *Aurora Torealis*, ed. Marco Beretta et al. (Sagamore Beach, MA: Science History Publications, 2008), 129–146. For a biography of Charles Hovey, see B. June Hutchinson, "A Taste for Horticulture," *Arnoldia* 40, no. 1 (1980), 31–48.

21. Hovey, *Fruits*, v–vi: "Pomologists have long been devoted to the attempt to reduce the chaos of names to something like order...To contribute my share towards the accomplishment of this important work, has been the principal object of the publication of the Fruits of America...the great importance and value of colored drawings in identifying fruits, and detecting synonmes [are] now generally acknowledged, when accurately and truthfully executed—and accompanied with faithful descriptions—to be the only safe and reliable means of arriving at certain and satisfactory conclusions." For the historical significance of this breakthrough, see Daniel J. Kevles, "How to Trademark a Fruit," *Smithsonian Magazine* (August 2011): http://www.smithsonianmag.com/arts-culture/How-to-Trademark-a-Fruit.html

22. John Fisk Allen, *Victoria Regia; or, The Great Water Lily of America* (Boston: Dutton and Wentworth for the author, 1854). The Mertz Library also has the English series imitated by Sharp: William Jackson Hooker, *Victoria Regia* (London: Reeve and Benham, 1851).

23. Robert Jay, *The Trade Card in Nineteenth-Century America* (Columbia, MO: University of Missouri Press, 1987), 28–60.

24. The seed merchants have been overlooked as pioneers of branding in histories of advertising. For example, Juliann Sivulka, *Soap, Sex, and Cigarettes: A Cultural History of American Advertising* (Belmont, CA: Wadsworth, 1997), 47, identifies Quaker Oats as the first marketing success of branded packaging, but this did not occur until after 1888. Reid opened his seed business in Rochester in 1872. His undated card can be placed sometime during the 1880s when the high-wheeled bicycle was popular, and before the printers Mensing & Stecher dissolved their partnership in 1886

25. *The Garden of the Genesee* (Rochester Historical Society, 1940), 13–21: also Blake McKelvey, "The Flower City: Center of Nurseries and Fruit Orchards," *Publications*, Rochester Historical Society, 18, part 2 (Rochester, NY, 1940), 121–169.

26. On Ellwanger & Barry see Diane H. Grosso, "From the Genesee to the World," *The University of Rochester Library Bulletin* 35 (1982), 3–25. On their importance as the pioneers of the tree agent system see Cheryl Lyon-Jenness, "A Telling Tirade: What Was the Controversy Surrounding Nineteenth-Century Midwestern Tree Agents Really All About?" *Agricultural History* 72, no. 4 (1998), 681–683.

27. Charles Van Ravenswaay, *Drawn from Nature: The Botanical Art of Joseph Prestele and his Sons* (Washington, DC: Smithsonian Institution Press, 1984). This is an important source of information on the nurserymen's specimen plates.

28. The Mertz Library has a nearly complete collection of Prestele's published botanical plates, both European and American.

29. Prestele's correspondence with Torrey from 1845 to 1858 is located in Archives NYBG, Torrey Papers, folder 7.7.

30. A bound set of fruit portraits donated by David L. Andrews includes four with the label "Painted Expressly for James H. Watts, Rochester, New York." Watts was a mid-century nurseryman and Treasurer of the Horticultural Society of the Valley of the Genesee.

31. Attitudes to the stereotypical peddler are discussed in Jackson Lears, *Fables of Abundance: A Cultural History of Advertising in America* (New York: Basic Books, 1994), 63–74.

32. E. B. & E. C. Kellogg, lithographers, title page of *The Specimen Book of Fruits, Flowers and Ornamental Trees* (Rochester: D. M. Dewey, ca. 1862). Nancy Finlay, "From Hartford to Everywhere: The History of the Kellogg Firm and its Associates," in *Picturing Victorian America: Prints by the Kellogg Brothers of Hartford, Connecticut, 1830–1880*, ed. Nancy Finlay (Hartford: Connecticut Historical Society and Wesleyan University Press, 2009), 17–19. The Kellogg partnership dissolved in 1867.

33. Delon Marcus Dewey, "The History and Practical Use of the Colored Plate Book," in *The Tree Agents' Private Guide...*, 2nd edition (Rochester: D. M. Dewey, 1876), 10–16; consulted at the Library of Congress. "About eighteen years since Mr. D. M. DEWEY, bookseller, Arcade hall, Rochester, N.Y., conceived the idea of furnishing for the nurserymen of the United States, portraits colored from nature, of the various fruits, flowers and ornamental trees grown by them, and binding these portraits or fruit plates as they are called into specimen books, for the use of agents in the sale of nursery products...." Van Ravenswaay, *Drawn from Nature*, 77–81, traces Dewey's appropriation of the genre.

34. John Jacobs Thomas, "Outlines and Descriptions of Fruits," (1837–1892), a manuscript donated to The New York Botanical Garden by David L. Andrews.

35. The Mertz Library holds seven editions of this work dating from 1849–1897. Thomas also wrote and served as horticultural editor of *The Genesee Farmer*, *The Cultivator*, *The Country Gentleman*, and *Rural Affairs*, all of which are in the Library's collection of periodicals.

36. The architecture of the "Pleasant Home" suggests an 1860s or early 1870s date for this image.

37. On the heyday of the tree agents, see Cheryl Lyon-Jenness (1998), 675–707. See also "Dishonest Tree Agents," *Horticulturist* 26, no. 296 (1871), 45–46, reprinted from the *Massachusetts Ploughman*.

38. On Rochester as a nursery plate center, see Karl Sanford Kabelac, "Nineteenth-Century Rochester Fruit and Flower Plates," *University of Rochester Library Bulletin* 35 (1982), 93–113.

39. David Jaffee, "Peddlers of Progress and the Transformation of the Rural North, 1760–1860," *The Journal of American History* 78, no. 2 (1991), 511–516, 521–524, 534–535.

40. *The Floral Magazine and Botanical Repository* (Philadelphia: D. & C. Landreth, 1832–1834). For a chronology of Landreth company history, see http://www.saveseeds.org/biography/landreth/landreth_timeline.html

41. David Landreth & Sons, *Landreth's Rural Register and Almanac* (Philadelphia: D. Landreth, 1847). The significance of this publication is stated in the introduction to Landreth's *Almanac* (1879), 5.

42. Described in *Pennsylvania Illustrated* (Philadelphia: Porter & Coates, 1874), 95–96; and reprinted the following year in Landreths' *Almanac*.

43. On Landreth's expansion see Hedrick, *History of Horticulture*, 249–250; also Landreths' *Almanac* (1879), 4.

44. Pieters, "Seed Selling," 558–560. According to these figures, compared with Landreth's statement that they were growing seeds on 1,574 acres, Landreth may have owned as much as one fifth of the American land farmed for seeds during the 1870s.

45. Wayne E. Fuller, *The American Mail: Enlarger of the Common Life*, ed. Daniel J. Boorstin (Chicago: University of Chicago Press, 1972), 126–138. Jane Kennedy, "Development of Postal Rates: 1845–1955," *Land Economics* 33, no. 2 (1957), 93–112. Plant materials were alternately classified as third or fourth class mail from 1863 onward.

46. "Seeds Sent By Mail," in *Buist's Almanac and Garden Manual* (Philadelphia: C. Sherman & Son, printers, for R. Buist, Jr., 1875), 24.

47. See for example Thomas J. Schlereth, "Country Stores, County Fairs, and Mail-Order Catalogues: Consumption in Rural America," in *Consuming Visions: Accumulation and Display of Goods in America, 1880–1920*, ed. Simon J. Bronner (Winterthur, DE: Winterthur Museum and New York: Norton, 1989), 339–375.

48. Fuller, *American Mail*, 134.

49. In 1876, D. M. Ferry called his *Seed Annual* "a Standard Treaties on the Cultivation of Vegetables and Flowers."

50. Peter Henderson, *Gardening for Profit* (New York: Orange Judd, [1867]). Peter Henderson, *Practical Floriculture* (New York: Orange Judd, 1869).

51. *Peter Henderson & Cos. Catalogue of Everything for the Garden* (New York: Peter Henderson & Co., 1869 and 1870); kept at the Liberty Hyde Bailey Hortorium Library of Cornell University. The Mertz Library has an incomplete collection of Henderson catalogues from 1877 to 1952. For biographical information including the importance of his books for market gardeners and commercial florists, see Alfred Henderson, *Peter Henderson, Gardener—Author—Merchant* (New York: McIlroy & Emmet, 1890), 17–28.

52. Henry Ward Beecher, "A Few Words to Remember," *Horticulturist* 4, no. 5 (May 1850), 501.

53. For example, the "monstrously large fruit" of a New Rochelle Blackberry fills a page in a *Descriptive Catalogue of Fruits* (Rochester, NY: Ellwanger & Barry, 1860), 48.

54. Neil Harris, "Pictorial Perils: the Rise of American Illustration," in *American Illustrated Book*, ed. Ward, 3–19. Clarence P. Hornung, *Handbook of Early Advertising Art, Mainly from American Sources*, 3rd ed. (New York: Dover, 1956), xl.

55. Hedrick, *History of Horticulture*, 250–251. Without citing his untraceable source, Hedrick states that Benjamin Bliss added color to his seed catalogue as early as 1853. Charles W. Chapin, *History of the 'Old High School' on School Street, Springfield* (Springfield, MA.: Press of the Springfield Printing & Binding Co., 1890), 46, says that Bliss ran a drug store in Springfield with a nursery and seed business on the side from 1845 to 1865, then sold the drug store and moved his seed business to New York 1867–1885.

56. *Vick's Illustrated Catalogue* (Rochester, NY: James Vick, 1869), 2.

57. Vick advertised the addition of color to his catalogue in the *American Agriculturist* 23 (February, March, and November, 1864), 58, 91, 327.

58. *Vick's Illustrated Catalogue* (1869), 4. The frontispiece of this catalogue is "Engraved on Wood and printed in Colors by Geo. Frauenberger."

59. Benjamin K. Bliss, *Catalogue* (Springfield, MA: Samuel Bowles & Co., printers for Benjamin K. Bliss, 1867). Bliss' *Autumn Catalogue* of 1867–1868 with a chromolithographed frontispiece is held by the Bailey Hortorium Library at Cornell University and the Massachusetts Horticultural Society.

60. Briggs & Bro., *Flora Illustrated* (Rochester: Democrat and Chronicle Book and Job Print, James Lennox electrotyper, 1873).

61. "Albert Blanc," in *Philadelphia and Popular Philadelphians* (Philadelphia: The North American, 1891), 227. Blanc advertised over 5,000 electrotypes in stock and offered to work on commission in a book he published with J. Horace McFarland, *Floral Designs* (Philadelphia and Harrisburg: A. Blanc and J. Horace McFarland, 1888), 160.

62. Peter Henderson's catalogue of 1896 contained a "Coloritype" view in Central Park. *The Inland and American Printer and Lithographer* 17 (1896), 668, remarked on the importance of the Coloritype Company, founded in 1893: "What heretofore only the chromolithographer could produce, after months of labor and the requisition of twenty and more stones, is now accomplished by the [patented] coloritype process within eight days in three printings."

63. Sivulka, *Soap, Sex, and Cigarettes*, 50–51, refers to the beginning of federal trademark protection.

64. *Peter Henderson & Co.'s Manual of Everything for the Garden for 1884.*

65. William I. Aeberli and Margaret Becket, "Joseph Harris: Captain of the Rochester Seed Industry," *University of Rochester Library Bulletin* 35 (1982), 69–83.

66. On hybridizing fruit during this period see Kingsbury, *Hybrid*, 128–140. Ken Kraft, *Garden to Order: the Story of Mr. Burpee's Seeds and How They Grow* (New York: Doubleday, 1962), 5, states that controlled crosses became the principal origin of new Burpee introductions only after 1940.

67. *Buist's Almanac and Garden Manual* (Philadelphia, 1875), 24.

68. *Vick's Illustrated Catalogue* (1869), 3.

69. John Bersey, ed., "Dexter M. Ferry," in *Cyclopedia of Michigan* (New York and Detroit: Western Publishing and Engraving Co., 1890), 134–136, citing statistics for 1888.

70. "The Record of a Busy Day," in *Burpee's Farm Annual* (Philadelphia: W. Atlee Burpee Co., 1895), 8.

71. John Lewis Childs, *New Rare and Beautiful Flowers* (Floral Park, NY, 1898), 6.

72. *Peter Henderson & Co's Catalogue of Everything for the Garden* (New York, 1881): 2. See also A. Henderson, *Peter Henderson* (1890), 9.

73. "Dexter M. Ferry," *Magazine of Western History* 4 (1886), 266. See also Charles Moore, "Dexter M. Ferry," in *History of Michigan* (Chicago: Lewis Publishing Company, 1915) 2, 1113–1116.

74. The front cover of *R. Buist's Select Catalogue* (Philadelphia: T.K. and P.G. Collins, printers, 1859), consulted at the Massachusetts Horticultural Society, displays a black and white "View of the Green House Department of Rosedale Nursery, Philadelphia."

75. *Landreth's Rural Register and Almanac* (Philadelphia: M'Calla & Stavely, 1873). The price to commission a comparable four-inch image in a Michigan atlas of the time was $28, according to Cheryl Lyon-Jenness, "Picturing Progress: Assessing the Nineteenth-Century Atlas-Map Bonanza," *Michigan Historical Review* 30, no. 2 (Fall 2004), 198.

76. *Pennsylvania Illustrated* (Philadelphia: Porter & Coates, 1874), 95–96.

77. *Vick's Illustrated Monthly Magazine* 2, no. 9 (September 1879), 258–261.

78. "Dexter M. Ferry," *Magazine of Western History* 4 (1886), 263–271. D. M. Ferry & Co., *Seed Annual* (Detroit: D. M. Ferry & Co., 1881).

79. *Flower Seeds from Miss C. H. Lippincott* (Minneapolis: Miss C. H. Lippincott, 1898).

80. Sally Pierce, "The Railroad in the Pasture: Industrial Development and the New England Landscape," in *Aspects of American Printmaking, 1800–1950*, ed. James F. O'Gorman (Syracuse: Syracuse University Press, 1988), 75, discusses the replacement of an older type of pastoral landscape view with the industrialized bird's-eye view.

81. During the 1880s, this prospect appeared in their catalogs and on their trade cards. Thomas P. Conard, "Conard, Alfred Fellenberg," in Bailey, *Cyclopedia* 2, 1569. On the advertising imperative caused by mass production see for example Daniel Pope, *The Making of Modern Advertising* (New York: Basic Books, 1983), 33.

82. For a corporate history of John Lewis Childs with details of order volume and publishing operations, see the Childs catalog *New Rare and Beautiful Flowers* (Floral Park, NY, 1898), 6–7.

83. Ian Berry, "They Say Tomato," *The Wall Street Journal* (October 15, 2012), R5.

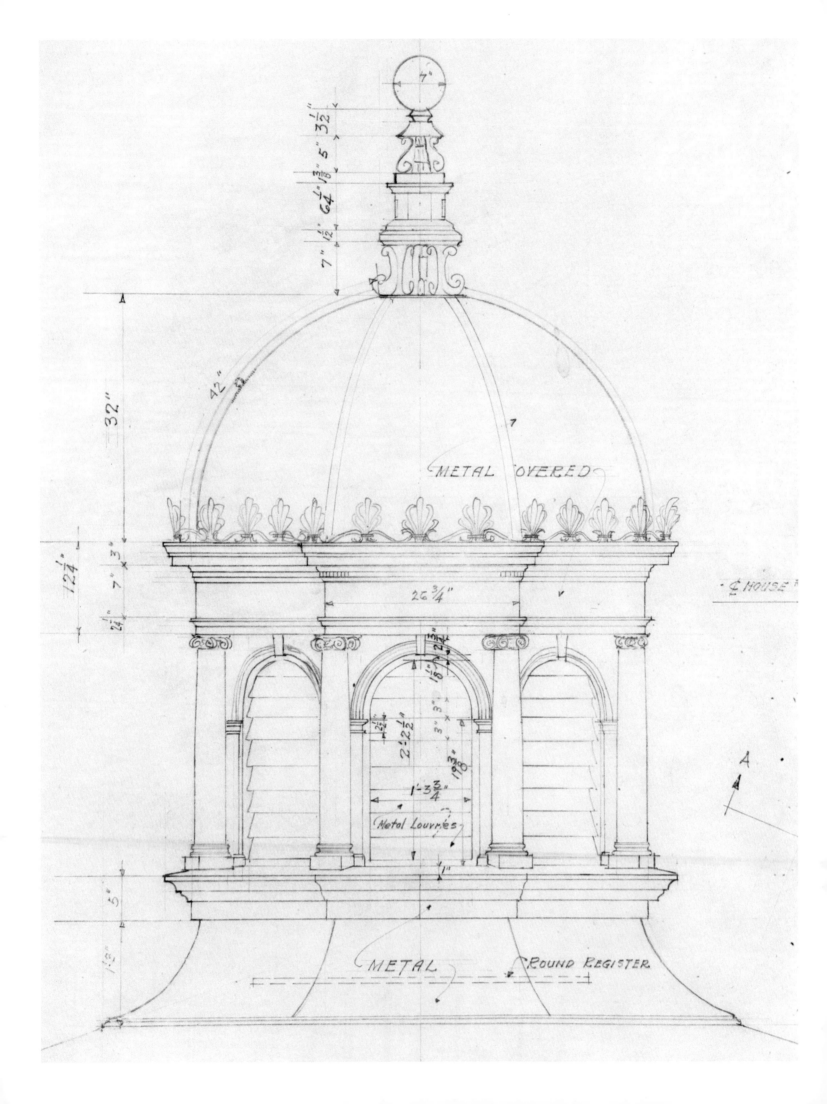

7"

7"

$6\frac{1}{4}$"

$\frac{3}{8}$" 5" $3\frac{1}{32}$"

7" $1\frac{1}{2}$"

42"

32"

METAL COVERED

$124\frac{1}{2}$"

3"

7"

$2\frac{1}{2}$"

26$\frac{3}{4}$"

₵ HOUSE

$2\frac{1}{4}$"

18" 9" $2\frac{1}{2}$"

$2\frac{1}{2}$"

3" 3"

$2'-2\frac{1}{2}$"

$19\frac{3}{4}$"

$1\frac{1}{8}$"

$1'-3\frac{3}{4}$"

Metal Louvres

1"

A

A

5"

$1\frac{1}{2}$"

METAL

ROUND REGISTER

THE

Impressive collections of maps and architectural plans,

LANDSCAPE

preserved in the Mertz Library and the Archives,

OF THE

record the history of the Garden's layout as one of

NEW YORK

New York's premier cultural landscapes

BOTANICAL

that is both pleasure ground and education center.

GARDEN

Architectural drawing, pen on paper, of the cupola of the
Conservatory building by Lord & Burnham Co., 1937.

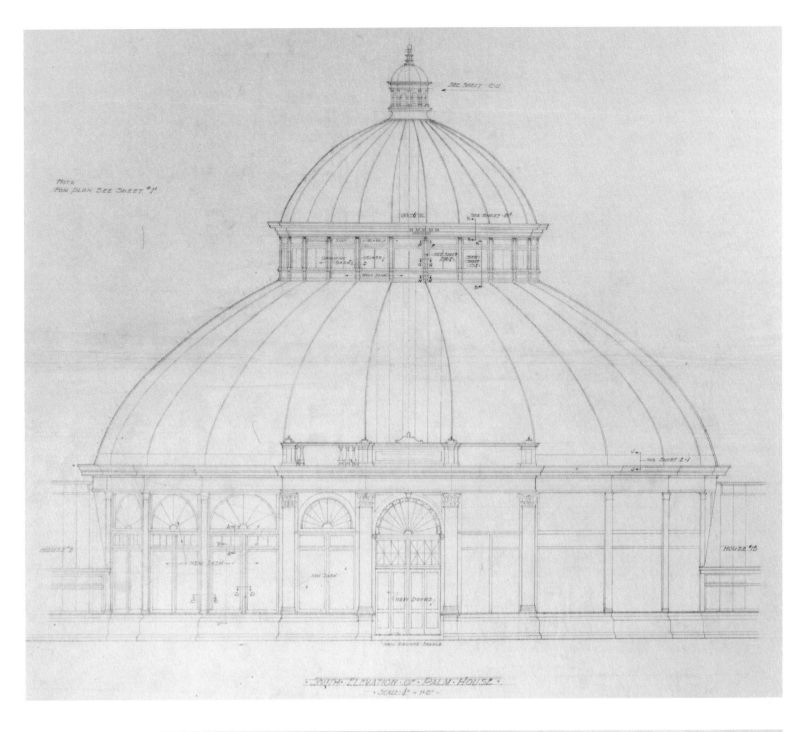

NOTE
FOR PLAN SEE SHEET #1.

SEE SHEET C-11

SEE SHEET B-1

HOUSE #2

HOUSE #15

·SOUTH·ELEVATION·OF·PALM·HOUSE·
·SCALE ¼″ = 1′-0″·

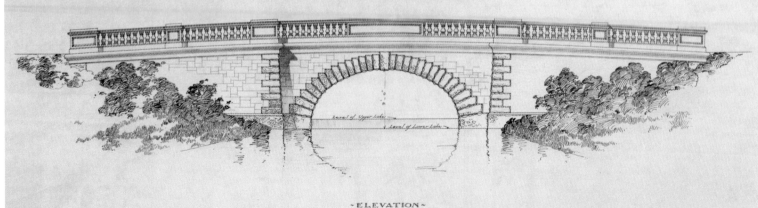

·NEW·YORK·BOTANICAL·GARDEN·
·BRONX·PARK·NEW·YORK·
PLAN·OF·
LAKE BRIDGE
JOHN·R·BRINLEY·OF·BRINLEY·&·HOLBROOK·CONSULTING·ENG·
·SCALE ⅛ INCH EQUALS 1 FT·

Level of Upper Lake
Level of Lower Lake

·ELEVATION·

"AN AMERICAN KEW"

ELIZABETH BARLOW ROGERS

To read original documents detailing the history of a particular landscape is a special experience. Because the institutional records of The New York Botanical Garden—including maps and architectural drawings—have been cataloged and preserved in the LuEsther T. Mertz Library, one can research the creation of its historic landscape and then take a walk through it, exploring the 250 acres, surrounding the grand neoclassical building that houses them. This then-and-now experience is instructive. As a surviving source of original documentation, the Archival Collections of largely unpublished maps, architectural plans, photographs, drawings, and watercolors, along with minutes of early Board meetings, the correspondence of the Garden's primary creator and first director, Nathaniel Lord Britton,

FIG. 11.10. One of the thousands of architectural drawings by Lord & Burnham, this is a design for the Conservatory building and its dome, ca. 1899. The central element of the Conservatory design reaches 90 feet in height and is topped by a decorative cupola. Archives NYBG, Lord & Burnham Collection, fol. 2464.

FIG. 11.11. John R. Brinley's design for a Lake Bridge at the Twin Lakes, dated February 1903, took its cues from the classical Italianate features of the nearby Beaux-Arts Museum building. Archives NYBG, Plan 11.

and files of old newspaper clippings, make possible a step-by-step, year-by-year tour of the construction of buildings and grounds as well as the institution itself—now a designated National Historic Landmark.

The tour on foot reveals the Garden's nineteenth-century origins in a fifty-acre forest remnant—the scenic stretch along the steep Bronx River gorge that originally drew its founders to the site—and through buildings, collections, and display areas created to support the institution's mission as a museum of plants. This inside-outside experience reveals how the site's natural scenery served as the template upon which changes, dictated by programmatic requirements necessary to foster the institution's educational mission, occurred over time. Since most of the Garden's major landscape features were in place by the middle of the twentieth century, this essay will concentrate primarily on the Garden's foundational years.

The story of The New York Botanical Garden is part of a larger story of New York City's cultural history. Its beginnings can be traced to three important, concurrent, motivating impulses: reform humanitarianism, the

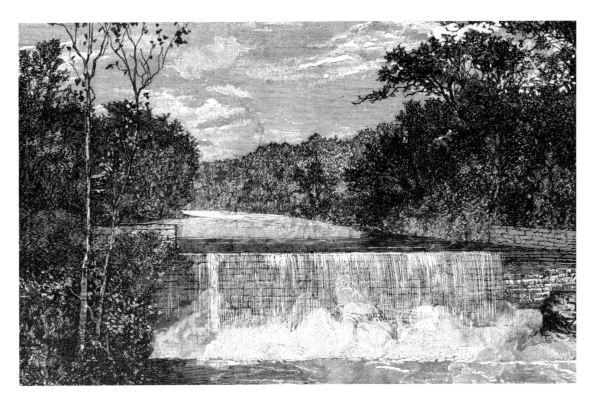

FIG. 11.1. Idyllic river view, "Bronx Park–The Cascade," in John Mullaly, *The New Parks Beyond the Harlem*, New York, 1887, p. 39. This is one of several waterfalls found along the 23-mile length of the Bronx River, New York City's only freshwater river.

beginning of scientific botany as a professional occupation, and Gilded Age civic pride. Specifically, they lie in the nineteenth-century parks-creation movement, which saw the building of Central Park in Manhattan and Prospect Park in Brooklyn; in the scientific and educational programs of the Royal Botanic Gardens, Kew, which in the late eighteenth century established the international model for the collection, display, and study of the world's plants; and in the decision of its founders to build a conservatory to rival that of Kew and a Beaux-Arts Museum building (now home to the Mertz Library) as grand as any of the other late nineteenth-century institutional buildings in New York, including the American Museum of Natural History and the Metropolitan Museum of Art.

In 1881, following the strong evidence confirming the wisdom of those who advocated for Central Park in the early 1850s, a second generation of foresighted citizens formed the New York Park Association, whose mission was to lobby for the creation of an entire system of parkway-linked parks in the Bronx. The association's prime mover was a newspaper reporter and editor, John Mullaly (1835–1915). After three years of contentious wrangling between advocates and opponents, in 1884 Mullaly and his cohorts were successful in their campaign for the enactment by the New York State Legislature of a bill that set aside 3,840 acres of land in a still-undeveloped region between the Long Island Sound and the Hudson River, now the Bronx. Here they envisioned the construction of six new parks—Pelham Bay, Van Cortlandt, Bronx, St. Mary's, Claremont, and Crotona—and three connecting parkways— Mosholu, Bronx River, and Pelham. In 1887, in the wake of this political achievement, Mullaly penned a narrative titled *The New Parks Beyond the Harlem*, in which he described with florid fervor the natural assets and beauties of the individual parks (fig. 11.1).[1] According to him, no extraordinary feats of engineering and design, such as those required by Central Park, would

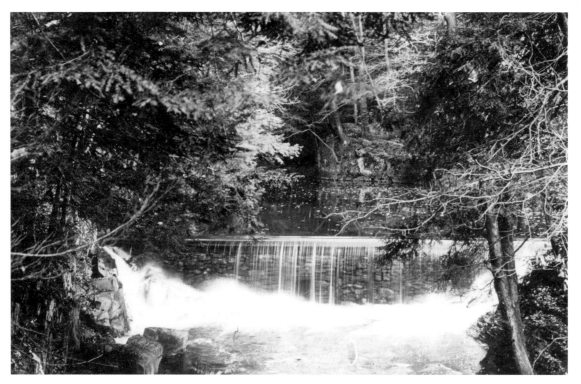

FIG. 11.2 The Bronx River plunges into a cascade over the dam as it winds through the native hemlock grove in this photograph of the Forest dating from the 1890s. This view, which has been preserved, closely corresponds to the print published in John Mullaly, *The New Parks Beyond the Harlem.* Archives NYBG, RG1 Photo Albums.

be necessary, so well-endowed by nature were the park sites already.

When it came to "rare sylvan beauties," Mullaly held that no other park was more lovely than Bronx Park (fig. 11.2), whose "character of scenery is so varied that every step is a surprise and the artist and 'the wayfaring man' might linger there.... The banks [of the Bronx River] rise to the height of fifty, eighty and even ninety feet; in some places abrupt and precipitous, in others easily surmounted. Gigantic trees, centuries old, crown these summits, while great moss and ivy-covered rocks project here and there at different heights above the surface of the river, increasing the wildness of the scene."[2] With its magnificent trees, dramatic topography, exposed bedrock knolls, and scenic river glade, Bronx Park was already a favorite haunt of prominent artists of the day (fig. 11.3).

But Bronx Park was envisioned by Mullaly as more than an artist's haunt. "No better place could be selected for a model botanical garden than Bronx Park," he declared, "and no better use could be made of any of the parks than to make them subserve educational purposes, practical schools of horticulture, zoology, arboriculture, etc., where children could learn without studying, acquire knowledge without opening a book."[3] In short, "a grand botanical garden in the Bronx Park would be the right thing in the right place."[4] According to an article published in 1891 in *The Commercial Advertiser,* an initial $250,000 would be necessary to launch the proposed botanical garden.[5] Happily, by the end of the nineteenth century, New York was home

FIG. 11.3. Sketch from *New York Herald*, March 22, 1891, "Where the Artists Congregate." Bronx resident Edgar Allan Poe found inspiration as he took exercise in long solitary walks and picnicked with his wife beside the Bronx River. Archives NYBG, RG1 Scrapbooks.

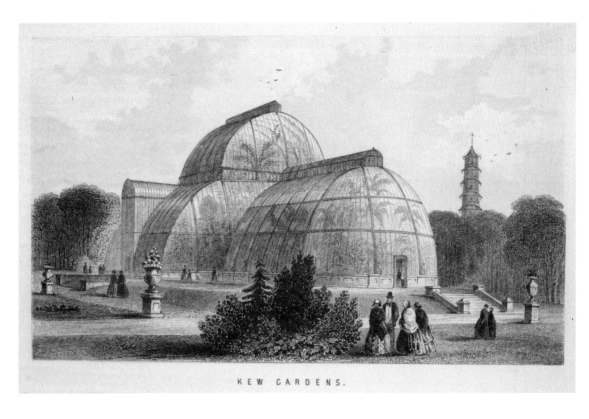

KEW GARDENS.

to some of the country's wealthiest, post-Civil War, industrial and financial magnates, and their philanthropic support of the Garden's beginnings was immediately forthcoming. But civic ambition and money were only part of the equation. A clear vision, combined with the leadership and management skills to realize such an immense project, embracing the building of an institution and the landscape and buildings to carry out its mission, was necessary as well. Fortunately, such a visionary leader was at hand.

Both as an institution and a landscape, much of The New York Botanical Garden as we know it today is the result of the life work of Nathaniel Lord Britton (1859–1934), its first director, who oversaw the Garden's creation and construction from its inception in 1895 until 1929. His wife, Elizabeth Gertrude Knight Britton (1858–1934), a botanical scientist herself and Britton's lifelong research collaborator, was of invaluable assistance in this endeavor. Both Brittons were members of the Torrey Botanical Club (later

called the Torrey Botanical Society), which was started in the 1860s under the aegis and inspiration of renowned botanist John Torrey (1796–1873).

The Brittons, like Andrew Jackson Downing (1815–1852), the well-known Hudson River Valley landscape designer, carried back from their trip through England in 1888 an overwhelming impression of the Royal Botanic Gardens at Kew. Downing, during his visit to Kew thirty-eight years earlier, had expressed nothing but the highest praise for both its grounds and its botanical displays. He not only applauded the way the 200-acre site was divided into a pleasure ground of 140 acres and a 60-acre botanic garden proper,[6] but also admired the enormous recently built Palm House (fig. 11.4).[7] But what had struck him and the Brittons most was the fact that the gardens at Kew were thronged with "a thousand or twelve hundred men, women, and children of all ages,—well dressed, orderly and neat, and examining all with interest and delight."[8]

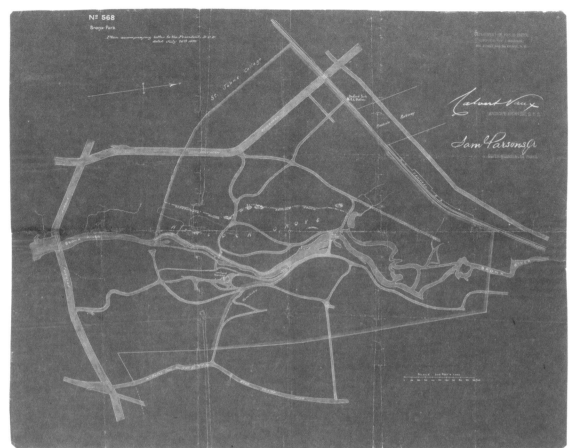

FIG. 11.5. Blueprint dated 1895 of the boundary map signed by Calvert Vaux, Landscape Architect, and Samuel Parsons Jr., Superintendent of Parks, commissioned in July 1895 to survey the proposed site for the Garden and develop its system of driveways. Archives NYBG, Plan 568.

"AN AMERICAN KEW"

Just as the parks of England had served as a competitive stimulus for the creation of New York's initial campaign for public parks, so now the notion of "an American Kew," as the *New York Herald* dubbed The New York Botanical Garden, took shape in the popular imagination.[9] Following Mrs. Britton's glowing description of Kew at a Torrey Botanical Club meeting in October 1888, a committee of the club formed with the purpose of appealing to the Department of Public Parks "for adequate space in one of the city parks, if any individual or organization should provide sufficient means for the establishment of [a botanical] garden." Thanks to the committee's efforts and the press attention they garnered, in 1891 The New York Botanical Garden was incorporated through an act of the state legislature of New York. By 1895 the $250,000 in private subscriptions that had

been mandated by the legislation approving the creation of a 250-acre garden had been raised from twenty-one wealthy men, with major contributions by Andrew Carnegie, J. P. Morgan, J. D. Rockefeller, and Cornelius Vanderbilt II, as well as Columbia College, which considered the Garden from its inception as an allied institution for botanical research. The newly formed Board of Managers appointed Nathaniel Lord Britton as secretary and director-in-chief of the Garden. In May 1895, Britton selected 250 picturesque acres within Bronx Park as the home for America's Kew.[10]

As New York City's foremost landscape architects and consultants to the Office of Public Parks, Calvert Vaux (1824–1895)—former partner of Frederick Law Olmsted (1822–1903)—and Samuel Parsons Jr. (1844–1929), both actively involved with the creation and development

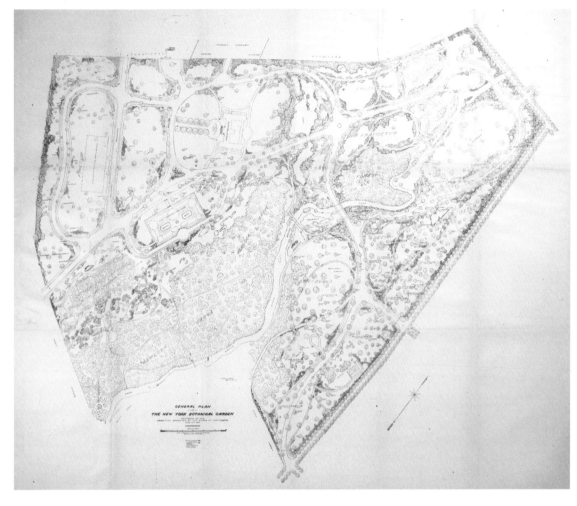

FIG. 11.6. General Plan of The New York Botanical Garden, 1896. Lithograph after the original plan by John Rowland Brinley. Drawn up by the Development Committee to present their ideas to Board members, this is the Garden's first detailed survey map, accompanying its first *Bulletin*. Archives NYBG, Map 151.

THE LANDSCAPE OF
THE NEW YORK
BOTANICAL GARDEN

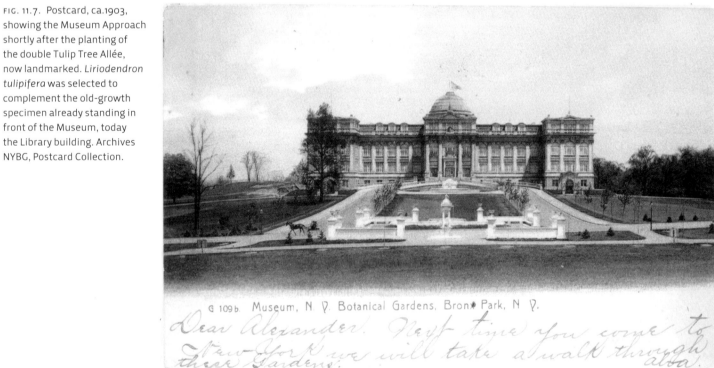

FIG. 11.7. Postcard, ca.1903, showing the Museum Approach shortly after the planting of the double Tulip Tree Allée, now landmarked. *Liriodendron tulipifera* was selected to complement the old-growth specimen already standing in front of the Museum, today the Library building. Archives NYBG, Postcard Collection.

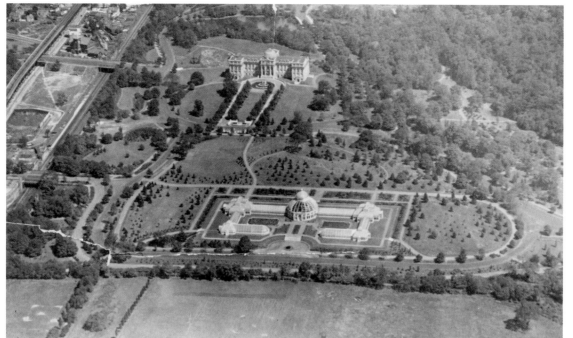

of Central Park,[11] were logical authorities to reconnoiter the site, together with Britton and the subcommittee formed to plan the Garden's layout. The boundaries selected by consensus encompassed the northern and most scenic part of Bronx Park, and a map signed by Vaux and Parsons shows the selected site along with existing buildings and abutting and interior roads (fig. 11.5). According to the board minutes of December 6, 1895, at a meeting held in the office of Cornelius Vanderbilt, "the subcommittee was given authority to consult Mr. F. L. Olmsted or other landscape engineers."[12] Olmsted was by this time in ill health. The board therefore turned to John Rowland Brinley (1861–1946), a civil and landscape engineer who had formerly worked on a surveying project with Olmsted's sons, Fredrick Law Olmsted Jr. (1870–1957) and John Charles Olmsted (1852–1920), the inheritors of their father's practice. Brinley was also an independent designer of several municipal parks and private estates, and as a talented watercolorist, he was able to give artistic expression to his renderings

of both current and anticipated projects.[13] He would remain the Garden's primary landscape consultant for the next thirty-six years.

Hand in hand with the building of The New York Botanical Garden as a world-class institution came the improvement of the grounds and the construction of the museum, conservatory, greenhouses, and other horticultural facilities necessary for botanical education and display. These projects were realized in accordance with the official General Plan (fig. 11.6) prepared in 1896 by Brinley, in conjunction with Parsons; head gardener Samuel Henshaw; Lucien Underwood, a professor on the Board of Scientific Directors at Columbia College; architect Robert W. Gibson; and Lincoln Pierson, a representative of the Lord & Burnham firm.[14]

Recognizing the great beauty and educational value of the natural features of the landscape, Brinley's plan preserved in its entirety the forest that Mullaly had so enthusiastically described. Moreover, the roads and paths were carefully routed around the venerable native trees in the orchards and pastures that surrounded

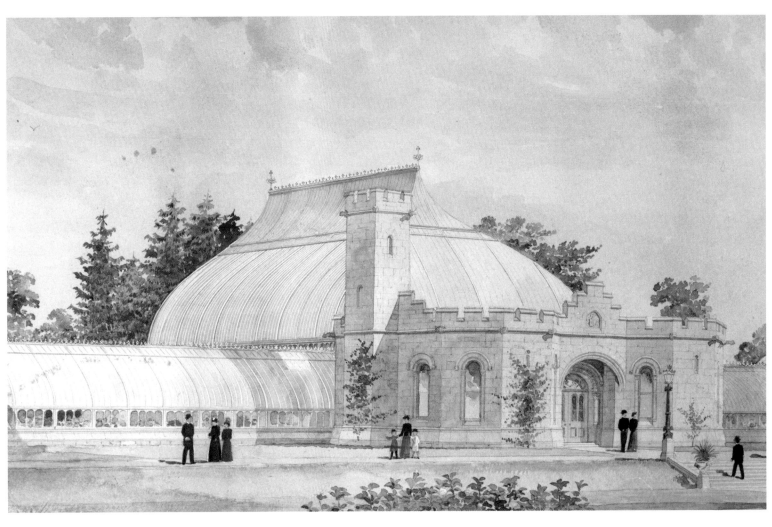

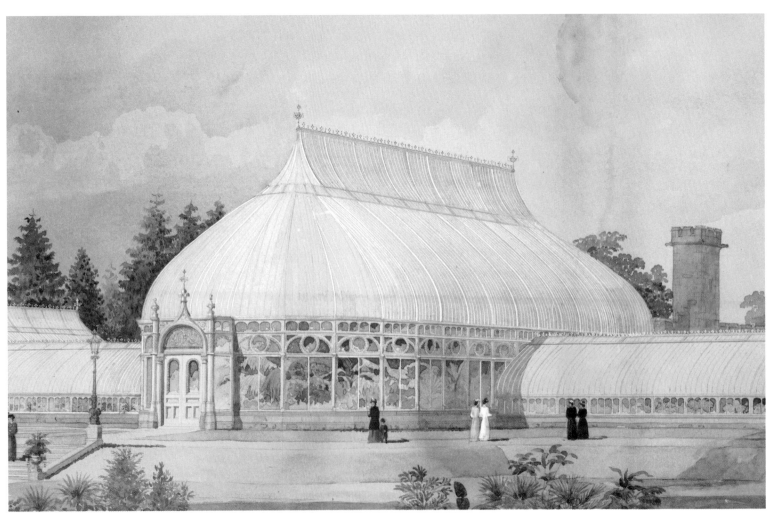

this natural woodland. The construction of the circuit of drives of crushed stone and gravel along the route originally proposed by Calvert Vaux and Samuel Parsons Jr. and the planting of the curated plant collections progressed year by year. Since glacier-scoured Bronx Park had only a thin soil cover, topsoil had to be imported in great quantities to insure an adequate depth for tree roots and to also make possible the grading of the ground's surface into a pleasing topography of gentle swells. By 1900 head gardener George Nash and the laborers working under him had established eight separate plantations in the Garden. In accordance with the 1896 plan, each held a different plant collection. Groupings included beds for herbaceous plants, a fruticetum for shrubs, a salicetum for the cultivation of willows and poplars, a viticetum for vines, and a pinetum for coniferous trees.

In 1897 ground was broken for Robert W. Gibson's Museum building.[15] In keeping with its neoclassical symmetry, a few years later the Tulip Tree Allée was planted on axis with the main entrance (fig. 11.7). The grandest element in the Garden's overall landscape (fig. 11.8), however—at once both educational and monumental—was the Conservatory designed by Lord & Burnham. Much to the satisfaction of the Garden's founders, it was a cynosure that did in fact rival the great Palm House at Kew. Several impressive presentation watercolors—among the more than 200,000 sheets of architectural plans in the Library's Lord & Burnham Collection—depict versions of the ambitious design (fig. 11.9 A–B). In 1899, after

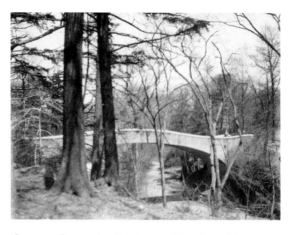

"AN AMERICAN KEW"

the one chosen by Britton and the board had been approved, construction began on a site that allowed the Conservatory's huge dome—the Garden's icon to this day—to be clearly visible from the main entrance (fig. 11.10, see p. 266). With nearly an acre under glass, this structure, the most sizable ever built by the firm, remains the largest nineteenth-century conservatory in the Americas.

In the early decades of the twentieth century, construction of other garden structures continued, among which the handsome, Italianate Lake Bridge at the Twin Lakes (fig. 11.11 , see p. 266),[16] and the elegant High Bridge spanning the Bronx River (fig. 11.12), are the most notable examples. The acquisition of 140 acres of adjacent public parkland in 1915 increased the size of the Garden's campus; the parcel included a mill,[17] stables, mansion, and other nineteenth-century structures built by the Lorillard family. The additional land made it possible for the board to commission landscape architect Beatrix Jones Farrand (1872–1959) to design a one-acre, triangular-shaped rose garden, with 139 beds divided by radial paths, emanating from a central roundel with an elegant, wrought-iron gazebo (fig. 11.13).[18] Just as Brinley's plan for the grand allée of tulip trees added a neoclassical design element that was in harmony with the adjacent naturalistic landscape, Farrand achieved the same result by

FIG. 11.9 A–B. Large watercolor renderings by Lord & Burnham, showing various design proposals for the Conservatory building, ca. 1899. One of the design proposals featured Gothic Revival elements, perhaps to complement the nearby Fordham University structures. Archives NYBG, Lord & Burnham Collection.

placing the Rose Garden in a valley surrounded by wooded slopes. Obtaining Board approval for Farrand's plan of the Rose Garden was one thing; underwriting its cost was another. Helped by the Women's Auxiliary Committee and Farrand's own cordial relationships with wealthy individuals, generous support was soon forthcoming for the Rose Garden's construction—a long-term project, however, that was not fully realized until the 1980s.[19]

Assisted by Louis F. Bird, another talented watercolorist, Brinley prepared a set of forty-one watercolor paintings representing the as-yet-unbuilt structures in the Garden. These beautiful renderings were displayed at a reception at Knoedler's Art Galleries in New York City on February 16, 1918, and later reproduced as hand-colored photographic images in an album titled "Structures designed for further development of The New York Botanical Garden in Bronx Park." Annotations in the album specifying the costs of various features, such as an Orchid Greenhouse for which Daniel and Murray Guggenheim contributed $25,000, and the impressive Rose Garden Stairway, for which Mrs. Robert E. Westcott donated the required $2,000 (fig. 11.14),[20] show that Britton quickly grasped how this approach to raising funds could aid his ambitious program of adorning other parts of the Garden with handsome gates, bridges, fountains, and garden shelters.

Photographs from the Library's Collections from the early 1920s show the Garden's landscape after a quarter century of growth and change. Brinley and Britton's evolving plan for this now thriving cultural landscape was developed under the director's firm guidance. Its primary aim was to support the institution's educational purposes and at the same time to allow the Garden to continue to serve as a public pleasure ground. By this time its fundamental

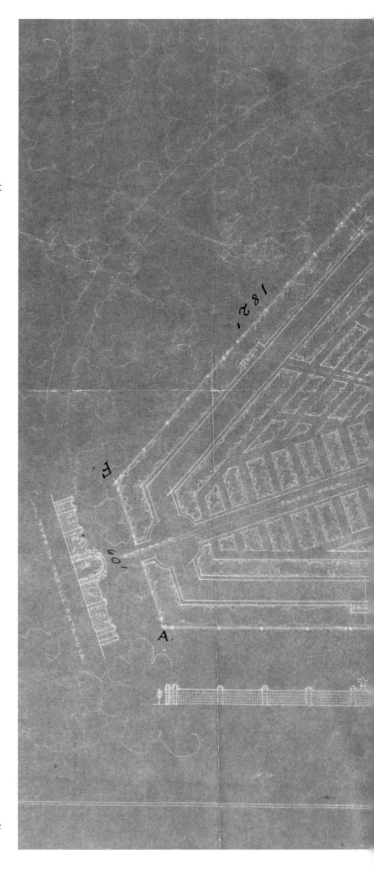

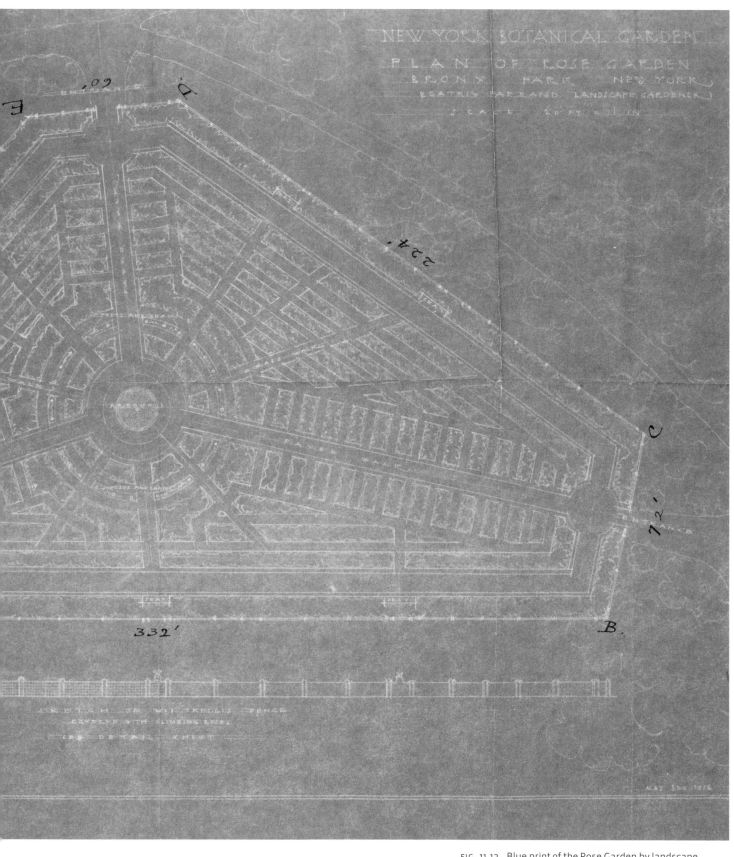

FIG. 11.13. Blue print of the Rose Garden by landscape architect Beatrix Jones Farrand, 1916, showing the unusual triangular form of the garden with its central circle, proposed pattern of paths, and arrangement of rose beds. Archives NYBG, Plan 432.

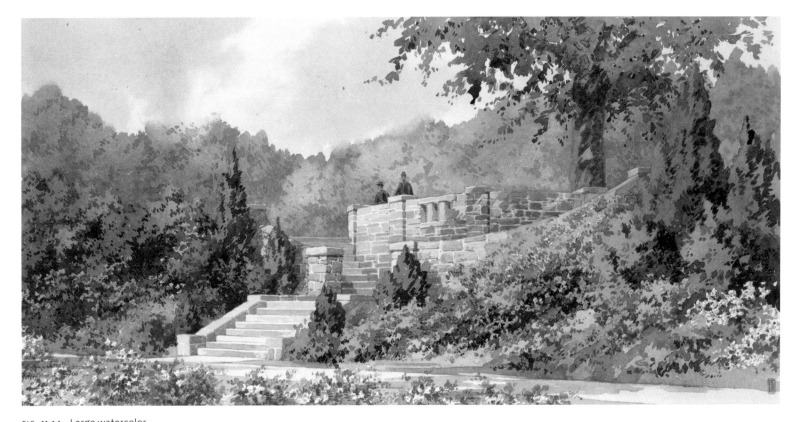

FIG. 11.14. Large watercolor rendering for the Rose Garden Stairway by Brinley and Holbrook, ca. 1916. Taking advantage of the sloping topography and the wooded and rocky surroundings, the steps would provide a grand entrance and offer views over the entire Rose Garden. Art and Illustration Collection, 12–44.

outlines had been filled in by maturing plant species, notably the straight allée of tulip trees in front of the neoclassical Museum, the spruces and firs of the pinetum grounding the iconic glass dome of the Conservatory, and the then still thriving hemlocks amid the wild scenery along the Bronx River that the Garden's founders had so admired and sought to preserve.

By 1923 the Garden had grown to 400 acres. It seemed appropriate therefore to review and possibly revise the original plan. Seeking the advice of the country's most prominent landscape architect, Frederick Law Olmsted Jr., the Board hired the firm of Olmsted Brothers to prepare a comprehensive report (fig. 11.15).[21] The resulting document focused on a circulation plan that would provide better access to the entire landscape. It also offered suggestions for improving the horticultural care of the Garden's collections and displays. Britton approved the report's recommendations regarding circulation within the Garden, but did not subscribe to the recommendation of rerouting the through traffic because, according to his response to the report,

"The roads are crowded by motor-cars during only a very small part of the time, estimated at not more than 200 hours during the year."[22] In the wake of the Olmsted Report, a great deal of landscape renovation and enhancement took place, and Brinley designed additional entrances, stairways, and bridges.[23]

Following the retirement of both Britton and Brinley in 1930, a period of transition ensued. In 1937, with the expansion of the Bronx River Parkway original shrub, vine, and willow collections were lost. During the following decades—in spite of the Great Depression and World War II—amateur gardening thrived. With organizations such as the Horticultural Society of New York and the Garden Club of America on the scene, the Garden became more than ever a botanical showcase and a key horticultural learning center for the home gardener. Flower collections expanded, and Flower Days, featuring single-genera gardens, attracted numerous visitors. In 1932 a Ladies' Border—a mixed planting of seasonally blooming bulbs, perennials, shrubs, and small

FIG. 11.15. "Guide Map New York Botanical Garden" by the Olmsted Brothers, addressing circulation, traffic, and maintenance issues in the Garden. Plan accompanying the *Report on The New York Botanical Garden*, New York, 1924.

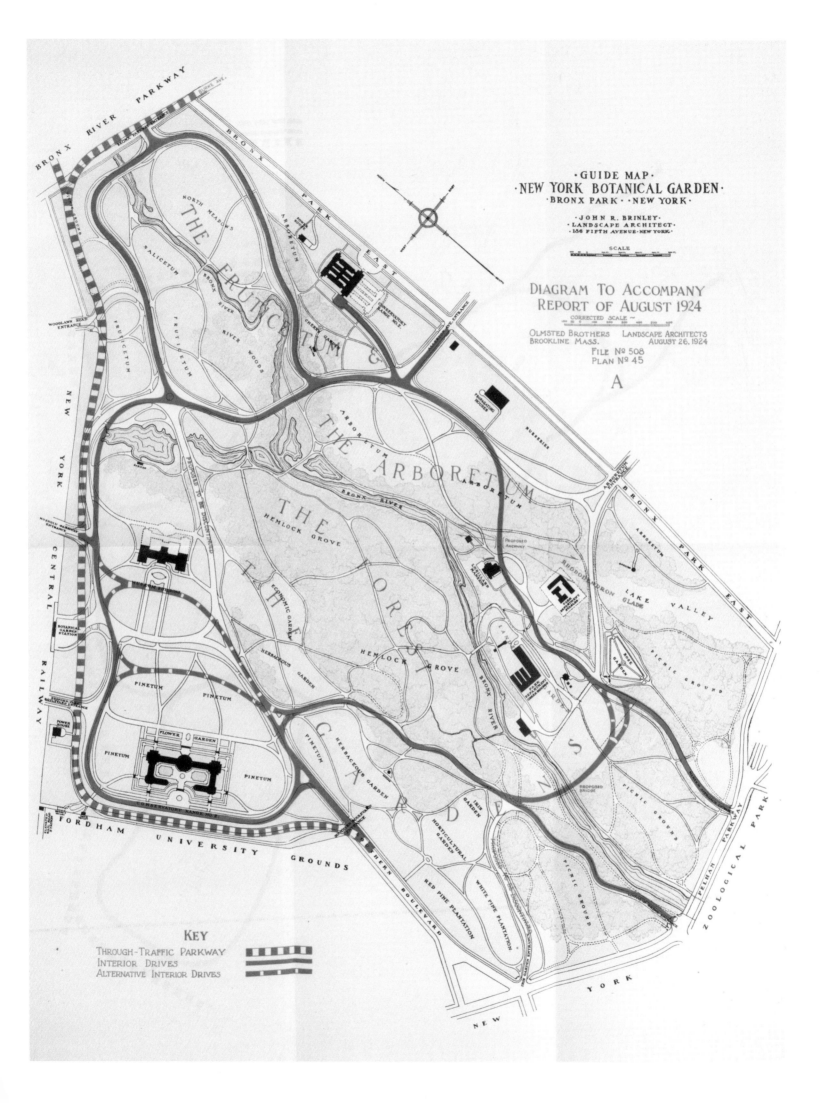

· GUIDE MAP ·
· NEW YORK BOTANICAL GARDEN ·
· BRONX PARK · NEW YORK ·

· JOHN R. BRINLEY ·
· LANDSCAPE ARCHITECT ·
· 156 FIFTH AVENUE · NEW YORK ·

SCALE

DIAGRAM TO ACCOMPANY
REPORT OF AUGUST 1924
~ CORRECTED SCALE ~

OLMSTED BROTHERS LANDSCAPE ARCHITECTS
BROOKLINE MASS. AUGUST 26, 1924
FILE Nº 508
PLAN Nº 45

A

KEY
THROUGH-TRAFFIC PARKWAY
INTERIOR DRIVES
ALTERNATIVE INTERIOR DRIVES

Section C — Bulb Planting Plan, Scale ¼"=1'-0"

Section C — Perennial Planting Plan, Scale ¼"=1'-0"

Section C — Shrub Planting Plan, Scale ¼"=1'-0"

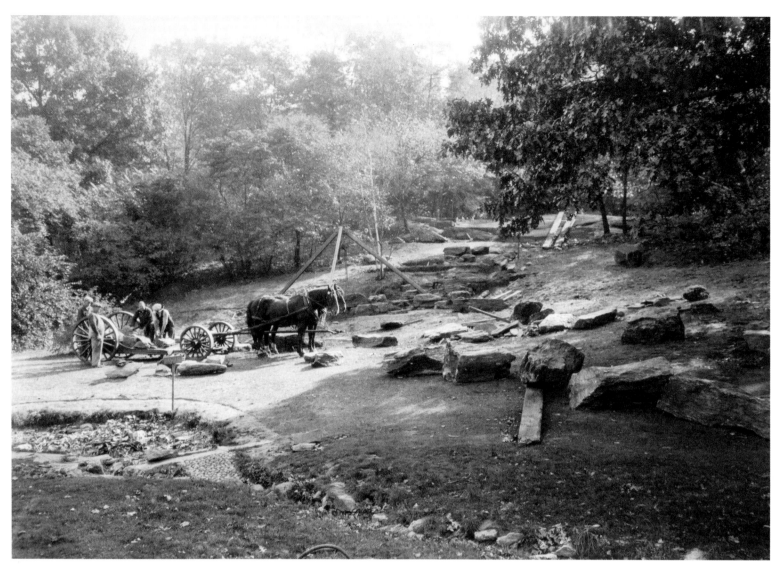

FIG. 11.17. A photograph
made during summer 1933,
showing the construction
of the Rock Garden. Designed
by Thomas H. Everett,
its creation involved
tremendous labor in moving
and positioning large rocks
from other parts of the
Garden grounds. Archives
NYBG, RG1 Photo Albums.

trees—was created along the southeast side
of the Conservatory by Ellen Biddle Shipman
(1869–1950), then considered the doyenne of
female landscape architects (fig. 11.16).[24] The
same year British-born horticulturist and
longtime member of the Garden staff Thomas H.
Everett (1903–1986) designed a new rock garden
(fig. 11.17).[25] This garden was followed a decade
later by the installation of the Montgomery
Conifer Collection (now the Benenson
Ornamental Conifers), designed by landscape
architect Marian Cruger Coffin (1876–1957), who
also designed improvements to the adjacent
Lilac Grove.[26]

In summary, the rich trove of documentation
found in the Mertz Library chronicles the
creation of The New York Botanical Garden,
showing how its existence is due to a propitious
constellation of forces—available land, capital
resources, and visionary leadership. Today the
Garden is recognized as a National Historic
Landmark because of its outstanding landscape
features and fine neoclassical architecture. Thus
have the decisions and actions of its founders
and their successors have been responsible for
perpetuating this extraordinary achievement,
fulfilling the original objective of creating "an
American Kew."

FIG. 11.16. Various designs for a 260-foot-long Ladies'
Border by Ellen Biddle Shipman, 1932. These plans for
the Garden's first hardy perennial border were carefully
detailed, dividing the border into four distinct interrelated
sections. Archives NYBG, Plan 397.

ENDNOTES

1. On the title page of *New Parks Beyond the Harlem* (New York: Record & Guide, 1887), Mullaly describes a host of recreational uses the new parks could accommodate: "a parade ground, a rifle range, baseball, lacrosse, polo, tennis and all athletic games; picnic and excursion parties and nine miles of waterfront for bathing fishing, yachting, rowing."

2. Mullaly, *New Parks*, 63.

3. Mullaly, *New Parks*, 67.

4. Mullaly, *New Parks*, 69.

5. *The Commercial Advertiser*, Thursday April 30, 1891: "Strive To Raise 250.000 For A Great Institution... An Instructive Resort That Will Be Open Sundays." Archives NYBG, RG1 Scrapbooks.

6. Andrew Jackson Downing, *Rural Essays* (New York: Leavitt & Allen, 1856), 486.

7. Downing, *Rural Essays*, 487. "A palace of glass—362 feet in length, and 66 feet high—and fairy-like and elegant in proportions, though of great strength; for the whole, framework and sashes, is of cast iron, glazed with 35,000 feet of glass."

8. Downing, *Rural Essays*, 489.

9. See *New York Herald*, March. 22, 1891, referring to NYBG as "AN AMERICAN KEW." And *New York World*, February 27, 1891: "New York may have a rival for London's Kew Gardens." Archives NYBG, RG1 Scrapbooks.

10. Peter Mickulas, *Britton's Botanical Empire: The New York Botanical Garden and American Botany, 1888–1929* (Bronx, NY: New York Botanical Garden, 2007), 77–78.

11. The Mertz Library has documents pertaining to the early development of Central Park, including a *Map of the Central Park: Showing the Progress of the Work up to January 1st 1860 / Frederick Law Olmsted Architect in Chief; Calvert Vaux Consulting Architect* (New York, NY: Sarony, Major & Knapp, [1860]).

12. Compare also comments in newspapers, including the *New York Tribune*, Dec. 20, 1891: "Proposed Botanic Garden. New York's Magnificent Opportunity. Everything but Funds Favorable—What Should be Done. A Talk with Ex-chief Justice Daly." Archives NYBG, RG1 Scrapbooks.

13. With a partner, John Holbrook, Brinley had set up a private landscape design practice known as Brinley and Holbrook.

14. Mickulas, *Britton's Botanical Empire*, 79.

15. Brinley and Holbrook made a large watercolor rendering of this building. Art and Illustration Collection, 12.

16. John R. Brinley, Design for Twin Lake Bridge, Feb. 1903. Archives NYBG, Plan 11.

17. The Stone Mill, recently restored by the Garden, is an important early industrial building and was named a National Historic Landmark in 1976. It was used to grind tobacco leaves into snuff.

18. Beatrix Jones Farrand, Design for the Rose Garden, 1916. The design was inspired by the layout of the *Roseraie* at l'Haÿ-les Roses near Paris. For a plan of this garden, see *Les Roses cultivées à l'Haÿ en 1902: Essai de classement, avant-propos de André Theuriet, aquarelles et dessins de S. Huggard* (Paris: Rousset, 1902). Archives NYBG, Plan 432.

19. Letter from Beatrix Jones Farrand to Nathaniel Lord Britton, dated May 12, 1916. Britton Records. In this letter, Farrand forwards her own fundraising suggestion, writing to Britton: "What do you think of getting estimates in separate sections, so that they could be tabulated and dangled before prospective subscribers?" Archives NYBG, RG3.

20. Brinley and Holbrook, Large watercolor design for the Rose Garden Stairway. Art and Illustration Collection, 12–44.

21. *Report on The New York Botanical Garden by Olmsted Brothers, 1924*. The report is accompanied by a plan, entitled "Guide Map New York Botanical Garden, Bronx Park, New York," with the subtitle "Diagram to accompany the Report on The New York Botanical Garden, Bronx Park, New York, 1924."

22. Letter by Nathaniel Lord Britton to F. S. Lee, dated September 4, 1924. Archives NYBG, RG3, Britton Records.

23. Brinley and Holbrook made, for example, an impressive watercolor design for Hemlock Grove Bridge. Art and Illustration Collection, 12–45.

24. Ellen Shipman's design for the Ladies' Border, 1932, shows how several layers of flowers and shrubs are to be planted for colorful displays. It was situated along the southeast side of the Conservatory building. Archives NYBG, Plan 397.

25. Everett, who rose from head gardener to senior curator of education and senior horticulture specialist between 1932 and 1968, was the editor of the ten-volume *The New York Botanical Garden Illustrated Encyclopedia of Horticulture*, published by the Garden in 1980–1982.

26. Marian Cruger Coffin, design for Montgomery Conifer Collection, 1947. Archives NYBG, Plan 162.

SELECTED
BIBLIOGRAPHY

ANDERSON, FRANK J. *An Illustrated History of the Herbals.* New York: Columbia University Press, 1977.

———. *Herbals through 1500. The Illustrated Bartsch,* vol. 90. New York: Abaris Books, 1984.

ARBER, AGNES. *Herbals: Their Origin and Evolution: A Chapter in the History of Botany 1470–1670.* Cambridge: Cambridge University Press, 1986.

BAATZ, SIMON. *Knowledge, Culture and Science in the Metropolis: The New York Academy of Sciences 1817–1970.* New York: New York Academy of Sciences, 1990.

BARKER, NICOLAS. *Hortus Eystettensis, The Bishop's Garden and Besler's Magnificent Book.* New York: Harry N. Abrams, 1994.

BAUMANN, B., H. BAUMANN, AND S. BAUMANN-SCHLEIHAUF. *Die Kräuterbuchhandschrift des Leonhart Fuchs.* Stuttgart: Ulmer, 2001.

BLUNT, WILFRID. *The Compleat Naturalist: A Life of Linnaeus*; Introduction by William T. Stearn. London: Collins, 1971, and 2nd Edition, London: Frances Lincoln, 2001.

BLUNT, WILFRID, AND WILLIAM T. STEARN. *The Art of Botanical Illustration.* Woodbridge, Suffolk: Antique Collectors' Club; London: In association with the Royal Botanic Gardens, Kew, 1994.

BRIDSON, GAVIN D.R., AND DONALD E. WENDEL. *Printmaking in the Service of Botany: 21 April to 31 July 1986, Catalogue of an Exhibition.* Pittsburgh, PA: Hunt Institute for Botanical Documentation, 1986.

BRITTON, NATHANIEL LORD. *History of The New York Botanical Garden.* Bronx, NY: The Garden, 1915.

Bulletin of The New York Botanical Garden. Published for the Garden by the New Era Printing Company, 1896–1932.

CALLERY, BERNADETTE G. "Collecting Collections: Building the Library of The New York Botanical Garden," *Brittonia* 47, no. 1 (1995): 44–56.

CARAUTA, J.P.P. "The Text of Vellozo's Flora Fluminensis and its Effective Date of Publication." *Taxon* 22 (1973): 281–284.

CLAYTON, VIRGINIA TUTTLE. *Gardens on Paper: Prints and Drawings, 1200–1900.* Washington, DC: National Gallery of Art; Philadelphia: Distributed by the University of Pennsylvania Press, 1990.

CLEVELAND, H.W.S. *Landscape Architecture: As Applied to the Wants of the West.* Chicago: Jansen, McClurg, & Co., 1873.

COFFIN, DAVID. *Magnificent Buildings, Splendid Gardens.* Vanessa Bezemer Sellers, ed. Princeton: Princeton University Press, 2008.

CONAN, MICHEL, AND W. JOHN KRESS, EDS. *Botanical Progress, Horticultural Innovations and Cultural Changes.* Washington, DC: Dumbarton Oaks, 2007.

DAIN, PHYLLIS. *The New York Public Library: A History of its Founding and Early Years.* New York: The New York Public Library, 1972.

DESMOND, RAY. *Kew: The History of the Royal Botanic Gardens.* London: Harvill Press, 1995.

DORR, LAURENCE, AND DAN NICOLSON. *Taxonomic Literature: a Selective Guide to Botanical Publications and Collections with Dates, Commentaries and Types.* Supplements 7 and 8. A.R.G. Gantner Verlag, 2008; 2009.

DOWNING, A.J. *Cottage Residences.* New York and London: Wiley and Putnam, 1842.

———. *The Fruits and Fruit-Trees of America.* New York and London: Wiley and Putnam, 1845.

—. *A Treatise on the Theory and Practice of Landscape Gardening, Adapted to North America.* New York and London: Wiley and Putnam, 1841; Boston: C. C. Little and Company, 1841.

EGMOND, FLORIKE. *The World of Carolus Clusius: Natural History in the Making, 1550–1610.* London; Brookfield, VT: Pickering & Chatto, 2010.

EGMOND, FLORIKE, PAUL HOFTIJZER, AND ROBERT VISSER, EDS. *Carolus Clusius, Towards a Cultural History of a Renaissance Naturalist.* Amsterdam: Koninklijke Nederlandse Akademie van Wetenschappen, 2007.

EHRLICH, TRACY L. *Landscape and Identity in Early Modern Rome: Villa Culture at Frascati in the Borghese Era.* Cambridge: Cambridge University Press, 2002.

ELIOT, CHARLES WILLIAM. *Charles Eliot: Landscape Architect.* Boston and New York: Houghton, Mifflin and Company; Cambridge: The Riverside Press, 1902.

ELLIOTT, F.R. *Hand Book of Practical Landscape Gardening Designed for City and Suburban Residences.* Rochester, NY: D. M. Dewey, 1881.

EUSTIS, ELIZABETH S. *European Pleasure Gardens: Rare Books and Prints of Historic Landscape Design from the Elizabeth K. Reilley Collection.* Bronx, NY: The New York Botanical Garden, 2003.

FESSENDEN, THOMAS G. *The New American Gardener.* Boston: J. B. Russell, 1828.

FITZPATRICK, JOHN T. "An Overview of American Nursery and Seed Catalogues, 1771–1832." In Peter Benes, ed. *Plants and People.* The Dublin Seminar for New England Folklife, Annual Proceedings, 1995. Boston: Boston University, 1996, 152–162.

FORZZA, R.C., ET AL., EDS. *Catálogo de plantas e fungos do Brasil,* 1–2. Rio de Janeiro: Jardim Botânico do Rio De Janeiro, Andrea Jakobsson Estudio, 2010.

FRASER, SUSAN. "The Genius of Georg Ehret: His Art and Influence." *The Botanical Artist* 15, no. 1 (2009): 22; 26.

FRYBERGER, BETSY G. *The Changing Garden.* Berkeley, Los Angeles, and London: University of California Press, 2003.

GIVENS, JEAN A., KAREN M. REEDS, AND ALAIN TOUWAIDE, EDS. *Visualizing Medieval Medicine and Natural History, 1200–1550.* Aldershot, England; Burlington, VT: Ashgate, 2006.

GRANDVILLE, J.J. *The Flowers Personified: Being a Translation of Grandville's "Les Fleurs Animées."* Translated by N. Cleaveland. New York: R. Martin, 1849.

HALEY, JACQUETTA M., ED. *Pleasure Grounds: Andrew Jackson Downing and Montgomery Place.* Tarrytown, NY: Sleepy Hollow Press, 1988.

HAWTHORNE, JULIAN. *An American Kew.* Philadelphia: J.B. Lippincott, 1891.

HEDRICK, ULYSSES P. *History of Horticulture in America to 1860.* Revised edition with an addendum by Elisabeth Woodburn of books published from 1861–1902. Portland, OR: Timber Press, 1988.

HELLER, JOHN, L. "Linnaeus on Sumptuous Books." *Taxon* 25, no. 1 (Feb. 1976), 33–52.

HENREY, BLANCHE. *British Botanical and Horticultural Literature Before 1800: Comprising a History and Bibliography of Botanical and Horticultural Books Printed in England, Scotland, and Ireland from the Earliest Times until 1800.* London: Oxford University Press, 1975.

HIBBERD, SHIRLEY. *Familiar Garden Flowers,* 5 vols. London, Paris, New York, Toronto, and Melbourne: Cassell and Company, 1879–1887.

—. *Rustic Adornments for Homes of Taste.* London: Groombridge and Sons, 1856.

HORBLIT, HARRISON D. *One Hundred Books Famous in Science.* New York: Grolier Club, 1964.

IBÁÑEZ MONTOYA, M.V. *La expedición Malaspina.* Tomo 4, Trabajos científicos y correspondencia de Tadeo Haenke. Madrid : Ministerio de Defensa: Museo Naval: Lunwerg Ed., 1992.

JANICK, J., AND G. CANEVA. "The First Images of Maize in Europe." *Maydica* 50, no. 1 (2005): 71–80.

JARVIS, CHARLIE E. *Order Out of Chaos: Linnaean Plant Names and Their Types.* London: Linnean Society of London in Association with the Natural History Museum, London, 2007.

JAY, ROBERT. *The Trade Card in Nineteenth-Century America.* Columbia, MO: University of Missouri Press, 1987.

JOHNSTON, STANLEY H. *The Cleveland Herbal, Botanical, and Horticultural Collections: a Descriptive Bibliography of pre-1830 Works from the Libraries of the Holden Arboretum, the Cleveland Medical Library Association, and the Garden Center of Greater Cleveland.* Kent, OH: Kent State University Press, 1992.

Journal of The New York Botanical Garden. Bronx, NY: The New York Botanical Garden, 1900–1950.

KABELAC, KARL SANFORD. "Nineteenth-Century Rochester Fruit and Flower Plates" *University of Rochester Library Bulletin* 35 (1982): 93–113.

KALWA, E. "Alexander von Humboldt, die Entdeckungsgeschichte Brasiliens und die brasilianische Geschichtsschreibung des 19. Jahrhunderts." In M. Zeuske and B. Schröter, eds. *Alexander von Humboldt und das neue Geschichtsbild von Lateinamerika,* Leipzig: Leipziger Universitätsverlag, 1992, 61–79.

KELLEY, THERESA M. *Clandestine Marriage: Botany and Romantic Culture.* Baltimore: The Johns Hopkins University Press, 2012.

Selected Bibliography

KEVLES, DANIEL J. "Fruit Nationalism—Horticulture in the United States from the Revolution to the First Centennial." In Marco Beretta et al, eds. *Aurora Torealis*. Sagamore Beach, MA: Science History Publications, 2008, 129–146.

———. "How to Trademark a Fruit." *Smithsonian Magazine* (August 2011): http://www.smithsonianmag.com/arts-culture/How-to-Trademark-a-Fruit.html

KINGSLAND, SHARON. *The Evolution of American Ecology, 1890–2000*. Baltimore: The Johns Hopkins University Press, 2005.

KNIGHT, LEAH. *Of Books and Botany in Early Modern England: Sixteenth-Century Plants and Print Culture*. Farnham, England and Burlington, VT: Ashgate, 2009.

KRAUS, MICHAEL. "Entdeckung und Kolonialisierung Brasiliens." In Michael Kraus and Hans. Ottomeyer, eds. *Novos Mundos—Neue Welten: Portugal und das Zeitalter der Entdeckungen*. Berlin/Dresden: Sandstein-Verlag, 2007, 115–127.

KURY, L., AND M.R. SÁ. "Flora brasileira, um percurso histórico." In A.C.I. Martins, ed. *Flora Brasileira: história, arte & ciência*. Rio de Janeiro: Casa da Palavra, 2009.

KUSUKAWA, SACHIKO. "Uses of Pictures in Printed Books: The Case of Clusius' *Exoticorum Libri Decem*." In Florike Egmond et al, eds. *Carolus Clusius. Towards a Cultural History of a Renaissance Naturalist*. Amsterdam: Koninklijke Akademie van Wetenschappen, 2007.

LACK, H. WALTER. *Alexander von Humboldt und die botanische Erforschung Amerikas*. Munich and New York: Prestel, 2009.

———. *Carl Friedrich Philipp von Martius. The Book of Palms—Das Buch der Palmen—Le Livre des palmiers*. Cologne: Taschen, 2010.

———. *Florilegium Imperiale: Botanical Illustrations for Francis I of Austria*. Munich: Prestel, 2006.

———. *Garden Eden: Masterpieces of Botanical Illustration*. Cologne and New York: Taschen, 2001.

———. *Jardin de la Malmaison: Empress Josephine's Garden*. Munich: Prestel, 2004.

———. "August Wilhelm Eichler (1839–1887)." *Willdenowia* 18, no. 1 (1988): 5–18.

———. "The Discovery, Naming and Typification of *Bougainvillea spectabilis* (Nyctaginaceae)." *Willdenowia* 42, no. 1 (2010): 117–126.

———. "Pohls Plantarum Brasiliae icones et descriptions." *Zandera* 1, no. 1 (1982): 3–7; no. 2 (1982): 13–20.

LAIRD, MARK. *The Flowering of the Landscape Garden: English Pleasure Grounds, 1720–1800*. Philadelphia: University of Pennsylvania Press, 1999.

———. *A Natural History of English Gardening, 1650–1800*. New Haven and London: Yale University Press, 2015.

———. "Plantings." In Sonja Dümpelmann, ed. *A Cultural History of Gardens*. Vol. 5: *A Cultural History of Gardens in the Age of Empire*. London: Bloomsbury, 2013, 69–89.

LAST, JAY T. *The Color Explosion*. Santa Ana, CA: Hillcrest Press, 2005.

LAZARUS, MAUREEN H., AND HEATHER S. PARDOE. "Bute's Botanical Tables: Dictated by Nature." *Archives of Natural History* 36, part 2 (2009): 277–298.

LESLIE, MICHAEL, AND JOHN DIXON HUNT, EDS. *A Cultural History of Gardens*. 6 vols. London: Bloomsbury, 2013.

LINDLEY, JOHN. *Ladies' Botany, or, A Familiar Introduction to the Study of the Natural System of Botany*. London: J. Ridgway, 1834–1837.

LINDORF, H. "Notices on the Austrian Expedition in a Venezuelan Document Dated 1787 and Comments on Botanical Names Linked to the Collections." *Acta Botanica Venezuelica*, no. 1 (2004): 57–64.

LINNÉ, CARL VON. *Linnaeus' Philosophia botanica*. Translated by Stephen Freer. Oxford and New York: Oxford University Press, 2005.

———. *Musa Cliffortiana: Clifford's Banana Plant*. Translated by Stephen Freer. Introduction by Staffan Müller-Wille. Ruggell, Liechtenstein: Published for IAPT by A.R.G. Ganter; Königstein, Germany: Distributed by Koeltz, 2007.

———. *Species plantarum*. A facsimile of the 1st ed., 1753. Vol. 1. With an Introduction by W.T. Stearn and a Supplement to the Introduction by C.E. Jarvis. London: Printed for the Ray Society, 2013.

———. *Species plantarum*. A facsimile of the 1st ed., 1753. Vol. 2. With a Supplement by C.E. Jarvis to the Appendix by J.L. Heller and W.T. Stearn. London: Printed for the Ray Society, 2013.

LONG, GREGORY, AND ANNE SKILLION, EDS. *The New York Botanical Garden*. New York: Harry N. Abrams, 2006.

LOUDON, JOHN CLAUDIUS. *The Derby Arboretum*. London: Longman, Orme, Brown, Green, and Longmans, 1840.

LOUDON, MRS. [JANE]. *Botany for Ladies; or, A Popular Introduction to the Natural System of Plants, According to the Classification of De Candolle*. London: J. Murray, 1842.

———. *Gardening for Ladies, and, Companion to the Flower-Garden*. A.J. Downing, ed. New York: Wiley & Putnam, 1843.

LYON-JENNESS, CHERYL. *For Shade and for Comfort: Democratizing Horticulture in the Nineteenth-Century Midwest*. West Lafayette, IN: Purdue University Press, 2004.

MacPHAIL, IAN. *André & François-André Michaux*. Lisle, IL: The Morton Arboretum, 1981.

MacPhail, Ian, and Joseph Ewan. *Hortus Botanicus: The Botanic Garden and the Book*. Chicago: The Newberry Library, 1972.

Madriñán, Santiago. *Nikolaus Joseph Jacquin's American Plants: Botanical Expedition to the Caribbean (1754–1759) and the Publication of the Selectarum stirpium Americanarum historia*. Boston: Brill, 2013.

Major, Judith K. *Mariana Griswold Van Rensselaer: A Landscape Critic in the Gilded Age*. Charlottesville and London: University of Virginia Press, 2013.

———. *To Live in the New World: A. J. Downing and American Landscape Gardening*. Cambridge, MA and London: MIT Press, 1997.

Marzio, Peter C. *Chromolithography, 1840–1900: The Democratic Art*. Boston: David Godine; Forth Worth, TX: Amon Carter Museum, 1979.

McKelvey, Blake. "The Flower City: Center of Nurseries and Fruit Orchards." *Rochester Historical Society Publications* 18, part 2 (1940): 121–169.

Meyers, Amy R.W., ed. *Knowing Nature: Art and Science in Philadelphia, 1740–1840*. New Haven and London: Yale University Press, 2011.

Mickulas, Peter. *Britton's Botanical Empire: The New York Botanical Garden and American Botany, 1888–1929*. New York: The New York Botanical Garden Press, 2007.

———. "Cultivating the Big Apple: The New York Horticultural Society, Nineteenth-Century New York Botany, and The New York Botanical Garden," *New York History* 83, no. 1 (Winter 2002): 34–54.

Miller, Wilhelm. "Horticulture." In Liberty Hyde Bailey, ed. *The Standard Cyclopedia of Horticulture*, vol. 2, 1516–1518. Revised edition, New York: MacMillan, 1942.

Morawetz, W., and M. Röser. *Eduard Friedrich Poeppig 1798–1868: Gelehrter und Naturforscher in Südamerika*. Leipzig: Universität Leipzig Institut für Botanik, 1998.

Mosser, Monique, and Georges Teyssot, eds. *The Architecture of Western Gardens: A Design History from the Renaissance to the Present*. Cambridge, MA: MIT Press, 1991.

Mullaly, John. *The New Parks Beyond the Harlem*. New York: Record & Guide, 1887.

Myers, K.A. *Fernández de Oviedo's Chronicle of America: A New History for a New World*. Austin, TX: University of Texas Press, 2007.

Nissen, Claus. *Die botanische Buchillustration, ihre Geschichte und Bibliographie*. Stuttgart: Hiersemann, 1966.

O'Donnell, Patricia. *The New York Botanical Garden Cultural Landscape Report: Landscape History*. Charlotte, VT: Heritage Landscapes, 2008.

Olmsted Brothers. *Report on The New York Botanical Garden*, 1924.

O'Malley, Therese. *Glasshouses: The Architecture of Light and Air*. Bronx, NY: The New York Botanical Garden, 2005.

———. *Keywords in American Landscape Design*. With contributions by Elizabeth Kryder-Reid and Anne L. Helmreich. New Haven and London: Yale University Press, 2010.

Paine, Lincoln P. *Ships of Discovery and Exploration*. Boston: Houghton Mifflin Co., 2000.

Paris, H.S., M.C. Daunay, M. Pitrat, and J. Janick. "First Known Image of *Cucurbita* in Europa, 1503–1508." *Annals of Botany* 98, no. 1 (2006): 41–47.

Parsons, Samuel, Jr. *How to Plan the Home Grounds*. New York: Doubleday & McClure Co., 1899.

Pauly, Philip J. *Fruits and Plains: The Horticultural Transformation of America*. Cambridge, MA: Harvard University Press, 2007.

Prince, Sue Ann, ed. *Of Elephants & Roses: Encounters with French Natural History, 1790–1830*. American Philosophical Society, 2013.

Rand, Edward Sprague, Jr. *Flowers for the Parlor and Garden*. Boston: J.E. Tilton & Company, 1863.

Raphael, Sandra, and Greg Heins. *An Oak Spring Sylva: A Selection of the Rare Books on Trees in the Oak Spring Garden Library*. Upperville, VA: Oak Spring Garden Library, 1989.

Reed, John F. "The Library of The New York Botanical Garden." *Garden Journal* (May/June 1969): 77–88.

Riddle, John M. *Dioscorides on Pharmacy and Medicine*. Austin, TX: University of Texas Press, 1985.

Riedl-Dorn, C. *Die grüne Welt der Habsburger: zur Ausstellung auf Schloß Artstetten 1. April bis 2. November 1989*. Vienna: Naturhistorisches Museum Wien, 1989.

———. "Eduard Poeppigs Briefe an Stephan L. Endlicher und seine Bilder im Naturhistorischen Museum in Wien." In W. Morawetz, and M Röser, eds. *Eduard Poeppig 1798–1868: Gelehrter und Naturforscher in Südamerika*. Leipzig: Universität Leipzig Institut für Botanik, 1998, 87–143.

Rix, Martyn. *The Art of the Plant World: The Great Botanical Illustrators and Their Work*. Woodstock, NY: Overlook Press, 1981.

Robbins, Christine Chapman. "David Hosack's Herbarium and its Linnaean Specimens." *Proceedings of the American Philosophical Society* 104, no. 3 (June 1960): 293–313.

Selected Bibliography

ROCHE, Y.T., A. PRESOTTO, AND F. CAVALHEIRO. "The Representation of *Caesalpinia echinata* (brazilwood) in Sixteenth and Seventeenth-Century Maps." *Anais da Academia Brasileira de Ciências* 79, no. 4 (2007): 751–765.

ROGERS, ELIZABETH BARLOW. *Landscape Design. A Cultural and Architectural History.* New York: Harry N. Abrams, 2001.

ROGERS, ELIZABETH BARLOW, ELIZABETH S. EUSTIS, AND JOHN BIDWELL. *Romantic Gardens: Nature, Art, and Landscape Design.* New York: The Morgan Library and Museum and the Foundation for Landscape Studies; Jaffrey, NH: David R. Godine, 2010.

RUDOLPH, EMANUEL DAVID. *Emanuel D. Rudolph's Studies in the History of North American Botany.* Fort Worth, TX: Botanical Research Institute of Texas, 2000.

SAUNDERS, GIL. *Picturing Plants, An Analytical History of Botanical Illustration.* London: Victoria and Albert Museum, 1995.

SCHLERETH, THOMAS J. "Country Stores, County Fairs, and Mail-Order Catalogues: Consumption in Rural America." In Simon J. Bronner, ed. *Consuming Visions: Accumulation and Display of Goods in America, 1880–1920*, Winterthur, DE: Winterthur Museum and New York: Norton, 1989, 339–375.

SCHMUTZER, K. *Der Liebe zur Naturgeschichte halber: Johann Natterers Reisen in Brasilien 1817–1836.* Vienna: Verlag der Österreichischen Akademie der Wissenschaften, 2011.

SELLERS, VANESSA BEZEMER. *Courtly Gardens in Holland 1600–1650: The House of Orange and the Hortus Batavus.* Amsterdam: Architectura & Natura Press, 2001.

SHOEMAKER, CANDICE A. *Chicago Botanic Garden Encyclopedia of Gardens: History and Design.* 3 vols. Chicago and London: Fitzroy Dearborn Publishers, 2001.

SHTEIR, ANN B. *Cultivating Woman, Cultivating Science: Flora's Daughters and Botany in England, 1760 to 1860.* Baltimore and London: The Johns Hopkins University Press, 1996.

SINON, STEPHEN. "Botanica Collected: Nicolas Robert." *The Botanical Artist* 19, no. 2, (2013): 28–29.

STAFLEU, FRANS A. "Jacquin, European Botanist." In *Nicolai Josephi Jacquin Selectarum stirpium Americanarum historia.* New York: Hafner Publishing Co., 1971.

——. *Linnaeus and the Linnaeans. The Spreading of Their Ideas in Systematic Botany, 1735–1789* [Published for the International Association for Plant Taxonomy]. Utrecht: Oosthoek, 1971.

STAFLEU, FRANS A., AND RICHARD S. COWAN. *Taxonomic Literature: A Selective Guide to Botanical Publications and Collections with Dates, Commentaries and Types*, 2nd ed. Utrecht: Bohn, Scheltema and Holkema, 1976–1988.

STAFLEU, FRANS A., E.A. MENNEGA, AND L.J. DORR. *Taxonomic Literature: a Selective Guide to Botanical Publications and Collections with Dates, Commentaries and Types.* Supplement 1–6. Königstein: Koeltz Scientific Books, 1992–2009.

STEARN, WILLIAM T. "Botanical Gardens and Botanical Literature in the Eighteenth Century." *Catalogue of Botanical Books in the Collections of Rachel McMasters Miller Hunt.* Pittsburgh: Hunt Foundation, 1961.

——. *Three Prefaces on Linnaeus and Robert Brown, by William T. Stearn.* Weinheim: J. Cramer, 1962.

STEELE, ARTHUR R. *Flowers for the King: The Expedition of Ruiz and Pavon and the Flora of Peru.* Durham, NC: Duke University Press, 1964.

ŠUR, LEONID A., ED. *Materialy e'kspedicii akademika Grigorija Ivanoviča Langsdorfa v Braziliju v 1821–1829 gg.* Leningrad: Izd. Nauka, 1973.

SWAN, CLAUDIA. "The Uses of Botanical Treatises in The Netherlands, c. 1600." In Therese O'Malley and Amy R. W. Meyers, eds. *The Art of Natural History. Illustrated Treatises and Botanical Paintings, 1400–1850.* New Haven and London: Yale University Press, 2008, 62–81.

TAYLOR, PATRICK, ED. *The Oxford Companion to the Garden.* Oxford and New York: Oxford University Press, 2006.

THACHER, JAMES. *The American Orchardist.* Boston: Joseph W. Ingraham, 1822.

TOMASI, LUCIA TONGIORGI. *An Oak Spring Herbaria: Herbs and Herbals from the Fourteenth to the Nineteenth Centuries: a Selection of the Rare Books, Manuscripts and Works of Art in the Collection of Rachel Lambert Mellon.* Upperville, VA: Oak Spring Garden Library, 2009.

——. *The Renaissance Herbal.* Catalog published in association with the exhibition held in the William D. Rondina and Giovanni Foroni LoFaro Gallery, the LuEsther T. Mertz Library at The New York Botanical Garden. Bronx, NY: The New York Botanical Garden, 2013.

UNCLE PHILIP [FRANCIS L. HAWKS]. *The American Forest, or, Uncle Philip's Conversations with the Children about the Trees of America.* New York: Harper & Brothers, 1868.

URBAN, IGNATZ. "Vitae itineraque collectorum botanicorum, notae collaboratorum biographicae, florae Brasiliensis ratio edendi chronologica, systema, index familiarum." In Carl Friedrich Philipp von Martius, ed. *Flora Brasiliensis. Enumeratio plantarum in Brasilia hactenus detectarum quas suis aliorumque botanicorum studiis descriptas et methodo naturali digestas partim icone illustratas*, 1 (1). Monachii, Lipsiae: Apud R. Oldenbourg in comm., 1906.

VAN RAVENSWAAY, CHARLES. *Drawn from Nature: The Botanical Art of Joseph Prestele and His Sons.* Washington, DC: Smithsonian Institution Press, 1984.

VAN RENSSELAER, MRS. SCHUYLER. *Art Out-of-Doors: Hints on Good Taste in Gardening.* New York: Charles Scribner's Sons, 1893.

VAUX, CALVERT. *Villas and Cottages: A Series of Designs Prepared for Execution in the United States.* New York: Harper & Brothers, 1857.

WARD, N.B. *On the Growth of Plants in Closely Glazed Cases.* London: J. Van Voorst, 1842.

WEIDENMANN, JACOB. *Beautifying Country Homes: A Handbook of Landscape Gardening. Illustrated by Plans of Places Already Improved.* New York: Orange Judd and Company, 1870.

WHITEHEAD, P.J.P. "The Biography of Georg Marcgraf (1610–1643/44) by His Brother Christian, Translated by James Petiver." *Journal of the Society for the Bibliography of Natural History* 9, no. 3 (1979): 301–314.

———. "The Original Drawings of the Historia Naturalis Brasiliae of Piso and Marcgrave (1648)." *Journal of the Society for the Bibliography of Natural History* 7, no. 4 (1976): 409–422.

WOODBURN, ELISABETH. "Horticultural Heritage: The Influence of U.S. Nurserymen." In Alan E. Fusonie and Leila P. Moran, eds. *Agricultural Literature: Proud Heritage—Future Promise.* Washington, DC: National Agricultural Library, 1977, 109–141.

WOUDSTRA, JAN. "From *bosquet a l'angloise* to *jardin a l'anglaise.* The Progression of the Mingled Manner of Planting from Its Inception to Its Decline and Survival." *Studies in the History of Gardens and Designed Landscapes* 33, no. 2 (2013): 71–95.

CONTRIBUTORS

GINA DOUGLAS is the Honorary Archivist and a Fellow of the Linnean Society, London. In her position as Librarian and Archivist of the Society from 1983 to 2007, she was closely involved with the creation of the online library catalog, the Linnaeus Link Project, and the digitization of the Linnaean biological collections. She was also involved with the project of converting to digital form the correspondence of James Edward Smith and the specimens of his herbarium. Since her retirement, she has returned to the Linnean Society on a volunteer basis. Douglas is one of the founding members of the European Botanical and Horticultural Libraries' group and has been Meetings Secretary for the Society for the History of Natural History since 2000. She has contributed to numerous scholarly publications, including *Linnaeus in Italy: The Spread of a Revolution in Science* (Uppsala Studies in History of Science 34, 2007), edited by M. Beretta and A. Tosi.

ELIZABETH S. EUSTIS is an independent scholar specializing in the art history of gardens. Member of The New York Botanical Garden Library Visiting Committee, she curated the LuEsther T. Mertz Library's exhibition *European Pleasure Gardens: Rare Books and Prints of Historic Landscape Design from the Collection of Elizabeth Kals Reilley* and wrote its catalog (2003). Co-curator and co-author of *Romantic Gardens: Nature, Art, and Landscape Design* at The Morgan Library (2010), she also contributed to the Stanford University catalog *Viewing the Changing Garden* (1993). Educated at Smith College, the Cooper Hewitt National Design Museum, and the Bard Graduate Center, she has taught at the Radcliffe Landscape Seminars, the Arnold Arboretum of Harvard University, and The Landscape Institute of Boston Architectural College. She was former President of the New England Wild Flower Society's Board of Trustees.

SUSAN M. FRASER is Director of the LuEsther T. Mertz Library at The New York Botanical Garden, where she oversees an outstanding collection of print and non-print resources. She plays a pivotal role in the Garden's digitization program, as well as the exhibition program in the William D. Rondina and Giovanni Foroni

Contributors

LoFaro Gallery. She received her MLS from Columbia University. She is an active member of the Council of Botanical and Horticultural Libraries (CBHL), is on the Executive Committee of the Biodiversity Heritage Library (BHL), and also serves on the Council of the Torrey Botanical Society as the Society's Historian. Her publications include "Henry Hurd Rusby: The Father of Economic Botany at The New York Botanical Garden," in *Brittonia* 44, 3 (1992); "Botanical Information: Resource and User Needs," in *Science and Technology Libraries* 21, 3–4 (2003); "A Treasury of Botanical Knowledge: The LuEsther T. Mertz Library," in *The New York Botanical Garden*, edited by Gregory Long and Anne Skillion (Abrams, 2006); and "The Genius of Georg Ehret: His Art and Influence," in *The Botanical Artist* (2009).

H. WALTER LACK is Director at the Botanic Garden and Botanical Museum Berlin-Dahlem, Professor Extraordinarius at the Freie Universität Berlin and Head of the Science Libraries of the University. He has published extensively and widely on the history of plant taxonomy, notably on botanical illustration and exploration, and the taxonomy of *Cichorieae*. He has organized major exhibitions in several venues, including Berlin and Vienna. Lack has been Visiting Professor at several universities and Visiting Fellow at Magdalen College, Oxford. He is a recipient of the prestigious Engler Medal of IAPT and a member of the Academy of Sciences at Erfurt. His recent publications include *The Flora Graeca Story* (Oxford University Press, 1999), *A Garden Eden* (Taschen, 2008), and *Alexander von Humboldt and the Botanical Exploration of the Americas* (Prestel, 2009).

MARK LAIRD, Senior Lecturer in the History of Landscape Architecture at the Graduate School of Design, Harvard University, teaches early modern landscape history. Based in Toronto as a consultant in historic landscape preservation, he advises on sites in Europe, America, and Canada, notably Strawberry Hill (England), Belvedere (Austria), and Fürst-Pückler Park (Germany). Laird's research on eighteenth-century planting developed from his practice at Painshill and is presented in *The Flowering of the Landscape Garden* (University of Pennsylvania Press, 1999). Writing extensively on the history of horticulture and natural history, and on preservation philosophy and practice, his most recent publications include "Greenhouse Technologies and Horticulture," in *Technology and the Garden*, Michael G. Lee and Kenneth I. Helphand, eds. (Dumbarton Oaks, 2014), and *A Natural History of English Gardening: 1650–1800* (Yale Univerisity Press, forthcoming in 2015). Educated at the Universities of Oxford, Edinburgh, and York, he was Research Fellow at Chelsea Physic Garden in London, and at Dumbarton Oaks, where he recently served as a Senior Fellow.

JUDITH K. MAJOR is a landscape historian and author of *To Live in the New World: A. J. Downing and American Landscape Gardening* (MIT Press, 1997), and *Mariana Griswold Van Rensselaer: A Landscape Critic in the Gilded Age* (University of Virginia Press, 2013). Major holds a Ph.D. in Architecture from the University of Pennsylvania with a field of specialization in nineteenth-century American landscape history and theory, and a Master of Landscape Architecture from the University of Virginia. She is Professor Emeritus of landscape architecture at Kansas State University.

THERESE O'MALLEY is Associate Dean at the Center for Advanced Study in the Visual Arts at the National Gallery of Art in Washington, D.C. where she has worked since 1984. She has published and lectured widely on the history of landscape architecture and garden design, primarily in the eighteenth and nineteenth centuries, concentrating on the transatlantic exchange of plants, ideas, and people. Her recent publications include a reference work entitled *Keywords in American Landscape Design* (National Gallery of Art/Yale University Press, 2010) and "Mildred Barnes Bliss' Garden Library at Dumbarton Oaks" (Dumbarton Oaks, 2011). She was curator of *Glasshouses, The Architecture of Light and Air* at The New York Botanical Garden in 2005.

ELIZABETH BARLOW ROGERS is the President of the Foundation for Landscape Studies. A native of San Antonio, Texas, Rogers earned a B.A. from Wellesley College and M.A. in City Planning from Yale University. In 1979 she was appointed Central Park Administrator, and was instrumental in founding the Central Park Conservancy in 1980. A writer on the history of landscape design and the cultural meaning of place, Rogers is the author of *The Forests and Wetlands of New York City* (1971); *Frederick Law Olmsted's New York* (1972); *Rebuilding Central Park: A Management and Restoration Plan* (1987); *Landscape Design: A Cultural and Architectural History* (2001); *Romantic Gardens: Nature, Art, and Landscape Design* (2010); *Writing the Garden: A Literary Conversation Across Two Centuries* (2011), and *Learning Las Vegas: Portrait of a Northern New Mexican Place* (2013).

VANESSA BEZEMER SELLERS, garden and landscape historian, studied at Leiden University, the Netherlands, and received her Ph.D. from Princeton University. She was a fellow at Dumbarton Oaks, the Harvard Research Institute for Garden and Landscape Studies. Sellers taught at the Bard Graduate Center and worked for the Metropolitan Museum of Art in New York, and lectured extensively in the United States and abroad. Executive editor of *Flora Illustrata*, she heads the Humanities Institute at The New York Botanical Garden and is also a member of the Garden's Library Visiting Committee. Her publications include *Courtly Gardens in Holland 1600-1650* (Amsterdam, 2001); *Magnificent Buildings, Splendid Gardens*, David R. Coffin (Princeton, 2008) (editor); *Gijsbert van Laar (1767-1820) Storehouse of Garden Ornaments* (New York: Foundation for Landscape Studies, 2011).

LUCIA TONGIORGI TOMASI was Full Professor and former Vice Rector of the University of Pisa. She was inducted in 2010 into the University's *Ordine del Cherubino* for her outstanding academic achievements. She has been Visiting Professor at the Getty Center and at Oxford University, a Fellow of the Linnean Society of London, a Paul Mellon Senior Fellow at the Center for Advanced Studies and at Dumbarton Oaks in Washington, DC. Tomasi has been the curator of various exhibitions both in Italy and abroad, most recently for *The Renaissance Herbal* at The New York Botanical Garden in 2013. She collaborated on *Jacopo Ligozzi, "pittore universalissimo"* (Florence, Galleria Palatina, 2014), and *Arcimboldo. Artista Milanese tra Leonardo et Michelangelo* (Milan, 2011). She was co-curator and author of *The Flowering of Florence: Botanical Art for the Medici* at the National Gallery of Art (Washington, DC, 2008). A prolific writer, she has authored more than 120 publications—all focusing on the relationship among art, science, and nature, including her award-winning book, *An Oak Spring Herbaria* (2009).

INDEX